ONE HUNDRED
SAINTS

ONE HUNDRED
SAINTS

THEIR LIVES AND LIKENESSES
DRAWN FROM BUTLER'S
"LIVES OF THE SAINTS"
AND GREAT WORKS
OF WESTERN
ART ~

A BULFINCH PRESS BOOK
LITTLE, BROWN AND COMPANY

Boston ~ New York ~ London

CONTENTS

EDITOR'S NOTE

Saints are with us always. As namesakes or patrons, historical figures or spiritual models, the company of saints has played an important role in the lives of millions of people. They have also provided the basis for some of the greatest Western art. Whether the result of personal devotion or church patronage, magnificent mosaics, frescoes, canvases, sculptures, stained-glass windows, illuminated manuscripts and engravings have been created bearing the likenesses of these blessed individuals.

There is no lack of books that recount stories of saints, and scholarly compilations of black-and-white, postage stamp–size reproductions of hagiographical works of art are available as well. The surprise, then, lies in the dearth of books that bring together the stories and the pictures. *One Hundred Saints* has been compiled to provide such a book. Selection of the saints was directed by their popularity and by the availability of exemplary art.

The text is adapted from the Reverend Alban Butler's long-revered *The Lives of the Saints,* first published in London between 1756 and 1759 under the title *The Lives of the Fathers, Martyrs and other Principal Saints.* The stories of all but one of the saints presented herein are derived from the 1926–1938 edition, which resulted from the thorough revision carried out by Father Herbert Thurston, S.J., and, later, Donald Attwater. The life of that one remaining saint — Elizabeth Ann Seton, the first, and so far only, American-born saint — comes from the 1991 "New Concise Edition," edited by Michael Walsh.

Regardless of edition, Butler tells much about the history and lore that surround these true-life figures. His sources ranged from the New Testament to *The Golden Legend,* firsthand accounts of witnesses and letters from the pens of the saints themselves. The resulting narrative recalls men and women steeped in knowledge or little educated; worldly or reclusive; of great emotional and physical courage or removed from the cares and stresses of everyday life. Scholars, politicians, innovators, monks, nuns, priests, peasants, kings and queens — all have one common trait: a life devoted to God.

Illustrating such a book with great art can prove to be both frustrating and revelatory. While magnificent depictions abound of John the Baptist, Jerome or Catherine of Alexandria, other members of the holy company seem nearly to have eluded the brush or the sculptor's tools. Depictions of some of the modern saints, born during a time when most artists had opted for non-sacred subject matter, may at first seem out of place amidst the glories created by the likes of Raphael, Titian, Rubens or Zurbarán. But since pictures by these more recent figures reflect the ways in which artists grappled with ideas about religion during times of growing doubt and faithlessness, these works of art have their place here as revelations of personal spirituality as well as examples of public devotional items.

One Hundred Saints has been compiled as a gift to the Christian faithful. Our aim in publishing this volume is to provide a beautiful, informative book for those wishing to know more about the saints and the varieties of Christian art. It is intended for anyone whose interest is attended by a willingness to go back in time in order to comprehend the holiness of mere mortals and the good works they performed for the world, in honor of their God.

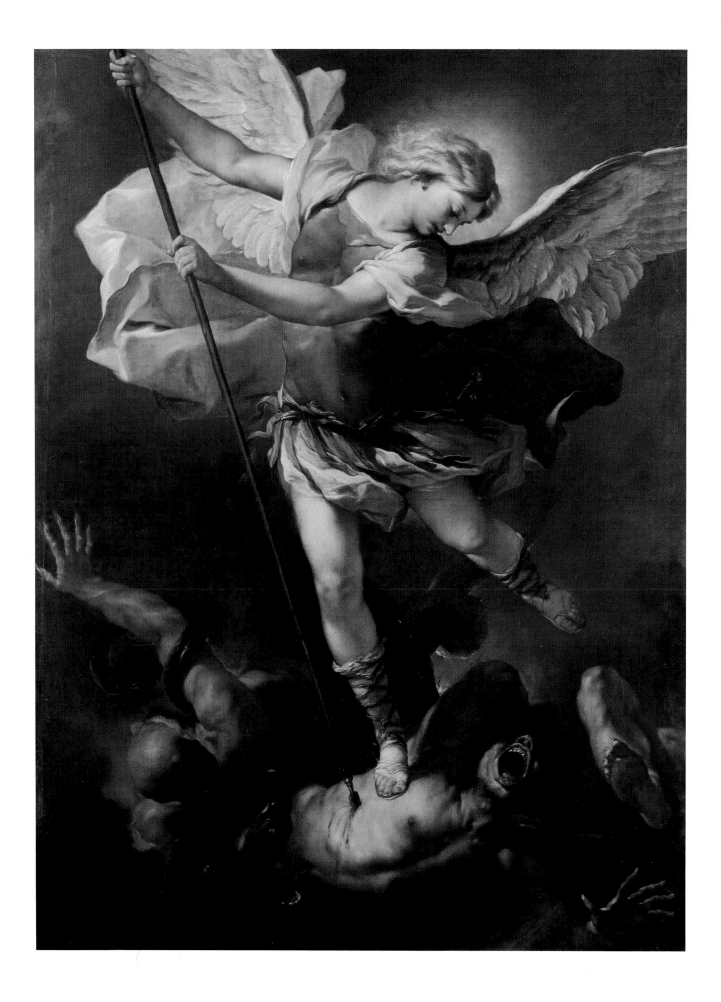

ST. MICHAEL THE ARCHANGEL

May 8 and September 29

Patron Saint of Germany; Grocers; Paratroopers; Police; Radiologists; the Sick

THE TENTH AND TWELFTH chapters of the Book of Daniel speak of Michael as "one of the chief princes," the special protector of Israel, and describe how at that time shall Michael rise up, "the great prince who standeth for the children of thy people" (Dan. xii 1). In the *Book of Henoch,* in the Old Testament apocrypha, Michael "is set over the best part of mankind," i.e. over the chosen race who are the inheritors of the promises. He is merciful, and it is he who will explain the mystery which underlies the dread judgments of the Almighty. Michael is depicted as ushering Henoch himself into the divine presence, but he is also associated with the other great archangels, Gabriel, Raphael and Phanuel, in binding the wicked potentates of earth and casting them into a furnace of fire.

In New Testament times it is written in the Apocalypse of St. John (xii 7–9) that "there was a great battle in Heaven. Michael and his angels fought with the dragon, and the dragon fought and his angels; and they prevailed not, neither was their place found any more in Heaven. And that great dragon was cast out, that old serpent who is called the Devil and Satan, who seduceth the whole world: and he was cast unto the earth, and his angels were thrown down with him." In a very extravagant apocryphal writing of Jewish origin known as the *Testament of Abraham* Michael is presented to the reader as God's commander-in-chief, the organizer of all the divine relations with earth, one whose intervention is so powerful with God that at his word souls can be rescued even from Hell itself.

Michaelmas has been kept with great solemnity at the end of September ever since the sixth century at least. The Roman Martyrology implies that the dedication of the famous church of St. Michael on Mount Gargano gave occasion to the institution of this feast in the West, but it would appear that it really celebrates the dedication of a basilica in honor of St. Michael on the Salarian Way six miles north of Rome. In the East, where he was regarded as having care of the sick, veneration of this archangel began yet earlier.

Though only St. Michael be mentioned in the title of this festival, it appears from the prayers of the Mass that all the good angels are its object. On it we are called upon to give thanks to God for the glory which the angels enjoy and to rejoice in their happiness; to thank Him for His mercy in constituting such beings to minister to our salvation by aiding us; to join them in worshipping and praising God, praying that we may do His will as it is done by these blessed spirits in Heaven; and lastly, we are invited to honor them and implore their intercession and succor.

Editor's note: The Church calendar includes two feasts for St. Michael — that commemorating his appearance, on May 8, and that for the dedication of his basilica, on September 29. The latter, known as Michaelmas, is the source for the entry presented here.

ST. MICHAEL THE ARCHANGEL
Luca Giordano. *St. Michael,* c. 1663. Gemäldegalerie, Berlin

ST. RAPHAEL THE ARCHANGEL

October 24

Patron Saint of the Blind; Nurses; Physicians; Travelers

OF THE SEVEN ARCHANGELS, who in both Jewish and Christian tradition are venerated as pre-eminently standing before the throne of God, three only are mentioned by name in the Bible, Michael, Gabriel and Raphael. These have been venerated in the Church from early times, especially in the East, but it was not till the pontificate of Pope Benedict XV that the liturgical feasts of the two last were made obligatory throughout the Western church.

It is recorded in the sacred book of the history of Tobias that St. Raphael was sent by God to minister to the old Tobias, who was blind and greatly afflicted, and to Sara, daughter of Raguel, whose seven bridegrooms had each perished on the night of their wedding. And when the young Tobias was sent into Media to collect money owing to his father, it was Raphael who, in the form of a man and under the name of Azarias, accompanied him on the journey, helped him in his difficulties, and taught him how safely to enter into wedlock with Sara. "He conducted me," says Tobias, "and brought me safe again. He received the money of Gabelus. He caused me to have my wife, and he chased from her the evil spirit. He gave joy to her parents. Myself he delivered from being devoured by the fish; thee also he hath made to see the light of Heaven; and we are filled with all good things through him." The offices of healing performed by the angel in this story and the fact that his name signifies "God has healed" has caused Raphael to be identified with the angel who moved the waters of the healing sheep-pool (John v 1–4); this identity is recognized in the liturgy by the reading of that passage of the gospel in the Mass of St. Raphael's feast. In Tobias xii 12 and 15, the archangel directly speaks of himself as "one of the seven who stand before the Lord," and says that he continually offered the prayers of young Tobias up to God.

ST. RAPHAEL THE ARCHANGEL
Bacchiacca. *Tobias and the Angel.* Wadsworth Athenaeum, Hartford

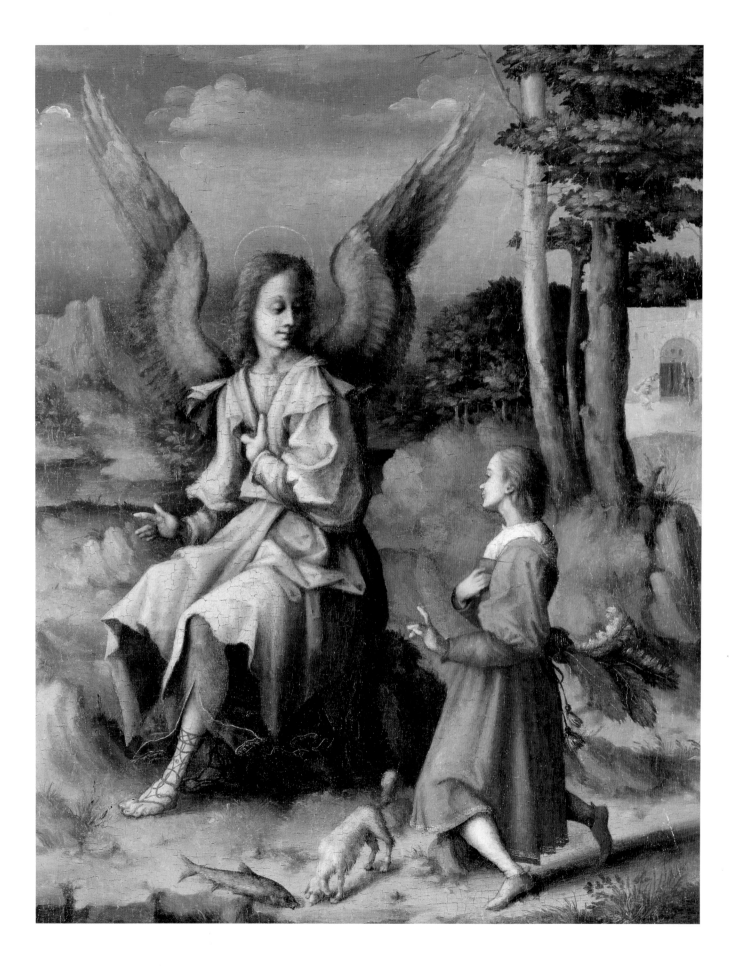

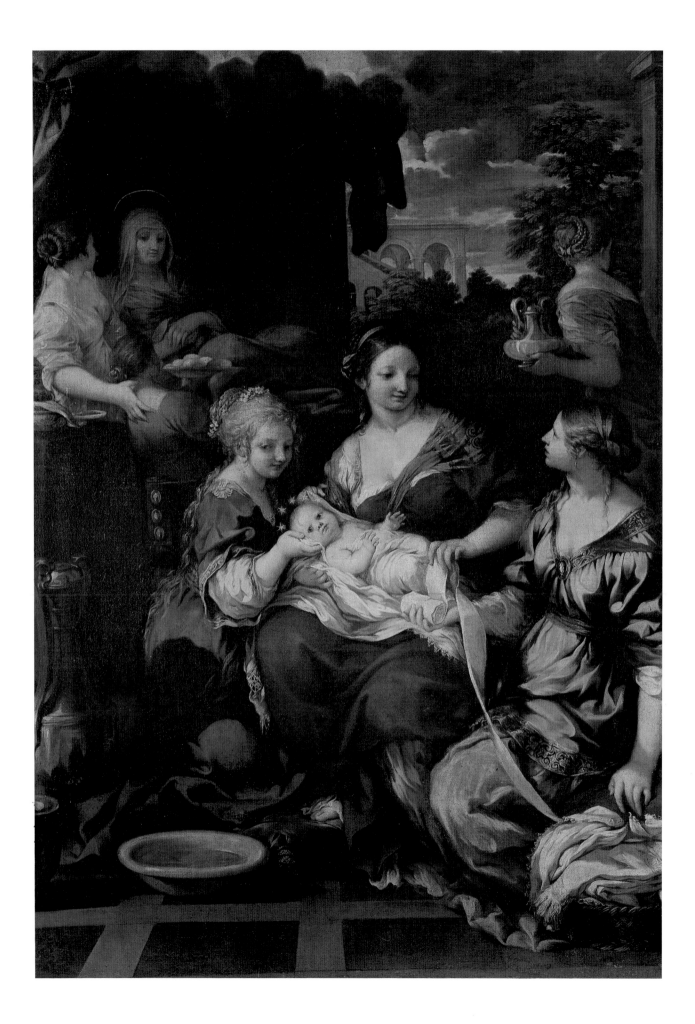

ST. ANNE, MATRON

July 26

Patron Saint of Canada; Cabinetmakers; Housewives; Women in Labor

OF THE MOTHER OF OUR LADY nothing is certainly known; even for her name and that of her husband Joachim we have to depend on the testimony of the apocryphal *Protevangelium of James* which, though its earliest form is very ancient, is not a trustworthy document. The story there told is that his childlessness was made a public reproach to Joachim, who retired to the desert for forty days to fast and pray to God. At the same time Anne (*Hannah,* which signifies "grace") "mourned in two mournings, and lamented in two lamentations," and as she sat praying beneath a laurel bush an angel appeared and said to her, "Anne, the Lord hath heard thy prayer, and thou shalt conceive and bring forth, and thy seed shall be spoken of in all the world." And Anne replied, "As the Lord my God liveth, if I beget either male or female I will bring it as a gift to the Lord my God; and it shall minister to Him in holy things all the days of its life." Likewise an angel appeared to her husband, and in due time was born of them Mary, who was to be the mother of God. It will be noticed that this story bears a startling resemblance to that of the conception and birth of Samuel, whose mother was called Anne (I Kings i); the early Eastern fathers saw in this only a parallel, but it is one which suggests confusion or imitation in a way that the obvious parallel between the parents of Samuel and those of St. John the Baptist does not.

The early *cultus* of St. Anne in Constantinople is attested by the fact that in the middle of the sixth century the Emperor Justinian I dedicated a shrine to her. The devotion was probably introduced into Rome by Pope Constantine (708–715). There are two eighth-century representations of St. Anne in the frescoes of S. Maria Antiqua; she is mentioned conspicuously in a list of relics belonging to S. Angelo in Pescheria, and we know that Pope St. Leo III (795–816) presented a vestment to St. Mary Major which was embroidered with the Annunciation and St. Joachim and St. Anne. But though there is very little to suggest any widespread *cultus* of the saint before the middle of the fourteenth century, this devotion a hundred years afterwards became enormously popular, and was later on acrimoniously derided by Luther. The so-called *selbdritt* pictures (i.e. Jesus, Mary and Anne) were particularly an object of attack. The first papal pronouncement on the subject, enjoining the observance of an annual feast, was addressed by Urban VI in 1382, at the request of certain English petitioners, to the bishops of England alone. It is quite possible that it was occasioned by the marriage of King Richard II to Anne of Bohemia in that year. The feast was extended to the whole Western church in 1584.

ST. ANNE
Pietro da Cortona. *The Nativity of the Virgin.* Louvre, Paris

ST. GABRIEL THE ARCHANGEL

March 24

Patron Saint of Broadcasters; Clerics; Messengers; Postal Workers; Radio Workers;
Telecommunications Workers; Telephone Workers; Television Workers

B Y A DECREE of the Congregation of Sacred Rites dated October 26, 1921, issued by command of Pope Benedict XV, it was directed that the feast of St. Gabriel the Archangel should be kept in future as a greater double on March 24 throughout the Western church. According to Daniel (ix 21) it was Gabriel who announced to the prophet the time of the coming of the Messiah, that it was he again who appeared to Zachary "standing on the right side of the altar of incense" (Luke i 10 and 19) to make known the future birth of the Precursor, and finally that it was he who as God's ambassador was sent to Mary at Nazareth (Luke i 26) to proclaim the mystery of the Incarnation. It was therefore very appropriate that Gabriel should be honored on this day which immediately precedes the feast of the Annunciation of the Blessed Virgin. There is abundant archaeological evidence that the *cultus* of St. Gabriel is in no sense a novelty. An ancient chapel close beside the Appian Way, rescued from oblivion by Armellini, preserves the remains of a fresco in which the prominence given to the figure of the archangel, his name being written underneath, strongly suggests that he was at one time honored in that chapel as principal patron. There are also many representations of Gabriel in the early Christian art both of East and West which make it plain that his connection with the sublime mystery of the Incarnation was remembered by the faithful in ages long anterior to the devotional revival of the thirteenth century.

This messenger is the appropriate patron-saint of postal, telegraph and telephone workers.

ST. GABRIEL THE ARCHANGEL
Eustache Le Sueur. *The Annunciation*, c. 1650. Toledo Museum of Art, Toledo, Ohio

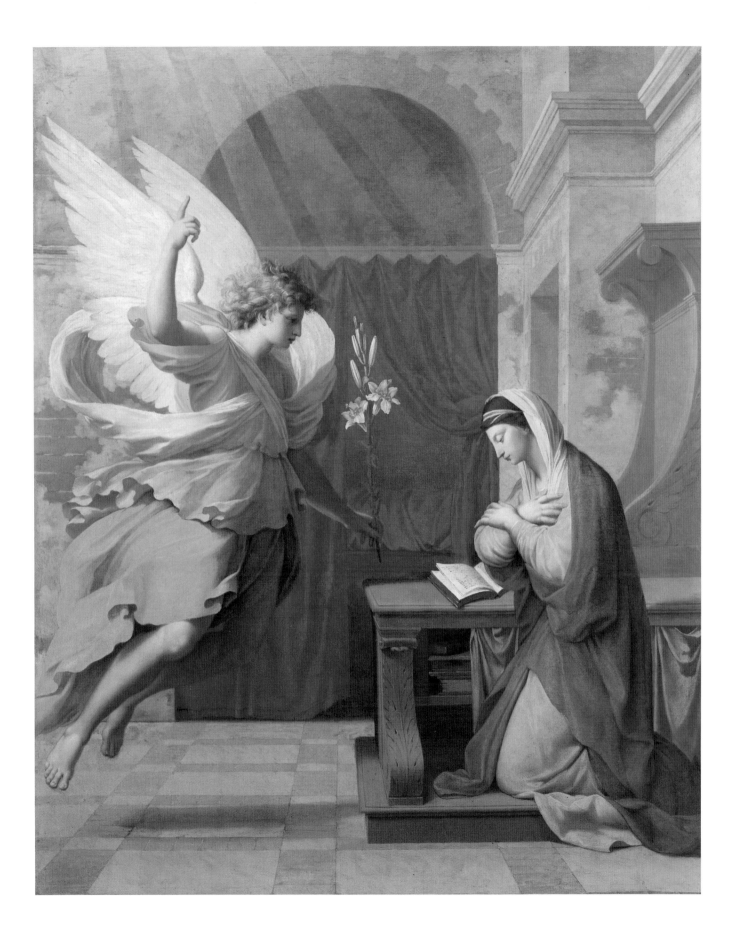

ST. JOSEPH,
HUSBAND OF OUR LADY ST. MARY

March 19

Patron Saint of Belgium; Canada; China; Peru; Carpenters; the Church; the Dying;
Fathers of Families; Social Justice; Workingmen

ACCORDING TO THE ROMAN MAR-
TYROLOGY March 19 is "the [heavenly] birthday of St. Joseph, husband of the most Blessed Virgin Mary and confessor, whom the Supreme Pontiff Pius IX, assenting to the desires and prayers of the whole Catholic world, has proclaimed patron of the Universal Church." The history of his life, says Butler, has not been written by men, but his principal actions, through the inspired evangelists, are recorded by the Holy Ghost Himself. What is told in the gospels concerning him is so familiar that it needs no commentary. He was of royal descent and his genealogy has been set out for us both by St. Matthew and by St. Luke. He was the protector of our Lady's good name, and in that character of necessity the confidant of Heaven's secrets, and he was the foster-father of Jesus, charged with the guidance and support of the holy family, and responsible in some sense for the education of Him who, though divine, loved to call Himself "the son of man." It was Joseph's trade that Jesus learnt, it was his manner of speech that the boy will have imitated, it was he whom our Lady herself seemed to invest with full parental rights when she said without qualification, "Thy father and I have sought thee sorrowing." No wonder that the evangelist adopted her phrase and tells us, in connection with the incidents which attended the Child's presentation in the Temple, that "His father and mother were wondering at those things which were spoken concerning Him."

None the less our positive knowledge concerning St. Joseph's life is very restricted, and the "tradition" enshrined in the apocryphal gospels must be pronounced to be quite worthless. We may assume that he was betrothed to Mary his bride with the formalities prescribed by Jewish ritual, but the nature of this ceremonial is not clearly known, especially in the case of the poor; and that Joseph and Mary were poor is proved by the offering of only a pair of turtle-doves at Mary's purification in the Temple. By this same poverty the story of the competition of twelve suitors for Mary's hand, of the rods deposited by them in the care of the High Priest and of the portents which distinguished the rod of Joseph from the rest, is shown to be quite improbable. The details furnished in the so-called "Protevangelium," in the "Gospel of Pseudo-Matthew," in the "History of Joseph the Carpenter," etc., are in many respects extravagant and inconsistent with each other. We must be content to know the simple facts that when Mary's pregnancy had saddened her husband his fears were set at rest by an angelic vision, that he was again warned by angels — first to seek refuge in Egypt, and afterwards to return to Palestine — that he was present at Bethlehem when our Lord was laid in the manger and the shepherds came to worship Him, that he was present also when the Infant was placed in the arms of Holy Simeon, and finally that he shared his wife's sorrow at the loss of her Son and her joy when they found Him debating with the doctors in the Temple. St. Joseph's

ST. JOSEPH
Guido Reni. *St. Joseph with the Christ Child in His Arms*, 1620s. Hermitage, St. Petersburg

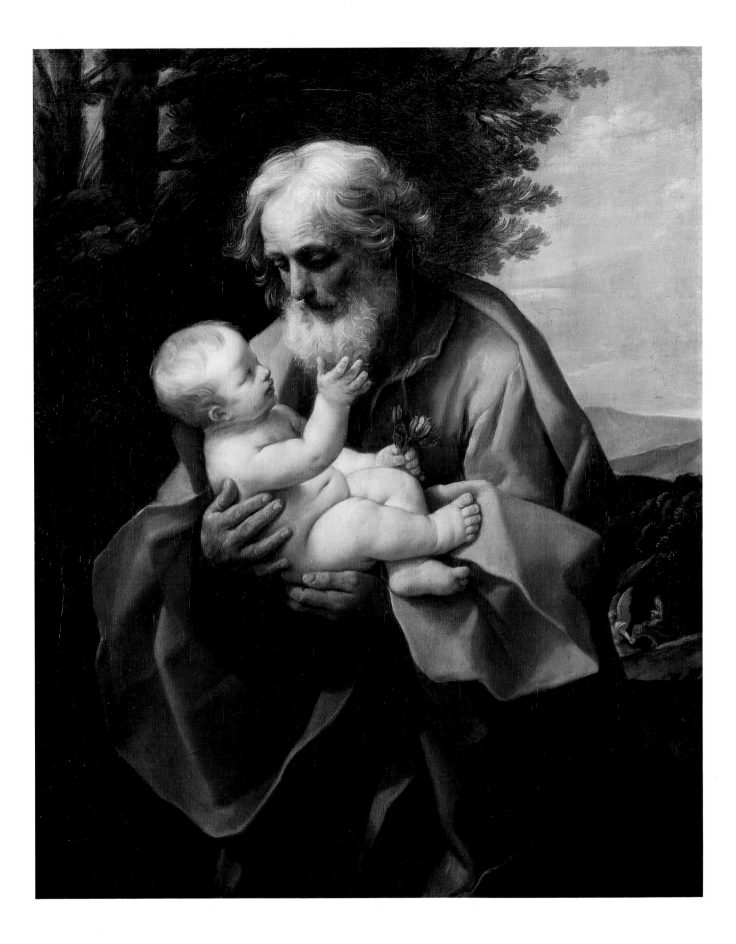

merit is summed up in the phrase that "he was a just man," that is to say, a godly man. This was the eulogy of Holy Writ itself.

Although St. Joseph is now specially venerated in connection with prayers offered for the grace of a happy death, this aspect of popular devotion to the saint was late in obtaining recognition. The *Rituale Romanum,* issued by authority in 1614, while making ample provision of ancient formularies for the help of the sick and dying, nowhere — the litany not excepted — introduces any mention of the name of St. Joseph. Many Old Testament examples are cited, our Lady of course is appealed to, and there are references to St. Michael, SS. Peter and Paul, and even to St. Thecla, but St. Joseph is passed over, and it is only in recent times that the omission has been repaired. What makes this silence the more remarkable is the fact that the account given of the death of St. Joseph in the apocryphal "History of Joseph the Carpenter" seems to have been very popular in the Eastern church, and to have been the real starting-point of the interest aroused by the saint. Moreover, it is here that we find the first suggestion of anything in the nature of a liturgical celebration. In this document a very full account is given of St. Joseph's last illness, of his fear of God's judgments, of his self-reproach, and of the efforts made by our Lord and His mother to comfort him and to ease his passage to the next world, and of the promises of protection in life and death made by Jesus to such as should do good in Joseph's name.

In the first printed Roman Missal (1474) no commemoration of St. Joseph occurs, nor does his name appear even in the calendar. We find a Mass in his honor at Rome for the first time in 1505, though a Roman Breviary of 1482 assigns him a feast with nine lessons. But in certain localities and under the influence of individual teachers a notable *cultus* had begun long before this. Probably the mystery plays in which a prominent role was often assigned to St. Joseph contributed something to this result. Bd. Herman, a Premonstratensian who lived in the second half of the twelfth century, took the name of Joseph, and believed that he had received assurance of his special protection. St. Margaret of Cortona, Bd. Margaret of Città di Castello, St. Bridget of Sweden and St. Vincent Ferrer seem to have paid particular honor to St. Joseph in their private devotions. Early in the fifteenth century influential writers like Cardinal Peter d'Ailly, John Gerson and St. Bernardino of Siena warmly espoused his cause, and it was no doubt mainly due to the influence they exercised that before the end of the same century his feast began to be liturgically celebrated in many parts of western Europe. The Carmelite chapter of 1498 held at Nîmes was the first to give formal authorization to this addition to the calendar of the order. But from that time forward the devotion spread rapidly, and there can be no question that the zeal and enthusiasm displayed by the great St. Teresa in St. Joseph's cause produced a profound impression upon the Church at large. In 1621 Pope Gregory XV made St. Joseph's feast a holiday of obligation, and though this has been subsequently abrogated in England and elsewhere there has been no diminution down to our own time in the earnestness and the confidence of his innumerable clients. The number of churches now dedicated in his honor and the many religious congregations both of men and women which bear his name are a striking evidence of the fact.

ST. JOHN THE BAPTIST

May 30: Birthday August 29: Beheading

Patron Saint of Farriers

ST. AUGUSTINE, remarking that the Church celebrates the festivals of saints on the day of their death, which in the true estimate of things is their great birthday, their birthday to eternal life, adds that the birthday of St. John the Baptist forms an exception because he was sanctified in his mother's womb, so that he came into the world sinless. Indeed, the majority of divines are disposed to think that he was already invested with sanctifying grace, which would have been imparted by the invisible presence of our divine Redeemer at the time that the Blessed Virgin visited her cousin, St. Elizabeth. But in any case the birth of the Forerunner was an event which brought great joy to mankind, announcing that their redemption was at hand.

John's father, Zachary, was a priest of the Jewish law, and Elizabeth his wife was also descended of the house of Aaron; and the Holy Scriptures assure us that both of them were just, with a virtue which was sincere and perfect — "and they walked in all commandments and justifications of the Lord without blame." It fell to the lot of Zachary in the turn of his ministration to offer the daily morning and evening sacrifice of incense; and on a particular day while he did so, and the people were praying outside the sanctuary, he had a vision, the angel Gabriel appearing to him standing on the right side of the altar of incense. Zachary was troubled and stricken with fear, but the angel encouraged him, announcing that his prayer was heard, and that in consequence his wife, although she was called barren, should conceive and bear him a son. The angel told him: "Thou shalt call his name John, and thou

shalt have joy and gladness, and many shall rejoice in his birth, for he shall be great before the Lord." John was chosen to be the herald and harbinger of the world's Redeemer, the voice to proclaim to men the eternal Word, the morning star to usher in the sun of justice and the light of the world. Other saints are often distinguished by certain privileges belonging to their special character; but John eminently excelled in graces and was at once a teacher, a virgin and a martyr. He was, moreover, a prophet, and more than a prophet, it being his office to point out to the world Him whom the ancient prophets had foretold obscurely and at a distance.

Innocence undefiled is a precious grace, and the first-fruits of the heart are particularly due to God. Therefore the angel ordered that the child should be consecrated to the Lord from his very birth, and as an indication of the need to lead a mortified life if virtue is to be protected, no fermented liquor would ever pass his lips. The circumstance of the birth of John proclaimed it an evident miracle, for Elizabeth at that time was advanced in years and according to the course of nature past child-bearing. God had so ordained all things that the event might be seen to be the fruit of long and earnest prayer. Still, Zachary was amazed, and he begged that a sign might be given as an earnest of the realization of these great promises. The angel, to grant his request, and in a measure to rebuke the doubt which it implied, answered that he should continue dumb until such moment as the child was born. Elizabeth conceived; and in the sixth month of her pregnancy received a visit from the Mother of God,

who greeted her kinswoman: "and it came to pass that when Elizabeth heard the salutation of Mary, the infant leaped in her womb."

Elizabeth, when the nine months of her pregnancy were accomplished, brought forth her son, and he was circumcised on the eighth day. Though the family and friends wished him to bear his father's name, Zachary, the mother urged that he should be called John. The father confirmed the desire by writing on a tablet "John is his name"; and immediately recovering the use of speech, he broke into that great canticle of love and thanksgiving, the *Benedictus,* which the Church sings every day in her office and which she finds it not inappropriate to repeat over the grave of every one of her faithful children when his remains are committed to the earth.

The Birthday of St. John the Baptist was one of the earliest feasts to find a definite place in the Church's calendar, no other than where it stands now, June 24. We have sermons of St. Augustine delivered on this particular festival which sufficiently indicate the precise time of year by referring to those words of John reported in the Fourth Gospel: "He must increase, but I must decrease." St. Augustine finds this appropriate, for he tells us that after the birthday of St. John the days begin to get shorter, whereas after the birthday of our Lord the days begin to grow longer.

John the Baptist began to fulfill his unique office in the desert of Judaea, upon the banks of the Jordan, towards Jericho. Clothed in skins, he announced to all men the obligation of washing away their sins with the tears of sincere penitence, and proclaimed the Messiah, who was about to make his appearance among them. He exhorted all to charity and to a reformation of their lives, and those who came to him in these dispositions he baptized in the river. The Jews practiced religious washings of the body as legal purifications, but no baptism before this of John had so great and mystical a signification. It chiefly represented the manner in which the souls of men must be cleansed from all sin to be made partakers of Christ's spiritual kingdom,

and it was an emblem of the interior effects of sincere repentance; a type of that sacrament of baptism which was to come with our Lord. When he had already preached and baptized for some time our Redeemer went from Nazareth and presented Himself among the others to be baptized by him. The Baptist knew Him by a divine revelation and at first excused himself, but at length acquiesced out of obedience. The Savior of sinners was pleased to be baptized among sinners, not to be cleansed himself but to sanctify the waters, says St. Ambrose, that is, to give them the virtue to cleanse away the sins of men.

The solemn admonitions of the Baptist, added to his sanctity and the marks of his divine commission, gained for him veneration and authority among the Jews, and some began to look upon him as the Messiah himself. But he declared that he only baptized sinners with water to confirm them in repentance and a new life: that there was One ready to appear among them who would baptize them with the Holy Ghost, and who so far exceeded him in power and excellence that he was not worthy to untie His shoes. Nevertheless, so strong was the impression which the preaching and behavior of John made upon the minds of the Jews that they sent priests and Levites from Jerusalem to inquire of him if he were not the Christ. And St. John "confessed . . . I am not the Christ." The Baptist proclaimed Jesus to be the Messiah at His baptism; and, the day after the Jews consulted him from Jerusalem, seeing Him come towards him, he called Him, "the Lamb of God." Christ declared John to be greater than all the saints of the old law, the greatest that had been born of woman.

Herod Antipas, Tetrarch of Galilee, had put away his wife and was living with Herodias, who was both his niece and the wife of his half-brother Philip. St. John Baptist boldly reprehended the tetrarch and his accomplice for so scandalous a crime. Herod feared and reverenced John, knowing him to be a holy man, but he was highly offended at the liberty which the preacher took. His anger got the better of him and was

ST. JOHN THE BAPTIST
Bartolomé Estéban Murillo. *The Baptism of Christ,* c. 1655. Gemäldegalerie, Berlin

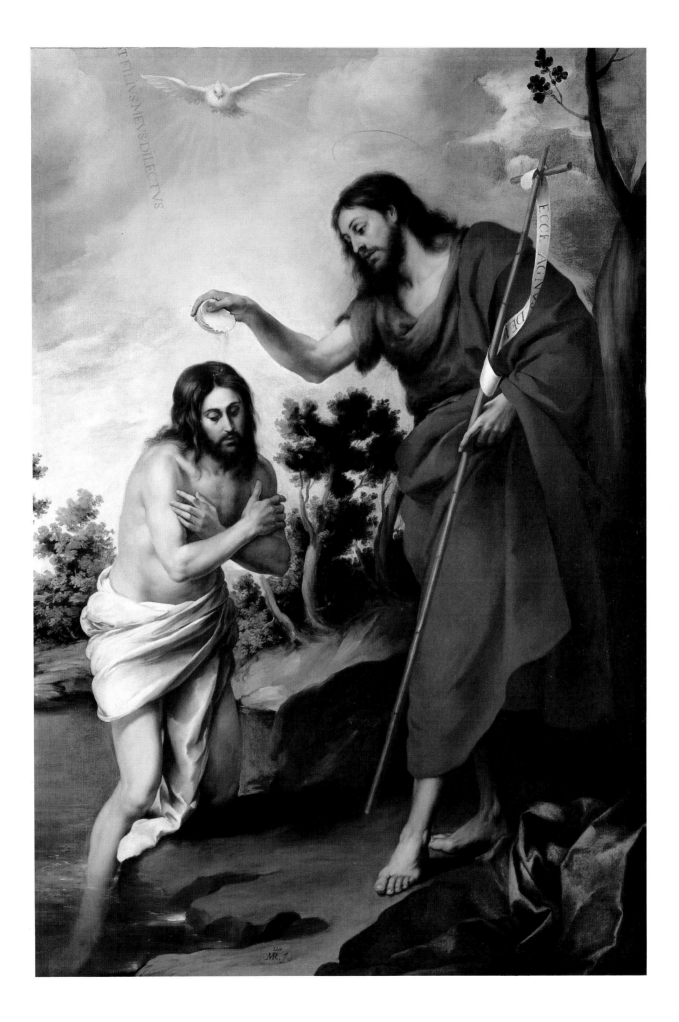

nourished by the clamor and artifices of Herodias. Herod, to content her, and perhaps somewhat because he feared John's influence over the people, cast the saint into prison.

Herodias never ceased to endeavor to exasperate Herod against John and to seek an opportunity for his destruction. Her chance at length came when Herod on his birthday gave a feast to the chief men of Galilee. At this entertainment Salome, a daughter of Herodias by her lawful husband, pleased Herod by her dancing so much that he promised her with an oath to grant her whatever she asked though it amounted to half his dominions. Herodias thereupon told her daughter to demand the death of John the Baptist and, for fear the tyrant might relent if he had time to think it over, instructed the girl to add that the head of the prisoner should be forthwith brought to her in a dish. This strange request startled Herod: "The very mention of such a thing by a lady, in the midst of a feast and solemn rejoicing, was enough to shock even a man of uncommon barbarity." But because of his oath, a double sin, rashly taken and criminally kept, as St. Augustine says, he would not refuse the request. Without so much as the formality of a trial he sent a soldier to behead John in prison, with an order to bring his head in a dish and present it to Salome. This being done, the girl was not afraid to take that present into her hands, and deliver it to her mother. His disciples so soon as they heard of his death came and took his body and laid it in a tomb, and came and told Jesus. "Which when Jesus had heard, He retired . . .

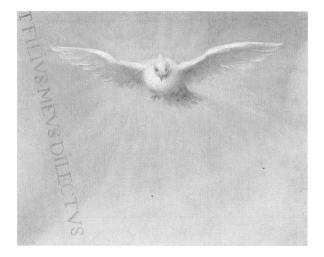

into a desert place apart." Josephus, in his *Jewish Antiquities,* gives remarkable testimony to the sanctity of John, and says, "He was indeed a man endued with all virtue, who exhorted the Jews to the practice of justice towards men and piety towards God; and also to baptism, preaching that they would become acceptable to God if they renounced their sins and to the cleanness of their bodies added purity of soul." He adds that the Jews ascribed to the murder of John the misfortunes into which Herod fell.

Editor's note: The Church calendar includes two feasts for St. John the Baptist — that commemorating his birthday, on May 30, and that for his beheading, on August 29. The preceding material is composed of excerpts from both entries in Butler's Lives of the Saints.

ST. ANDREW, APOSTLE

November 30

Patron Saint of Greece; Russia; Scotland; Fishermen

St. Andrew was a native of Bethsaida, a town in Galilee upon the banks of the lake of Genesareth. He was the son of Jona, a fisherman of that town, and brother to Simon Peter, but whether older or younger the Holy Scriptures do not say. They had a house at Capharnaum, where Jesus lodged when he preached in that city. When St. John Baptist began to preach penance, Andrew became his disciple, and he was with his master when St. John, seeing Jesus pass by the way after He had been baptized by him, said, "Behold the Lamb of God!" Andrew was so far enlightened as to comprehend this mysterious saying, and without delay he and another disciple of the Baptist went after Jesus, who saw them with the eyes of His spirit before He beheld them with His corporal eyes. Turning back as he walked, he said, "What seek ye?" They said they wanted to know where He dwelt, and He bade them come and see. There remained but two hours of that day, which they spent with him, and Andrew clearly learned that Jesus was the Messiah and resolved from that moment to follow Him; he was thus the first of His disciples, and therefore is styled by the Greeks the *Protoclete* or First-called. He then fetched his brother, that he might also know Him, and Simon was no sooner come to Jesus than the Savior admitted him also as a disciple, and gave him the name of Peter. From this time they were his followers, not constantly attending Him as they afterwards did, but hearing Him as frequently as their business would permit and returning to their trade and family affairs again. When Jesus, going up to Jerusalem to celebrate the Passover, stayed some days in Judaea and baptized in the Jordan,

Peter and Andrew also baptized by His authority and in His name. Our Savior, being come back into Galilee and meeting Peter and Andrew fishing in the lake, He called them permanently to the ministry of the gospel, saying that He would make them fishers of men. Whereupon they immediately left their nets to follow Him, and never went from Him again. The year following our Lord chose twelve to be His apostles, and St. Andrew is named among the first four in all the biblical lists. He is also mentioned in connection with the feeding of the five thousand (John vi 8, 9) and the Gentiles who would see Jesus (John xii 20–22).

Apart from a few words in Eusebius, who informs us that St. Andrew preached in Scythia and that certain spurious "acts" bearing his name were made use of by heretics, we have practically nothing but apocryphal writings which profess to tell us anything of the later history of St. Andrew. There is, however, one curious mention in the ancient document known as the Muratorian Fragment. This dates from the very beginning of the third century and therein it is stated: "The fourth gospel [was written by] John one of the disciples [i.e. apostles]. When his fellow disciples and bishops urgently pressed him, he said, 'Fast with me from today, for three days, and let us tell one another what revelation may be made to us, either for or against [the plan of writing].' On the same night it was revealed to Andrew, one of the apostles, that John should relate all in his own name, and that all should review his writing." Theodoret tells us that Andrew passed into Greece; St. Gregory Nazianzen mentions particularly Epirus, and St. Jerome Achaia. St. Philastrius says that he came out of Pontus into Greece, and that in his

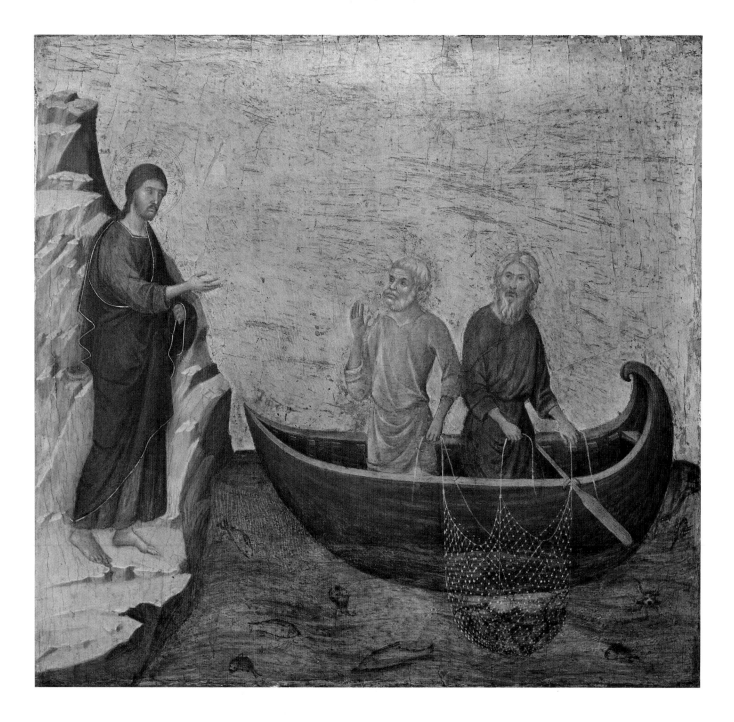

ST. ANDREW

Duccio di Buoninsegna. *The Calling of the Apostles Peter and Andrew*, 1308/1311. National Gallery of Art, Washington, D.C.

time (fourth century) people at Sinope believed that they had his true picture and the *ambo* from which he preached in that city. Though there is agreement among these as to the direction of St. Andrew's apostolate there is no certainty about it. The favorite view of the middle ages was that he eventually came to Byzantium and there left his disciple Stachys (Romans xvi 9) as bishop. This tradition is due to a document forged at a time when it was a great help to the ecclesiastical position of Constantinople apparently to have an apostolic origin for their church, like Rome, Alexandria and Antioch.

The place and manner of the death of St. Andrew are equally in doubt. His apocryphal *passio* says that he was crucified at Patras in Achaia, being not nailed but bound to a cross, on which he suffered and preached to the people for two days before he died. The idea that his cross was of the kind called saltire or decussate (X-shaped) was apparently not known before the fourteenth century. Under the Emperor Constantius II (d. 361) what purported to be the relics of St. Andrew were translated from Patras to the church of the Apostles at Constantinople; after the seizure of that city by the Crusaders in 1204 they were stolen and given to the cathedral of Amalfi in Italy.

St. Andrew is the patron saint of Russia, on account of a valueless tradition that he preached in that country so far as Kiev, and of Scotland. It is not claimed that he preached in Scotland, but the legend preserved by John of Fordun and in the Aberdeen Breviary is no less undeserving of credence. According to this a certain St. Rule (Regulus), who was a native of Patras and had charge of the relics of St. Andrew in the fourth century, was warned by an angel in a dream to take a part of those relics and convey them to a place that would be indicated. He did as he was told, going forth in a north-westerly direction "towards the ends of the earth," until by a sign the angel stopped him at the place we call Saint Andrews, where he built a church to shelter them, was made its first bishop, and evangelized the people for thirty years. This story may have originated in the eighth century. A feast of the translation is observed in the archdiocese of Saint Andrews on May 9.

The name of St. Andrew appears in the canon of the Mass with those of the other apostles, and he is also named with our Lady and SS. Peter and Paul in the embolism after the Lord's Prayer. This is generally attributed to the personal devotion of Pope St. Gregory the Great for the saint, but may antedate his time.

ST. JAMES THE GREATER, APOSTLE

July 25

Patron Saint of Chile; Spain; Laborers; Pharmacists;
Pilgrims; Rheumatism Sufferers

St. James, the brother of St. John Evangelist, son of Zebedee, was called the Greater to distinguish him from the other apostle of the same name, surnamed the Less because he was the younger. St. James the Greater was by birth a Galilean, and by trade a fisherman with his father and brother, living probably at Bethsaida, where St. Peter also dwelt at that time. Jesus walking by the lake of Genesareth saw Peter and Andrew fishing, and He called them to come after Him, promising to make them fishers of men. Going a little farther on the shore, He saw two other brothers, James and John, in a ship, with Zebedee their father, mending their nets, and He also called them; who forthwith left their nets and their father and followed Him. Probably by conversing with Peter, their townsman, and by other means, they had before this call a conviction that Jesus was the Christ; and no sooner did they hear His invitation, and felt the divine will directing them, but the same moment they quitted all things to answer this summons.

St. James was present with his brother St. John and St. Peter at the cure of Peter's mother-in-law, and the raising of the daughter of Jairus from the dead, and in the same year Jesus formed the company of His apostles, into which He adopted James and John. He gave these two the surname of Boanerges, or "Sons of Thunder," seemingly on account of an impetuous spirit and fiery temper. For example, when a town of the Samaritans refused to entertain Christ, they suggested that He should call down fire from Heaven to consume it; but our Redeemer gave them to understand that meekness and patience were the arms by which they were to conquer. "You know not of what spirit you are. The Son of Man came not to destroy souls but to save." But the instruction and example of the Son of God did not fully enlighten the understanding of the apostles nor purify their hearts, until the Holy Ghost had shed His light upon them: their virtue was still imperfect, as appeared when the mother of James and John, imagining that He was going to set up a temporal monarchy, according to the notion of the Jews concerning the Messiah, asked Him that her two sons might sit, the one on His right hand, and the other on His left, in His kingdom. The two sons of Zebedee spoke by the mouth of their mother as well as by their own, but Christ directed His answer to them, telling them they knew not what they asked; for in His kingdom preferments are attainable, not by the forward and ambitious, but by the most humble, the most laborious, and the most patient. He therefore asked them if they were able to drink of His cup of suffering. The two apostles, understanding the condition under which Christ offered them His kingdom and ardent for His sake, without hesitation answered, "We can." Our Lord told them they should indeed have their portion of suffering; but He could make no other disposal of the honors of His kingdom than according to the proportion of every one's charity and patience in suffering: "The Son of Man also is not come to be

ministered unto, but to minister and to give His life a redemption for many."

Nevertheless, those apostles who from time to time acted impetuously, and had to be rebuked, were the very ones whom our Lord turned to on special occasions. Peter, this James and John alone were admitted to be spectators of His glorious transfiguration, and they alone were taken to the innermost recesses of Gethsemane on the night of agony and bloody sweat at the beginning of His passion.

Where St. James preached and spread the gospel after the Lord's ascension we have no account from the writers of the first ages of Christianity. According to the tradition of Spain, he made an evangelizing visit to that country, but the earliest known reference to this is only in the later part of the seventh century, and then in an oriental, not a Spanish source. St. Julian of Toledo himself resolutely rejected this alleged visit of the apostle to his country. At no time has the tradition been unanimously received, and there are grave arguments against it, e.g. in St. Paul's letter to the Romans xv 20 and 24. St. James was the first among the apostles who had the honor to follow his divine Master by martyrdom, which he suffered at Jerusalem under King Herod Agrippa I, who inaugurated a persecution

of Christians in order to please the Jews. Clement of Alexandria, and from him Eusebius, relate that his accuser, observing the courage and constancy of mind wherewith the apostle underwent his trial, was so impressed that he repented of what he had done, declared himself a Christian, and was condemned to be beheaded. As they were both led together to execution, he begged pardon of the apostle for having apprehended him. St. James, after pausing a little, turned to him and embraced him, saying, "Peace be with you." He then kissed him, and they were both beheaded together. The Holy Scriptures simply say that Agrippa "killed James, the brother of John, with the sword" (Acts xii 2). He was buried at Jerusalem, but, again according to the tradition of Spain, dating from about 830, the body was translated first to Iria Flavia, now El Padron, in Galicia, and then to Compostela, where during the middle ages the shrine of Santiago became one of the greatest of all Christian shrines. The relics still rest in the cathedral and were referred to as authentic in a bull of Pope Leo XIII in 1884. Their genuineness is seriously disputed, but it does not depend in any way on the truth or falseness of the story of St. James's missionary visit to Spain.

ST. JOHN THE EVANGELIST, APOSTLE

December 27

Patron Saint of Asia Minor

ST. JOHN THE EVANGELIST, distinguished as the "disciple whom Jesus loved" and often called in England, as by the Greeks, "the Divine" (i.e. the Theologian), was a Galilean, the son of Zebedee and brother of St. James the Greater with whom he was brought up to the trade of fishing. He was called to be an apostle with his brother, as they were mending their nets on the sea of Galilee, soon after Jesus had called Peter and Andrew. St. John is said to have been the youngest of all the apostles, and outlived the others, being the only one of whom it is sure that he did not die a martyr. In the gospel which he wrote he refers to himself with a proud humility as "the disciple whom Jesus loved," and it is clear he was one of those who had a privileged position. Our Lord would have him present with Peter and James at His transfiguration and at His agony in the garden; and He showed St. John other instances of kindness and affection above the rest, so that it was not without human occasion that the wife of Zebedee asked the Lord that her two sons might sit the one on His right hand and the other on His left in His kingdom. John was chosen to go with Peter into the city to prepare the last supper, and at that supper he leaned on the breast of Jesus and elicited from Him, at St. Peter's prompting, who it was should betray Him. It is generally believed that he was that "other disciple" who was known to the high priest and went in with Jesus to the court of Caiaphas, leaving St. Peter at the outer door. He alone of the apostles stood at the foot of the cross with Mary and the other faithful women, and received the sublime charge to care for the mother of his Redeemer. " 'Woman, behold thy son.' 'Behold thy mother.' And from that hour the disciple took her to his own." Our Lord calls us all brethren, and He recommends us all as such to the loving care of His own mother: but amongst these adoptive sons St. John is the first-born. To him alone was it given to be treated by her as if she had been his natural mother, and to treat her as such by honoring, serving and assisting her in person.

When Mary Magdalen brought word that Christ's sepulchre was open, Peter and John ran there immediately, and John, who was younger and ran faster, arrived first. But he waited for St. Peter to come up, and followed him in: "and he saw and believed" that Christ was indeed risen. A few days later Jesus manifested Himself for the third time, by the sea of Galilee, and He walked along the shore questioning Peter about the sincerity of his love, gave him the charge of His Church, and foretold his martyrdom. St. Peter, seeing St. John walk behind and being solicitous for his friend, asked Jesus, "Lord, what shall this man do?" And Jesus replied, "If I will have him to remain till I come, what is it to thee? Follow thou me." It is therefore not surprising that it was rumored among the brethren that John should not die, a rumor which he himself disposes of by pointing out that our Lord did not say, "He shall not die." After Christ's ascension we find these two same apostles going up to the Temple and miraculously healing a cripple. They were imprisoned, but released again with an order no more to preach Christ, to which they answered, "If it be just in the sight of God to hear you rather than God, judge ye. For we cannot but speak the things we have seen and heard." Then they were sent by the other apostles to

confirm the converts which the deacon Philip had made in Samaria. When St. Paul went up to Jerusalem after his conversion he addressed himself to those who "seemed to be pillars" of the Church, chiefly James, Peter and John, who confirmed his mission among the Gentiles, and about that time St. John assisted at the council which the apostles held at Jerusalem. Perhaps it was soon after this that John left Palestine for Asia Minor. No doubt he was present at the passing of our Lady, whether that took place at Jerusalem or Ephesus; St. Irenaeus says that he settled at the last-named city after the martyrdom of SS. Peter and Paul, but how soon after it is impossible to tell. There is a tradition that during the reign of Domitian he was taken to Rome, where an attempt to put him to death was miraculously frustrated; and that he was then banished to the island of Patmos, where he received those revelations from Heaven which he wrote down in his book called the Apocalypse.

After the death of Domitian in the year 96 St. John could return to Ephesus, and many believe that he wrote his gospel at this time. His object in writing it he tells us himself: "These things are written that you may believe that Jesus is the Christ, the Son of God; and that, believing, you may have life in His name." It is entirely different in character from the other three gospels, and a work of such theological sublimity that, as Theodoret says, it "is beyond human understanding ever fully to penetrate and comprehend." His soaring thought is aptly represented by the eagle which is his symbol. St. John also wrote three epistles. The first is called catholic, as addressed to all Christians, especially his converts, whom he urges to purity and holiness of life and cautions against the craft of seducers. The other two are short, and directed to particular persons: the one probably to a local church; the other to Gaius, a courteous entertainer of Christians. The same inimitable spirit of charity reigns throughout all his writings.

Early writers speak of St. John's determined opposition to the heresies of the Ebionites and of the followers of the gnostic Cerinthus. On one occasion he was going to the baths when, learning that Cerinthus was within, he started back and said to some friends that were with him, "Let us, brethren, make haste and be gone, lest the bath wherein is Cerinthus, the enemy of truth, should fall upon our heads." St. Irenaeus tells us he received this from the mouth of St. Polycarp, St. John's personal disciple. Clement of Alexandria relates that in a certain city St. John saw a young man of attractive appearance in the congregation, and being much taken with him he presented him to the bishop whom he had ordained there, saying, "In the presence of Christ and before this congregation I commend this young man to your care." The young man was accordingly lodged in the bishop's house, instructed, kept to good discipline, and at length baptized and confirmed. But the bishop's attention then slackened, the neophyte got into bad company, and became a highway robber. Some time after St. John was again in that city, and said to the bishop, "Restore to me the trust which Jesus Christ and I committed to you in presence of your church." The bishop was surprised, imagining he meant some trust of money. But when John explained that he spoke of the young man, he replied, "Alas! he is dead." "What did he die of?" asked St. John. "He is dead to God and is turned robber," was the reply. Thereupon the aged apostle called for a horse and a guide, and rode away to the mountain where the robber and his gang lived. Being made prisoner he cried out, "It is for this that I am come: lead me to such an one." When the youth saw it was St. John he began to make off with shame. But John cried out after him, "Child, why do you run from me, your father, unarmed, and an old man? There is time for repentance. I will answer for you to Jesus Christ. I am ready to lay down my life for you. I am sent by Christ." At these words the young man stood still and burst into tears, tears wherein, as Clement says, he sought to find a second baptism. Nor would St. John leave that place until he had reconciled the sinner to the Church. This charity which he had so conspicuously himself he

ST. JOHN THE EVANGELIST
Hans Burgkmair the Elder. Panel from *St. John Altar: St. John the Evangelist on Patmos,* 1518. Alte Pinakothek, Munich

22

constantly and affectionately urged in others. St. Jerome writes that when age and weakness grew upon him at Ephesus so that he was no longer able to preach to the people, he used to be carried to the assembly of the faithful, and every time said to his flock only these words: "My little children, love one another." When they asked him why he always repeated the same words, he replied, "Because it is the word of the Lord, and if you keep it you do enough." St. John died in peace at Ephesus about the third year of Trajan, that is, the hundredth of the Christian era, being then about ninety-four years old according to St. Epiphanius.

As we may learn from St. Gregory of Nyssa, from the Syriac *breviarium* of the early fifth century, and from the Carthaginian Calendar, the practice of celebrating the feast of St. John immediately after that of St. Stephen is of very ancient date. In the original text of the *Hieronymianum* (about A.D. 600) the commemoration seems to have been thus entered: "The Assumption of St. John the Evangelist at Ephesus and the ordination to the episcopate of St. James, our Lord's brother, who was the first of the Jews to be ordained by the apostles bishop of Jerusalem and gained the crown of martyrdom at the time of the pasch." One might have expected John and James, the sons of Zebedee, to be coupled in such a notice, but this is clearly the other James, the son of Alpheus, who is now honored with St. Philip on May 1. The phrase "Assumption of St. John" is notable, containing as it

does a clear reference to the last portion of the apocryphal "Acts of St. John." In this widely circulated fiction, dating from the late second century, it was represented (evidently in view of the saying that this particular disciple "should not die," John xxi 23) that St. John at the end of his days in Ephesus simply disappeared: his body was never found. On the other hand, according to the Greeks his resting-place at Ephesus was well known, and famed for marvels. The *Acta Johannis*, though preserved to us only imperfectly and condemned for heretical tendencies by many early authorities, e.g. Eusebius, Epiphanius, Augustine and Turibius of Astorga, seems to have done much to create a traditional legend. From this source, or in any case from pseudo-Abdias, comes the story which was the basis of the frequently recurring representation of St. John with a chalice and a viper. The apostle was challenged by Aristodemus, the high priest of Diana at Ephesus, to drink of a poisoned cup. He did so without sustaining any harm and thereby converted the high priest himself. Upon this incident seems to be founded the folk-custom, prevalent especially in Germany, of the "*Johannis-Minne*," the loving-cup or *poculum charitatis*, which was drunk in honor of St. John. In medieval *ritualia* a number of forms of blessing are preserved which were supposed to render such a draught efficacious against dangers to health and helpful to the attaining of Heaven.

ST. MARY MAGDALEN

July 22

THE STORY OF St. Mary Magdalen, as generally received in the West following St. Gregory the Great, is one of the most moving and encouraging in the Holy Scriptures. Mention is made in the gospels of a woman who was a sinner (Luke vii 37–50, etc.), of Mary Magdalen, a follower of our Lord (John xx 10–18, etc.), and of Mary of Bethany, the sister of Lazarus (Luke x 38–42, etc.), and the liturgy of the Roman church by identifying these three as one single individual has set its approval on the ancient tradition and popular belief of Western Catholics.

Mary Magdalen, whom our English ancestors called "Mawdleyn," probably received her name from Magdala, a place on the western shore of the sea of Galilee, near to Tiberias, and our Lord first met her when on His Galilean ministry. St. Luke records that she was a sinner, and evidently a notorious sinner (though he says nothing to suggest that she was a public harlot, as is commonly supposed), and goes on to describe how, Christ having accepted an invitation to dine with a Pharisee, she came into the house while they were at table, fell weeping before Jesus, and, having wiped His feet with her own hair, anointed them with ointment from an alabaster box. The Pharisee murmured at what seemed to him the unbecoming acquiescence of a prophet in the presence of a great sinner, and Jesus, knowing his thoughts, rebuked him; first by asking which of two released debtors, a great and a small, had the more cause to be grateful to their creditor, and then directly:

"Dost thou see this woman? I entered into thy house — thou gavest me no water for my feet. But she

with tears hath washed my feet, and with her hair hath wiped them. Thou gavest me no kiss. But she, since she came in, hath not ceased to kiss my feet. My head with oil thou didst not anoint — but she with ointment hath anointed my feet. Wherefore I say to thee: Many sins are forgiven her, because she hath loved much. But to whom less is forgiven, he loveth less." And to the penitent woman he said, "Thy sins are forgiven thee. Thy faith hath made thee safe. Go in peace."

In his very next chapter St. Luke, in speaking of the missionary travels of our Lord in Galilee, tells us that He and His apostles were accompanied and ministered to by certain women, among them (by name) Mary Magdalen, "out of whom seven devils had gone forth." Later, He entered into a certain town and was received by Martha and her sister Mary, who supposedly had come to live with their brother Lazarus at Bethany in order to be nearer the Master who, at their instance, had restored him to life. Martha, busy about the house, appealed to Him to urge Mary to help her, rather than to sit continually at His feet listening to His words, and received that answer which has puzzled and consoled all succeeding ages: "Martha, Martha, thou art careful and art troubled about many things. But one thing is necessary. Mary hath chosen the best part, which shall not be taken away from her." Mary the sinner had become Mary the contemplative.

On the day before the triumphal entry into Jerusalem which was the prelude to His passion, Jesus supped with the family of Lazarus at Bethany (Jesus loved them, St. John tells us), and on this occasion Mary again anointed His head and feet and wiped them with her hair, so that "the house was filled with

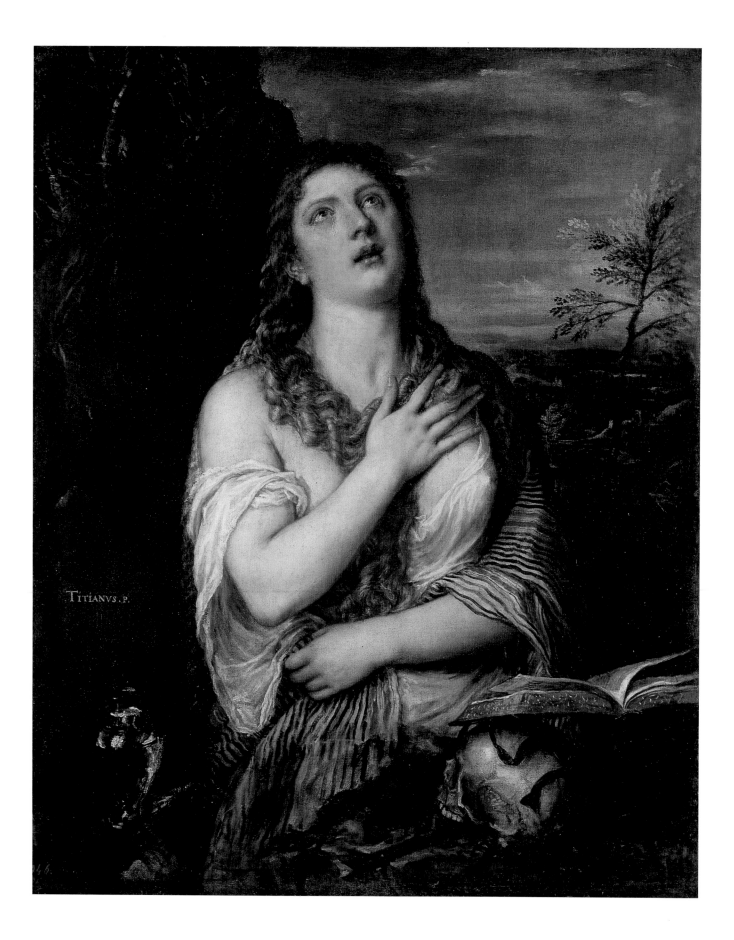

the fragrance of the ointment." And again there was a critic present, this time Judas Iscariot the apostle, scandalized not because he was self-righteous but because he was dishonest and avaricious; and even the other disciples were distressed at what seemed a waste. And again Jesus vindicated Magdalen:

"Let her alone! Why do you molest her? She hath wrought a good work upon me. For the poor you have always with you, and whensoever you will you may do them good; but me you have not always. She hath done what she could: she is come beforehand to anoint my body for the burial. Amen, I say to you — wheresoever this gospel shall be preached in the whole world, that also which she hath done shall be told for a memorial of her."

And yet Mary Magdalen is remembered at least as well for other things. In the darkest hour of our Lord's life she stood at some distance, watching Him on the cross; and with "the other Mary" she saw the great stone rolled before the door of the tomb wherein lay the body of the Lord. But the crowning mercy of the life of Mary Magdalen was yet to come, for it was she who, bearing sweet spices and weeping by the sepulchre early on the first day of the week, was the first to see, to be greeted by, and to recognize, the risen Christ; she, the contemplative, was the first witness to that resurrection without which our faith and our preaching are alike vain.

Jesus saith to her, "Mary!" She, turning, saith to Him, "Master!" Jesus saith to her: "Do not touch me, for I am not yet ascended to my Father. But go to my brethren and say to them: I ascend to my Father and to your Father, to my God and to your God."

According to Eastern tradition, Mary Magdalen after Pentecost accompanied our Lady and St. John to Ephesus where she died and was buried; the English pilgrim St. Willibald was shown her shrine there in the middle of the eighth century. But according to the tradition of France, in the Roman Martyrology and by the granting of various local feasts, she, with Lazarus, Martha, and others, evangelized Provence. The last thirty years of her life, it is claimed, she spent in a cavern of a rock, La Sainte Baume, high up among the Maritime Alps, to be transported miraculously, just before she died, to the chapel of St. Maximin; she received the last sacraments from and was buried by that saint.

The earliest known reference to the coming of the Palestinians to France is of the eleventh century, in connection with the relics of St. Mary Magdalen claimed by the abbey of Vézelay in Burgundy; the elaborations of the story seem to have spread in Provence only during the thirteenth. From 1279 the relics of the Magdalen are said to be in the keeping of the monks of Vézelay and of the Dominican friars of Saint-Maximin, to the shrine in which church and the cave at La Sainte Baume pilgrimage is still popular.

Among the other curious and baseless tales current about the saint in the middle ages is that she was affianced to St. John the Evangelist when Christ called him. "She had thereof indignation that her husband was taken from her, and went and gave herself to all delight; but because it was not fitting that the calling of St. John should be the occasion of her damnation, therefore our Lord mercifully converted her to penance, and because He had taken from her sovereign delight of the flesh, He replenished her with sovereign spiritual delight before all other, that is, the love of God" *(The Golden Legend)*.

ST. MARTHA, VIRGIN

July 29

Patron Saint of Cooks; Hospital Dieticians; Servants

ARTHA WAS SISTER to Mary (who is usually identified with Magdalen) and Lazarus, and lived with them at Bethany, a small town two miles distant from Jerusalem, a little beyond Mount Olivet. Our blessed Redeemer had made His residence usually in Galilee, till in the third year of His public ministry. He preached frequently in Judaea, during which interval He frequented the house of these three disciples, who perhaps had removed from Galilee to be nearer Him. St. John particularly tells us that "Jesus loved Martha and her sister Mary and Lazarus." Martha seems to have been the eldest, and to have had the chief care and direction of the household, for, when Jesus visited them, St. Luke tells us that Martha showed great solicitude to entertain and serve Him, to be herself busy in preparing everything for their guest. Mary sat all the while at our Savior's feet, feeding her soul with heavenly doctrine.

With so great love did Martha wait on our Redeemer that, as we cannot doubt, she thought that if the whole world were occupied in attending to so great a guest, all would be too little. She wished that all men would employ their hands, feet and hearts, all their faculties and senses, with their whole strength, in serving their Creator who was made for us our brother. Therefore she asked Him to bid her sister Mary help her. Our Lord was indeed well pleased with the affection and devotion wherewith Martha waited on Him; yet He commended more the quiet repose with which Mary attended only to that which is of the greatest importance, the attendance of the soul on God. "Martha, Martha," said He, "thou art careful and troubled about many things; but one thing is necessary. Mary hath chosen the best part. . . ." In active works the soul is often distracted or entirely drawn off, whereas in heavenly contemplation the heart is wholly taken up in God, and united to Him by worship and love. This is the novitiate of Heaven, where it is the uninterrupted occupation of the blessed. In this sense Christ so highly commends the choice of Mary, affirming that her happy employment would never be taken from her. He added, "One thing is necessary," that is, "Eternal salvation is our only concern."

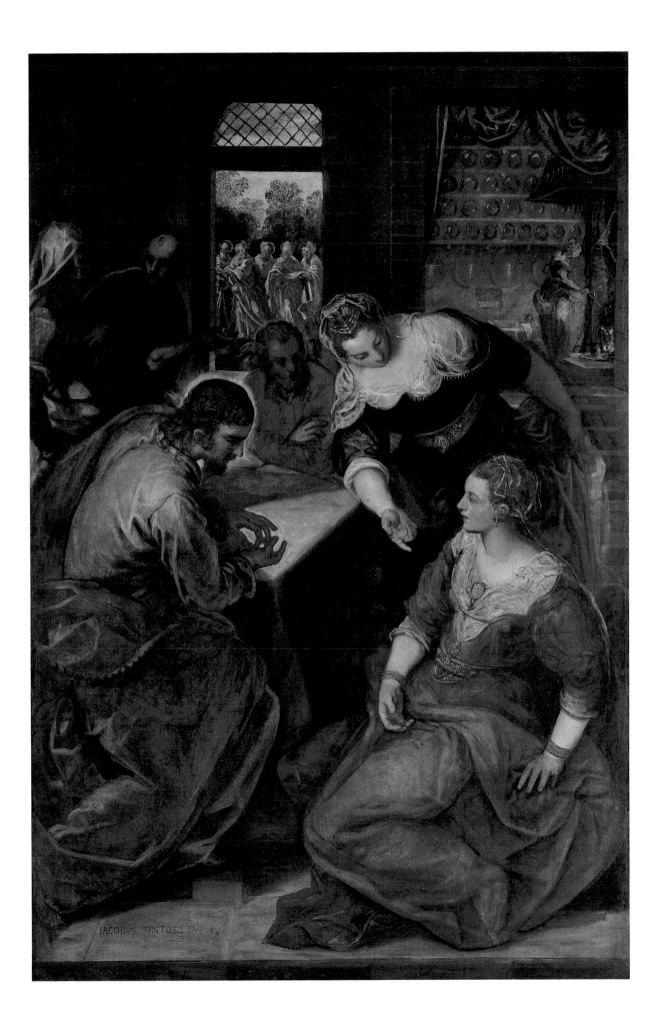

ST. PHILIP, APOSTLE

May 1

ST. PHILIP THE APOSTLE came from Bethsaida in Galilee, and seems to have belonged to a little group of earnest men who had already fallen under the influence of St. John the Baptist. In the synoptic gospels there is no mention of Philip except in the list of apostles which occurs in each. But St. John's gospel introduces his name several times, recording in particular that the call of Philip came the day after that given to St. Peter and St. Andrew. Jesus, we are told, "found Philip" and said to him, "Follow me." More than a century and a half later Clement of Alexandria avers that St. Philip was the young man who, when our Lord said to him, "Follow me," begged leave to go home first and bury his father, which occasioned the reply, "Let the dead bury their dead; but go thou and preach the kingdom of God" (Luke ix 60). The position of the incident of this rebuke in the narrative of St. Luke, and also in that of St. Matthew, clearly suggests that it occurred some time after the beginning of the public life, when our Lord was already attended by His little company of apostles. On the other hand, St. Philip was certainly called before the marriage feast at Cana, though, as our Savior Himself declared, His hour had not yet come, i.e. He had not yet embarked on the public activities of His great mission.

From the account given by the evangelist, we should naturally infer that Philip responded without hesitation to the call he had received. Though his knowledge was imperfect, so much so that he describes Jesus as "the son of Joseph of Nazareth," he goes at once to find his friend Nathanael (in all probability to be identified with the apostle Bartholomew) and tells him, "We have found him of whom Moses, in the law and the prophets did write," being plainly satisfied that this was in truth the Messiah. At the same time Philip gives proof of a sober discretion in his missionary zeal. He does not attempt to force his discovery upon unwilling ears. When Nathanael objects, "Can anything good come from Nazareth?" his answer is not indignant declamation, but an appeal for personal inquiry — "Come and see." In the description of the feeding of the five thousand Philip figures again. "When Jesus," we are told, "had lifted up His eyes and seen that a very great multitude cometh to Him, He said to Philip, 'Whence shall we buy bread that these may eat?' And this He said to try him; for He Himself knew what He would do." Once more we get an impression of the sober literalness of St. Philip's mental outlook when he replies: "Two hundred pennyworth of bread is not sufficient for them that every one may take a little." It is in accord with the same amiable type of character which hesitates before responsibilities that, when certain Gentiles among the crowds who thronged to Jerusalem for the pasch came to Philip saying, "Sir, we would see Jesus," we find him reluctant to deal with the request without taking counsel. "Philip cometh and telleth Andrew. Again Andrew and Philip told Jesus." Finally another glimpse is afforded us of the apostle's earnestness and devotion conjoined with defective spiritual insight, when on the evening before the Passion our Lord announced, "No man cometh to the Father but by me. If you had known me, you would without doubt have known my Father also: and from henceforth you shall know Him, and you have seen Him." Philip saith to Him: "Lord, show us

Peter Paul Rubens. *St. Philip*, c. 1610–1612. Prado, Madrid

the Father, and it is enough for us." Jesus saith to him: "Have I been so long a time with you; and have you not known me? Philip, he that seeth me seeth the Father also. How sayest thou: Show us the Father?" (John xiv 6–9).

Apart from the fact that St. Philip is named with the other apostles who spent ten days in the upper room awaiting the coming of the Holy Ghost at Pentecost, this is all we know about him with any degree of certainty.

On the other hand, Eusebius, the church historian, and some other early writers, have preserved a few

details which tradition connected with the later life of Philip. The most reliable of these is the belief that he preached the gospel in Phrygia, and died at Hierapolis, where he was also buried. Sir W. M. Ramsay found among the tombs of that city a fragmentary inscription which refers to a church there dedicated in honor of St. Philip. We know also that Polycrates, bishop of Ephesus, writing to Pope Victor towards the close of the second century, refers to two daughters of St. Philip the Apostle, who had lived in virginity until old age at Hierapolis, and mentions also another daughter who was buried in his own city of Ephesus. Papias, who was himself bishop of Hierapolis, seems to have known personally the daughters of St. Philip and to have learnt from them of a miracle attributed to him, no less than the raising of a dead man to life. Heracleon, the gnostic, about the year 180, maintained that the apostles Philip, Matthew and Thomas died a natural death, but Clement of Alexandria contradicted this, and the opinion commonly accepted at a later date was that Philip was crucified head downwards under Domitian. One fact which introduces much uncertainty into these obscure fragments of evidence is the confusion which undoubtedly arose between Philip the Apostle and Philip the Deacon, sometimes also called "the Evangelist," who figures so prominently in chapter viii of the Acts of the Apostles. Both, in particular, are alleged to have had daughters who enjoyed exceptional consideration in the early Church. It is stated that the remains of St. Philip the Apostle were eventually brought to Rome, and that they have been preserved there in the basilica of the Apostles since the time of Pope Pelagius (A.D. 561). A late apocryphal document in Greek, dating from the close of the fourth century at earliest, purports to recount the missionary activities of St. Philip in Greece, as well as in the land of the Parthians and elsewhere, but it echoes the received tradition so far as regards his death and burial at Hierapolis.

ST. BARTHOLOMEW, APOSTLE

August 24

Patron Saint of Armenia; Plasterers

THE NAME GIVEN to this apostle is probably not his proper name, but his patronymic, meaning the son of Tolmai, and beyond the fact of his existence nothing is certainly known of him. Many scholars, however, take him to have been the same person as Nathanael, a native of Cana in Galilee, of whom our Lord said, "Behold! an Israelite indeed, in whom there is no guile" (John i 47). Among the reasons advanced for this supposition is that, as St. John never mentions Bartholomew among the Apostles, so the other three evangelists take no notice of the name of Nathanael; and they constantly put together Philip and Bartholomew, just as St. John says Philip and Nathanael came together to Christ; moreover, Nathanael is reckoned with other apostles when Christ appeared to them at the sea of Galilee after His resurrection (John xxi 2).

The popular traditions concerning St. Bartholomew are summed up in the Roman Martyrology, which says he "preached the gospel of Christ in India; thence he went into Greater Armenia, and when he had converted many people there to the faith he was flayed alive by the barbarians, and by command of King Astyages fulfilled his martyrdom by beheading." The place is said to have been Albanopolis (Derbend, on the west coast of the Caspian Sea), and he is represented to have preached also in Mesopotamia, Persia, Egypt and elsewhere. The earliest reference to India is given by Eusebius in the early fourth century, when he relates that St. Pantaenus, about a hundred years earlier, going into India (St. Jerome adds "to preach to the Brahmins"), found there some who still retained the knowledge of Christ and showed him a copy of St. Matthew's Gospel in Hebrew characters, which they assured him that St. Bartholomew had brought into those parts when he planted the faith among them. But "India" was a name applied indifferently by Greek and Latin writers to Arabia, Ethiopia, Libya, Parthia, Persia and the lands of the Medes, and it is most probable that the India visited by Pantaenus was Ethiopia or Arabia Felix, or perhaps both. Another eastern legend says the apostle met St. Philip at Hierapolis in Phrygia, and traveled into Lycaonia, where St. John Chrysostom affirms that he instructed the people in the Christian faith. That he preached and died in Armenia is possible, and is a unanimous tradition among the later historians of that country; but earlier Armenian writers make little or no reference to him as connected with their nation. The journeys attributed to the relics of St. Bartholomew are even more bewildering than those of his living body; alleged relics are venerated at present chiefly at Benevento and in the church of St. Bartholomew-in-the-Tiber at Rome.

ST. BARTHOLOMEW
Konrad Witz. *St. Bartholomew.* Kunstmuseum, Basel

ST. MATTHEW,
APOSTLE AND EVANGELIST

September 21

Patron Saint of Accountants; Bankers; Bookkeepers; Tax Collectors

S T. MATTHEW SEEMS to have been a Galilean by birth, and was by profession a publican, or gatherer of taxes for the Romans, a profession which was infamous to the Jews, especially those of the Pharisees' party; they were in general so grasping and extortionate that they were no more popular among the Gentiles. The Jews abhorred them to the extent of refusing to marry into a family which had a publican among its members, banished them from communion in religious worship, and shunned them in all affairs of civil society and commerce. But it is certain that St. Matthew was a Jew, as well as a publican.

The story of Matthew's call is told in his own gospel. Jesus had just confounded some of the Scribes by curing a man who was sick of the palsy, and passing on saw the despised publican in his custom-house. "And He saith to him, 'Follow me.' And he arose up and followed him." Matthew left all his interests and relations to become our Lord's disciple and to embrace a spiritual commerce.

The calling of St. Matthew happened in the second year of the public ministry of Christ, who adopted him into that holy family of the apostles, the spiritual leaders of His Church. It may be noted that whereas the other evangelists in describing the apostles by pairs rank Matthew before St. Thomas, he places that apostle before himself and in this list adds to his own name the epithet of "the publican." He followed our Lord throughout His earthly life, and wrote his gospel or short history of our blessed Redeemer. We are not told that Christ gave any charge about committing to writing His history or doctrine, but it was nevertheless by special inspiration of the Holy Ghost that this work was undertaken by each of the four evangelists, and the gospels are the most excellent part of the sacred writings. For in them Christ teaches us, not by His prophets but by His own mouth, the great lessons of faith and of eternal life; and in the history of His life the perfect pattern of holiness is set before our eyes for us to strive after.

It is said that St. Matthew, after having made a harvest of souls in Judaea, went to preach Christ to the nations of the East, but of this nothing is known for certain. He is venerated by the Church as a martyr, though the time, place and circumstances of his end are unknown. The fathers find a figure of the four evangelists in the four living animals mentioned by Ezekiel and in the Apocalypse of St. John. The eagle is generally said to represent St. John himself, who in the first lines of his gospel soars up to the contemplation of the eternal generation of the Word. The ox agrees to St. Luke, who begins his gospel with the mention of the sacrificing priesthood. Some made the lion the symbol of St. Matthew, who explains the royal dignity of Christ; but St. Jerome and St. Augustine give it to St. Mark, and the man to St. Matthew, who begins his gospel with Christ's human genealogy.

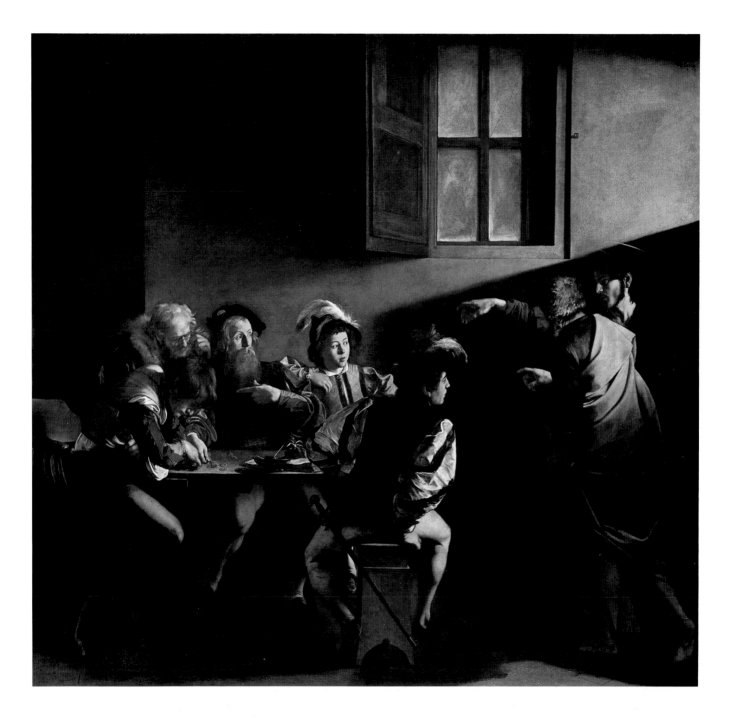

ST. MATTHEW
Caravaggio. *The Calling of St. Matthew,* 1599–1600. Contrarelli Chapel, S. Luigi dei Francesi, Rome

ST. VERONICA

July 12

Few Christian legends are better known and more valued than that of St. Veronica, who compassionately wiped the face of Jesus when He fell beneath the load of His cross on the way to Calvary. Nor is that to be wondered at, for it is a most touching story that appeals at once to the heart of every Christian and, in the version which makes her the wife of a Roman officer, is a moving example of contempt of public opinion and human respect. But the legend, though ancient, has only a vague tradition to support it, and the identifications of the woman to whom the name Veronica has been given are several and various. In its origins the story seems to have been more concerned with the miraculous image of our Lord's face imprinted on the cloth with which it was wiped than with the love and charity that prompted the action. Thus in a widespread western version Veronica came to Rome and cured the Emperor Tiberius with the precious relic, which at her death she left to Pope St. Clement. In France, on the other hand, she is called the wife of Zacchaeus (Luke xix 2–10), who when her husband becomes a hermit, helps to evangelize the south of France. Other versions make her the same person as Martha, the sister of Lazarus, the daughter of the woman of Canaan (Matt. xv 22–28), a princess of Edessa, or the wife of an unknown Gallo-Roman officer.

The name Veronica has been the subject of a good deal of speculation. It has been suggested and widely received that among several alleged authentic likenesses of our Lord the one on the handkerchief of the kind woman was distinguished as *vera icon,* the "true image"; this became *veronica* and was transferred to the woman as a personal name. Certainly such images were and are called holy veronica.

St. Veronica is not mentioned in any of the earliest historical martyrologies, nor is she named in the Roman Martyrology today, and St. Charles Borromeo removed her feast and office from the church of Milan. A house of Veronica was pointed out at Jerusalem in the early fifteenth century, when the devotion of the stations of the cross was beginning to take its present form; but the Veronica incident, in common with several others, only gradually became a permanent station in the series. It was omitted in Vienne so late as 1799.

That a compassionate woman wiped the face of our suffering Lord may well have happened, and Christians do well to ponder her action and revere her traditional memory. The existence of a cloth claimed to be the original veil of Veronica in St. Peter's at Rome is a greatly venerated witness to the tradition, but from the nature of the case there can be no guarantee of its authenticity.

ST. VERONICA
Jacques Blanchard. *St. Veronica.* Hermitage, St. Petersburg

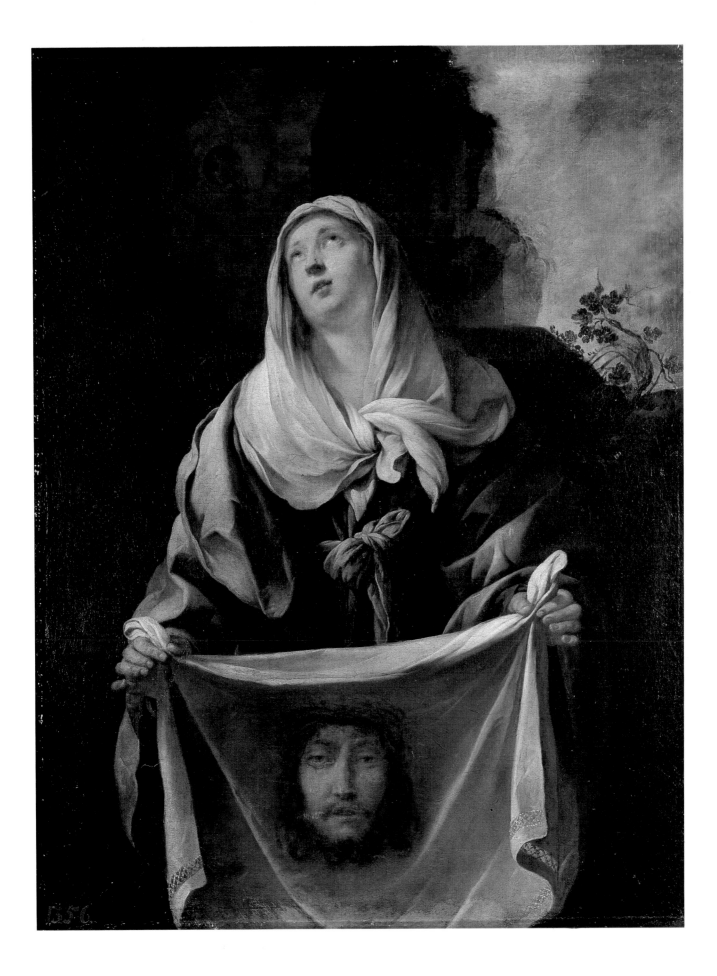

ST. THOMAS, APOSTLE

December 21

Patron Saint of the East Indies; Architects

S T. THOMAS WAS A JEW and probably a Galilean of humble birth, but we are not told the circumstances in which our Lord made him an apostle. His name is Syriac, and means the "twin." When Jesus was going up to the neighborhood of Jerusalem in order to raise Lazarus to life the rest of the disciples endeavored to dissuade Him, saying, "Rabbi, the Jews but now sought to stone thee; and goest thou thither again?" But St. Thomas said, "Let us also go, that we may die with Him," so ardent was his love of his Master. At the last supper, when our Lord said, "Whither I go you know, and the way you know," it was Thomas who asked, "Lord, we know not whither thou goest, and how can we know the way?" and so drew from Him those words in which are contained the whole Christian faith, "I am the Way and the Truth and the Life. No man cometh to the Father but by me." But this apostle is especially remembered for his incredulity after our Lord had suffered, risen from the dead, and on the same day appeared to His disciples to convince them of the truth of His resurrection. Thomas was not then with them and refused to believe their report that He was truly risen. Eight days later, when they were all together and the doors shut, the risen Christ was suddenly in the midst of them, greeting them. Then He turned to Thomas and said, "Put in thy finger hither, and see my hands; and bring hither thy hand and put it into my side. And be not faithless, but believing." And Thomas fell at His feet, exclaiming, "My Lord and my God!"

Jesus answered, "Because thou hast seen me, Thomas, thou hast believed. Blessed are they that have not seen, and have believed."

This is all that we are told of St. Thomas in the New Testament, but there are traditions about his missionary activities after the descent of the Holy Ghost at Pentecost. The most persistent tradition says that he preached the gospel in India. This is supported from several seemingly independent sources, of which the chief is the *Acta Thomae*, a document dating apparently from the first quarter of the third century: When the Apostles at Jerusalem divided the countries of the world for their labors, India fell to the lot of Thomas. He was unwilling to go, pleading lack of strength and that a Hebrew could not teach Indians, and even a vision of our Lord could not alter his resolution. Thereupon Christ appeared to a merchant named Abban, the representative of Gundafor, a Parthian king who ruled over part of India, and sold Thomas to him as a slave for his master. When he understood what had taken place, Thomas said, "As thou wilt, Lord, so be it," and embarked with Abban.

Abban and Thomas came to Gundafor's court in India, and when the king asked the apostle's trade he replied, "I am a carpenter and builder. I can make yokes and ploughs and ox-goads, oars for boats and masts for ships; and I can build in stone, tombs and monuments and palaces for kings." So Gundafor ordered him to build a palace, and Thomas laid out the plans, with "doors towards the east for light, windows

towards the west for air, a bake-house on the south, and water-pipes for the service of the house on the north." Gundafor went on a journey, and in his absence Thomas did no building but spent all the money given him for the work on the poor, saying, "That which is the king's to the kings shall be given." And he went about the land preaching and healing and driving out evil spirits. On his return Gundafor asked to be shown his new palace. "You cannot see it now, but only when you have left this world," replied Thomas. Whereupon the king cast him into prison and purposed to flay him alive. But just then Gundafor's brother died, and being shown in Heaven the palace that Thomas's good works had prepared for Gundafor, he was allowed to come back to earth and offer to buy it from the king. Gundafor declined to sell, and in admiration released Thomas and received baptism together with his brother and many of his subjects.

Afterwards Thomas was preaching and doing marvels throughout India, until he got into trouble with a King Mazdai for converting his wife, his son and other important people. Eventually Thomas was led to the top of a hill where, having had orders from the king, "soldiers came and struck him all together, and he fell down and died." He was buried in a royal sepulchre, but afterwards some of the brethren carried away his relics to the West.

It is now commonly agreed that there is no truth behind the story just outlined, though there was undoubtedly a king named Gondophernes or Guduphara, whose dominions about the year A.D. 46 included the territory of Peshawar; and attempts have been made to identify King Mazdai with the contemporary King Vasudeva of Mathura. Unfortunately, speculation about St. Thomas cannot be left there. At the other end of India from the Punjab, along what is known as the Malabar Coast, there is a large population of native Christians who call themselves "the Christians of St. Thomas." Their history is known in detail since the sixteenth century, but their origin has not yet been indisputably determined. There have certainly been Christians there since very early times, and in their liturgy they use forms and a language (Syriac) that undoubtedly were derived from Mesopotamia and Persia. They claim to have been originally evangelized by St. Thomas in person and have an ancient oral tradition that he landed at Cranganore on the west coast and established seven churches in Malabar; then passed eastward to the Coromandel Coast, where he was martyred, by spearing, on the "Big Hill," eight miles from Madras; and was buried at Mylapore, now a suburb of that city. There are several medieval references to the tomb of St. Thomas in India, some of which name Mylapore; and in 1522 the Portuguese discovered the alleged tomb there, with certain small relics now preserved in the cathedral of St. Thomas at Mylapore. But the bulk of his reputed relics were certainly at Edessa in the fourth century, and the *Acta Thomae* relate that they were taken from India to Mesopotamia. They were later translated from Edessa to the island of Khios in the Aegean, and from thence to Ortona in the Abruzzi, where they are still venerated.

The Roman Martyrology combines several legends and adopts the view that St. Thomas preached the gospel to the Parthians, Medes, Persians and Hyrcanians, passed into India, and was there martyred at "Calamina." The Martyrology mentions the translation of his relics to Edessa on July 3, but in Malabar, and indeed throughout the Syrian churches, this date is the principal feast of St. Thomas, commemorating his martyrdom "in the year 72 A.D."

ST. PETER, PRINCE OF THE APOSTLES

June 29

Patron Saint of Fishermen

THE STORY OF ST. PETER as recounted in the gospels is so familiar that there can be no need to retrace it here in detail. We know that he was a Galilean, that his original home was at Bethsaida, that he was married, a fisherman, and that he was brother to the apostle St. Andrew. His name was Simon, but our Lord, on first meeting him, told him that he should be called Kephas, the Aramaic equivalent of the Greek word whose English form is Peter (i.e. rock). No one who reads the New Testament can be blind to the predominant role which is everywhere accorded to him among the immediate followers of Jesus. It was he who, as spokesman of the rest, made the sublime profession of faith: "Thou art the Christ, the Son of the living God"; and it was to him personally that our Savior, with a solemnity of phrase which finds no parallel in the rest of the gospel narrative, addressed the words: "Blessed art thou Simon bar-Jona, because flesh and blood hath not revealed it to thee, but my Father who is in Heaven. And I say to thee, that thou art Peter, and upon this rock I will build my Church, and the gates of Hell shall not prevail against it; and I will give to thee the keys of the kingdom of Heaven; and whatsoever thou shalt bind upon earth, it shall be bound also in Heaven; and whatsoever thou shalt loose on earth, it shall be loosed also in Heaven."

Not less familiar is the story of Peter's triple denial of his Master in spite of the warning he had previously received. The very fact that his fall is recorded by all four evangelists with a fullness of detail which seems out of proportion to its relative insignificance amid the incidents of our Savior's passion, is itself a tribute to the position which St. Peter occupied among his fellows. On the other hand, if our Lord's warning met with no response, we must also remember that it was prefaced by those astounding words, with their strange change from the plural to the singular: "Simon, Simon, behold Satan hath desired to have you that he may sift you as wheat; but I have prayed for thee, that thy faith fail not, and thou, being once converted, confirm thy brethren." Equally impressive is the triple reparation which our Lord tenderly but almost cruelly extorted from His shamefaced disciple beside the Sea of Galilee. "When therefore they had dined, Jesus saith to Simon Peter, 'Simon, son of John, lovest thou me more than these?' He saith to him: 'Yea, Lord, thou knowest that I love thee.' He saith to him: 'Feed my lambs.' He saith to him again: 'Simon, son of John, lovest thou me?' He saith to Him: 'Yea, Lord, thou knowest that I love thee.' He saith to him: 'Feed my lambs.' He said to him the third time: 'Simon, son of John, lovest thou me?' Peter was grieved, because He had said to him the third time: lovest thou me? And he said to Him: 'Lord, thou knowest all things: thou knowest that I love thee.' He said to him: 'Feed my sheep.' " But the prophecy which follows is almost more wonderful; for Jesus went on: "Amen, amen, I say to thee, when thou wast younger thou didst gird thyself and didst walk where thou wouldst. But when thou shalt be old, thou shalt stretch forth thy hands, and another shall gird thee and lead thee whither thou wouldst not." "And this," adds the evangelist, "He said, signifying by what death he should glorify God."

After the Ascension we find St. Peter everywhere taking a leading part. It is he who is named first

in the group of apostles who, in the upper room, "persevered with one mind in prayer with the women and Mary the mother of Jesus," until the coming of the Holy Ghost on the day of the Pentecost. It was he, also, who took the initiative in the choosing of a new apostle in the place of Judas, and he who first addressed the jeering crowd, bearing testimony to "Jesus of Nazareth, a man approved of God among you, by miracles and wonders and signs which God did by Him in the midst of you, whom God raised again, whereof all we are witnesses." Further, we are told: "Now when they had heard these things, they had compunction in their heart, and said to Peter and to the rest of the apostles: 'What shall we do, men and brethren?' Peter said to them: 'Repent, and be baptized every one of you in the name of Jesus Christ.'" Whereupon "they that received his word were baptized; and there were added in that day about three thousand souls." It is Peter, too, who is recorded to have done the first miracle of healing known in the Christian Church. A man lame from his birth was lying at the gate of the Temple when Peter and John went up to pray, and he asked them for an alms. "Peter with John fastening his eyes upon him said: 'Look upon us.' But he looked earnestly upon them, hoping that he should receive something of them. But Peter said: 'Silver and gold I have none, but what I have, I give thee: in the name of Jesus Christ of Nazareth, arise and walk.' And taking him by the right hand, he lifted him up, and forthwith his feet and soles received strength. And he leaping up, stood and walked, and went with them into the temple, walking and leaping and praising God."

When the outbreak of persecution began which culminated in the martyrdom of St. Stephen in the presence of Saul, the future apostle of the Gentiles, the new converts to Christ's teaching, for the most part, scattered, but the Apostles stood their ground in Jerusalem until news came of the favorable reception accorded in Samaria to the preaching of St. Philip the Deacon. Then St. Peter and St. John betook themselves to the field of these labors and imposed hands upon (gave confirmation to?) those whom St. Philip had already baptized. Among these last was a man, best known to us as Simon Magus, who claimed to possess occult powers and had acquired great influence by his sorceries. Being apparently impressed by what he witnessed in those who had been newly confirmed, he came to the Apostles, saying, "Give me also this power, that on whomsoever I shall lay my hands, he may receive the Holy Ghost." But, offering them money, he only met with a stern rebuke; for Peter said, "Keep thy money to thyself, to perish with thee, because thou hast thought that the gift of God may be purchased with money."

Again, in the apocryphal "Acts of St. Peter," there is a dramatic story of the Magus's attempt to gain over the Emperor Nero by a demonstration of his occult power in flying through the air. According to this legend, SS. Peter and Paul were present and by their prayers rendered the sorcerer's magic ineffective. He fell to the ground and died soon afterwards of his injuries. Other, and quite contradictory stories, are repeated by Hippolytus and by other early writers, always turning upon some sort of conflict between Simon and the two great apostles, with Rome as the background of the drama. Unconvincing as the evidence is, there is a general disposition among early Christian writers, such, for instance, as St. Irenaeus, to regard Simon Magus as "the father of heresies," and as in some special way the antagonist of SS. Peter and Paul, the representatives of Christian truth in the capital of the world.

Almost all that we know for certain about the later life of St. Peter is derived from the Acts of the Apostles and from slight allusions in his own epistles and those of St. Paul. Of special importance is the account of the conversion of the centurion Cornelius; for this raised the question of the continuance of the rite of circumcision and the maintenance of the prescriptions of the Jewish law in such matters as food and intercourse

ST. PETER
Annibale Carracci. *Christ Appearing to St. Peter on the Appian Way (Domine Quo Vadis?)*, 1601–1602.
National Gallery, London

with the Gentiles. Instructed by a special vision, St. Peter, albeit with some hesitancy, came to see that the old dispensation was at an end, and that the Church founded by Christ was to be the Church of the Gentiles as well as of the Jews, which led to what has been called the Council of Jerusalem. The resolution of this council was that the Gentile converts to Christianity need not be circumcised or required to observe the law of Moses. On the other hand, to avoid too grievous a shock to Jewish susceptibilities, they were to abstain from blood and from things strangled, as well as from fornication and from idol-offerings. This decision was communicated to Antioch and served to calm the troubled feelings of the fast-growing Christian community in that great city.

It is possible, though we have no really reliable evidence upon the point, that before the Jerusalem council (A.D. 49?) St. Peter had already, for two years or more, been bishop of Antioch, and that he may even have made his way to Rome, thus taking possession of what was to be his permanent see. A striking incident recorded in the Acts is the violent outbreak of persecution under Herod Agrippa I, probably in the year 43. We are told that Herod "slew James the brother of John with the sword" — this, of course, was the elder James, the apostle whose feast is kept on July 25 — and that then he proceeded to arrest Peter also. However, "prayer was earnestly being offered to God by the Church in his behalf," and Peter, though "he was sleeping between two soldiers bound with two chains, and sentries outside the door were guarding the prison," was released by an angel and was able to make his way to a safe refuge. After that we are only told that "he departed and went to another place," by which might be meant Antioch, or even Rome. From this point Peter is mentioned no more in the Acts except in connection with the council at Jerusalem as described above.

The passion of St. Peter took place in Rome during the reign of Nero (A.D. 54–68), but no written account of it (if there was such a thing) has survived. According to an old but unverifiable tradition he was confined in the Mamertine prison, where the church of San Pietro in Carcere now stands. Tertullian says that

the apostle was crucified; and Eusebius adds, on the authority of Origen, that by his own desire he suffered head downwards. The place has always been believed to be the gardens of Nero, which saw so many scenes of terror and glory at this time. The, at one time, generally accepted tradition that St. Peter's pontificate lasted twenty-five years is probably no more than a deduction based upon inconsistent chronological data. The beautiful legend that St. Peter, departing out of Rome at the earnest request of his flock, met our Lord coming in, and asked Him, *"Domine quo vadis?"* (Lord, whither goest thou?), is first told by St. Ambrose in his sermon against Auxentius. Our Lord answered, "I am coming to be crucified a second time," and St. Peter at once turned back, realizing that the cross of which the Savior spoke was that which was destined for himself.

According to a view which has been accepted by many Roman archaeologists, the bodies both of St. Peter and St. Paul were in the year 258 conveyed from their respective tombs beside the Vatican and on the Ostian Way to some hiding-place, *ad catacumbas,* on the Appian Way, close to the site where the basilica of St. Sebastian now stands. Excavations in 1915–1922 were undertaken to find this hiding-place, or at any rate some trace of it, but in this respect the investigation does not seem to have been crowned with success. There was found, however, the basin or hollow *(kumbe)* in the tufa, from which the now familiar name "catacomb" is derived. The place was called *ad catacumbas* because its most conspicuous original feature was a series of sepulchral chambers constructed in the tufa beside a natural depression in the ground *(kata kumbas)*.

Close beside these, however, there were found the walls of a large room, open on one side to the air, which must have been constructed about the year 250. From its decorations and other details it was clearly a place intended for meetings of a more or less convivial and ceremonial character. There is good reason to suppose that it was the scene of those repasts called *agapae,* the Christian love-feasts of the early centuries. What is beyond question is that the remains of the plaster coating left here and there on the walls are covered with *graffiti* which can be dated with security

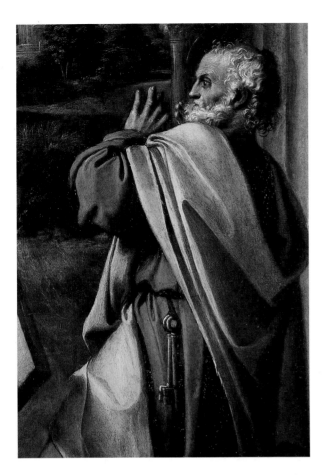

the triumph of St. Peter was to be found on the Vatican hill, whereas the martyrdom of St. Paul was honored on the Ostian Way. The inscription set up by Pope St. Damasus I (d. 384) at the place near St. Sebastian's would therefore merely commemorate the institution of a festival in 258 which, for convenience or some other reason, was celebrated *ad catacumbas.*

Since the above was written the results of the excavations, begun under St. Peter's basilica in 1938, have been made public. The site and fragmentary remains of the Apostle's tomb there seem to have been established and identified beyond reasonable doubt; but whether the human remains found in close proximity are those of St. Peter can at present, and perhaps for ever, be only a matter of surmise. This discovery on the Vatican hill revives interest in the San Sebastiano site; but the theory that, after a translation *ad catacumbas* in 258, the bones of St. Peter remained there permanently is for several reasons a most unlikely one.

The joint feast of SS. Peter and Paul seems always to have been kept at Rome on June 29, and Duchesne considers that the practice goes back at least to the time of Constantine; but the celebration in the East was at first commonly assigned to December 28. This was the case at Oxyrhynchus in Egypt, as surviving papyri attest, as late as the year 536, but in Constantinople and elsewhere in the Eastern empire the Roman date for the commemoration gradually won acceptance. The joint feast was kept in Syria in the early fifth century, as we learn from the Syriac *breviarium* of that period, which has an entry in this form: "December 28, in the City of Rome, Paul the Apostle, and Simon Kephas (i.e. Peter), the chief of the Apostles of the Lord."

as belonging to the second half of the third century. They seem to have been a rather uneducated crowd who scrawled their pious sentiments upon the plaster, but their devotion to Peter and Paul is made everywhere manifest. These spontaneous and often quite illiterate appeals point clearly to a great popular *cultus* of SS. Peter and Paul at this spot.

Already, at the beginning of the third century, Caius, as quoted by Eusebius, records that the scene of

ST. JAMES THE LESS

May 1

Patron Saint of Druggists; Hatters

THE APOSTLE St. James — the Less, or the younger — is most commonly held to be the same individual who is variously designated "James, the son of Alpheus" (e.g. Matt. x 3, and Acts i 13), and "James, the brother of the Lord" (Matt. xiii 55; Gal. i 19). He may also possibly be identical with James, son of Mary and brother of Joseph (Mark xv 40). It may be assumed then that the apostle James who became bishop of Jerusalem (Acts xv and xxi 18) was the son of Alpheus and "brother" (i.e. first cousin) of Jesus Christ. We learn from St. Paul that he was favored with a special appearing of our Lord before the Ascension. Further, when St. Paul, three years after his conversion, went up to Jerusalem and was still regarded with some suspicion by the apostles who remained there, James, with St. Peter, seems to have bid him a cordial welcome. Later we learn that Peter, after his escape from prison, sent a special intimation to James, apparently as to one whose pre-eminence was recognized among the Christians of the holy city. At what is called the Council of Jerusalem, where it was decided that the Gentiles who accepted Christian teaching need not be circumcised, it was St. James who, after listening to St. Peter's advice, voiced the conclusion of the assembly in the words, "it hath seemed good to the Holy Ghost and to us" (Acts xv). He was, in fact, the bishop of Jerusalem, as Clement of Alexandria and Eusebius expressly state. Even Josephus, the Jewish historian, bears testimony to the repute in which James was held, and declares, so Eusebius asserts, that the terrible calamities which fell upon the people of that city were a retribution for their treatment of one "who was the most righteous of

men." The story of his martyrdom, as told by Hegesippus, runs as follows:

Together with the apostles, James, our Lord's brother, succeeded to the government of the Church. He received the name of "the Just" from all men from the time of our Lord even to our own; for there were many called James. Now he was holy from his mother's womb, drank no wine nor strong drink nor ate anything in which was life. No razor came upon his head; he anointed himself not with oil, and used no bath. To him alone it was permitted to enter the holy place; for he wore nothing woollen, but linen garments [i.e. the priestly robes]. And alone he entered into the sanctuary and was found on his knees asking forgiveness on behalf of the people, so that his knees became hard like a camel's, for he was continually bending the knee in worship to God and asking forgiveness for the people. In fact, on account of his exceeding great justice he was called "the Just" and "Oblias," that is to say, bulwark of the people.

We learn further from Hegesippus that:

As many as came to believe did so through James. When, therefore, many also of the rulers were believers, there was an uproar among the Jews and scribes and pharisees, for they said: "There is danger that the whole people should expect Jesus as the Christ." Coming together, therefore, they said to James: "We beseech thee, restrain the people, for they are gone astray unto Jesus, imagining that he is the Christ. We beseech thee to persuade all who come for

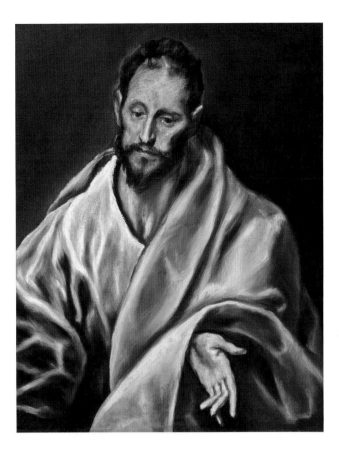

ST. JAMES THE LESS

El Greco. *St. James the Less*, c. 1586–1590. Art Institute of Chicago

the day of the Passover concerning Jesus, for in thee do we all put our trust. For we bear thee witness, as do all the people, that thou art just and that thou acceptest not the person of any. Persuade, therefore, the multitude that they go not astray concerning Jesus. For, of a truth, the people, and we all, put our trust in thee. Stand, therefore, upon the pinnacle of the temple, that from thy lofty station thou mayest be evident, and thy words may easily be heard by all the people. For on account of the Passover all the tribes, with the Gentiles also, have come together." Therefore the aforesaid scribes and pharisees set James upon the pinnacle of the temple, and cried aloud to him saying: "O Just One, in whom we ought all to put our trust, inasmuch as the people is gone astray after Jesus who was crucified, tell us what is the door of Jesus" (cf. John x 1–9). And he

replied with a loud voice: "Why ask ye me concerning the Son of Man, since He sitteth in Heaven on the right hand of the Mighty Power, and shall come on the clouds of Heaven?" And when many were fully persuaded and gave glory at the testimony of James and said: "Hosanna to the son of David," then once more the same scribes and pharisees said among themselves: "We do ill in affording such a testimony to Jesus. Let us rather go up and cast him down, that being affrighted they may not believe him." And they cried aloud saying: "Ho, ho, even the Just One has gone astray!" And they fulfilled the scripture that is written in Isaiah: "Let us take away the just one, for he is troublesome to us. Therefore they shall eat the fruit of their doings." Going up therefore they cast the Just One down. And they said to each other: "Let us stone James the Just." And they began to stone him, for the fall did not kill him. But turning he kneeled down and said: "I beseech thee, O Lord God, Father, forgive them, for they know not what they do." And while they thus were stoning him, one of the priests of the sons of Rechab, the son of Rachabim, who had witness borne to them by Jeremiah the prophet, cried aloud, saying: "Cease ye; what do ye? The Just One is praying on your behalf." And one of them, a fuller, took the stick with which he beat out the clothes, and brought it down on the Just One's head. Thus he was martyred. And they buried him at the spot beside the temple. . . .

The story is told somewhat differently by Josephus, who informs us that he was stoned to death, and assigns this to the year 62. In relation to the festivals kept by the Church liturgically under the designation of "St. Peter's Chair," it is interesting to note that Eusebius speaks of the "throne," or chair, of St. James as still preserved and venerated by the Christians of Jerusalem. This St. James is commonly held to be the author of the epistle in the New Testament which bears his name and which, by its insistence on good works, was highly obnoxious to those who preached the doctrine of justification by faith alone.

ST. JUDE, OR THADDEUS, APOSTLE

October 28

Patron Saint of Desperate Situations

THE APOSTLE JUDE (Judas), also called Thaddeus (or Lebbeus), "the brother of James," is usually regarded as the brother of St. James the Less. It is not known when and by what means he became a disciple of Christ, nothing having been said of him in the gospels before we find him enumerated among the apostles. After the Last Supper, when Christ promised to manifest Himself to His hearers, St. Jude asked Him why He did not manifest Himself to the rest of the world; and Christ answered that He and the Father would visit all those who love Him, "we will come to him, and will make our abode with him" (John xiv 22–23). The history of St. Jude after our Lord's ascension and the descent of the Holy Ghost is as unknown as that of St. Simon. Jude's name is borne by one of the canonical epistles, which has much in common with the second epistle of St. Peter. It is not addressed to any particular church or person, and in it he urges the faithful to "contend earnestly for the faith once delivered to the saints. For certain men are secretly entered in . . . ungodly men, turning the grace of our Lord God into riotousness, and denying the only sovereign ruler and our Lord Jesus Christ."

According to a Western tradition St. Jude was martyred with St. Simon in Persia. Eusebius quotes a story that two grandsons of St. Jude, Zoker and James, were brought before the Emperor Domitian, who had been alarmed by the report that they were of the royal house of David. But when he saw they were poor, hard-working peasants, and heard that the kingdom for which they looked was not of this world, he dismissed them with contempt.

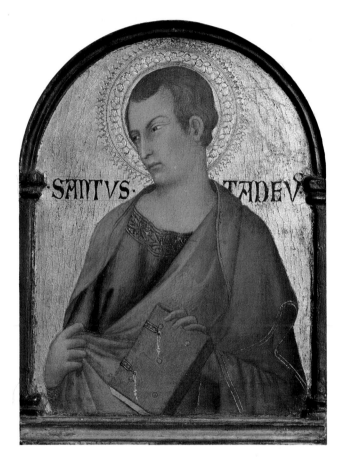

ST. JUDE

Workshop of Simone Martini. *St. (Jude) Thaddeus,* probably c. 1320. National Gallery of Art, Washington, D.C.

ST. SIMON, APOSTLE

October 28

Patron Saint of Tanners

ST. SIMON IS SURNAMED the Cananean or Zelotes in the Holy Scriptures, words which both mean "the Zealous." Some have mistakenly thought that the first of these names was meant to imply that St. Simon was born at Cana in Galilee. The name refers to his zeal for the Jewish law before his call, and does not necessarily mean that he was one of that particular party among the Jews called Zealots. No mention of him appears in the gospels beyond that he was chosen among the apostles. With the rest he received the Holy Ghost, but of his life after Pentecost we have no information whatever; it is not possible to reconcile the various traditions. The Menology of Basil says that St. Simon died in peace at Edessa, but the Western tradition recognized in the Roman liturgy is that, after preaching in Egypt, he joined St. Jude from Mesopotamia and that they went as missionaries for some years to Persia, suffering martyrdom there. They are accordingly commemorated together in the West, but in the East separately and on various dates.

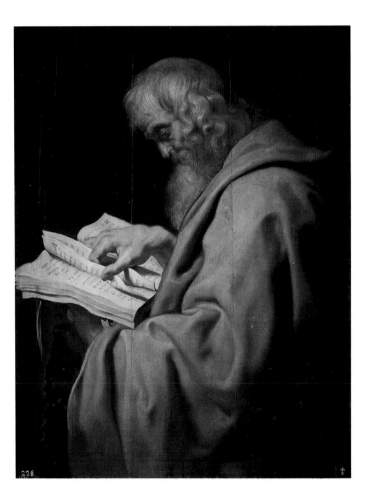

ST. SIMON

Peter Paul Rubens. *St. Simon*, c. 1610–1612. Prado, Madrid

ST. LUKE, EVANGELIST

October 18

Patron Saint of Artists; Brewers; Butchers; Glassworkers; Notaries;
Painters; Physicians; Surgeons

IT IS FROM ST. PAUL HIMSELF that we learn that St. Luke was a Gentile, for he is not named among those of his helpers whom Paul mentions as Jews (Col. iv 10–11); that he was a fellow worker with the apostle; and that he was a medical man, who doubtless had the care of Paul's much-tried health. But nowhere does St. Paul refer to Luke's writings. The first time in the history of the mission of St. Paul that Luke speaks in his own name in the first person is when the apostle sailed from Troas into Macedonia (Acts xvi 10). Before this he had doubtless been for some time a disciple of St. Paul. According to Eusebius, Luke's home was at Antioch, and he was almost certainly a Greek; and his journeyings and tribulations with St. Paul are, of course, set out by Luke himself in the Acts of the Apostles.

It is only in the gospel of St. Luke that we have a full account of the annunciation of the mystery of the Incarnation to the Blessed Virgin, of her visit to St. Elizabeth, and of the journeys to Jerusalem (ix 51; xix 28). He relates six miracles and eighteen parables not mentioned in the other gospels. He wrote the book called the Acts of the Apostles as an appendix to his gospel, to prevent false relations by leaving an authentic account of the wonderful works of God in planting His Church and of some of the miracles by which He confirmed it. Having related some general transactions of the principal apostles in the first establishment of the Church, beginning at our Lord's ascension, he from the thirteenth chapter almost confines himself to the actions and miracles of St. Paul, to most of which he had been privy and an eye-witness.

Luke was with St. Paul in his last days: after writing those famous words to Timothy, "The time of my dissolution is at hand. I have fought a good fight: I have finished my course: I have kept the faith . . . ," the apostle goes on to say, "Only Luke is with me." Of what happened to St. Luke after St. Paul's martyrdom we have no certain knowledge. But according to a fairly early and widespread tradition he was unmarried, wrote his gospel in Greece, and died at the age of 84 in Boeotia.

As well as of physicians and surgeons, St. Luke is the patron saint of painters of pictures. A writer of the earlier sixth century states that the Empress Eudokia had a century before sent to St. Pulcheria from Jerusalem an icon of our Lady painted by St. Luke. Other pictures were afterwards attributed to him; but St. Augustine states clearly that nothing was known about the bodily appearance of the Virgin Mary. On the other hand there can be no question of the many subjects suggested to so many artists by St. Luke's descriptions of events in his writings. In accommodating the four symbolical representations mentioned in Ezekiel to the four evangelists, the ox or calf was assigned to Luke; St. Irenaeus explains this by reference to the sacrificial element in the beginning of his gospel.

ST. LUKE
Marten de Vos. *St. Luke Painting the Virgin's Portrait*, 1602. Koninklijk Museum voor Shone Kunsten, Antwerp

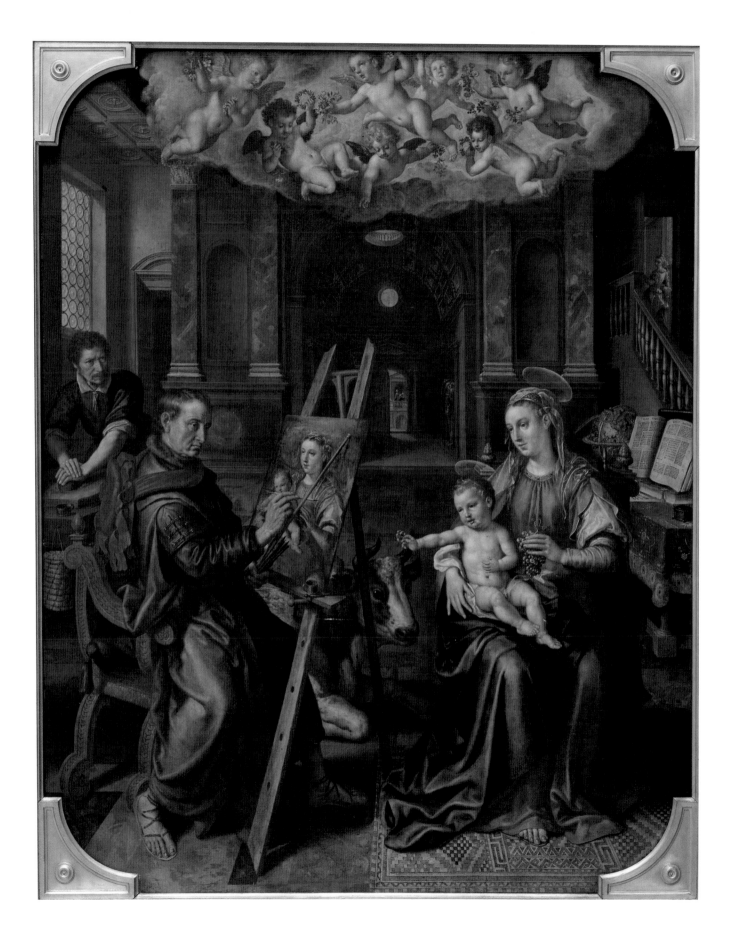

ST. MARK, EVANGELIST

April 25

Patron Saint of Venice; Notaries

OR OUR KNOWLEDGE of the personal history of St. Mark, the author of the second gospel, we are dependent more or less upon conjecture. It is generally believed that he must be identical with the "John surnamed Mark" of Acts xii 12 and 25, and that the Mary whose house in Jerusalem was a kind of rendezvous for the apostles was consequently his mother. From Col. iv 10 we learn that Mark was a kinsman of St. Barnabas who, as stated in Acts iv 36, was a Levite and a Cypriot, and from this it is not unlikely that St. Mark was of a levitical family himself. When Paul and Barnabas returned to Antioch, after leaving in Jerusalem the alms they had brought, they took John surnamed Mark with them, and in their apostolic mission at Salamis in Cyprus, Mark helped them in their ministry (Acts xiii 5), but when they were at Perga in Pamphylia he left and returned to Jerusalem (Acts xiii 13). St. Paul seems consequently to have suspected Mark of a certain instability, and later, when preparing for a visitation of the churches in Cilicia and the rest of Asia Minor, he refused to include John Mark, though Barnabas desired his company. The difference of opinion ended in Barnabas separating from St. Paul and going with Mark again to Cyprus. None the less when Paul was undergoing his first captivity in Rome, Mark was with him and a help to him (Col. iv 10). Also in his second Roman captivity, shortly before his martyrdom, St. Paul writes to Timothy, then at Ephesus, enjoining him

to "take Mark and bring him with thee, for he is profitable to me for the ministry."

On the other hand tradition testifies strongly in the sense that the author of the second gospel was intimately associated with St. Peter. Clement of Alexandria (as reported by Eusebius), Irenaeus and Papias speak of St. Mark as the interpreter or mouthpiece of St. Peter, though Papias declares that Mark had not heard the Lord and had not been His disciple. In spite of this last utterance, many commentators incline to the view that the young man (Mark xiv 51) who followed our Lord after His arrest was no other than Mark himself. What is certain is that St. Peter, writing from Rome (I Peter v 13), speaks of "my son Mark" who apparently was there with him. We can hardly doubt that this was the evangelist, and there is at any rate nothing which conclusively shows that this young man is a different person from the "John surnamed Mark" of the Acts.

Turning to more uncertain documents, we have in the first place to note a narrative which purports to have been written by the same John Mark to give an account of that second visit of Barnabas and himself to Cyprus, which ended in the martyrdom of the former, here assigned to A.D. 53. It is noteworthy that the compiler of this apocryphal "passion" had apparently no idea that Mark was himself the author of the second gospel, for great prominence is given to the possession by Barnabas of a record of our Lord's sayings and doings which he had obtained from St. Matthew. This

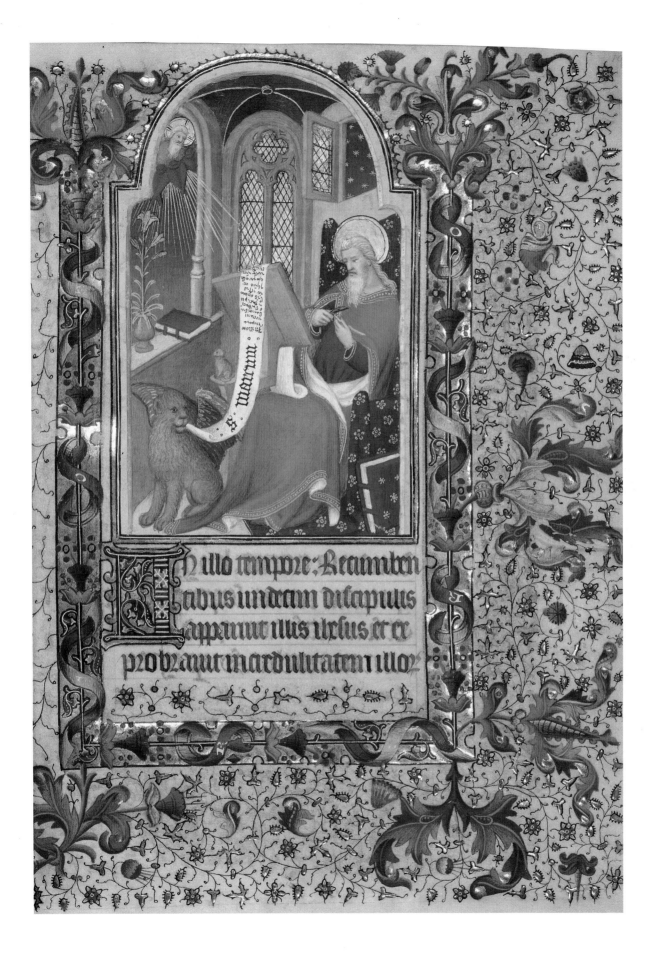

In illo tempore: Recumben
tibus undecim discipulis
apparuit illis ihesus et ex
probauit incredulitatem illo

seems an unlikely detail to be invented and put in the mouth of one who was himself known to be one of the four evangelists. On the other hand the concluding passage represents Mark as sailing for Alexandria and there devoting himself to the work of teaching others "what he had learned from the apostles of Christ."

That St. Mark lived for some years in Alexandria and became bishop of that see is an ancient tradition, though his connection with their native city is not mentioned either by Clement of Alexandria or by Origen. Eusebius, however, records it, and so also does the ancient Latin preface to the vulgate of St. Mark's Gospel. This last notice, referring to some personal deformity of the evangelist, mentioned also at an earlier date by Hippolytus, suggests that it was a mutilation self-inflicted to prevent his ordination to the priesthood of which he deemed himself unworthy. But while it is quite probable that St. Mark did end his days as bishop of Alexandria, we can put no confidence in the "acts" of his supposed martyrdom. These are briefly summarized in the notice which still stands in the Roman Martyrology: "At Alexandria, the birthday of St. Mark the Evangelist, who was the disciple and interpreter of Peter the Apostle. He was sent for to Rome by the brethren and there wrote a gospel, and having finished it, went into Egypt. He was the first to preach Christ at Alexandria and formed a church there. Later he was arrested for his faith in Christ, bound with cords and grievously tortured by being dragged over stones. Then, while shut up in prison, he was comforted by the visit of an angel, and finally, after our Lord Himself had appeared to him, he was called to the heavenly kingdom in the eighth year of Nero."

The city of Venice claims to possess the body of St. Mark which is supposed to have been brought there from Alexandria early in the ninth century. The authenticity of the remains preserved for so many hundred years has not passed unquestioned, and in any case it may be doubted whether the percolation of water, which for long periods rendered the subterranean *confessio* where they repose quite inaccessible, has not wrought irreparable damage to the frail contents of the shrine. It is certain, however, that St. Mark has been honored from time immemorial as principal patron of the city. St. Mark's emblem, the lion, like the emblems of the other evangelists, is of very ancient date. Already in the time of St. Augustine and St. Jerome, "the four living creatures" of Apoc. iv 7–8 were held to be typical of the evangelists, and these holy doctors were reduced to tracing a connection between St. Mark and his lion by the consideration that St. Mark's Gospel begins with a mention of the desert and that the lion is lord of the desert.

On St. Mark's day are celebrated the *litaniae majores,* but it should be pointed out that this solemn procession, formerly associated with a fast, has no connection of origin with the festival of the holy evangelist. It is not improbable that the *litaniae majores* date back in Rome to the time of St. Gregory the Great or even earlier, whereas the liturgical recognition of St. Mark on this day was only introduced at a much later period.

In the martyrologies and liturgical tradition of both East and West, Mark the Evangelist and John Mark are regarded as being separate persons. John Mark is in the Greek *Menaion* on September 27, and on the same date the Roman Martyrology has: "At Byblos in Phoenicia, St. Mark the bishop, who by blessed Luke is also called John and who was the son of that blessed Mary whose memory is noted on June 29." That he became a bishop at Byblos or elsewhere is a tradition of the Greeks, from whom the West acquired it.

ST. PAUL, APOSTLE OF THE GENTILES

January 25: His Conversion June 29: His Martyrdom

Patron Saint of Public Relations (for hospitals)

THE APOSTLE OF THE GENTILES was a Jew of the tribe of Benjamin. He received the name of Saul, and being born at Tarsus in Cilicia he was by privilege a Roman citizen. His parents sent him when young to Jerusalem, and there he was instructed in the law of Moses. Later on Saul, surpassing his fellows in zeal for the Jewish law and traditions, which he thought the cause of God, became a persecutor and enemy of Christ. He was one of those who took part in the murder of St. Stephen, and by looking after the garments of those who stoned that holy martyr he is said by St. Augustine to have stoned him by the hands of all the rest. To the martyr's prayers for his enemies we may ascribe Saul's conversion. "If Stephen," St. Augustine adds, "had not prayed, the Church would never have had St. Paul."

In the fury of his zeal he applied to the high priest for a commission to arrest all Jews at Damascus who confessed Jesus Christ, and bring them bound to Jerusalem. But God was pleased to show forth in him His patience and mercy. Saul was almost at the end of his journey to Damascus when, about noon, he and his company were on a sudden surrounded by a great light from Heaven. They all saw this light, and being struck with amazement fell to the ground. Then Saul heard a voice which to him was articulate and distinct, though not understood by the rest: "Saul, Saul, why dost thou persecute me?" Saul answered, "Who art thou, Lord?" Christ said, "Jesus of Nazareth, whom thou persecutest. It is hard for thee to kick against the goad." In other words, by persecuting My church you only hurt yourself. Trembling and astonished, he cried out, "Lord, what wilt thou have me to do?" Christ told him

to arise and proceed on his journey to his destination, where he would learn what was expected of him. When he got up from the ground Saul found that though his eyes were open he could see nothing. He was led by the hand like a child to Damascus, and was lodged in the house of a Jew named Judas, and there he remained three days, blind, and without eating or drinking.

There was a Christian in Damascus much respected for his life and virtue, whose name was Ananias. Christ appeared to this disciple and commanded him to go to Saul. Ananias trembled at the name of Saul, being no stranger to the mischief he had done in Jerusalem, or to the errand on which he had traveled to Damascus. But our Redeemer overruled his fears, and charged him a second time to go. Saul in the meantime saw in a vision a man entering, and laying his hands upon him to restore his sight. Ananias arose, went to Saul, and laying his hands upon him said, "Brother Saul, the Lord Jesus, who appeared to thee on thy journey, hath sent me that thou mayest receive thy sight, and be filled with the Holy Ghost." Immediately something like scales fell from his eyes, and he recovered his sight. Ananias went on, "The God of our fathers hath chosen thee that thou shouldst know His will and see the Just One and hear the voice from His mouth: and thou shalt be His witness to all men of what thou hast seen and heard. Why dost thou tarry? Arise, be baptized and washed from thy sins, invoking the name of the Lord." Saul arose, was baptized, and ate. He stayed some days with the disciples at Damascus, and began immediately to preach in the synagogues that Jesus was the Son of God, to the great astonishment of all that heard him. Thus a blas-

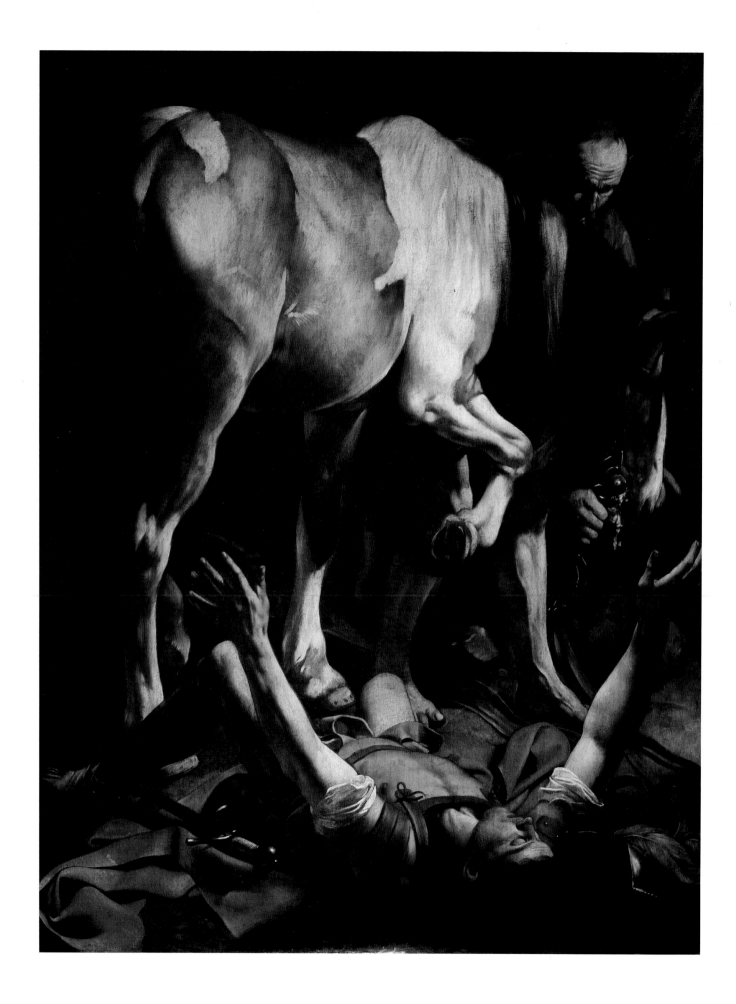

phemer and a persecutor was made an apostle, and chosen to be one of the principal instruments of God in the conversion of the world.

The fury against his teaching in Damascus was such that he had to make his escape, being let down the city wall in a basket. He directed his steps to Jerusalem, and there, perhaps not unnaturally, he was at first regarded by the Apostles and their converts with considerable suspicion, until the generous support of Barnabas allayed their fears. In Jerusalem, however, he could not stay — the resentment of the Jews against him was too strong — and being warned by a vision which came to him in the temple, Saul went back for a time to his native city of Tarsus. Thither Barnabas went to seek him, and yielding to his persuasion Saul accompanied him to Antioch in Syria, where the two preached with such success that a great community of believers was founded who, in that city for the first time, began to be known as "Christians."

After a twelve-months' stay Saul, in 44, paid his second visit to Jerusalem, coming with his companion to bring contributions to the brethren who were suffering from famine. By this time all doubts concerning Saul's stability had been laid at rest. By the direction of the Holy Spirit he and Barnabas, after their return to Antioch, were ordained, and forthwith set out on a missionary journey, first to Cyprus and then to Asia Minor.

The years from 49 to 52 were spent by St. Paul in his second great missionary journey. Taking Silas with him, he traveled through Derbe to Lystra and he was rewarded by the faithful discipleship of Timothy, whose parents dwelt there. Accompanied by both Timothy and Silas, St. Paul went through Phrygia and Galatia preaching and founding churches. The third

missionary journey is thought to have covered the years 52 to 56. St. Paul traversed Galatia, the Roman province of "Asia," Macedonia, Achaia, crossed back to Macedonia, and made a return by sea to Jerusalem.

The later movements and history of the great apostle are very uncertain. We have evidence of yet another, a fourth, missionary journey. It is held by some that he visited Spain, but we can affirm with greater confidence that he found his way to Macedonia once more and probably spent the winter of 65–66 at Nicopolis. Returning to Rome he was again arrested and imprisoned. Whether he was condemned in company with St. Peter is not certain, but as a Roman citizen his punishment was different. There is a strong and seemingly reliable tradition that he was beheaded on the Ostian Way, near where the basilica of St. Paul Outside the Walls stands to-day; and in that church his burial-place is venerated. It is commonly said that St. Paul suffered on the same day of the same year as did St. Peter, but there is no certainty about this. Shortly before, he had written to St. Timothy those famous words: "I am even now ready to be sacrificed, and the time of my dissolution is at hand. I have fought a good fight; I have finished my course; I have kept the faith. As for the rest, there is laid up for me a crown of justice which the Lord, the just judge, will render to me in that day: and not only to me, but to them also that love His coming."

Editor's note: The Church calendar includes two feasts for St. Paul — that commemorating his conversion, on January 25, and that for his supposed martyrdom, on June 29. The preceding material is composed of excerpts from both entries in Butler's Lives of the Saints.

ST. PAUL
Caravaggio, *The Conversion of St. Paul,* 1600–1601. Sta. Maria del Popolo, Rome

ST. TIMOTHY, BISHOP AND MARTYR

January 24

St. Timothy, the beloved disciple of St. Paul, was probably a native of Lystra in Lycaonia. His father was a Gentile, but his mother Eunice was Jewish. She, with Lois, his grandmother, embraced the Christian religion, and St. Paul commends their faith. Timothy had made the Holy Scriptures his study from early youth. When St. Paul preached in Lycaonia the brethren of Iconium and Lystra gave Timothy so good a character that the apostle, being deprived of St. Barnabas, took him for his companion, but first circumcised him at Lystra. St. Paul refused to circumcise Titus, born of Gentile parents, in order to assert the liberty of the gospel, and to condemn those who affirmed circumcision to be still of precept in the New Law. On the other hand, he circumcised Timothy, born of a Jewish mother, that he might make him more acceptable to the Jews, and might show that he himself was no enemy of their law. Chrysostom here commends the prudence of Paul and, we may add, the voluntary obedience of the disciple. Then St. Paul, by the imposition of hands, committed to him the ministry of preaching, and from that time regarded him not only as his disciple and most dear son, but as his brother and the companion of his labors. He calls him a man of God, and tells the Philippians that he found no one so truly united to him in spirit as Timothy.

We learn that St. Timothy drank only water, but his austerities having prejudiced his health, St. Paul, on account of his frequent infirmities, directed him to take a little wine. Upon which Chrysostom observes, "He did not say simply 'take wine' but 'a little wine,' and this not because Timothy stood in need of that advice but because we do." St. Timothy, it seems, was still young — perhaps about forty. It is not improbable that he went to Rome to confer with his master. We must assume that Timothy was made by St. Paul bishop at Ephesus before St. John arrived there. There is a strong tradition that John also resided in that city as an apostle, and exercised a general inspection over all the churches of Asia. St. Timothy is styled a martyr in the ancient martyrologies.

The "Acts of St. Timothy," which are in some copies ascribed to the famous Polycrates, Bishop of Ephesus, but which seem to have been written at Ephesus in the fourth or fifth century, and abridged by Photius, relate that under the Emperor Nerva in the year 97 St. Timothy was slain with stones and clubs by the heathen; he was endeavoring to oppose their idolatrous ceremonies on a festival called the Katagogia, kept on January 22, on which day they walked in troops, everyone carrying in one hand an idol and in the other a club. We have good evidence that what purported to be his relics were translated to Constantinople in the reign of Constantius. The supernatural manifestations said to have taken place at the shrine are referred to as a matter of common knowledge by both Chrysostom and St. Jerome.

ST. TIMOTHY
St. Timothy, 12th-century. From Abbey of Neuwiller en Alsace. Musée Cluny, Paris

ST. BARNABAS, APOSTLE

June 11

Patron Saint of Cyprus

Although St. Barnabas was not one of the twelve chosen by our Lord, yet he is styled an apostle by the early fathers and by St. Luke himself on account of the special commission he received from the Holy Ghost and the great part he took in apostolic work. He was a Jew of the tribe of Levi, but was born in Cyprus; his name was originally Joseph, but the apostles changed it to Barnabas — which word St. Luke interprets as meaning "man of encouragement." The first mention we find of him in the Holy Scriptures is in the fourth chapter of the Acts of the Apostles, where it is stated that the primitive converts at Jerusalem lived in common and that as many as were owners of lands or houses sold them and laid the proceeds at the feet of the apostles for distribution. St. Barnabas's sale of his estate is singled out for mention on this occasion.

Some time later, certain disciples having preached the Gospel with success at Antioch, it was thought desirable that someone should be sent by the Church in Jerusalem to guide and confirm the neophytes. The man selected was St. Barnabas. Finding himself in need of an able assistant he went to Tarsus to enlist the co-operation of St. Paul, who accompanied him back and spent a whole year at Antioch. Their labors were crowned with success, and it was in that same city and at this period that the name Christians was first given to the followers of our Lord.

A little later the flourishing church of Antioch raised money for the relief of the poor brethren in Judaea during a famine. This they sent to the heads of the church of Jerusalem by the hands of Paul and Barnabas, who returned accompanied by John Mark.

Antioch was by this time well supplied with teachers and prophets, amongst whom were Simeon called Niger, Lucius of Cyrene, and Herod's foster-brother Manahen. As they were worshipping God, the Holy Ghost said to them by some of these prophets, "Separate me Paul and Barnabas for the work whereunto I have taken them." Accordingly, Paul and Barnabas received their commission by the laying on of hands and set forth on their first missionary journey.

At Iconium, the capital of Lycaonia, they narrowly escaped stoning at the hands of the mob whom the rulers had stirred up against them. A miraculous cure wrought by St. Paul upon a cripple at Lystra led the pagan inhabitants to conclude that the gods were come amongst them. They hailed St. Paul as Hermes or Mercury because he was the chief speaker, and St. Barnabas as Zeus or Jupiter. After a stay at Derbe, where they made many converts, the two apostles retraced their steps, passing through the cities they had previously visited in order to confirm the converts and to ordain presbyters. Their first missionary journey thus completed, they returned to Antioch in Syria well satisfied with the result of their efforts.

It seems clear, from the allusion to Barnabas in I Corinthians ix, 5 and 6 that he was living and working in A.D. 56 or 57, but St. Paul's subsequent invitation to John Mark to join him when he was a prisoner in Rome leads us to infer that by A.D. 60 or 61 St. Barnabas must have been dead: he is said to have been stoned to death at Salamis. Actually nothing is known of him beyond what is to be found in the New Testament.

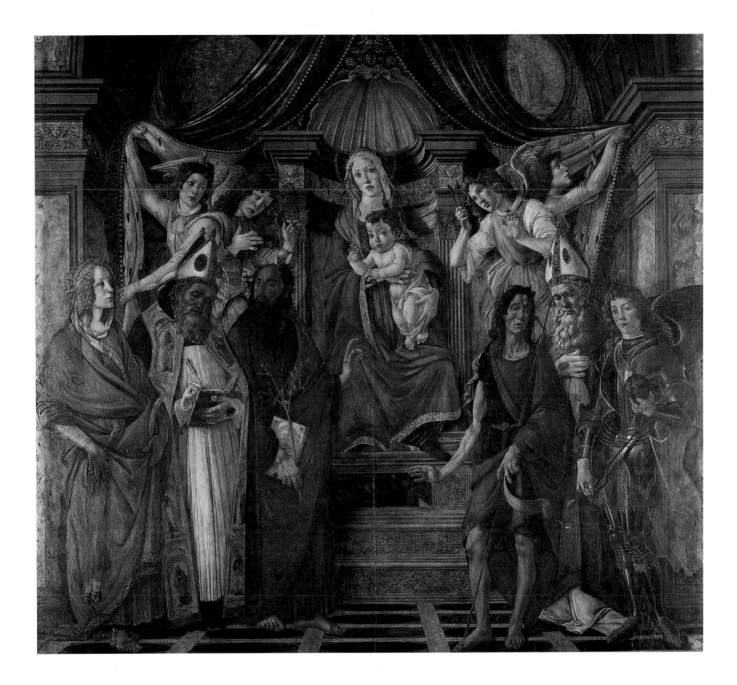

Sandro Botticelli. *Saint Barnabas Altarpiece,* c. 1488. Uffizi, Florence (from left to right: SS. Catherine of Alexandria, Augustine, and Barnabas; the Blessed Virgin Mary with the Infant Jesus; SS. John the Baptist, Ignatius, and Michael)

ST. STEPHEN

Pietro da Cortona. *The Stoning of St. Stephen*, 1660. Hermitage, St. Petersburg

ST. STEPHEN, THE FIRST MARTYR

December 26

Patron Saint of Hungary; Poland; Bricklayers; Stonemasons

THAT ST. STEPHEN was a Jew is unquestionable. The circumstances of his conversion to Christianity are not known, but we are told of him in the book of the Acts of the Apostles, when, there being numerous converts, the Hellenists murmured against the Hebrews, complaining that their widows were neglected in the daily ministration. The Apostles assembled the faithful and told them that they could not relinquish the duties of preaching and prayer to attend to the care of tables; and recommended them to choose seven men of good character, full of the Holy Ghost and wisdom, who might superintend that business. The suggestion was approved, and the people chose Stephen, Philip, Prochorus, Nicanor, Timon, Parmenas and Nicholas a proselyte of Antioch. These seven were presented to the Apostles, who praying, imposed hands upon them, and so ordained them the first deacons.

"And the word of the Lord increased, and the number of the disciples was multiplied in Jerusalem exceedingly; a great number also of the priests obeyed the faith. And Stephen, full of grace and fortitude, did great wonders and signs among the people." He spoke with such wisdom and spirit that his hearers were unable to resist him, and a plot was laid by the elders of certain synagogues in Jerusalem. At first they undertook to dispute with Stephen; but finding themselves unequal to the task they suborned false witnesses to charge him with blasphemy against Moses and against God. The indictment was laid in the Sanhedrin, and he was dragged thither. The main point urged against him was that he affirmed that the temple would be destroyed, that the Mosaic traditions were but shadows and types no longer acceptable to God, Jesus of Nazareth having put an end to them. "And all that sat in the council, looking on him, saw his face as if it had been the face of an angel." Then leave was given him to speak, and in a long defense, set out in Acts vii 2–53, he showed that Abraham, the father and founder of their nation, was justified and received the greatest favors of God in a foreign land; that Moses was commanded to set up a tabernacle, but foretold a new law and the Messiah; that Solomon built the Temple, but it was not to be imagined that God was confined in houses made by hands: the temple and the Mosaic law were temporary, and were to give place when God introduced more excellent institutions by sending the Messiah himself.

The whole assembly raged at Stephen, but he, being full of the Holy Ghost and looking up steadfastly to the heavens, saw them opened and beheld the glory of God and the Savior standing at the right hand of the Father. "And they, crying out with a loud voice, . . . with one accord ran violently upon him. And, casting him forth without the city, they stoned him; and the witnesses laid down their garments at the feet of a young man whose name was Saul. And they stoned Stephen, invoking and saying, 'Lord Jesus, receive my spirit.' And falling on his knees, he cried with a loud voice, saying, 'Lord, lay not this sin to their charge.' And when he had said this he fell asleep in the Lord." The reference to the witnesses required by the law of Moses, and the whole circumstances, suggest that this was not an act of mob violence, but a judicial execution.

ST. AGATHA, VIRGIN AND MARTYR

February 5

Patron saint of the Guilds of Bell-founders; Nurses

THE CITIES OF PALERMO AND CATANIA in Sicily dispute the honor of St. Agatha's birth, but it is agreed that she received the crown of martyrdom at Catania. Her "acts" state that she belonged to a rich and illustrious family and, having been consecrated to God from her earliest years, she triumphed over many assaults upon her purity. Quintian, a man of consular dignity, thought he could carry out his evil designs upon Agatha by means of the emperor's edict against Christians. Seeing herself in the hands of her persecutors, she prayed, "Jesus Christ, Lord of all, thou seest my heart, thou knowest my desires. Do thou alone possess all that I am. I am thy sheep: make me worthy to overcome the Devil." Quintian ordered her to be handed over to a house of ill-fame. In this dreadful place Agatha suffered assaults and stratagems upon her honor more terrible to her than torture or death, but she stood firm. After a month, Quintian tried to frighten her with threats, but she remained undaunted and declared that to be a servant of Jesus Christ was to be truly at liberty. The judge, offended by her resolute answers, commanded her to be beaten and taken to prison. The next day she underwent another examination, and she asserted that Jesus Christ was her light and salvation. Quintian then ordered her to be stretched on the rack. The governor, enraged at seeing her suffer all this with cheerfulness, ordered her breasts to be cruelly crushed and then cut off. Afterwards he remanded her to prison, enjoining that neither food nor medical care should be supplied to her. But God gave her comfort: she had a vision of St. Peter who filled her dungeon with a heavenly light, and who consoled and healed her. Four days later Quintian caused her to be rolled naked over live coals mixed with broken potsherds. As she was carried back to prison, she prayed, "Lord, my Creator, thou hast always protected me from the cradle; thou hast taken me from the love of the world and given me patience to suffer. Receive now my soul." After saying these words, she breathed out her life.

There is good evidence of the early *cultus* of St. Agatha, but we can affirm nothing with confidence concerning her history. She is depicted in the procession of the saints at Sant' Apollinare Nuovo at Ravenna. As an attribute in art her breasts are often shown on a dish. These in the middle ages were often mistaken for loaves, and from this a practice seems to have arisen of blessing bread on St. Agatha's feast which is brought on a dish to the altar. As in Sicily she was credited with the power of arresting the eruptions of Mount Etna, so she is invoked against any outbreak of fire. Two sixth-century churches in Rome were dedicated in her honor, and she is named in the canon of the Mass.

ST. AGATHA
Giovanni Battista Tiepolo. *The Martyrdom of St. Agatha*, c. 1750. Gemäldegalerie, Berlin

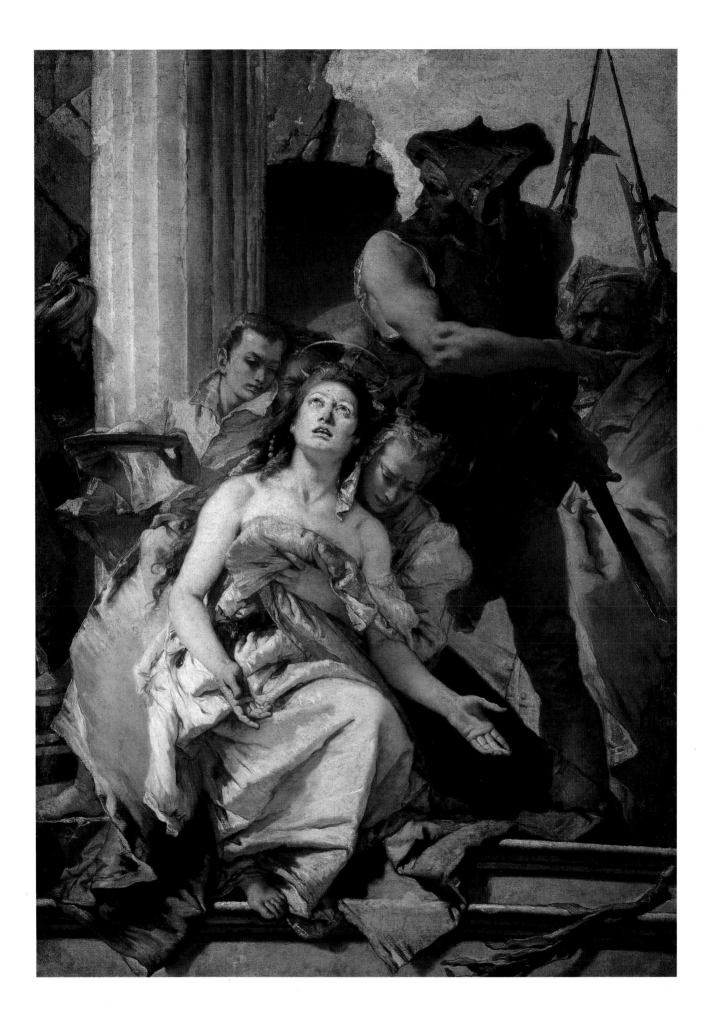

ST. CECILIA, OR CECILY, VIRGIN AND MARTYR

November 22

Patron Saint of Music and Musicians; Poets; Singers

For over a thousand years St. Cecilia has been one of the most greatly venerated of the maiden martyrs of the early Church and is one of those named in the canon of the Mass. She was a patrician girl of Rome, brought up a Christian, and determined to remain a maiden for the love of God. But her father had other views, and gave her in marriage to a young patrician named Valerian. On the day of the marriage Cecilia sat apart, singing to God in her heart and praying for help in her predicament. When they retired to their room, she said to her husband gently, "I have a secret to tell you. You must know that I have an angel of God watching over me. If you touch me in the way of marriage he will be angry and you will suffer; but if you respect my maidenhood he will love you as he loves me." "Show me this angel," Valerian replied. "If he be of God, I will refrain as you wish." And Cecilia said, "If you believe in the living and one true God and receive the water of baptism, then you shall see the angel." Valerian agreed and was baptized. Then he returned to Cecilia, and found standing by her side an angel, who put upon the head of each a chaplet of roses and lilies.

From that time forth Valerian and his brother Tiburtius gave themselves up to good works. Because of their zeal in burying the bodies of martyrs they were both arrested. Almachius, the prefect before whom they were brought, began to cross-examine them. Valerian testified that he and his brother were under the charge of Jesus Christ, the Son of God, who could impart to them His own wisdom. Almachius told him to tell the court if he would sacrifice to the gods and go forth free. Tiburtius and Valerian both replied: "No, not to the gods, but to the one God to whom we offer sacrifice daily." They were accordingly condemned to death and were beheaded. With them perished a man called Maximus, who had declared himself a Christian after witnessing their fortitude.

Cecilia in turn was called on to repudiate her faith. Instead she converted those who came to induce her to sacrifice; and when Pope Urban visited her at home he baptized over 400 persons there. At length she was sentenced to be suffocated to death in the bathroom of her own house. But though the furnace was fed with seven times its normal amount of fuel, Cecilia remained for a day and a night without receiving any harm, and a soldier was sent to behead her. He struck at her neck three times. She was not dead and lingered three days, during which she formally made over her house to Urban and committed her household to his care. She was buried next to the papal crypt in the catacomb of St. Callistus.

Pope St. Paschal I (817–824) translated the supposed relics of St. Cecilia, together with those of SS. Valerian, Tiburtius and Maximus, to the church of Santa Cecilia in Trastevere. In 1599 Cardinal Sfondrati in repairing this church reinterred the relics of the four martyrs, the body of Cecilia being alleged to be then still incorrupt and complete.

Today perhaps St. Cecilia is most generally known as the patron-saint of music and musicians. At her wedding, the *acta* tell us, while the musicians played, Cecilia sang to the Lord in her heart. In the later middle ages she was represented as actually playing the organ and singing aloud.

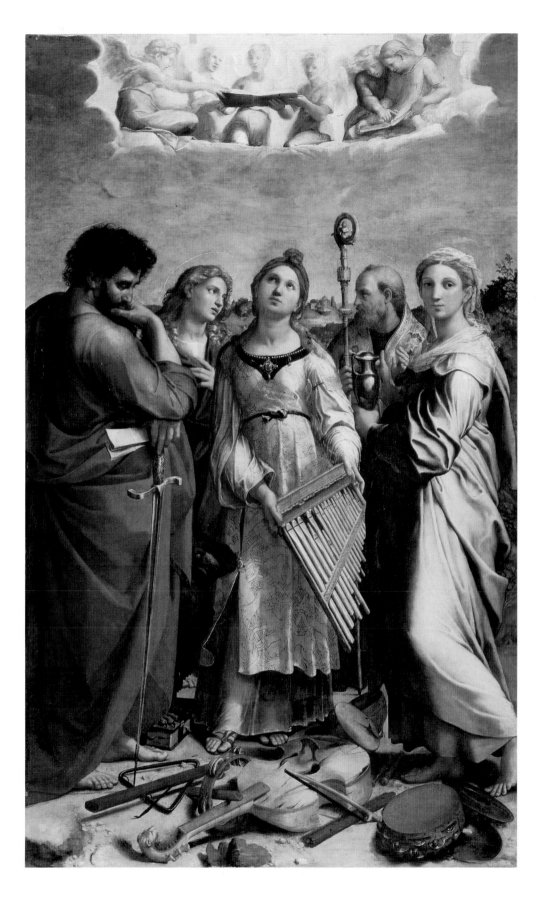

ST. APOLLONIA, VIRGIN AND MARTYR

February 9

Patron Saint of Dentists

ST. DIONYSIUS OF ALEXANDRIA wrote to Fabius, Bishop of Antioch, on account of the persecution of the Christians by the heathen populace of Alexandria in the last year of the reign of the Emperor Philip (A.D. 249). The Christians offered no resistance but betook themselves to flight, abandoning their goods without complaint because their hearts had no ties upon earth. Their constancy was so general that St. Dionysius knew of none who had renounced Christ. Apollonia, an aged deaconess, was seized. With blows in the face they knocked out all her teeth, and then, kindling a great fire outside the city, they threatened to cast her into it unless she uttered certain impious words. She begged for a moment's delay, as if to consider the proposal; then, to convince her persecutors that her sacrifice was perfectly voluntary, she no sooner found herself free than she leaped into the flames of her own accord.

We meet with churches and altars dedicated in honor of St. Apollonia in most parts of the Western church, but she is not venerated in any Oriental church, though she suffered in Alexandria. To account for her action in thus anticipating her death St. Augustine supposes that she acted by a particular direction of the Holy Ghost, since it would not otherwise be lawful for anyone to hasten his own end. She is invoked against toothache and all dental diseases, and her more common attributes in art are a pair of pincers holding a tooth, or else a golden tooth suspended on her necklace.

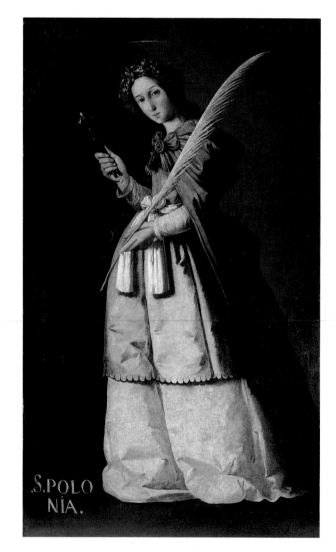

ST. APOLLONIA

Francisco de Zurbarán. *St. Apollonia.* Louvre, Paris

ST. CHRISTOPHER, MARTYR

July 25

Patron Saint of Motorists; Porters; Sailors; Travelers

CHRISTOPHER BEFORE HIS BAPTISM was named Reprobus, but afterwards he was named Christopher, which is as much as to say as bearing Christ, for that he bare Christ in four manners: he bare Him on his shoulders by conveying and leading, in his body by making it lean, in mind by devotion, and in his mouth by confession and preaching.

"Christopher was of the lineage of the Canaanites, and he was of a right great stature and had a terrible and fearful face and appearance. . . . It came in his mind that he would seek the greatest prince that was in the world, and him would he serve and obey. And so far he went that he came to a right great king, of whom the renown generally was that he was the greatest of the world. And when the king saw him, he received him into his service, and made him to dwell in his court. Upon a time a minstrel sang before him a song in which he named oft the Devil, and the king, who was a Christian man, when he heard him name the Devil, made anon the sign of the cross on his visage. And when Christopher saw that, he had a great marvel what sign it was and wherefore the king made it, and he demanded of him. . . . And then the king told him, saying: 'Alway when I hear the Devil named I fear that he should have power over me, and I garnish me with this sign that he grieve me not nor annoy me.' Then Christopher said to him: 'Doubtest thou the Devil that he hurt thee? Then is the Devil more mighty and greater than thou art. I am then deceived of my hope and purpose, for I had supposed I had found the most mighty and the most greatest lord in the world, but I commend thee to God, for I will go seek him for to be my lord, and I his servant.'

"And then he departed from this king and hasted him for to seek the Devil. And as he went by a great desert he saw a great company of knights, of which a knight cruel and horrible came to him and demanded whither he went, and Christopher answered him and said: 'I go seek the Devil, for to be my master.' And he said: 'I am he that thou seekest.' And then Christopher was glad, and bound him to be his servant perpetual and took him for his master and lord. And as they went together by a common way, they found there a cross erect and standing. And anon as the Devil saw the cross he was afeared and fled. . . . And after, when they were past the cross, he brought him to the highway that they had left. And when Christopher saw that, he marvelled, and demanded whereof he doubted and had left the high and fair way and had gone so far about by so rough a desert. . . . Wherefore the Devil was constrained to tell him, and said: 'There was a man called Christ which was hanged on the cross, and when I see His sign I am sore afraid and flee from it wheresover I see it.' To whom Christopher said: 'Then He is greater and more mightier than thou, when thou art afraid of His sign, and I see well that I have laboured in vain when I have not founden the greatest lord of the world. And I will serve thee no longer; go thy way then, for I will go seek Christ.'

"And when he had long sought and demanded where he should find Christ at last he came into a great desert, to an hermit that dwelt there, and this hermit preached to him of Jesu Christ and informed him in

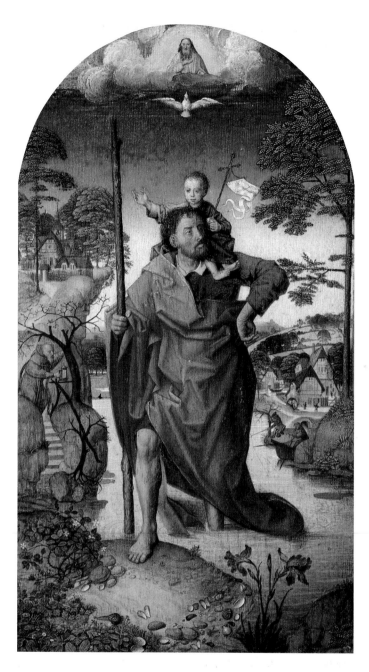

ST. CHRISTOPHER

Master of the Embroidered Foliage. *St. Christopher.*
Gemäldegalerie, Dresden

the faith diligently and said to him: 'This King whom thou desirest to serve requireth the service that thou must oft fast.' And Christopher said to him: . . . 'Knowest thou such-and-such a river, where many be perished and lost?' To whom Christopher said: 'I know

it well.' Then said the hermit: 'Because thou art noble and high of stature and strong in thy members thou shalt be resident by that river, and thou shalt bear over all them that shall pass there, which shall be a thing right pleasing to our Lord Jesu Christ whom thou desirest to serve, and I hope He shall show Himself to thee.' . . . Then went Christopher to this river and made there a dwelling-place for himself, and bare a great pole in his hand instead of a staff by which he sustained himself in the water, and bare over all manner of people without ceasing. And there he abode, thus doing, many days.

"And in a time, as he slept in his lodge, he heard the voice of a child which called him and said: 'Christopher, come out and bear me over.' Then he awoke and went out, but found no man. And when he was again in his house he heard the same voice, and he ran out and found nobody. The third time he was called and came thither and found a child beside the edge of the river, which prayed him goodly to bear him over the water. And then Christopher lift up the child on his shoulders, and took up his staff, and entered into the river for to pass. And the water of the river arose and swelled more and more; and the child was heavy as lead, and always as he went farther the water increased and grew more, and the child more and more waxed heavy, insomuch that Christopher had great anguish and was afeared to be drowned. And then he was escaped with great pain, and passed the water and set the child aground, he said to the child: 'Child, thou hast put me in great peril; thou weighest almost as I had all the world upon me: I might bear no greater burden.' And the child answered: 'Christopher, marvel thee nothing; for thou hast not only borne all the world upon thee, but thou hast borne Him that created and made all the world, upon thy shoulders. I am Jesu Christ, the King whom thou servest in this work. And because that thou know what I say to be the truth, set thy staff in the earth by thy house and thou shalt see to-morrow that it shall bear flowers and fruit,' and anon He vanished from his eyes. And then Christopher set his staff in the earth, and when he arose on the morn he found his staff like a palm tree, bearing flowers, leaves and dates.

"And then Christopher went into the city of Lycia, and understood not their language. Then he prayed our Lord that he might understand them and so he did. . . . And then when Christopher understood the language, he covered his visage and went to the place where they martyred Christian men, and comforted them in our Lord. And then the judges smote him in the face, and Christopher said to them: 'If I were not a Christian, I should avenge mine injury.' And then Christopher pitched his rod in the earth and prayed to our Lord that for to convert the people it might bear flowers and fruit; and anon it did so. And then he converted eight thousand men. And then the king sent two knights for to fetch him, and they found him praying, and durst not tell him so. And anon after the king sent as many more, and anon they set them down for to pray with him. And when Christopher arose, he said to them: 'What seek ye?' And when they saw him in the visage, they said to him: 'The king hath sent us, that we should lead thee bound unto him.' And Christopher said to them: 'If I would, ye should not lead me to him, bound or unbound.' And they said to him: "If thou wilt go thy way, go quit, where thou wilt. And we shall say to the king that we have not found thee.' 'It shall not be so,' said he, 'but I shall go with you.' And then he converted them in the Faith, and commanded them that they should bind his hands behind his back and lead him so bound to the king. And when the king saw him he was afeared and fell down off the seat; and his servants lifted him up again. . . . To whom Christopher said: 'Thou art rightfully called Dagnus, for thou art the death of the world and fellow of the Devil, and thy gods be made with the hands of men.' And the king said to him: 'Thou wert nourished among wild beasts and therefore thou mayst not say but wild language and words unknown to men. And if thou wilt now do sacrifice to the gods, I shall give to thee great gifts and great honours, and if not, I shall destroy thee and consume thee by great pains and torments.' But for all this he would in no wise do sacrifice, wherefore he was sent into prison, and the king did behead the other knights, that he had sent for him, whom he had converted.

"After this Christopher was brought before the king, and the king commanded that he should be beaten with rods of iron, and that there should be set upon his head a cross of iron red hot and burning, and then after he had made a seat of iron and had Christopher bound thereon, and after fire set under it, and cast therein pitch. But the seat melted like wax, and Christopher issued out without any harm or hurt. And when the king saw that, he commanded that he should be bound to a strong stake and that he should be through-shotten with arrows by forty knights archers. But none of the knights might attain him, for the arrows hung in the air about, nigh him, without touching. Then the king weened that he had been through-shotten by the arrows of the knights, and addressed him for to go to him. And one of the arrows returned suddenly from the air and smote him in the eye and blinded him. To whom Christopher said: 'Tyrant, I shall die to-morrow. Make a little clay, mixed with my blood, and anoint therewith thine eye, and thou shalt receive health.' Then by the commandment of the king he was led for to be beheaded, and then there made he his orison, and his head was smitten off, and so suffered martyrdom. And the king then took a little of his blood and laid it on his eye, and said: 'In the name of God and of St. Christopher!' and was anon healed. Then the king believed in God, and gave commandment that if any person blamed God or St. Christopher, he should anon be slain with the sword."

That, with a few verbal alterations, is the story of St. Christopher from the *Golden Legend* as put into English by William Caxton, a story known all over Christendom, both East and West. From it arose the popular belief that he who looked on an image of the saint should not that day suffer harm: a belief that was responsible for the putting of large statues or frescoes representing him opposite the doors of churches, so that all who entered might see it; he was the patron-saint of travelers and was invoked against perils from water, tempests and plagues; and in recent times has found a revived popularity as the patron of motorists.

ST. DIONYSIUS, OR DENIS, BISHOP OF PARIS, MARTYR

October 9

Patron Saint of France

S<small>T</small>. G<small>REGORY OF</small> T<small>OURS</small>, writing in the sixth century, tells us that St. Dionysius of Paris was born in Italy and sent in the year 250 with six other missionary bishops into Gaul, where he suffered martyrdom. The "Martyrology of Jerome" mentions St. Dionysius on October 9, joining with him St. Rusticus and St. Eleutherius; later writers make of these the bishop's priest and deacon, who with him penetrated to Lutetia Parisiorum and established Christian worship on an island in the Seine. Their preaching was so effective that they were arrested and, after a long imprisonment, all three were beheaded. The bodies of the martyrs were thrown into the Seine, from which they were rescued and given honorable burial. A chapel was later built over their tomb, around which arose the great abbey of Saint-Denis.

This monastery was founded by King Dagobert I (d. 638), and it is possible that some century or so later the identification of St. Dionysius with Dionysius the Areopagite began to gain currency, or at least the idea that he was sent by Pope Clement I in the first century. But it was not everywhere or even widely accepted until the time of Hilduin, abbot of Saint-Denis. In the year 827 the Emperor Michael II sent as a present to the emperor of the West, Louis the Pious, copies of the writings ascribed to St. Dionysius the Areopagite. By an unfortunate coincidence they arrived in Paris and were taken to Saint-Denis on the eve of the feast of the patron of the abbey. Hilduin translated them into Latin, and when some years later Louis asked him for a life of St. Dionysius of Paris, the abbot produced a work which persuaded Christendom for the next seven hundred years that Dionysius of Paris, Dionysius of Athens, and the author of the "Dionysian" writings were one and the same person. In his "Areopagitica" Abbot Hilduin made use of spurious and worthless materials, and it is difficult to believe in his complete good faith: the life is a tissue of fables. The Areopagite comes to Rome where Pope St. Clement I receives him and sends him to evangelize the Parisii. They try in vain to put him to death by wild beasts, fire and crucifixion; then, together with Rusticus and Eleutherius, he is successfully beheaded on Montmartre. The dead body of St. Dionysius rose on its feet and, led by an angel, walked the two miles from Montmartre to where the abbey church of Saint-Denis now stands, carrying its head in its hands and surrounded by singing angels, and so was there buried. Of which marvel the Roman Breviary makes mention.

The *cultus* of St. Dionysius, better known, even in England, as Denis, was very strong during the middle ages; already in the sixth century Fortunatus recognizes him as the saint of Paris *par excellence,* and he is popularly regarded as the patron saint of France.

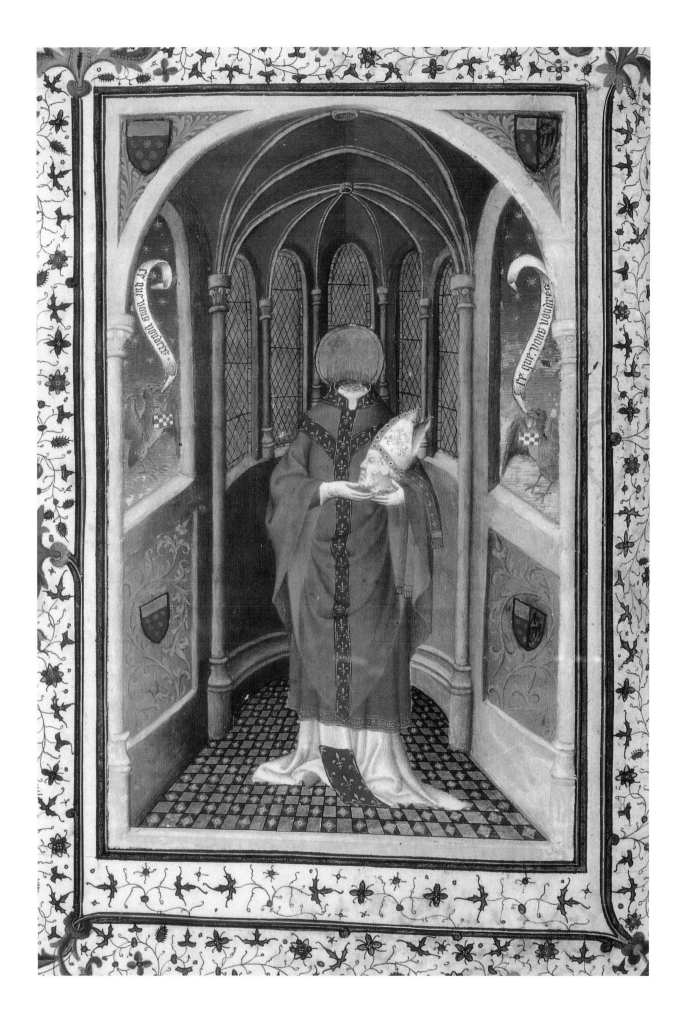

ST. LAURENCE, MARTYR

August 10

Patron Saint of Sri Lanka; Cooks; the Poor

THERE ARE FEW MARTYRS in the Church whose names are so famous as that of St. Laurence, in whose praises the most illustrious among the Latin fathers have written, and whose triumph, to use the words of St. Maximus, the whole Church joins in a body to honor with universal joy and devotion. He was one among the seven deacons who served the Roman church; this was a charge of great trust, to which was annexed the care of the goods of the church, and the distribution of its alms among the poor. The Emperor Valerian in 257 published his edicts against Christians and Pope St. Sixtus, the second of that name, was apprehended the year following and put to death; on the fourth day after the faithful Laurence followed him to martyrdom. That is all that is known for certain of the life and death of St. Laurence, but Christian piety has adopted and consecrated as its own the details supplied by St. Ambrose, the poet Prudentius, and others; though it must be regretfully admitted that good reasons have been adduced for doubting the historical reliability of such moving incidents as St. Laurence's presentation of the goods of the Church, and the manner of his death.

According to these traditions, as Pope St. Sixtus was led to execution, his deacon Laurence followed him weeping, and said to him, "Father, where are you going without your deacon?" The pope answered, "I do not leave you, my son. You shall follow me in three days." Laurence was full of joy, hearing that he should be so soon called to God; he set out immediately to seek all the poor, widows and orphans, and gave among them the money which he had in his hands; he even sold the sacred vessels to increase the sum, employing it all in the like manner. When then the prefect of Rome was informed of these charities, imagining that the Christians had hid considerable treasures, he wanted to secure them: for he was no less a worshipper of gold and silver than of Jupiter and Mars. With this view he sent for St. Laurence, and said to him, "You Christians often complain that we treat you with cruelty, but no tortures are here thought of; I only inquire mildly after what concerns you. I am informed that your priests offer in gold, that the sacred blood is received in silver cups, and that in your nocturnal sacrifices you have wax tapers fixed in golden candlesticks. Bring out these treasures; the emperor has need of them for the maintenance of his forces. I am told that according to your doctrine you must render to Caesar the things that belong to him. I do not think that your God causes money to be coined; He brought none into the world with Him; He only brought words. Give us therefore the money, and be rich in words." St. Laurence replied, without showing any concern, "The Church is indeed rich; nor hath the emperor any treasure equal to what it possesses. I will show you a valuable part; but allow me a little time to set everything in order, and to make an inventory." The prefect did not understand of what treasure Laurence spoke, but, imagining the hidden wealth already in his hands, was satisfied with this answer and granted him three days.

During this interval Laurence went all over the city, seeking out the poor who were supported by the Church. On the third day he gathered together a great number of them, and placed them in rows, the

ST. LAURENCE

Titian. *The Martyrdom of
St. Laurence,* 1548–1559.
Church of the Gesuiti,
Venice

decrepit, the blind, the lame, the maimed, the lepers, orphans, widows and maidens; then he went to the prefect and invited him to come and see the treasure of the Church. The prefect, astonished to see such an assembly of misery and misfortune, turned to the deacon with threatening looks, asked him what all this meant, and where the treasures were which he had promised to show him. St. Laurence answered, "What are you displeased at? These *are* the treasure of the Church." The prefect's anger was not allayed but redoubled, and in a fury of rage he shouted, "You mock me! The axes and the fasces, the ensigns of the Roman power, are not to be insulted! I know that you desire to die: that is your madness and vanity: but you shall not die immediately, as you imagine. You shall die by inches!" Then he had a great gridiron made ready, and glowing coals put under it, that the martyr might be slowly burnt. Laurence was stripped and bound upon this iron bed over the slow fire, which roasted his flesh by little and little. His face appeared to the Christians to be surrounded with a beautiful light, and his suffering body to give off a sweet smell; but the unbelievers neither saw this light nor perceived this smell. The martyr felt not the torments of the persecutor, says St. Augustine, so passionate was his desire of possessing Christ: and St. Ambrose observes that whilst his body burned in the material flames, the fire of divine love was far more active within his breast and made him regardless of the pain. Having suffered a long time, he turned to the judge and said with a cheerful smile, "Let my body be turned; one side is broiled enough." When the executioner had turned

him, he said, "It is cooked enough, you may eat." Then, having prayed for the conversion of the city of Rome that the faith of Christ might spread thence throughout the world, St. Laurence gave up the ghost.

Prudentius ascribes to his prayer the entire conversion of Rome, and says God began to grant his request at the very time he made it; for several senators who were present at his death were so moved by his heroic fortitude and piety that they became Christians upon the spot. These noblemen took up the martyr's body on their shoulders and gave it honorable burial on the Via Tiburtina. His death, says Prudentius, was the death of idolatry in Rome, which from that time began to decline; and now (*c.* 403) the senate itself venerates the tombs of the apostles and martyrs. He describes with what devotion and fervor the Romans frequented the church of St. Laurence and commended themselves to his patronage; and the happy issue of their prayers proves how great his power is with God. St. Augustine assures us that God wrought in Rome many miracles through the intercession of St. Laurence, and St. Gregory of Tours, Fortunatus, and others, relate several in other places. St. Laurence has been one of the most venerated martyrs of the Roman church since the fourth century, and he is named in the canon of the Mass. He was certainly buried in the cemetery of Cyriaca *in agro Verano* on the Via Tiburtina, where Constantine built the first chapel on the site of what is now the church of St. Laurence-outside-the-Walls, the fifth patriarchal basilica of the city.

ST. SEBASTIAN, MARTYR

January 20

Patron Saint of Archers; Athletes; Soldiers

ACCORDING TO THE "ACTS," assigned without any adequate reason to the authorship of St. Ambrose, St. Sebastian was born at Narbonne in Gaul, though his parents had come from Milan, and he was brought up in that city. He was a fervent servant of Christ, and though his natural inclinations were averse to a military life, yet to be better able to assist the confessors and martyrs in their sufferings without arousing suspicion, he went to Rome and entered the army under the Emperor Carinus about the year 283. It happened that the martyrs Marcus and Marcellian, under sentence of death, appeared in danger of faltering in their resolution owing to the tears of their friends; Sebastian, seeing this, intervened, and made them a long exhortation to constancy, which he delivered with an ardor that strongly affected his hearers. Zoë, the wife of Nicostratus, who had for six years lost the use of speech, fell at his feet, and when the saint made the sign of the cross on her mouth, she spoke again distinctly. Thus Zoë, with her husband, Nicostratus, who was master of the rolls, the parents of Marcus and Marcellian, the gaoler Claudius, and sixteen other prisoners were converted; and Nicostratus, who had charge of the prisoners, took them to his own house, where Polycarp, a priest, instructed and baptized them. Chromatius, governor of Rome, being informed of this, and that Tranquillinus, the father of Marcus and Marcellian, had been cured of the gout by receiving baptism, desired to follow their example, since he himself was grievously afflicted with the same malady. Accordingly, having sent for Sebastian, he was cured by him, and baptized with his son Tiburtius. He then released the converted prisoners, made his slaves free, and resigned his prefectship.

Not long after Carinus was defeated and slain in Illyricum by Diocletian, who the year following made Maximian his colleague in the empire. The persecution was still carried on by the magistrates in the same manner as under Carinus, without any new edicts. Diocletian, admiring the courage and character of St. Sebastian, was anxious to keep him near his person; and being ignorant of his religious beliefs he created him captain of a company of the pretorian guards, which was a considerable dignity. When Diocletian went into the East, Maximian, who remained in the West, honored Sebastian with the same distinction and respect. Chromatius retired into the country in Campania, taking many new converts along with him. Then followed a contest of zeal between St. Sebastian and the priest Polycarp as to which of them should accompany this troop to complete their instruction, and which should remain at the post of danger in the city to encourage and assist the martyrs. Pope Caius, who was appealed to, judged that Sebastian should stay in Rome. In the year 286, the persecution growing fiercer, the pope and others concealed themselves in the imperial palace, as the place of greatest safety, in the apartments of one Castulus, a Christian officer of the court. Zoë was first apprehended, when praying at St. Peter's tomb on the feast of the apostles. She was stifled with smoke, being hung by the heels over a fire. Tranquillinus, ashamed to show less courage than a woman, went to pray at the tomb of St. Paul, and there

was seized and stoned to death. Nicostratus, Claudius, Castorius and Victorinus were taken, and after being thrice tortured, were thrown into the sea. Tiburtius, betrayed by a false brother, was beheaded. Castulus, accused by the same wretch, was twice stretched upon the rack, and afterwards buried alive. Marcus and Marcellian were nailed by the feet to a post, and having remained in that torment twenty-four hours were shot to death with arrows.

St. Sebastian, having sent so many martyrs to Heaven before him, was himself impeached before Diocletian; who, after bitterly reproaching him with his ingratitude, delivered him over to certain archers of Mauritania, to be shot to death. His body was pierced through with arrows, and he was left for dead. Irene, the widow of St. Castulus, going to bury him, found him still alive and took him to her lodgings, where he recovered from his wounds, but refused to take to flight. On the contrary, he deliberately took up his station one day on a staircase where the emperor was to pass, and there accosting him, he denounced the abominable cruelties perpetrated against the Christians. This freedom of language, coming from a person whom he supposed to be dead, for a moment kept the emperor speechless; but recovering from his surprise, he gave orders for him to be seized and beaten to death with cudgels, and his body thrown into the common sewer. A lady called Lucina, admonished by the martyr in a vision, had his body secretly buried in the place called *ad catacumbas,* where now stands the basilica of St. Sebastian.

The story recounted above is now generally admitted by scholars to be no more than a pious fable, written perhaps before the end of the fifth century. All that we can safely assert regarding St. Sebastian is that he was a Roman martyr, that he had some connection with Milan and was venerated there even in the time of St. Ambrose, and that he was buried on the Appian Way, probably quite close to the present basilica of St. Sebastian, in the cemetery *ad catacumbas.* Although in late medieval and renaissance art St. Sebastian is always represented as pierced with arrows, or at least as holding an arrow, this attribute does not appear until comparatively late. A mosaic dating from about 680 in San Pietro in Vincoli shows him as a bearded man carrying a martyr's crown in his hand, and in an ancient glass window in Strasbourg Cathedral he appears as a knight with sword and shield, but without arrows. St. Sebastian was specially invoked as a patron against the plague, and certain writers of distinction (e.g. Mâle and Perdrizet) urge that the idea of protection against contagious disease was suggested, in close accord with a well-known incident in the first book of the *Iliad,* by Sebastian's undaunted bearing in face of the clouds of arrows shot at him; but Father Delehaye is probably right in urging that some accidental cessation of the plague on an occasion when St. Sebastian had been invoked would have been sufficient to start the tradition. That St. Sebastian was the chosen patron of archers, and of soldiers in general, no doubt followed naturally from the legend.

ST. VALENTINE

Bartholomeus Zeitblom. *St. Valentine Heals the Epileptics and Rebukes the Worshippers of False Gods.* Bayerische
Staatsgemäldesammlungen, Munich

ST. VALENTINE, MARTYR

February 14

Patron Saint of Lovers

THE COMMEMORATION of St. Valentine on February 14 affords an interesting example of the mixture of truth and fiction which is commonly to be found in such abstracts of traditional belief as the notices in the Roman Martyrology. Alban Butler, who deserves credit for using the best sources available in his day, drew up his summary in the following terms:

Valentine was a holy priest in Rome, who, with St. Marius and his family, assisted the martyrs in the persecution under Claudius II. He was apprehended, and sent by the emperor to the prefect of Rome, who, on finding all his promises to make him renounce his faith ineffectual, commanded him to be beaten with clubs, and afterwards to be beheaded, which was executed on February 14, about the year 270. Pope Julius I is said to have built a church near Ponte Mole to his memory, which for a long time gave name to the gate now called Porta del Popolo, formerly Porta Valentini. The greatest part of his relics are now in the church of St. Praxedes.

The first objection that might be raised against the celebration of a feast in St. Valentine's honor is the fact that the Roman Martyrology on this day makes mention, not of one, but of two St. Valentines, both martyrs put to death by decapitation and both on the Flaminian Way, though one died at Rome and the other is located some sixty miles from Rome at Interamna (Terni). Moreover, when we study the so-called "acts" of the Roman martyr, who is alone referred to by Butler, we find that the greater part of his story has been taken over bodily from a similar narrative dealing with the martyrdom of SS. Marius and Martha.

Nevertheless there seems no conclusive reason for doubting the real existence of either of these two martyrs. The evidence of early local *cultus* in both cases is strong. The Roman Valentine seems to have been a priest. He probably did suffer on February 14 in the persecution of Claudius the Goth about the year 269. He was buried on the Flaminian Way, a basilica was erected as early as 350, a catacomb was later on formed on this spot, the location of his remains was known, and they were subsequently translated. On the other hand, the connection with Interamna of a St. Valentine, martyr, who is also described as bishop of that town, is attested by the martyrology known as the "Hieronymianum," and there is some other evidence of a similar nature. It might, of course, have happened that in the persecution of the Emperor Claudius the Goth, Valentine, Bishop of Interamna, was taken to Rome after his arrest and was there put to death.

The custom for young men and maidens to choose each other for Valentines on this day, is probably based on the popular belief which we find recorded in literature as early as the time of Chaucer, that the birds began to pair on St. Valentine's Day. The sending of a missive of some kind was only a natural development of this choosing. One of the earliest references to the custom of choosing a Valentine is to be found in *The Paston Letters.*

Although on account of the custom connected with his feast the name of St. Valentine was very familiar in England, no church is known to have been dedicated in his honor in this country.

ST. GEORGE, MARTYR, PROTECTOR OF THE KINGDOM OF ENGLAND

April 23

Patron Saint of Aragon; Genoa; Portugal; Boy Scouts; Knighthood; Soldiers

Throughout Europe in the later middle ages the story of St. George was best known in the form in which it was presented in the *Legenda Aurea* of Bd. James de Voragine. William Caxton translated the work and printed it. Therein we are told that St. George was a Christian knight and that he was born in Cappadocia. It chanced, however, that he was riding one day in the province of Lybia, and there he came upon a city called Sylene, near which was a marshy swamp. In this lived a dragon "which envenomed all the country." The people had mustered together to attack and kill it, but its breath was so terrible that all had fled. To prevent its coming nearer they supplied it every day with two sheep, but when the sheep grew scarce, a human victim had to be substituted. This victim was selected by lot, and the lot just then had fallen on the king's own daughter. No one was willing to take her place, and the maiden had gone forth dressed as a bride to meet her doom. Then St. George, coming upon the scene, attacked the dragon and transfixed it with his lance. Further, he borrowed the maiden's girdle, fastened it round the dragon's neck, and with this aid she led the monster captive into the city. "It followed her as if it had been a meek beast and debonair." The people in mortal terror were about to take to flight, but St. George told them to have no fear. If only they would believe in Jesus Christ and be baptized, he would slay the dragon. The king and all his subjects gladly assented. The dragon was killed and

four ox-carts were needed to carry the carcass to a safe distance. "Then were there well XV thousand men baptized without women and children." The king offered St. George great treasures, but he bade them be given to the poor instead. Before taking his leave the good knight left behind four behests: that the king should maintain churches, that he should honor priests, that he should himself diligently attend religious services, and that he should show compassion to the poor.

At this period under the Emperors Diocletian and Maximian (A.D. 303) a great persecution began against the Christians. George, seeing that some were terrified into apostasy, in order to set a good example went boldly into a public place and cried out, "All the gods of the paynims and gentiles are devils. My God made the heavens and is very God." Datianus the "provost" arrested him and failing to move him by cajolery had him strung up and beaten with clubs and then tortured with red-hot irons. Our Savior, however, came in the night to restore him to health. Next a magician was brought to prepare a potion for George with deadly poison, but the draught took no effect and the magician, being converted, himself died a martyr. Then followed an attempt to crush the saint between two spiked wheels, and after that to boil him to death in a cauldron of molten lead: but without any result. So Datianus once more had recourse to promises and soft words, and George, pretending to be shaken, let them think that he was willing to offer sacrifice. All the

ST. GEORGE
Raphael. *St. George and the Dragon*, c. 1506. National Gallery of Art, Washington, D.C.

people of the city assembled in the temple to witness the surrender of this obstinate blasphemer of the gods; but George prayed, and fire coming down from Heaven destroyed the building, the idols and the heathen priests, while the earth opened at the same time to swallow them up. Datianus's wife witnessing these things was converted; but her husband ordered the saint to be decapitated, which took place without difficulty, though Datianus himself returning from the scene was consumed by fire from Heaven.

This is a comparatively mild version of the Acts of St. George, which existed from an early date in a great variety of forms. It should be noted, however, that the story of the dragon, though given so much prominence, was a later accretion, of which we have no sure traces before the twelfth century. This puts out of court the attempts made by many folklorists to present St. George as no more than a christianized survival of pagan mythology, of Theseus, for example, or Hercules, the former of whom vanquished the Minotaur, the latter the hydra of Lerna. There is every reason to believe that St. George was a real martyr who suffered at Diospolis (i.e. Lydda) in Palestine, probably before the time of Constantine. Beyond this there seems to be nothing which can be affirmed with any confidence. The cult is certainly early, though the martyr is not mentioned in the Syriac "Breviarium." But his name (on April 25) is entered in the "Hieronymianum" and assigned to Diospolis, and such pilgrims as Theodosius, the so-called Antoninus and Arculf, from the sixth to the eighth century, all speak of Lydda or Diospolis as the seat of the veneration of St. George and as the resting place of his relics. The idea that St. George was a Cappadocian and that his *acta* were compiled in Cappadocia "is entirely the responsibility of the compiler of the *acta* who confused the martyr with his namesake, the celebrated George of Cappadocia, the Arian intruder into the see of Alexandria and enemy of St. Athanasius" (Father H. Delehaye).

It is not quite clear how St. George came to be specially chosen as the patron saint of England. His fame had certainly traveled to the British Isles long before the Norman Conquest. The *Félire* of Oengus, under April 23, speaks of "George, a sun of victories with thirty great thousands," while Abbot Aelfric tells the whole extravagant story in a metrical homily. William of Malmesbury states that Saints George and Demetrius, "the martyr knights," were seen assisting the Franks at the battle of Antioch in 1098, and it seems likely that the crusaders, notably King Richard I, came back from the east with a great idea of the power of St. George's intercession. At the national synod of Oxford in 1222 St. George's day was included among the lesser holidays, and in 1415 the constitution of Archbishop Chichele made it one of the chief feasts of the year. In the interval King Edward III had founded the Order of the Garter, of which St. George has always been the patron. During the seventeenth and eighteenth centuries (till 1778) his feast was a holiday of obligation for English Catholics, and Pope Benedict XIV recognized him as the Protector of the Kingdom.

ST. BARBARA, VIRGIN AND MARTYR

Patron Saint of Architects and Builders; Fire Prevention; Founders;
Gunners; Prisoners; Stonemasons

I N THE TIME THAT MAXIMIAN REIGNED there was a rich man, a paynim, which adored and worshipped idols, which man was named Dioscorus. This Dioscorus had a young daughter which was named Barbara, for whom he did make a high and strong tower in which he did keep and close this Barbara to the end that no man should see her because of her great beauty. Then came many princes unto the same Dioscorus for to treat with him for the marriage of his daughter, which went anon unto her and said: 'My daughter, certain princes be come to me which require me for to have thee in marriage, wherefore tell to me thine intent and what will ye have to do.' Then St. Barbara returned all angry towards her father and said: 'My father, I pray you that ye will not constrain me to marry, for thereto I have no will nor thought.' . . . After this he departed thence and went into a far country where he long sojourned.

"Then St. Barbara, the handmaid of our Lord Jesu Christ, descended from the tower for to come to see [a bath-house which her father was having built] and anon she perceived that there were but two windows only, that one against the south, and that other against the north, whereof she was much abashed and amarvelled, and demanded of the workmen why they had not made no more windows, and they answered that her father had so commanded and ordained. Then St. Barbara said to them: 'Make me here another window.' . . . In this same bath-house was this holy maid baptized of a holy man, and lived there a certain space of time, taking only for her refection honeysuckles and locusts, following the holy precursor of our Lord, St. John Baptist. This bath-house is like to the fountain of

Siloe, in which he that was born blind recovered there his sight. . . . On a time this blessed maid went upon the tower and there she beheld the idols to which her father sacrificed and worshipped, and suddenly she received the Holy Ghost and became marvellously subtle and clear in the love of Jesu Christ, for she was environed with the grace of God Almighty, of sovereign glory and pure chastity. This holy maid Barbara, adorned with faith, surmounted the Devil, for when she beheld the idols she scratched them in their visages, despising them all and saying: 'All they be made like unto you which have made you to err, and all them that have faith in you'; and then she went into the tower and worshipped our Lord.

"And when the work was full performed her father returned from his voyage, and when he saw there three windows he demanded of the workmen: 'Wherefore have ye made three windows?' And they answered: 'Your daughter hath commanded so.' Then he made his daughter to come afore him and demanded her why she had do make three windows, and she answered to him and said: 'I have done them to be made because three windows lighten all the world and all creatures, but two make darkness.' Then her father took her and went down into the bath-house, demanding her how three windows give more light than two. And St. Barbara answered: 'These three windows betoken clearly the Father, the Son and the Holy Ghost, the which be three persons and one very God, on whom we ought to believe and worship.' Then he, being replenished with fury, incontinent drew his sword to have slain her, but the holy virgin made her prayer and then marvellously she was taken in a stone

and borne into a mountain on which two shepherds kept their sheep, the which saw her fly. . . . And then her father took her by the hair and drew her down from the mountain and shut her fast in prison. . . . Then sat the judge in judgment, and when he saw the great beauty of Barbara he said to her: 'Now choose whether ye will spare yourself and offer to the gods, or else die by cruel torments.' St. Barbara answered to him: 'I offer myself to my God, Jesu Christ, the which hath created Heaven and earth and all other things. . . .' "

When she had been beaten, and comforted by a vision of our Lord in her prison, and again scourged and tortured, "the judge commanded to slay her with the sword. And then her father, all enraged, took her out of the hands of the judge and led her up on a mountain, and St. Barbara rejoiced in hastening to receive the salary of her victory. And then when she was drawn thither she made her orison, saying: 'Lord Jesu Christ, which hast formed Heaven and earth, I beseech thee to grant me thy grace and hear my prayer for all they that have memory of thy name and my passion; I pray thee, that thou wilt not remember their sins, for thou knowest our fragility.' Then came there a voice down from Heaven saying unto her: 'Come, my spouse Barbara, and rest in the chamber of God my Father which is in Heaven, and I grant to thee that thou hast required of me.' And when this was said, she came to her father and received the end of her martyrdom, with St. Juliana. But when her father descended from the mountain, a fire from Heaven descended on him, and consumed him in such wise that there could not be found only ashes of all his body. This blessed virgin, St. Barbara, received martyrdom with St. Juliana the second nones of December. A noble man called Valentine buried the bodies of these two martyrs, and laid them in a little town in which many miracles were showed in praise and glory of God Almighty."

So is told in Caxton's version of the *Golden Legend* the story of one of the most popular saints of the middle ages. There is, however, considerable doubt of the existence of a virgin martyr called Barbara and it is quite certain that her legend is spurious. There is no mention of her in the earlier martyrologies, her legend is not older than the seventh century, and her *cultus* did not spread till the ninth. Various versions differ both as to the time and place of her martyrdom: it is located in Tuscany, Rome, Antioch, Heliopolis and Nicomedia. St. Barbara is one of the Fourteen Holy Helpers and that she is invoked against lightning and fire and, by association, as patroness of gunners, military architects and miners is attributed to the nature of the fate that overtook her father. The tower represented in her pictures and her directions to the builders of the bath-house have caused her to be regarded as a patroness of architects, builders and stonemasons; and her prayer before her execution accounts for the belief that she is an especial protectress of those in danger of dying without the sacraments.

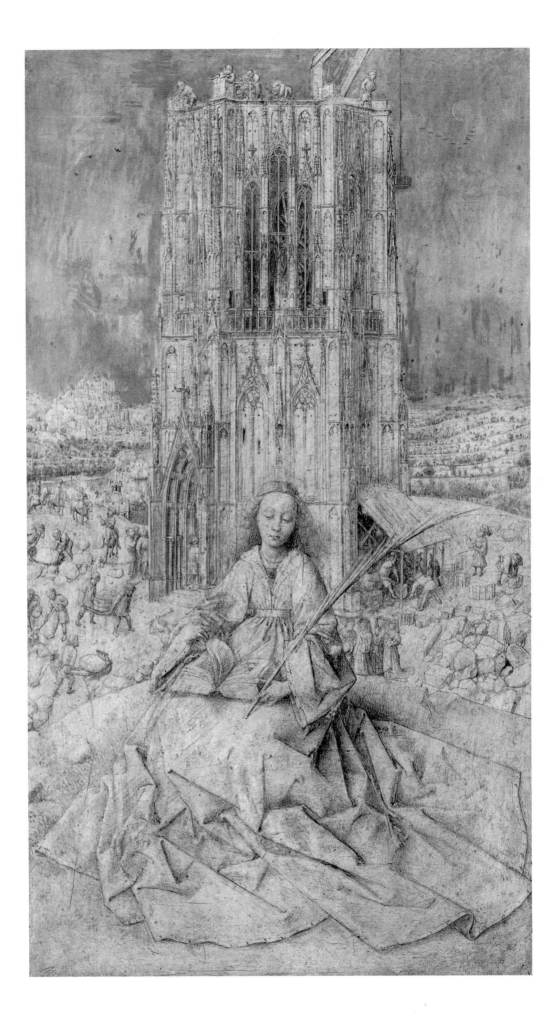

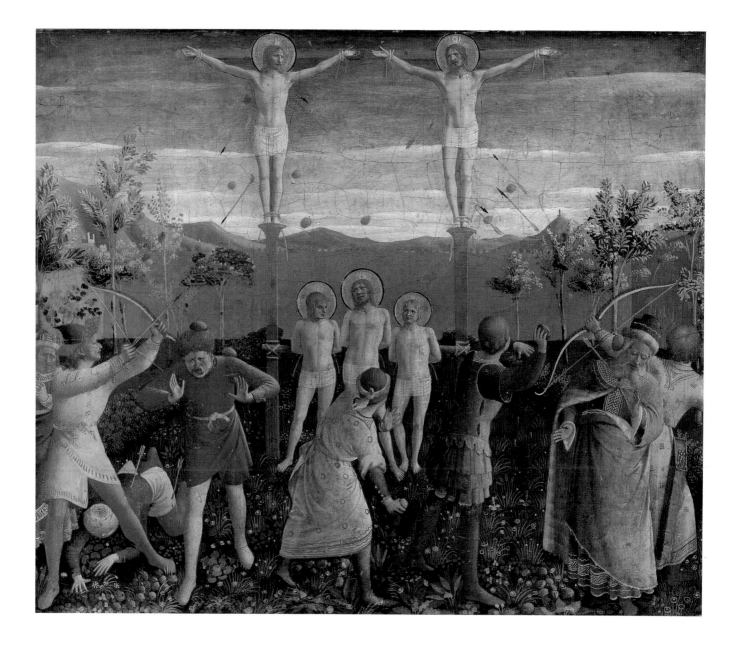

SS. COSMAS AND DAMIAN

Fra Angelico. *The Crucifixion of SS. Cosmas and Damian.* Alte Pinakothek, Munich

SS. COSMAS AND DAMIAN, MARTYRS

September 27

Patron Saints of Barbers; Druggists; Pharmacists;
Physicians; Surgeons

COSMAS AND DAMIAN are the principal and best known of those saints venerated in the East as "moneyless ones," because they practiced medicine without taking reward from their patients. They were twin brothers, born in Arabia, who studied the sciences in Syria and became eminent for their skill in medicine. Being Christians, and full of that holy temper of charity in which the spirit of our divine religion consists, they practiced their profession with great application and success, but never took any fee for their services. They lived at Aegeae on the bay of Alexandretta in Cilicia, and were remarkable both for the love and respect which the people bore them on account of the good offices which they received from their charity, and for their zeal for the Christian faith, which they took every opportunity their profession gave them to propagate. When persecution began to rage, it was impossible for persons of so distinguished a character to lie concealed. They were therefore apprehended by the order of Lysias, governor of Cilicia, and after various torments were beheaded for the faith. Their bodies were carried into Syria, and buried at Cyrrhus, which was the chief center of their *cultus* and where the earliest references locate their martyrdom.

The legends pad out this simple story with numerous marvels. For example, before they were eventually beheaded they defied death by water, fire and crucifixion. While they were hanging on the crosses the mob stoned them, but the missiles recoiled on the heads of the throwers; in the same way the arrows of archers who were brought up to shoot at them turned in the air and scattered the bowmen (the same thing is recorded of St. Christopher and others). Many miracles of healing were ascribed to them after their death, the saints sometimes appearing to the sufferers in sleep and prescribing for them or curing them there and then, as was supposed to happen to pagan devotees in the temples of Aesculapius and Serapis. Their basilica at Rome with its lovely mosaics was dedicated *c.* 530. SS. Cosmas and Damian are named in the canon of the Mass, and they are, with St. Luke, the patrons of physicians and surgeons. Happy are they in that profession who are glad to take the opportunities of charity which their art continually offers, of giving comfort and corporal, if not often also spiritual, succor to the suffering and distressed, especially among the poor. St. Ambrose, St. Basil and St. Bernard warn us against too anxious a care of health as a mark of untrustingness and self-love, nor is anything generally more hurtful to health. But as man is not master of his own life or health, he is bound to take a reasonable care not to throw them away; and to neglect the more simple and ordinary aids of medicine when they are required is to transgress that charity which every one owes to himself. The saints who condemned difficult or expensive measures as contrary to their state were, with St. Charles Borromeo, scrupulously attentive to prescriptions of physicians in simple and ordinary remedies.

ST. LUCY, VIRGIN AND MARTYR

December 13

Patron Saint of Sufferers of Eye Trouble; Writers

THE ENGLISH BISHOP St. Aldhelm of Sherborne at the end of the seventh century celebrated St. Lucy in both prose and verse, but unfortunately the "acts" on which he relied are a worthless compilation. They relate that Lucy was a fourth-century Sicilian, born of noble and wealthy parents in the city of Syracuse, and brought up in the faith of Christ. She lost her father in infancy, and she was yet young when she offered her virginity to God. This vow, however, she kept a secret, and her mother, Eutychia, pressed her to marry a young man who was a pagan. Eutychia was persuaded by her daughter to go to Catania and offer up prayers to God at the tomb of St. Agatha for relief of a hemorrhage from which she suffered. St. Lucy accompanied her, and their prayers were answered. Then the saint disclosed her desire of devoting herself to God and bestowing her fortune on the poor, and Eutychia in gratitude left her at liberty to pursue her inclinations. Her suitor was very indignant, and in his anger accused her before the governor as a Christian, the persecution of Diocletian then being at its height. When Lucy remained resolute the judge commanded her to be exposed to prostitution in a brothel; but God rendered her immovable, so that the guards were not able to carry her thither. Then attempt was made to burn her, but this also was unsuccessful. At length a sword was thrust into her throat. This occurred in A.D. 304.

Though the *acta* of St. Lucy, preserved in various recensions both Latin and Greek, are quite unhistorical, her connection with Syracuse and her early *cultus* admit of no question. She was honored at Rome in the sixth century amongst the most illustrious virgin martyrs whose triumphs the Church celebrates, and her name was inserted in the canon of the Mass at both Rome and Milan. Possibly on account of her name, which is suggestive of light or lucidity, she was invoked during the middle ages by those who suffered from eye-trouble, and various legends grew up, e.g. that her eyes were put out by the tyrant, or that she herself tore them out to present them to an unwelcome suitor who was smitten by their beauty. In either case they were miraculously restored to her, more beautiful than before.

ST. LUCY

Pietro Perugino. *St. Lucy*, 1505. Metropolitan Museum of Art, New York

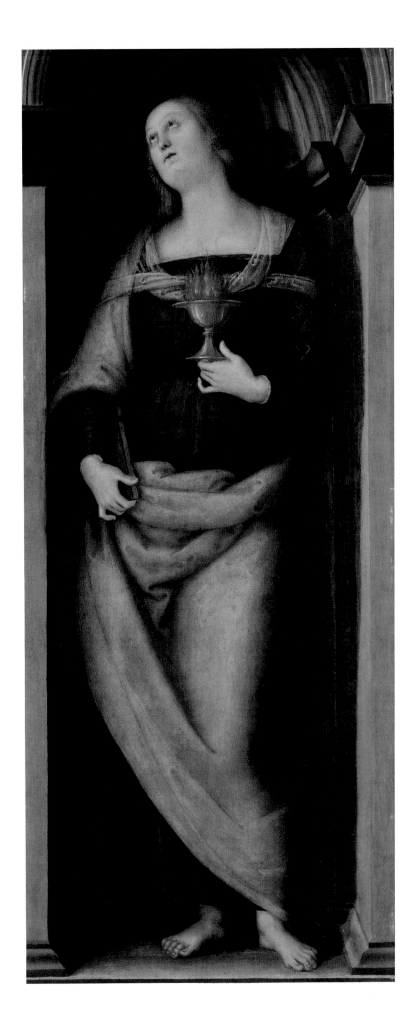

ST. CATHERINE OF ALEXANDRIA, VIRGIN AND MARTYR

November 25

Patron Saint of Maidens; Philosophers; Preachers; Students

SINCE ABOUT THE TENTH CENTURY or earlier veneration for St. Catherine of Alexandria has been marked in the East, but from the time of the Crusades until the eighteenth century her popularity was even greater in the West. Numerous churches were dedicated in her honor and her feast was kept with great solemnity; she was included among the Fourteen Holy Helpers and venerated as the patroness of maidens and women students, of philosophers, preachers and apologists, of wheelwrights, millers and others. But not a single fact about the life or death of Catherine of Alexandria has been established.

It is said that she belonged to a patrician family of Alexandria and devoted herself to learned studies, in the course of which she learnt about Christianity. She was converted by a vision of our Lady and the Holy Child. When Maxentius began persecuting, Catherine, still only eighteen years old and of great beauty, went to him and rebuked him for his tyranny. He could not answer her arguments against his gods, so summoned fifty philosophers to oppose her. These confessed themselves convinced by the learning of the Christian girl, and were therefore burned to death by the infuriated emperor. Then he tried to seduce Catherine with an offer of a consort's crown, and on her indignant refusal she was beaten and imprisoned, and Maxentius went off to inspect a camp. On his return he discovered that his wife, Faustina, and an officer had gone to

see Catherine out of curiosity and had both been converted, together with two hundred soldiers of the guard. They accordingly were all slain and Catherine was sentenced to be killed on a spiked wheel (whence our "catherine-wheel"). When she was placed on it, her bonds were miraculously loosed and the wheel broke, its spikes flying off and killing many of the onlookers. Then she was beheaded, and there flowed from her severed veins a white milk-like liquid.

All the texts of the "acts" of St. Catherine state that her body was carried by angels to Mount Sinai, where a church and monastery were afterwards built, but the legend was not known to the earliest pilgrims to the mountain. In 527 the Emperor Justinian built a fortified monastery for the hermits of this place, and the supposed body of St. Catherine was said to have been taken there in the eighth or ninth century, since when it has borne her name, and the alleged relics of St. Catherine still repose there, in the care of monks of the Eastern Orthodox Church. Alban Butler quotes Archbishop Falconio of Santa Severina as saying, "As to what is said, that the body of this saint was conveyed by angels to Mount Sinai, the meaning is that it was carried by the monks of Sinai to their monastery, that they might devoutly enrich their dwelling with such a treasure. It is well known that the name of angelical habit was often used for a monastic habit, and that monks on account of their heavenly purity and functions were anciently called *angels.*"

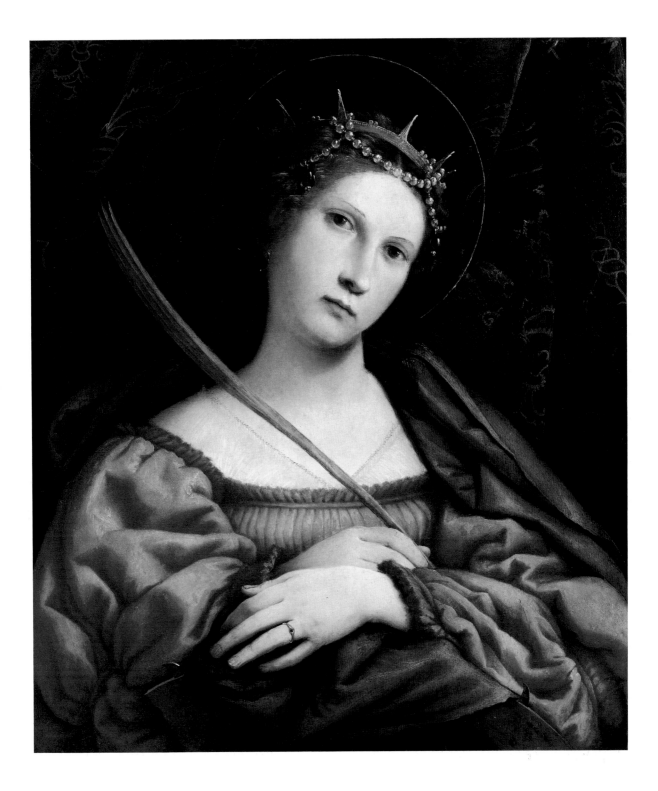

ST. CATHERINE OF ALEXANDRIA

Lorenzo Lotto. *St. Catherine of Alexandria*, 1522. National Gallery of Art, Washington, D.C.

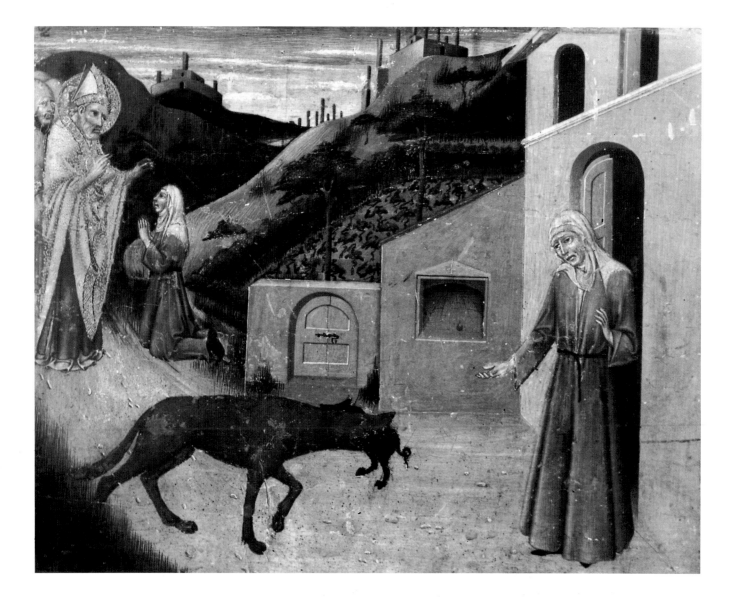

ST. BLAISE
Sano di Pietro. Predella panel from *Stories from Life of St. Blaise: The Wolf Returning the Pig to the Poor Widow.*
Pinacoteca, Siena

ST. BLAISE,
BISHOP OF SEBASTEA, MARTYR

February 3

Patron Saint of Throat Sufferers; Wild Animals

THERE SEEMS TO BE no evidence earlier than the eighth century for the *cultus* of St. Blaise, but the accounts furnished at a later date agree in stating that he was bishop of Sebastea in Armenia and that he was crowned with martyrdom in the persecution of Licinius by command of Agricolaus, governor of Cappadocia and Lesser Armenia. It is mentioned in the legendary acts of St. Eustratius, who is said to have perished in the reign of Diocletian, that St. Blaise honorably received his relics, deposited them with those of St. Orestes, and punctually executed every article of the last will and testament of St. Eustratius.

This is all which can be affirmed concerning St. Blaise, but in view of the honor in which he is held in Germany and France a few words may be said of his legendary acts. According to these he was born of rich and noble parents, receiving a Christian education and being made a bishop while still quite young. When persecution arose, he withdrew by divine direction to a cave in the mountains which was frequented only by wild beasts. These he healed when they were sick or wounded, and they used to come round him to receive his blessing. Hunters, who had been sent to secure animals for the amphitheatre, found the saint surrounded by the beasts, and, though greatly amazed, they seized him and took him to Agricolaus. On their way they met a poor woman whose pig had been carried off by a wolf; at the command of St. Blaise, the wolf restored the pig unhurt. On another occasion a woman brought to him a little boy who was at the point of death owing to a fishbone in his throat, and the saint healed him. On account of this and other similar cures St. Blaise has been invoked during many centuries past for all kinds of throat trouble. The governor ordered him to be scourged and deprived of food, but the woman whose pig had been restored brought provisions to him and also tapers to dispel the darkness of his gloomy prison. Then Licinius tortured him by tearing his flesh with iron combs, and afterwards had him beheaded (*c.* A.D. 316).

In course of time many alleged relics of St. Blaise were brought to the West, and his *cultus* was propagated by the rumor of miraculous cures. He is the patron saint of woolcombers, of wild animals and of all who suffer from affections of the throat. In many places a blessing is given on the day of his feast or to individual sufferers at other times. Two candles (said to be in memory of the tapers brought to the saint in his dungeon) are blessed and held like a St. Andrew's cross either against the throat or over the head of the applicant, with the words *Per intercessionem Sancti Blasii liberet te Deus a malo gutturis et a quovis alio malo.* We also read of "the water of St. Blaise," which is blessed in his honor, and is commonly given to cattle that are sickly.

ST. AGNES, VIRGIN AND MARTYR

January 21

Patron Saint of Girls

St. Agnes has always been looked upon in the Church as a special patroness of bodily purity. She is one of the most popular of Christian saints, and her name is commemorated every day in the canon of the Mass. Rome was the scene of her triumph, and Prudentius says that her tomb was shown within sight of that city. She suffered perhaps not long after the beginning of the persecution of Diocletian, whose cruel edicts were published in March in the year 303. We learn from St. Ambrose and St. Augustine that she was only thirteen years of age at the time of her glorious death. Her riches and beauty excited the young noblemen of the first families in Rome to contend as rivals for her hand. Agnes answered them all that she had consecrated her virginity to a heavenly husband, who could not be beheld by mortal eyes. Her suitors, finding her resolution unshakable, accused her to the governor as a Christian, not doubting that threats and torments would prove more effective with one of her tender years on whom allurements could make no impression. The judge at first employed the mildest expressions and most seductive promises, to which Agnes paid no regard, repeating always that she could have no other spouse but Jesus Christ. He then made use of threats, but found her endowed with a masculine courage, and even eager to suffer torment and death. At last terrible fires were made, and iron hooks, racks and other instruments of torture displayed before her, with threats of immediate execution. The heroic child surveyed them undismayed, and made good cheer in the presence of the fierce and cruel executioners. She was so far from betraying the least symptom of terror that she even expressed her joy at the sight, and offered herself to the rack. She was then dragged before the idols and commanded to offer incense, but could, St. Ambrose tells us, by no means be compelled to move her hand, except to make the sign of the cross.

The governor, seeing his measures ineffectual, said he would send her to a house of prostitution, where what she prized so highly should be exposed to the insults of the brutal and licentious youth of Rome. Agnes answered that Jesus Christ was too jealous of the purity of His chosen ones to suffer it to be violated in such a manner, for He was their defender and protector. "You may," she said, "stain your sword with my blood, but you will never be able to profane my body, consecrated to Christ." The governor was so incensed at this that he ordered her to be immediately led to the place of shame with liberty to all to abuse her person at pleasure. Many young profligates ran thither, full of wicked desires, but were seized with such awe at the sight of the saint that they durst not approach her; one only excepted, who, attempting to be rude to her, was that very instant, by a flash, as it were of lightning from Heaven, struck blind, and fell trembling to the ground. His companions, terrified, took him up and carried him to Agnes, who was singing hymns of praise to Christ, her protector. The virgin by prayer restored his sight and his health.

The chief accuser of the saint, who had at first sought to gratify his lust and avarice, now, in a spirit of vindictiveness, incited the judge against her, his passionate fondness being changed into fury. The governor needed no encouragement, for he was highly

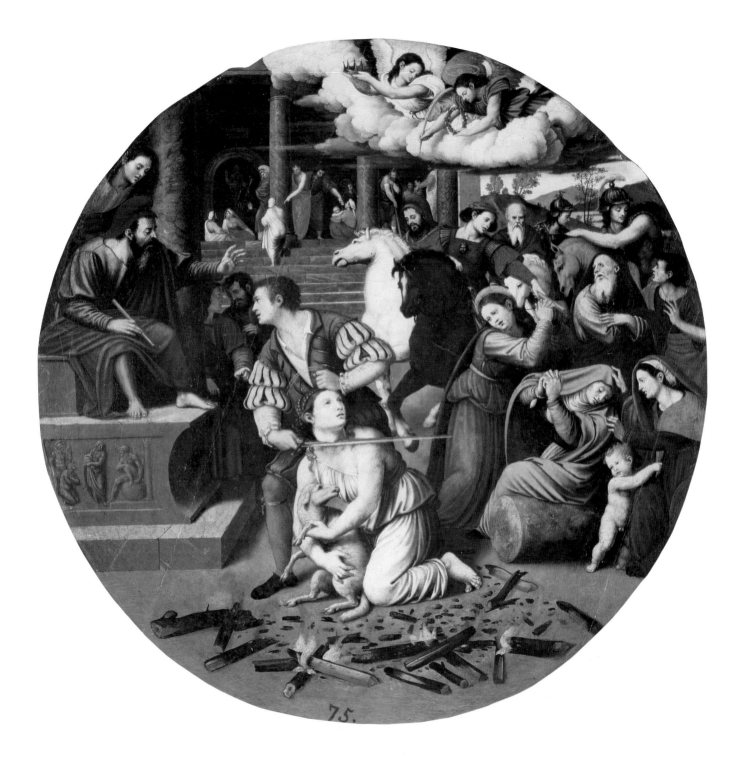

Juan Vicente Masip. *The Martyrdom of St. Agnes.* Prado, Madrid

buried at a short distance from Rome, beside the Nomentan road.

Modern authorities incline to the view that little reliance can be placed on the details of the story. In any case, however, there can be no possible doubt of the fact that St. Agnes was martyred, and that she was buried beside the Via Nomentana in the cemetery afterwards called by her name. Here a basilica was erected in her honor before 354 by Constantina, daughter of Constantine and wife of Gallus. There is also abundant subsidiary evidence of the early *cultus* in the frequent occurrence of representations of the child martyr in "gold glasses," etc., and in the prominence given to her name in all kinds of Christian literature. "Agnes, Thecla and Mary were with me," said St. Martin to Sulpicius Severus, where he seems to assign precedence to Agnes even above our Blessed Lady.

In art St. Agnes is commonly represented with a lamb and a palm, the lamb, no doubt, being originally suggested by the resemblance of the word *agnus* (a lamb) to the name Agnes. In Rome on the feast of St. Agnes each year, while the choir in her church on the Via Nomentana are singing the antiphon *Stans a dextris ejus agnus nive candidior* (On her right hand a lamb whiter than snow), two white lambs are offered at the sanctuary rails. They are blessed and then cared for until the time comes for shearing them. Out of their wool are woven the pallia which, on the vigil of SS. Peter and Paul, are laid upon the altar in the *Confessio* at St. Peter's immediately over the body of the Apostle. These pallia are sent to archbishops throughout the Western church, "from the body of Blessed Peter," in token of the jurisdiction which they derive ultimately from the Holy See, the center of religious authority.

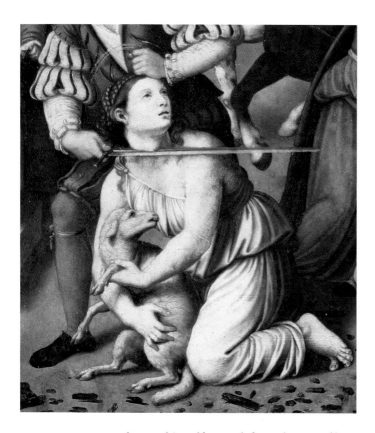

exasperated to see himself set at defiance by one of her tender age and sex. Being resolved therefore upon her death, he condemned her to be beheaded. Agnes, filled with joy on hearing this sentence, "went to the place of execution more cheerfully," says St Ambrose, "than others go to their wedding." The executioner had instructions to use all means to induce her to give way, but Agnes remained constant; and having made a short prayer, bowed down her neck to receive the death stroke. The spectators shed tears to see this beautiful child loaded with fetters, and offering herself fearlessly to the sword of the executioner, who with trembling hand cut off her head at one stroke. Her body was

ST. ANTONY THE ABBOT

January 17

Patron Saint of Basket-makers; Butchers; Domestic Animals; Gravediggers

ST. ANTONY WAS BORN at a village south of Memphis in Upper Egypt in 251. His parents, who were Christians, kept him always at home, so that he grew up in ignorance of what was then regarded as polite literature, and could read no language but his own. At their death he found himself possessed of a considerable estate and charged with the care of a younger sister, before he was twenty years of age. Some six months afterwards he heard read in the church those words of Christ to the rich young man: "Go, sell what thou hast, and give it to the poor, and thou shalt have treasure in Heaven." Considering these words as addressed to himself, he went home and made over to his neighbors his best land, and the rest of his estate he sold and gave the price to the poor, except what he thought necessary for himself and his sister. Soon after, hearing in the church those other words of Christ, "Be not solicitous for tomorrow," he also distributed in alms the movables which he had reserved, and placed his sister in a house of maidens, which is commonly assumed to be the first recorded mention of a nunnery. Antony himself retired into solitude. Manual labor, prayer and reading were his whole occupation; and such was his fervor that if he heard of any virtuous recluse, he sought him out to take advantage of his example and instruction. In this way he soon became a model of humility, charity, prayerfulness and many more virtues.

The Devil assailed Antony by various temptations, representing to him first of all many good works he might have been able to carry out with his estate in the world. Being repulsed by the young novice, he varied his method of attack, and harassed him night and day with gross and obscene imaginations. Antony opposed to his assaults the strictest watchfulness over his senses, austere fasts and prayer, till Satan at length confessed himself vanquished. The saint's food was only bread, with a little salt, and he drank nothing but water; he never ate before sunset, and sometimes only once in three or four days. When he took his rest he lay on a rush mat or the bare floor. In quest of a more remote solitude he withdrew to an old burial-place, to which a friend brought him bread from time to time. Satan was here again permitted to assault him in a visible manner, and to terrify him with gruesome noises; indeed, on one occasion he so grievously beat him that he lay almost dead, and in this condition was found by his friend. When he began to come to, Antony cried out to God, "Where wast thou, my Lord and Master? Why wast thou not here from the beginning of this conflict to render me assistance?" A voice answered, "Antony, I was here the whole time; I stood by thee and beheld thy combat; and because thou hast manfully withstood thy enemies, I will always protect thee, and will render thy name famous throughout the earth."

Hitherto Antony, ever since he turned his back on the world in 272, had lived in solitary places not very far from his village of Koman, until about the year 285 when, at the age of thirty-five, he crossed the eastern branch of the Nile and took up his abode in some ruins on the top of a mountain, in which solitude he lived almost twenty years, rarely seeing any man except one who brought him bread every six months.

To satisfy the importunities of others, about the year 305, the fifty-fourth of his age, he came down from his mountain and founded his first monastery, in

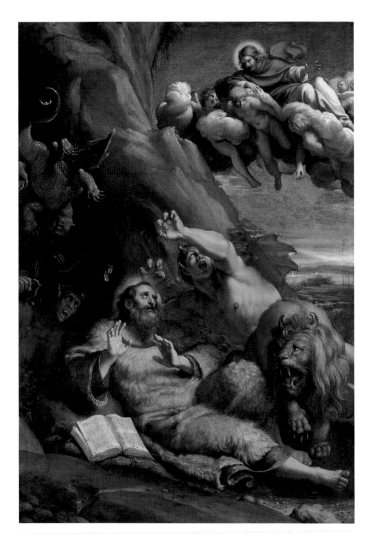

Annibale Carracci. *Christ Appearing to Saint Antony Abbot during His Temptation.* National Gallery, London

the Fayum. He did not stay permanently with any such community, but he visited them occasionally.

In the year 311, when the persecution was renewed under Maximinus, St. Antony went to Alexandria in order to give courage to the martyrs. He publicly wore his white tunic of sheep-skin and appeared in the sight of the governor. Later, the persecution having abated, he returned to his monastery, and some time after organized another, called Pispir, near the Nile; but he chose for the most part to shut himself up in a cell upon a mountain difficult of access with Macarius, a

disciple whose duty it was to interview visitors. If he found them to be *Hierosolymites,* i.e. spiritual men, St. Antony himself sat with them in discourse; if *Egyptians* (by which name they meant worldly persons), then Macarius entertained them, and Antony only appeared to give them a short exhortation.

St. Antony cultivated a little garden on his desert mountain, but this tillage was not the only manual labor in which he employed himself. St. Athanasius speaks of his making mats as an ordinary occupation. We are told that he once fell into dejection, finding uninterrupted contemplation above his strength; but was taught to apply himself at intervals to manual work by an angel in a vision, who appeared platting mats of palm-tree leaves, then rising to pray, and after some time sitting down again to work, and who at length said to him, "Do thus, and relief shall come to thee." But St. Athanasius declares that Antony continued in some degree to pray whilst he was at work. He spent a great part of the night in contemplation; and sometimes when the rising sun called him to his daily tasks he complained that its visible light robbed him of the greater interior light which he enjoyed when left in darkness and solitude.

St. Antony in the year 339 saw in a vision, under the figure of mules kicking down the altar, the havoc which the Arian persecution was to cause two years after in Alexandria. About the year 355, he took a journey to Alexandria to confute the Arians, preaching that God the Son is not a creature, but of the same substance with the Father; and that the Arians, who called him a creature, did not differ from the heathen themselves, "who worshipped and served the creature rather than the Creator." All the people ran to see him, and rejoiced to hear him; even the pagans, struck with the dignity of his character, flocked around him, saying, "We want to see the man of God." He converted many, and even worked miracles.

St. Jerome relates that at Alexandria Antony met the famous Didymus, the blind head of the catechetical school there, and exhorted him not to regret overmuch the loss of eyes, which were common even to insects, but to rejoice in the treasure of that inner light which the apostles enjoyed, by which we see God and kindle

the fire of His love in our souls. Heathen philosophers and others often went to discuss with him, and returned astonished at his meekness and wisdom. When certain philosophers asked him how he could spend his time in solitude without even the alleviation of books, he replied that nature was his great book and amply supplied the lack of all else. St. Athanasius assures us that no one visited St. Antony under any affliction who did not return home full of comfort.

About the year 337 Constantine the Great and his two sons, Constantius and Constans, wrote a letter to the saint, recommending themselves to his prayers. St. Antony, seeing his monks surprised, said, "Do not wonder that the emperor writes to us, a man even as I am; rather be astounded that God should have written to us, and that He has spoken to us by His Son." A maxim which he frequently repeats is, that the knowledge of ourselves is the necessary and only step by which we can ascend to the knowledge and love of God. It is further related that St. Antony, hearing his disciples express surprise at the multitudes who embraced the religious state, told them with tears that the time would come when monks would be fond of living in cities and stately buildings, of eating at well-laden tables, and be only distinguished from persons of the world by their dress; but that still some amongst them would rise to the spirit of true perfection.

St. Antony made a visitation of his monks a little before his death, which he foretold, but no tears could move him to die among them. He gave orders that he should be buried in the earth beside his mountain cell by his two disciples, Macarius and Amathas. Hastening back to his solitude on Mount Kolzim near the Red Sea, he some time after fell ill; whereupon he repeated to these disciples his orders that they should bury his body secretly in that place, adding, "In the day of the resurrection I shall receive it incorruptible from the hand of Christ." His death occurred in the year 356,

probably on January 17. He was one hundred and five years old. From his youth to that extreme old age he always maintained the same fervor and austerity; yet he lived without sickness, his sight was not impaired, his teeth were only worn, not one was lost or loosened. The two disciples interred him according to his directions. About 561 his remains are supposed to have been discovered and translated to Alexandria, thence to Constantinople, and eventually to Vienne, in France.

In art St. Antony is constantly represented with a *tau*-shaped crutch or cross, a little bell, a pig, and sometimes a book. The crutch, in this peculiarly Egyptian T-shaped form of the cross, may be simply an indication of the saint's great age and abbatial authority, or it may very possibly have reference to his constant use of the sign of the cross in his conflict with evil spirits. The pig, no doubt, in its origin, denoted the Devil, but in the course of the twelfth century it acquired a new significance owing to the popularity of the Hospital Brothers of St. Antony, founded at Clermont in 1096. Their works of charity endeared them to the people, and they obtained in many places the privilege of feeding their swine gratuitously upon the acorns and beech mast in the woods. For this purpose a bell was attached to the neck of one or more sows in a herd of pigs, or possibly their custodians announced their coming by ringing a bell. In any case, it seems that the bell became associated with the members of the order, and in that way developed into an attribute of their eponymous patron. The book, no doubt, has reference to the book of nature which compensated the saint for the lack of any other reading. He was, in particular, appealed to, probably on account of his association with the pig, as the patron of domestic animals and farm stock, so that guilds of butchers, brushmakers, etc., placed themselves under his protection.

ST. NICHOLAS, CALLED "OF BARI,"
BISHOP OF MYRA

December 6

Patron Saint of Apulia; Greece; Lorraine; Russia; Sicily; Bakers; Brides; Children;
Pawnbrokers; Prisoners; Storm-beset Sailors

THE GREAT VENERATION with which this saint has been honored for many ages and the number of altars and churches which have been everywhere dedicated in his memory are testimonials to his holiness and of the glory which he enjoys with God.

His parents died when he was a young man, leaving him well off, and he determined to devote his inheritance to works of charity. An opportunity soon arose. A citizen of Patara had lost all his money, and had moreover to support three daughters who could not find husbands because of their poverty; so the wretched man was going to give them over to prostitution. This came to the ears of Nicholas, who thereupon took a bag of gold and, under cover of darkness, threw it in at the open window of the man's house. Here was a dowry for the eldest girl, and she was soon duly married. At intervals Nicholas did the same for the second and third; at the last time the father was on the watch, recognized his benefactor, and overwhelmed him with his gratitude.

Coming to the city of Myra when the clergy and people of the province were in session to elect a new bishop, St. Nicholas was indicated by God as the man they should choose. This was at the time of the persecutions at the beginning of the fourth century, and, "As he was the chief priest of the Christians of this town and preached the truths of faith with a holy liberty, the divine Nicholas was seized by the magistrates, tortured, then chained and thrown into prison with many other Christians. But when the great and religious Constantine, chosen by God, assumed the imperial diadem of the Romans, the prisoners were released from their bonds and with them the illustrious Nicholas, who when he was set at liberty returned to Myra." St. Nicholas was tireless and took strong measures against paganism: among other temples he destroyed was that of Artemis, and the evil spirits fled howling before him. He was the guardian of his people as well in temporal affairs. The governor Eustathius had taken a bribe to condemn to death three innocent men. At the time fixed for their execution Nicholas came to the place, stayed the hand of the executioner, and released the prisoners. Then he turned to Eustathius and did not cease to reproach him until he admitted his crime and expressed his penitence. There were present on this occasion three imperial officers who were on their way to duty in Phrygia. Later, when they were back again in Constantinople, the jealousy of the prefect Ablavius caused them to be imprisoned on false charges and an order for their death was procured from the Emperor Constantine. That night St. Nicholas appeared in a dream to Constantine, and told him with threats to release the three innocent men, and Ablavius experienced the same thing. In the morning the emperor and the prefect compared notes, and the condemned men were sent for and questioned. When he heard that they had called on the name of the Nicholas of Myra who had appeared to him, Constantine set them free and sent them to the bishop with a letter asking him not to threaten him any more but to pray for the peace of the world.

St. Nicholas died and was buried in his episcopal city of Myra, and by the time of Justinian there was a basilica built in his honor at Constantinople. When

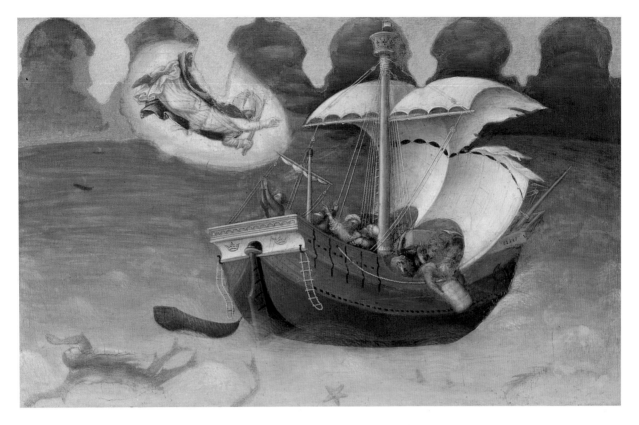

ST. NICHOLAS
Gentile da Fabriano. Predella panel from *Quartesi Altarpiece: St. Nicholas Saves a Storm-tossed Ship,* 1425.
Pinacoteca Vaticana, Rome

Myra and its great shrine finally passed into the hands of the Saracens, there was great competition for his relics between Venice and Bari. The last-named won, the relics were carried off under the noses of the lawful Greek custodians and their Mohammedan masters, and on May 9, 1087, were safely landed at Bari. At Myra "the venerable body of the bishop, embalmed as it was in the good ointments of virtue, exuded a sweet-smelling 'myrrh,' which kept it from corruption and proved a health-giving remedy against sickness, to the glory of him who had glorified Jesus Christ, our true God." The translation of the relics did not interrupt this phenomenon, and the "manna of St. Nicholas" is said to flow to this day. It was one of the great attractions which drew pilgrims to his tomb from all parts of Europe.

St. Nicholas is said to have been represented by Christian artists more frequently than any saint except our Lady. He is venerated as the patron-saint of several classes of people, especially, in the East, of sailors and,

in the West, of children. The first of these patronages is probably due to the legend that, during his life-time, he appeared to storm-tossed mariners who invoked his aid off the coast of Lycia, and brought them safely to port. Sailors in the Aegean and Ionian seas, following a common Eastern custom, had their "star of St. Nicholas" and wished one another a good voyage in the phrase "May St. Nicholas hold the tiller." The legend of the "three children" gave rise to his patronage of children and various observances, ecclesiastical and secular, connected therewith, especially the giving of presents in his name at Christmas time. The deliverance of the three imperial officers naturally caused St. Nicholas to be invoked by and on behalf of prisoners and captives, and many miracles of his intervention are recorded in the middle ages.

The greatest popularity of St. Nicholas is found in Russia. With St. Andrew the Apostle he is patron of the nation, and he is a patron-saint also of Greece, Apulia, Sicily and Lorraine.

ST. ZENO, BISHOP OF VERONA

April 12

Patron Saint of Verona

IT HAS BEEN conjectured that St. Zeno was born in Africa; and from the excellent flowing Latin of his writings and from the quotations he makes from Virgil, it is evident that he received a good classical education. He seems to have been made bishop of Verona in 362. From a collection of his discourses delivered to his flock, we learn that he baptized every year a great number of pagans, and that he exerted himself with zeal and success against the Arians, who had been emboldened by the favors they had enjoyed under the Emperor Constantius. When he had in a great measure purged the church of Verona from heresy and heathenism, his flock increased to an extent which necessitated the building of a large basilica. Contributions flowed in freely from the citizens, whose habitual liberality had become so great that their houses were always open to poor strangers, whilst none of their fellow citizens ever had occasion to apply for relief, so promptly were their wants forestalled.

St. Zeno himself always chose to live in great poverty. He often speaks of the clergy he trained and of the priests, his fellow-laborers, to whom offerings were allotted at Easter. He alludes to the ordinations he performed at the paschal season, as well as to the solemn reconciliation of penitents, which also took place in Holy Week. St. Ambrose makes mention of virgins, living in Verona in their own houses and wearing the veil, who had been consecrated to God by St. Zeno, as well as of others who dwelt in a convent of which he was both the founder and the director. This was before St. Ambrose had established anything of the kind in Milan. St. Zeno inveighed against the abuses of the *agape* or love-feast, which had become a scandal, and also against the practice of interrupting funeral Masses by loud lamentations. Many of the customs of the period are recorded in these discourses. St. Zeno is the only writer to allude to the habit of giving medals to the newly baptized.

St. Gregory the Great describes a remarkable miracle which occurred two centuries after St. Zeno's death. In the year 598 the river Adige threatened to submerge Verona. The people flocked to the church of their holy bishop and patron, Zeno. The waters seemed to respect the building for, although they rose outside as high as the windows, they never penetrated into the church but stood like a solid wall. The people remained within in prayer until, after twenty-four hours, the waters once more subsided. This miracle and others greatly increased the general devotion to the saint, and in the reign of King Pepin, Charlemagne's son, a new church was built to contain his relics, which are still preserved there in a subterranean chapel. St. Zeno is usually represented with a fishing-rod, from the end of which a fish is hanging. The emblem is accounted for locally by the tradition that the saint was fond of fishing in the Adige, but the fish may possibly be symbolical of baptism.

ST. ZENO OF VERONA

Bartolomeo Montagna. *Three Saints* [fragment]. National Gallery, London (from left to right: SS. Zeno, John the Baptist, and Catherine of Alexandria[?])

ST. MARTIN, BISHOP OF TOURS

November 11

Patron Saint of France; Soldiers

THE GREAT ST. MARTIN, the glory of Gaul and a light to the Western church in the fourth century, was a native of Sabaria, a town of Pannonia. From thence his parents, who were pagans, had to remove to Pavia in Italy, for his father was an officer in the army, who had risen from the ranks. Martin himself has come to be looked on as a "soldier saint." At the age of fifteen he was forced into the army against his will and for some years, though not yet formally a Christian, he lived more like a monk than a soldier. It was while stationed at Amiens that is said to have occurred the incident which tradition and image have made famous. One day in a very hard winter, during a severe frost, he met at the gate of the city a poor man, almost naked, trembling and shaking with cold, and begging alms of those that passed by. Martin, seeing those that went before take no notice of this miserable creature, thought he was reserved for himself, but he had nothing with him but his arms and clothes. So, drawing his sword, he cut his cloak into two pieces, gave one to the beggar and wrapped himself in the other half. Some of the bystanders laughed at the figure he cut, but others were ashamed not to have relieved the poor man. That night Martin in his sleep saw Jesus Christ, dressed in that half of the garment which he had given away, and heard Jesus say, "Martin, yet a catechumen, has covered me with this garment." His disciple and biographer Sulpicius Severus states that he had become a catechumen on his own initiative at the age of ten, and that as a consequence of this vision he "flew to be baptized."

Martin did not at once leave the army, and when he was about twenty there was a barbarian invasion of Gaul. With his comrades he appeared before Julian Caesar to receive a war-bounty, and Martin refused to accept it. "Hitherto," he said to Julian, "I have served you as a soldier; let me now serve Christ. Give the bounty to these others who are going to fight, but I am a soldier of Christ and it is not lawful for me to fight." Julian stormed and accused Martin of cowardice, who retorted that he was prepared to stand in the battle-line unarmed the next day and to advance alone against the enemy in the name of Christ. He was thrust into prison, but the conclusion of an armistice stopped further developments and Martin was soon after discharged. He went to Poitiers, where St. Hilary was bishop, and this doctor of the Church gladly received the young "conscientious objector" among his disciples.

In Illyricum he opposed the triumphant Arians with so much zeal that he was publicly scourged and had to leave the country. In Italy he heard that the church of Gaul also was oppressed by those heretics and St. Hilary banished, so he remained quietly at Milan. But Auxentius, the Arian bishop, soon drove him away. He then retired with a priest to the island of Gallinaria in the gulf of Genoa, and remained there till St. Hilary was allowed to return to Poitiers in 360. It being Martin's earnest desire to pursue his vocation in solitude, St. Hilary gave him a piece of land where he was soon joined by a number of other hermits. This community — traditionally the first monastic community founded in Gaul — grew into a great

ST. MARTIN

El Greco. *St. Martin and the Beggar*, 1597/99.
National Gallery of Art,
Washington, D.C.

monastery which continued till the year 1607, and was revived by the Solesmes Benedictines in 1852. St. Martin lived here for ten years, directing his disciples and preaching throughout the countryside, where many miracles were attributed to him. About 371 the people of Tours demanded Martin for their bishop. He was unwilling to accept the office, so a stratagem was made use of to call him to the city to visit a sick person, where he was conveyed to the church. Some of the neighboring bishops, called to assist at the election, urged that the meanness of his appearance and his unkempt air showed him to be unfit for such a dignity. But such objections were overcome by the acclamations of the local clergy and people.

St. Martin continued the same manner of life. He lived at first in a cell near the church, but not being able to endure the interruptions of the many visitors he retired from the city to where was soon the famous abbey of Marmoutier. The place was then a desert, enclosed by a steep cliff on one side and by a tributary of the river Loire on the other; but he had here in a short time eighty monks, with many persons of rank amongst them. A very great decrease of paganism in the district of Tours and all that part of Gaul was the fruit of the piety, miracles and zealous instruction of St. Martin. He destroyed many temples of idols and felled trees and other objects that were held sacred by the pagans. Having demolished a certain temple, he would also have cut down a pine that stood near it. The chief priest and others agreed that they themselves would fell it, upon condition that he who trusted so strongly in the God whom he preached would stand under it where they should place him. Martin consented, and let himself be tied on that side of the tree to which it leaned. When it seemed about to fall

on him he made a sign of the cross and it fell to one side. Another time, as he was pulling down a temple in the territory of Autun, a man attacked him sword in hand. The saint bared his breast to him; but the pagan lost his balance, fell backwards, and was so terrified that he begged for forgiveness. These and many other marvels are narrated by Sulpicius Severus. He also recounts several instances of revelations, visions and the spirit of prophecy with which the saint was favored by God. According to his biographer he extended his apostolate from Touraine to Chartres, Paris, Autun, Sens and Vienne.

St. Martin had a knowledge of his approaching death, which he foretold to his disciples, and with tears they besought him not to leave them. "Lord," he prayed, "if thy people still need me I will not draw back from the work. Thy will be done." He was at a remote part of his diocese when his last sickness came on him. He died on November 8, 397, and three days later was buried at Tours, where his successor St. Britius built a chapel over his grave, which was later replaced by a magnificent basilica. Its successor was swept away at the Revolution, but a church now stands over the site of the shrine, which was rifled by the Huguenots in 1562. Till that date the pilgrimage to Tours was one of the most popular in Europe, and a very large number of French churches are dedicated in St. Martin's honor. And not only in France. The oldest existing church in England bears his name, that one outside the eastern walls of Canterbury which St. Bede says was first built during the Roman occupation. If this be so, it doubtless at first had another dedication, but was called St. Martin's by the time St. Augustine and his monks came to use it. St. Martin was named in the canon of the Mass in the Bobbio Missal.

ST. BASIL THE GREAT, ARCHBISHOP OF CAESAREA AND DOCTOR OF THE CHURCH, PATRIARCH OF EASTERN MONKS

June 14

S T. BASIL WAS BORN at Caesarea, the capital of Cappadocia in Asia Minor, in the year 329. One of a family of ten, which included St. Gregory of Nyssa, St. Macrina the Younger and St. Peter of Sebaste, he was descended on both sides from Christians who had suffered persecution. His father, St. Basil the Elder, and his mother, St. Emmelia, were possessed of considerable landed property, and Basil's early years were spent at the country house of his grandmother, St. Macrina, whose example and teaching he never forgot. He studied at Constantinople and completed his education at Athens. He had there as fellow students St. Gregory of Nazianzus, who became his inseparable friend, and Julian, the future emperor and apostate. As soon as Basil had learnt all that his masters could teach him, he returned to Caesarea. For some years he taught rhetoric in the city, but on the very threshold of a brilliant career he was led to abandon the world through the influence of his eldest sister, Macrina, who, after helping to educate and settle her sisters and youngest brother, had retired with her widowed mother and other women to live a community life on one of the family estates at Annesi on the river Iris.

About the same time Basil appears to have been baptized; and determined from thenceforth to serve God in evangelical poverty, he visited the principal monasteries of Egypt, Palestine, Syria and Mesopotamia to study the religious life. Upon his return he withdrew and devoted himself to prayer and study. With the disciples who soon gathered round

him, including his brother Peter, he formed the first monastery in Asia Minor and for them he organized the life and enunciated the principles which have continued through the centuries down to the present day to regulate the lives of monks of the Eastern church. Basil lived the life of a monk in the strict sense for only five years; but in the history of Christian monachism he ranks in importance with St. Benedict himself.

At this time the Arian heresy was at its height, and heretical emperors were persecuting the orthodox. In 363 Basil was persuaded to be ordained deacon and priest at Caesarea; but the archbishop, Eusebius, became jealous of his influence, and the saint quietly retired again to Pontus to aid in the foundation and direction of new monasteries. In 365, St. Gregory of Nazianzus, on behalf of the orthodox, fetched Basil from his retreat to assist them in the defense of their faith, their clergy and their churches. A reconciliation was effected between him and Eusebius, Basil remained on in Caesarea to become the bishop's right hand and actually to rule the church, whilst tactfully giving credit to Eusebius for all that he was really doing himself. During a season of drought followed by famine he not only distributed his maternal inheritance in charity, but he also organized a great system of relief with a soup kitchen in which he could be seen, girt with an apron, dealing out food to the hungry. Eusebius died in 370, and Basil, in spite of considerable opposition, was elected to fill the vacant see on June 14.

Within twelve months of Basil's accession, the Emperor Valens was in Caesarea, after having conducted in Bithynia and Galatia a ruthless campaign of persecution. The holy bishop would not yield, either to keep silence about Arianism or to admit Arians to communion. Promises and threats were equally useless and violence Valens was unwilling — perhaps afraid — to attempt. He decided in favor of banishment, but thrice in succession the reed pen with which he was signing the edict split in his hand. A weak man himself, he was overawed and moved to reluctant admiration by Basil's determination, and eventually took his departure, never again to interfere with the ecclesiastical affairs of Caesarea.

Whilst he was thus engaged in defending the church of Caesarea against attacks upon its faith and jurisdiction, St. Basil was no less zealously fulfilling his strictly pastoral duties. Even on working days he preached morning and evening to congregations so vast that he himself compared them to the sea. For the benefit of the sick poor he organized outside the gate of Caesarea a hospital which St. Gregory of Nazianzus described as almost a new city and worthy to be reckoned one of the wonders of the world. In spite of chronic ill-health, he made frequent visitations into mountainous districts, and by his vigilant supervision of his clergy and his insistence on the ordination of none but suitable candidates he made of his archdiocese a model of ecclesiastical order and discipline.

On August 9, 378, the Emperor Valens was mortally wounded at the battle of Adrianople, and with the accession of his nephew, Gratian, came the end of the Arian ascendancy in the East. When the news reached St. Basil he was on his death-bed, but it brought him consolation in his last moments. He died on January 1, 379, at the age of forty-nine, worn out by his austerities, his hard work, and a painful disease. The whole of Caesarea mourned him as a father and protector — pagans, Jews, and strangers joining in the general lamentation. He was undoubtedly one of the most eloquent orators the Church has ever produced and his writings have entitled him to a high place amongst her doctors. In the Eastern church his chief feast-day is on January 1.

St. Basil required exact discipline from clergy and laity alike; he dealt with simony in ecclesiastical offices and the reception of unfit persons among the clergy; he fought the rapacity and oppression of officials, and excommunicated all concerned in the "white-slave traffic," which was widespread in Cappadocia. He could rebuke with dreadful severity, but preferred the way of gentleness. Nor was Basil silent when the well-to-do failed in their duty. "You refuse to give on the pretext that you haven't got enough for your own needs," he exclaimed in one of his sermons, "But while your tongue makes excuses, your hand convicts you — that ring shining on your finger silently declares you to be a liar! How many debtors could be released from prison with one of those rings? How many shivering people could be clothed from only one of your wardrobes? And yet you turn the poor away empty-handed." But he did not confine the obligation of giving to the rich alone. "You are poor? But there are others poorer than you. You have enough to keep you alive for ten days — but this man has enough for only one. . . . Don't be afraid to give away the little that you have. Don't put your own interests before the common need. Give your last loaf to the beggar at your door, and trust in God's goodness."

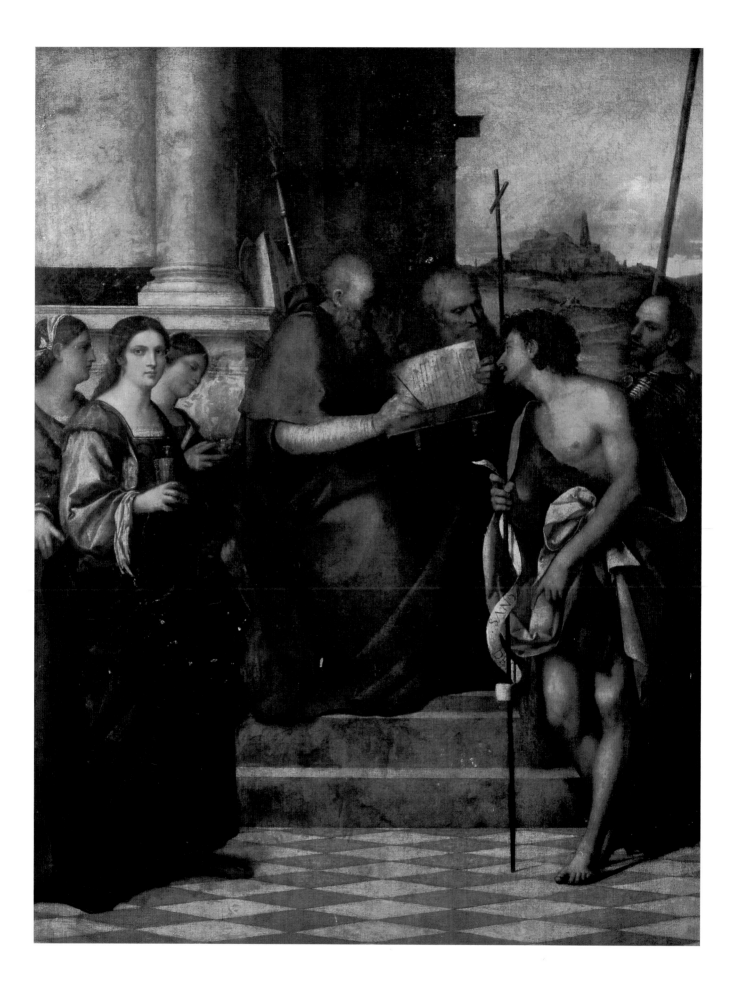

ST. JOHN CHRYSOSTOM, ARCHBISHOP OF CONSTANTINOPLE AND DOCTOR OF THE CHURCH

January 27

Patron Saint of Orators; Preachers

THIS INCOMPARABLE TEACHER, on account of the fluency and sweetness of his eloquence, obtained after his death the surname of Chrysostom, or Golden Mouth. But his piety and his undaunted courage are titles far more glorious, by which he may claim to be ranked among the greatest pastors of the Church. He was born about the year 347 at Antioch in Syria, the only son of Secundus, commander of the imperial troops. His mother, Anthusa, left a widow at twenty, divided her time between the care of her family and her exercises of devotion. Anthusa provided for her son the ablest masters which the empire at that time afforded. Eloquence was esteemed the highest accomplishment, and John studied that art under Libanius, the most famous orator of the age; and such was his proficiency that even in his youth he excelled his masters. Libanius being asked on his deathbed who ought to succeed him in his school, "John," said he, "would have been my choice, had not the Christians stolen him from us."

According to a common custom of those days young John was not baptized till he was over twenty years old, being at the time a law student. Soon after, together with his friends Basil, Theodore (afterwards bishop of Mopsuestia) and others, he attended a sort of school for monks, where they studied under Diodorus of Tarsus; and in 374 he joined one of the loosely-knit communities of hermits among the mountains south of Antioch. He afterwards wrote a vivid account of their austerities and trials. He passed four years under the direction of a veteran Syrian monk, and afterwards two years in a cave as a solitary. The dampness of this abode brought on a dangerous illness, and for the recovery of his health he was obliged to return into the city in 381. He was ordained deacon by St. Meletius that very year, and received the priesthood from Bishop Flavian in 386, who at the same time constituted him his preacher, John being then about forty. He discharged the duties of the office for twelve years, supporting during that time a heavy load of responsibility as the aged bishop's deputy. The instruction and care of the poor he regarded as the first obligation of all, and he never ceased in his sermons to recommend their cause and to impress on the people the duty of almsgiving.

The Emperor Theodosius I, finding himself obliged to levy a new tax on his subjects because of his war with Magnus Maximus, the Antiochenes rioted and vented their discontent on the emperor's statue, and those of his father, sons and late consort, breaking them to pieces. The magistrates were helpless. But as soon as the fury was over and they began to reflect on the probable consequences of their outburst, the people were seized with terror and their fears were heightened by the arrival of two officers from Constantinople to carry out the emperor's orders for punishment. In spite of his age, Bishop Flavian set out in the worst weather of the year to implore the imperial clemency for his flock, and Theodosius was

touched by his appeal: an amnesty was accorded to the delinquent citizens of Antioch. Meanwhile St. John had been delivering perhaps the most memorable series of sermons which marked his oratorical career, the famous twenty-one homilies "On the Statutes." They manifest in a wonderful way the sympathy between the preacher and his audience, and also his own consciousness of the power which he wielded for good. There can be no question that the Lent of 387, during which these discourses were delivered, marked a turning-point in Chrysostom's career, and that from that time forward his oratory became, even politically, one of the great forces by which the Eastern empire was swayed.

In 397 Nectarius, Archbishop of Constantinople, died and the Emperor Arcadius, at the suggestion of Eutropius, his chamberlain, resolved to procure the election of John to the see of that city. He therefore dispatched an order to the count of the East, enjoining him to send John to Constantinople, but to do so without making the news public, lest his intended removal should cause a sedition. The count repaired to Antioch, and desiring the saint to accompany him out of the city to the tombs of the martyrs, he there delivered him to an officer who, taking him into his chariot, conveyed him with all possible speed to the imperial city. Theophilus, Archbishop of Alexandria, a man of proud and turbulent spirit, had come thither to recommend a nominee of his own for the vacancy; but he had to desist from his intrigues, and John was consecrated by him on February 26 in 398.

It remained for St. Chrysostom to glorify God by his sufferings, as he had already done by his labors, and, if we contemplate the mystery of the Cross with the eyes of faith, we shall find him greater in the persecutions he sustained than in all the other occurrences of his life. His principal ecclesiastical adversary was Archbishop Theophilus of Alexandria, already mentioned, who had several grievances against his brother of Constantinople. A no less dangerous enemy was the empress Eudoxia. John was accused of referring to her as "Jezebel," and when he had preached a sermon against the profligacy and vanity of so many women it was represented by some as an attack leveled at the empress. Knowing the sense of grievance entertained by Theophilus, Eudoxia, to be revenged for the supposed affront to herself, conspired with him to bring about Chrysostom's deposition. Theophilus landed at Constantinople in June 403, with several Egyptian bishops; he refused to see or lodge with John; and got together a cabal of thirty-six bishops in a house at Chalcedon called The Oak. The main articles in the impeachment were: that John had deposed a deacon for beating a servant; that he had called several of his clergy reprobates; had deposed bishops outside his own province; had sold things belonging to the church; that nobody knew what became of his revenues; that he ate alone; and that he gave holy communion to persons who were not fasting — all which accusations were either false or frivolous. John held a legal council of forty bishops in the city at the same time, and refused to appear before that at The Oak. So the cabal proceeded to a sentence of deposition against him, which they sent to the Emperor Arcadius, accusing him also of treason, apparently in having called the empress "Jezebel." Thereupon the emperor issued an order for his banishment.

For three days Constantinople was in an uproar, and Chrysostom delivered a vigorous manifesto from his pulpit. "Violent storms encompass me on all sides: yet I am without fear, because I stand upon a rock. Though the sea roar and the waves rise high, they cannot overwhelm the ship of Jesus Christ. I fear not death, which is my gain; nor banishment, for the whole earth is the Lord's; nor the loss of goods, for I came naked into the world, and I can carry nothing out of it." He declared that he was ready to lay down his life for his flock, and that if he suffered now, it was only because he had neglected nothing that would help towards the salvation of their souls. Then he surrendered himself, unknown to the people, and an official conducted him to Praenetum in Bithynia. But his first exile was short. The city was slightly shaken by an earthquake. This terrified the superstitious Eudoxia, and she implored Arcadius to recall John; she got leave to send a letter the same day, asking him to return and protesting her own innocence of his banishment. All the city went out to meet him, and the Bosphorus

blazed with torches. Theophilus and his party fled.

But the fair weather did not last long. A silver statue of the empress having been erected before the great church of the Holy Wisdom, the dedication of it was celebrated with public games which, besides disturbing the liturgy, were an occasion of disorder, impropriety and superstition. St. Chrysostom had often preached against licentious shows, and the very place rendered these the more inexcusable. And so, fearing lest his silence should be construed as an approbation of the abuse, he with his usual freedom and courage spoke loudly against it. The vanity of the Empress Eudoxia made her take the affront to herself, and his enemies were invited back.

Chrysostom was suffered to remain at Constantinople two months after Easter. On Thursday in Whit-week the emperor sent an order for his banishment. The holy man bade adieu to the faithful bishops, and took his leave of St. Olympias and the other deaconesses, who were overwhelmed with grief. He then left the church by stealth to prevent a sedition, and was conducted into Bithynia, arriving at Nicaea on June 20, 404. After his departure a fire broke out and burnt down the great church and the senate house. The cause of the conflagration was unknown, and many of the saint's supporters were put to the torture on this account, but no discovery was ever made. The Emperor Arcadius chose Cucusus, a little place in the Taurus mountains of Armenia, for St. John's exile. He set out from Nicaea in July, and suffered very great hardships from the heat, fatigue and the brutality of his guards. After a seventy days' journey he arrived at Cucusus, where the good bishop of the place vied with his people in showing him every mark of kindness and respect. Some of the letters which Chrysostom addressed from exile to St. Olympias and others have survived, and it was to her that he wrote his treatise on the theme "That no one can hurt him who does not hurt himself."

Meanwhile Pope Innocent and the Emperor Honorius sent five bishops to Constantinople to arrange for a council, requiring that in the meantime Chrysostom should be restored to his see. But the deputies were cast into prison in Thrace, for the party of Theophilus (Eudoxia had died in childbed in October) saw that if a council were held they would inevitably be condemned. They also got an order from Arcadius that John should be taken farther away, to Pityus at the eastern end of the Black Sea, and two officers were sent to convey him thither. One of these was not altogether destitute of humanity, but the other was a ruffian who would not give his prisoner so much as a civil word. They often traveled in scorching heat, from which the now aged Chrysostom suffered intensely. When they reached Comana in Cappadocia he was very ill, yet he was hurried a further five or six miles to the chapel of St. Basiliscus. The next day, exhausted and ill, John begged that he might stay there a little longer. No attention was paid; but when they had gone four miles, seeing that he seemed to be dying, they brought him back to the chapel. There the clergy changed his clothes, putting white garments on him, and he received the Holy Mysteries. A few hours later St. John Chrysostom uttered his last words, "Glory be to God for all things," and gave up his soul to God. It was Holy Cross day, September 14, 407.

St. John's body was taken back to Constantinople in the year 438, the Emperor Theodosius II and his sister St. Pulcheria accompanying the archbishop St. Proclus in the procession, begging forgiveness of the sins of their parents who had so blindly persecuted the servant of God. It was laid in the church of the Apostles on January 27, on which day Chrysostom is honored in the West, but in the East his festival is observed principally on November 13, but also on other dates. In the Byzantine church he is the third of the Three Holy Hierarchs and Universal Teachers, the other two being St. Basil and St. Gregory Nazianzen, to whom the Western church adds St. Athanasius to make the four great Greek doctors; and in 1909 St. Pius X declared him to be the heavenly patron of preachers of the word of God. He is commemorated in the Byzantine, Syrian, Chaldean and Maronite eucharistic liturgies, in the great intercession or elsewhere.

ST. AMBROSE, BISHOP OF MILAN, DOCTOR OF THE CHURCH

December 7

Patron Saint of Learning

COURAGE AND CONSTANCY in resisting evil is a necessary part of virtue, especially in a bishop, and in this quality St. Ambrose was one of the most admirable among all the great pastors of God's Church since the Apostles, while his learning made him one of the four great doctors of the Western church. At the time of his birth at Trier, probably in 340, his father was prefect of Gaul. Ambrose, senior, died while his youngest child was still young, and his widow returned with her family to Rome. She took great care in the upbringing of her children, and Ambrose owed much both to her and to his sister, St. Marcellina. He learned Greek, became a good poet and orator, went to the bar, and was soon taken notice of. The emperor Valentinian made him governor of Liguria and Aemilia with full consular rank, one of the most responsible and important offices in the Western empire.

Auxentius, an Arian, who had held the see of Milan for almost twenty years, died in 374. The city was distracted by party strife about the election of a new bishop, some demanding an Arian, others a Catholic. To prevent, if possible, too outrageous a disorder St. Ambrose made a speech to the people, exhorting them to proceed in their choice in the spirit of peace and without tumult. While he was speaking a voice cried out: "Ambrose, bishop!" The whole assembly took up the cry with enthusiasm, and Catholics and Arians unanimously proclaimed him bishop of Milan. This unexpected choice astounded

Ambrose, the more that, though professedly a Christian, he was still unbaptized. He therefore was baptized, and received episcopal consecration on December 7, 374. He was about thirty-five years old.

Considering that he was no longer a man of this world and resolving to break all ties which could hold him to it, he gave his movables to the poor and his lands and estates to the Church, reserving only an income for the use of his sister, St. Marcellina. St. Ambrose was acutely conscious of his ignorance of theological science, and at once applied himself to study the Holy Scriptures and the works of religious writers, particularly Origen and St. Basil. He purged the diocese of the Arian heresy with such success that in ten years there was not one citizen of Milan infected with it, except a few Goths and some of those belonging to the imperial household. His personal life was one of simplicity and hard work. Every day he offered the Holy Sacrifice for his people, and devoted himself entirely to the service of his flock, any member of which could see and speak with him at any time, so that his people loved and admired him. Ambrose in his discourses frequently spoke in praise of the state and virtue of virginity undertaken for God's sake, and he had many consecrated virgins under his direction. He collected his sermons on this subject, making thereby a famous treatise. Mothers tried to keep their daughters away from his sermons, and he was charged with trying to depopulate the empire. "What man, I want to know, ever wanted to marry and could not find a

ST. AMBROSE
Pierre Subleyras. *The Emperor Theodosius Being Pardoned by St. Ambrose, Bishop of Milan.* Louvre, Paris

wife?" he retorted, and maintained that the population is highest where maidenhood is most esteemed. Wars, he said, and not maidens, are the destroyers of the human race.

The Goths having invaded Roman territories in the East, the Emperor Gratian determined to lead an army to the succor of his uncle, Valens. But in order to guard himself against Arianism, of which Valens was the protector, he asked St. Ambrose for instruction against that heresy. He accordingly wrote in 377 the work entitled *To Gratian, concerning the Faith,* which he afterwards expanded. The Goths had extended their ravages from Thrace to Illyricum, and St. Ambrose, not content to lay out all the money he could raise in redeeming captives, employed gold vessels belonging to the Church, which he had melted down. The Arians reproached him for this, alleging sacrilege. He answered that he thought it more expedient to save the souls of men than gold; ransom is the significance of the pouring of the blood of Jesus into golden vessels. After the murder of Gratian in 383 the Empress Justina implored St. Ambrose to treat with the usurper Maximus lest he attack her son, Valentinian II. He induced Maximus to confine himself to Gaul, Spain and Britain. This is said to have been the first occasion on which a minister of the gospel was called on to interfere in matters of high politics: and it was to vindicate right and order against a usurper in arms.

In January 386 Justina persuaded her son to make a law authorizing the religious assemblies of the Arians and, in effect, proscribing those of the Catholics. It forbade anyone, under pain of death, to oppose Arian assemblies, and no one could so much as present a petition against a church being yielded up to them without danger of being proscribed. St. Ambrose disregarded the law, would not give up a single church, and no one dared touch him. On Palm Sunday he preached on not giving up their churches, and then, fears being entertained for his life, the people barricaded themselves in the basilica with their pastor. The imperial troops surrounded the place to starve them out, but on Easter Sunday they were still there. To occupy their time Ambrose taught the people psalms and hymns composed by himself, which they sang at his direction

divided into two choirs singing alternate stanzas. Then Dalmatius, a tribune, came to St. Ambrose from the emperor, with an order that he should choose judges, as the Arian bishop, Auxentius, had done on his side, that his and Auxentius's cause might be tried before them; if he refused, he was forthwith to retire and yield his see to Auxentius. Ambrose wrote asking to be excused and forcibly reminding Valentinian that laymen could not judge bishops or make ecclesiastical laws. Then he occupied his episcopal *cathedra* and related to the people all that had passed between him and Valentinian during the previous year. And in a memorable sentence he summed up the principle at stake: "The emperor is in the Church, not over it."

In the meanwhile it became known that Maximus, using Valentinian's persecution of Catholics and alleged frontier irregularities as pretexts, was preparing to invade Italy. Valentinian and Justina were panic-stricken, and asked St. Ambrose to venture on a second embassy to stop the march of a usurper. Burying the memory both of public and private injuries he undertook the journey. At Trier, publicly, he demonstrated to Maximus that his projected offensive was unjustifiable and a breach of faith, and ended up by asking him to send the remains of Gratian to his brother as pledge of peace. The next day he was ordered to leave Trier. He therefore returned to Milan, writing in advance to Valentinian an account of events and advising him to be cautious how he treated with Maximus, a concealed enemy who pretended peace but intended war. Then Maximus suddenly and without opposition marched into Italy. Leaving St. Ambrose alone to meet the storm at Milan, Justina and Valentinian fled to Greece and threw themselves on the mercy of the Eastern emperor, Theodosius. He declared war on Maximus, defeated and executed him in Pannonia, and restored Valentinian to his own territories and to those of the dead usurper. But from henceforward Theodosius was the real ruler of the whole empire.

He stayed for a time at Milan, inducing Valentinian to abandon Arianism and to have respect for St. Ambrose as a true Catholic bishop. But conflicts arose between Theodosius himself and Ambrose, in the first of which right does not seem to have been wholly on

the side of the bishop. At Kallinikum, in Mesopotamia, certain Christians pulled down the Jewish synagogue. Theodosius when informed of the affair ordered the bishop (who was alleged to be directly implicated) to rebuild the synagogue. St. Ambrose was appealed to, and he wrote a letter to Theodosius in which he based his protest, not on the uncertainty of the actual circumstances, but on the excessive statement that no Christian bishop could in any conditions pay for the erection of a building to be used for false worship. Theodosius disregarded the protest, and Ambrose preached against him to his face; whereupon a discussion took place between them in the church, and he would not go up to the altar to sing Mass till he had procured a promise of the revocation of the order.

In the year 390 news of a dreadful massacre committed at Thessalonica was brought to Milan. Butheric, the governor, had a charioteer put in prison for having seduced a servant in his family, and refused to release him when his appearance in the circus was demanded by the public. The people were so enraged that some officers were stoned to death and Butheric himself was slain. Theodosius ordered reprisals of unbelievable savagery. While the people were assembled in the circus, soldiers surrounded it and rushed in on them. The slaughter continued for hours and seven thousand were massacred, without distinguishing age or sex or the innocent from the guilty. The world was aghast and all eyes were turned on Ambrose, who wrote Theodosius, exhorting him to penance, and declaring that he neither could nor would receive his offering at the altar or celebrate the Divine Mysteries before him till that obligation was satisfied.

The simple words in which St. Augustine (who had received baptism from St. Ambrose three years before) refers to the emperor's "religious humility" tell us that "Being laid hold of by the discipline of the Church, he did penance in such a way that the sight of the abasement of his imperial dignity made those who were interceding for him weep more than consciousness of offence had ever made them fear his anger." By

this triumph of grace in Theodosius and of pastoral duty in Ambrose Christianity was vindicated to the world as being no respecter of persons, its moral law was shown to bind all equally. And the emperor himself testified to the personal influence of St. Ambrose in it; he was, he said, the only bishop he knew who was worthy of the name. In 393 Theodosius died, in the arms of St. Ambrose, who in a funeral oration spoke eloquently of his love for the dead emperor and of the high obligations of his two sons in the control of an empire which was now held together by Christianity itself.

St. Ambrose survived Theodosius the Great by only two years, and one of his last treatises was on the "Goodness of Death." His written works were numerous; as the Roman empire declined in the West he inaugurated a new lease of life for its language, and in the service of Christianity. When he fell sick he foretold his death, but said he should live till Easter. He continued his usual studies, and expounded the forty-third psalm. Whilst he dictated, Paulinus, who was his secretary and afterwards his biographer, saw as it were a flame in the form of a small shield covering his head and by degrees passing into his mouth, and his face became white as snow. "I was so frightened," says Paulinus, "that I remained motionless and could not write. And on that day he left off both writing and dictating, so that he did not finish the psalm." On the day of his death he lay with his hands extended in the form of a cross for several hours, moving his lips in constant prayer. St. Honoratus of Vercelli was there, resting in another room, when he seemed to hear a voice crying three times to him, "Arise! Make haste! He is going." He went down and gave him the Body of the Lord, and soon after St. Ambrose was dead. It was Good Friday, April 4, 397, and he was about fifty-seven years old. He was buried on Easter day, and his relics rest under the high altar of his basilica, where they were buried in 835. The day of his feast is the anniversary of his episcopal consecration.

ST. MONICA, WIDOW

May 4

Patron Saint of Married Women; Mothers

THE CHURCH IS DOUBLY indebted to St. Monica, the ideal of wifely forbearance and holy widowhood, for she not only gave bodily life to the great teacher Augustine, but she was also God's principal instrument in bringing about his spiritual birth by grace. She was born in North Africa — probably at Tagaste, sixty miles from Carthage — of Christian parents, in the year 332. From the day of her baptism, which took place soon afterwards, she seems to have lived a life exemplary in every particular.

As soon as she had reached a marriageable age, her parents gave her as wife to a citizen of Tagaste, Patricius by name, a pagan not without generous qualities, but violent-tempered and dissolute. Monica had much to put up with from him, but she bore all with the patience of a strong, well-disciplined character. He, on his part, though inclined to criticize her piety and liberality to the poor, always regarded her with respect and never laid a hand upon her, even in his worst fits of rage. In the long run, Monica's prayers and example resulted in winning over to Christianity not only her husband, but also her cantankerous mother-in-law, whose presence as a permanent inmate of the house had added considerably to the younger woman's difficulties. Patricius died a holy death in 371, the year after his baptism. It was in the elder son, Augustine, that the parents' ambitions centered, for he was brilliantly clever, and they were resolved to give him the best possible education. Nevertheless, his waywardness, his love of pleasure and his fits of idleness caused his mother great anxiety. Monica was cut to the heart at the news that Augustine was leading a wicked life, and

had as well embraced the Manichean heresy. For a time after his return to Tagaste she went so far as to refuse to let him live in her house or eat at her table that she might not have to listen to his blasphemies. But she relented as the result of a consoling vision which was vouchsafed to her. She seemed to be standing on a wooden beam bemoaning her son's downfall when she was accosted by a radiant being who questioned her as to the cause of her grief. He then bade her dry her eyes and added, "Your son is with you." Casting her eyes towards the spot he indicated, she beheld Augustine standing on the beam beside her. Afterwards, when she told the dream to Augustine he flippantly remarked that they might easily be together if Monica would give up her faith, but she promptly replied, "He did not say that I was with you: he said that you were with me."

Monica never ceased her efforts on his behalf. She stormed heaven by her prayers and tears: she fasted: she watched: she importuned the clergy to argue with him, even though they assured her that it was useless in his actual state of mind. "The heart of the young man is at present too stubborn, but God's time will come," was the reply of a wise bishop who had formerly been a Manichean himself. Then, as she persisted, he said in words which have become famous: "Go now, I beg of you: it is not possible that the son of so many tears should perish." This reply and the assurance she had received in the vision gave her the encouragement she was needing, for there was as yet in her elder son no indication of any change of heart.

Augustine was twenty-nine years old when he resolved to go to Rome to teach rhetoric. Monica was determined to accompany him and followed him to

Luis Tristán. *St. Monica,* 1616. Prado, Madrid

To St. Ambrose she turned with heartfelt gratitude and found in him a true father in God. She deferred to him in all things, abandoning at his wish practices which had become dear to her. St. Ambrose, on his part, had the highest opinion of St. Monica and was never tired of singing her praises to her son.

At last, in August 386, there came the long-desired moment when Augustine announced his complete acceptance of the Catholic faith. He retired with his mother and some of his friends to the villa of one of the party. There the time of preparation before Augustine's baptism was spent in religious and philosophical conversations, some of which are recorded in the *Confessions.* In all these talks Monica took part, displaying remarkable penetration and judgment and showing herself to be exceptionally well versed in the Holy Scriptures. At Easter, 387, St. Ambrose baptized St. Augustine, together with several of his friends, and soon afterwards the party set out to return to Africa. They made their way to Ostia, there to await a ship, but Monica's life was drawing to an end, though no one but herself suspected it. In a conversation with Augustine shortly before her last illness she said, "Son, nothing in this world now affords me delight. I do not know what there is now left for me to do or why I am still here, all my hopes in this world being now fulfilled. All I wished to live for was that I might see you a Catholic and a child of Heaven. God has granted me more than this in making you despise earthly felicity and consecrate yourself to His service." She was taken ill, and she suffered acutely until the ninth day, when she passed to her eternal reward. She was fifty-five years of age.

In the *Confessions,* Augustine asks the prayers of his readers for Monica and Patricius, but it is her prayers which have been invoked by successive generations of the faithful who venerate her as a special patroness of married women and as a pattern for all Christian mothers.

the port of embarkation. Augustine, on the other hand, had made up his mind to go without her. He accordingly resorted to an unworthy stratagem. He pretended he was only going to speed a parting friend, and whilst Monica was spending the night in prayer in the church of St. Cyprian, he set sail alone. "I deceived her with a lie," he wrote afterwards in his *Confessions,* "while she was weeping and praying for me." Deeply grieved as Monica was when she discovered how she had been tricked, she was still resolved to follow him, but she reached Rome only to find that the bird had flown. Augustine had gone on to Milan. There he came under the influence of the great bishop St. Ambrose. When Monica at last tracked her son down, it was to learn from his own lips, to her unspeakable joy, that he was no longer a Manichean.

ST. AUGUSTINE, BISHOP OF HIPPO, DOCTOR OF THE CHURCH

August 28

Patron Saint of Brewers; Printers; Theologians

St. Augustine was born on November 13, 354, at Tagaste, a small town of Numidia in north Africa, not far from Hippo. Augustine was entered in his infancy among the catechumens, baptism itself being deferred, according to a common custom of the time; but in early youth he fell into evil ways and until the age of thirty-two led a life morally defiled by license and intellectually by Manicheism. Of this time, up to his conversion and the death of his mother, St. Monica, Augustine speaks at large in his *Confessions,* a book written for "a people curious to know the lives of others, but careless to amend their own"; written not indeed to satisfy such curiosity, but to show forth to his fellows the mercy of God and His ways as exemplified in the life of one sinner, and to endeavor that no one should think of him above that which he confessed himself to be. As a child Monica instructed him in the Christian religion and taught him to pray; falling dangerously ill, he desired baptism and his mother got everything ready for it: but he suddenly grew better, and it was put off. This custom of deferring baptism for fear of sinning under the obligations of that sacrament, St. Augustine later very properly condemns.

"And so I was put to school to learn those things in which, poor boy, I knew no profit, and yet if I was negligent in learning I was whipped: for this method was approved by my elders, and many that had trod that life before us had chalked out unto us these wearisome ways." He accuses himself of often studying only by constraint, disobeying his parents and masters, not writing, reading, or minding his lessons so much as was required of him; and this he did, not for want of wit or memory, but out of love of play. Nevertheless, "we were punished for play by them that were doing no better; but the boys' play of them that are grown up is named *business.*" "No one does well what he does against his will," he says, and takes notice that the master who corrected him for a small fault "if overcome in some petty dispute by a fellow teacher, was more envious and angry than the boy ever was when outdone by a playfellow at ball."

Augustine went to Carthage towards the end of the year 370, in the beginning of his seventeenth year. There he took a foremost place in the school of rhetoric and applied himself to his studies with eagerness and pleasure; but his motives were vanity and ambition, and to them he joined loose living, though it was acknowledged that he always loved decency and good manners even in his excesses. Soon he entered into relations with a woman, irregular but stable, to whom he remained faithful until he sent her from him at Milan in 385; she bore him a son, Adeodatus, in 372.

For nine years Augustine had his own schools of rhetoric and grammar at Tagaste and Carthage, while his devoted mother, spurred on by the assurance of a holy bishop that "the son of so many tears could not perish," never ceased by prayer and gentle persuasion to try to bring him to conversion and reform. He applied for and received a post as master of rhetoric in Milan. Here he was well received and the bishop, St. Ambrose, gave him marks of respect. Augustine was very desirous of knowing him, not as a teacher of the truth, but as a person of great learning and reputation. He often went to his sermons, not so much with any expectation of profiting by them as to gratify his

curiosity and to enjoy the eloquence, and they began to make impression on his heart and mind; at the same time he read Plato and Plotinus: "Plato gave me knowledge of the true God, Jesus Christ showed me the way." By listening to St. Ambrose and reading the Bible Augustine was convinced of the truth of Christianity, but there was still wanting the will to accept the grace of God. He says of himself: "I sighed and longed to be delivered but was kept fast bound, not with exterior chains but with my own iron will. The Enemy held my will, and of it he had made a chain with which he had fettered me fast; for from a perverse will was created wicked desire or lust, and the serving this lust produced custom, and custom not resisted produced a kind of necessity, with which, as with links fastened one to another, I was kept close shackled in this cruel slavery."

Pontitian, an African, came to visit Augustine and his friend Alipius. Finding a book of St. Paul's epistles lying on the table, he took occasion to speak of the life of St. Antony, and was surprised to find that his name was unknown to them. Pontitian then went on to speak of two men who had been suddenly turned to the service of God by reading a life of St. Antony. His words had a powerful influence on the mind of Augustine, and he saw, as it were in a glass, his own filthiness and deformity.

He got up and went into the garden. Alipius, astonished at his manner and emotion, followed, and they sat down as far as they could from the house, Augustine undergoing a violent inward conflict. He was torn between the voice of the Holy Ghost calling him to chastity and the seductive memory of his former sins, and going alone further into the garden he threw himself on the ground under a tree, crying out, "How long, O Lord? Wilt thou be angry for ever? Remember not my past iniquities!" As he spoke these things and wept with bitter contrition of heart, on a sudden he heard as it were the voice of a child singing from a neighboring house, which frequently repeated these words, *Tolle lege! Tolle lege!* "Take up and read! Take up and read!" And he began to consider whether in any game children were wont to sing any such words; and he could not call to mind that he had ever

heard them. Whereupon he rose up, suppressing his tears, and interpreted the voice to be a divine admonition, remembering that St. Antony was converted from the world by hearing a particular passage of the gospel read. He returned to where Alipius was sitting with the book of St. Paul's epistles, opened it, and read in silence the words on which he first cast his eyes: "Not in rioting and drunkenness; not in chambering and impurities; not in contention and envy; but put ye on the Lord Jesus Christ, and make not provision for the flesh in its concupiscences." All the darkness of his former hesitation was gone. He shut the book, and with a serene countenance told Alipius what had passed. Alipius asked to see the passage he had read, and found the next words to be: "Him that is weak in faith, take unto you"; which he applied to himself, and joined his friend in his resolution. They immediately went in and told St. Monica, who rejoiced and praised God. This was in September 386, and Augustine was thirty-two.

He at once gave up his school and retired to a country house at Cassiciacum, near Milan, which his friend Verecundus lent to him; he was accompanied by his mother Monica, his brother Navigius, his son Adeodatus, St. Alipius, and several other friends, and they lived a community life together. Augustine employed himself in prayer and study, and his study was a kind of prayer by the devotion of his mind therein. Here he sought by austere penance, by the strictest watchfulness over his heart and senses, and by humble prayer, to control his passions, and to prepare himself for the grace of leading a new life in Christ and becoming in Him a new creature. From the conferences and conversations which took place during these seven months St. Augustine drew up his three dialogues, *Against the Academicians, Of the Happy Life* and *Of Order.*

St. Augustine was baptized by St. Ambrose on Easter-eve in 387, together with Alipius and his dearly loved son Adeodatus, who was about fifteen years of age and was to die not long afterwards. In the autumn he resolved to return to Africa. Accordingly he went to Ostia with his mother and several friends, and there St. Monica died in November 387. He went on to Africa in

Vittore Carpaccio. *St. Augustine in His Study*, c. 1511. Scuola di San Giorgio degli Schiavoni, Venice

September 388, where he hastened with his friends to his house at Tagaste. There he lived almost three years, disengaged from temporal concerns, serving God in fasting, prayer, good works, meditating upon His law and instructing others by his discourses and books. He had no idea of becoming a priest, but in 391 he was ordained as an assistant to Valerius, Bishop of Hippo. So Augustine had to move to that city; and in a house adjoining the church he established a sort of monastery, modeled on his household at Tagaste, living there with St. Alipius, St. Evodius, St. Possidius, and others. Valerius, who was a Greek, and had, moreover, an impediment in speaking, appointed him to preach to the people in his own presence; he from that time never interrupted the course of his sermons till his death. We have nearly four hundred extant, though many were not written by him but taken down by others as he delivered them.

In 395 he was consecrated bishop as coadjutor to Valerius, and succeeded him in the see of Hippo on his death soon after. Augustine established regular and common life in his episcopal residence, and required all the priests, deacons, and subdeacons that lived with him to renounce property and to follow the rule he established there; nor did he admit any to holy orders who did not bind themselves to a similar manner of life. He also founded a community of religious women to whom he addressed a letter on the general ascetic principles of the religious life. This letter, together with two sermons on the subject, constitutes the so-called Rule of St. Augustine, which is the basis of the constitutions of many canons regular, friars and nuns. St. Augustine employed the revenues of his church in relieving the poor, as he had before given his own patrimony, and Possidius says that he sometimes melted down part of the sacred vessels to redeem

captives: in which he was authorized by the example of St. Ambrose. In several of his letters and sermons mention is made of the custom he had got his flock to establish, of clothing all the poor of each parish once a year, and he was not afraid sometimes to contract considerable debts to help the distressed.

There were few men endowed by nature with a more affectionate and friendly soul than St. Augustine. He conversed freely with infidels, and often invited them to his table; but generally refused to eat with Christians whose conduct was publicly scandalous, and was severe in subjecting them to canonical penance and to the censures of the Church. He never lacked courage to oppose iniquity without respect of persons, though he never forgot charity, meekness and good manners.

Throughout his thirty-five years as bishop of Hippo St. Augustine had to defend the Catholic faith against one heresy or another. Serious trouble was given by the Donatists, whose chief errors were that the Catholic Church by holding communion with sinners had ceased to be the Church of Christ and that no sacraments can be validly conferred by those that are not in the true Church. These Donatists carried their fury to the greatest excesses, murdering Catholics and committing all sorts of violence. By the learning and indefatigable zeal of St. Augustine, supported by the sanctity of his life, the Catholics began to gain ground; at which the Donatists were so exasperated that some preached publicly that to kill him would be doing service to their religion, and highly meritorious before God. Augustine was obliged in 405 to invoke the civil power to restrain the Donatists about Hippo from the outrages which they perpetrated, and in the same year the Emperor Honorius published severe laws against them. Augustine at first disapproved such measures, though he afterwards changed his opinion, except that he would not countenance a death-penalty. A great conference between the two parties at Carthage in 411 marked the beginning of the decline of these heretics.

When Rome was plundered by Alaric the Goth in 410 the pagans renewed their blasphemies against the Christian religion. To answer their slanders, St. Augus-tine began his great work *Of the City of God* in 413, though he only finished it in 426. In the *Confessions* St. Augustine, with the most sincere humility and contri-tion, lays open the errors of his conduct; in his seventy-second year he began to do the like for his judgment. In this work, his *Retractations,* he reviewed his writings, which were very numerous, and corrected with candor and severity the mistakes he had made, without seeking the least gloss or excuse to extenuate them.

Augustine's last years were full of turmoil. Count Boniface, who had been the imperial general in Africa, having unjustly incurred the suspicion of the regent Placidia and being in disgrace, incited Genseric, King of the Vandals, to invade the African provinces. Augus-tine wrote a wonderful letter to Boniface, recalling him to his duty, and the count sought a reconciliation with Placidia, but could not stay the Vandal invasion. St. Possidius describes the dreadful ravages by which they scattered horror and desolation as they marched. He saw the cities in ruin and the houses in the country razed to the ground, the inhabitants either being slain or fled. Mass was offered up in private houses, or not at all, for in many parts there were none left to demand the sacraments, nor was it easy elsewhere to find any to minister to those who required them. The bishops and the rest of the clergy who had escaped were stripped of everything, and reduced to beggary; and of the great number of churches in Africa, there were hardly three remaining (namely, Carthage, Hippo and Cirta) whose cities were yet standing.

Count Boniface fled to Hippo, and St. Possidius and several neighboring bishops took refuge in the same place. The Vandals appeared before it about the end of May 430, and the siege continued fourteen months. In the third month St. Augustine was seized with a fever, and from the first moment of his illness knew that it was the summons of God to Himself. The strength of his body daily and hourly declined, yet his senses and intellectual faculties continued sound to the last, and he calmly resigned his spirit into the hands of God on August 28, 430, after having lived seventy-six years and spent almost forty of them in the labors of the ministry.

ST. JEROME,
DOCTOR OF THE CHURCH

September 30

Patron Saint of Librarians

JEROME, THE FATHER OF THE CHURCH most learned in the Sacred Scriptures, was born about the year 342 at Stridon, a small town upon the confines of Pannonia, Dalmatia and Italy, near Aquileia. His father took great care to have his son instructed in religion and in the first principles of letters at home and afterwards sent him to Rome. He became master of the Latin and Greek tongues, and made progress in oratory; but being left without a guide under the discipline of a heathen master he forgot some of the true piety which had been instilled into him in his childhood. Jerome went out of this school free indeed from gross vices, but unhappily a stranger to a Christian spirit and enslaved to vanity and other weaknesses, as he afterward confessed and bitterly lamented. On the other hand he was baptized at Rome (he was a catechumen till he was at least eighteen) and he himself tells us that "it was my custom on Sundays to visit, with friends of my own age and tastes, the tombs of the martyrs and apostles, going down into those subterranean galleries whose walls on either side preserve the relics of the dead." After some three years in Rome he went to Trier. Here it was that the religious spirit with which he was so deeply imbued was awakened, and his heart was entirely converted to God.

In 370 Jerome settled down for a time at Aquileia, where the bishop, St. Valerian, had attracted so many good men that its clergy were famous all over the Western church. With many of these St. Jerome became friendly, but already he was beginning to make enemies and provoke strong opposition, and after two or three years an unspecified conflict broke up the group, and Jerome decided to withdraw into some distant country.

St. Jerome arrived in Antioch in 374 and made some stay there. In a letter to St. Eustochium he relates that in the heat of fever he fell into a delirium in which he seemed to himself to be arraigned before the judgment-seat of Christ. Being asked who he was, he answered that he was a Christian. "Thou liest," was the reply, "Thou art a Ciceronian: for where thy treasure is, there is thy heart also." This experience had a deep effect on him which was deepened by his meeting with St. Malchus. As a result, St. Jerome withdrew into the wilderness of Chalcis, a barren land to the south-east of Antioch, where he spent four years alone. He suffered much from ill health, and even more from strong temptations. To forestall and ward off the insurgence of the flesh he added to his corporal austerities a new study, which he hoped would fix his rambling imagination and give him the victory over himself. This was to learn Hebrew. "When my soul was on fire with bad thoughts," says he writing to the monk Rusticus in 411, "as a last resource I became a scholar to a monk who had been a Jew, to learn of him the Hebrew alphabet; and, from the judicious rules of Quintilian, the copious flowing eloquence of Cicero, the grave style of Fronto, and the smoothness of Pliny, I turned to this language of hissing and broken-winded

ST. JEROME
Giovanni Bellini. *St. Jerome Reading,* 1480/90. National Gallery of Art, Washington, D.C.

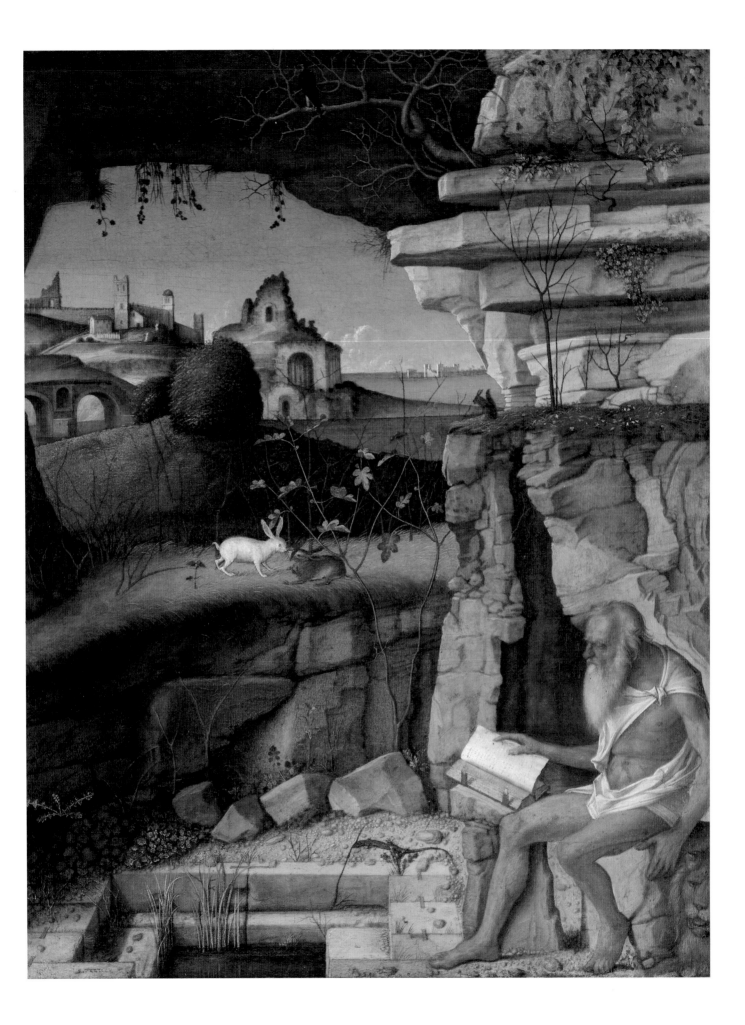

words. What labor it cost me, what difficulties I went through, how often I despaired and left off, and how I began again to learn, both I myself who felt the burden can witness, and they also who lived with me. And I thank our Lord, that I now gather such sweet fruit from the bitter sowing of those studies."

Upon St. Gregory's leaving Constantinople in 382, St. Jerome went to Rome with Paulinus of Antioch and St. Epiphanius to attend a council which St. Damasus held about the schism at Antioch. When the council was over, Pope Damasus detained him and employed him as his secretary; Jerome, indeed, claimed that he spoke through the mouth of Damasus. At the pope's request he made a revision, in accordance with the Greek text, of the Latin version of the gospels, and a first revision of the Latin psalter.

Side by side with this official activity he was engaged in fostering and directing the marvelous flowering of asceticism which was taking place among some of the noble ladies of Rome. But when St. Damasus died in 384, and his protection was consequently withdrawn from his secretary, St. Jerome found himself in a very difficult position. In the preceding two years, while impressing all Rome by his personal holiness, learning and honesty, he had also contrived to get himself widely disliked; on the one hand by pagans and men of evil life whom he had fiercely condemned and on the other by people of good will who were offended by the saint's harsh outspokenness and sarcastic wit. When he wrote in defense of the fashionable young widow, Blesilla, who had suddenly renounced the world, he was witheringly satirical of pagan society and worldly life, and opposed to her lowliness the conduct of those who "paint their cheeks with rouge and their eyelids with antimony; whose plastered faces, too white for those of human beings, look like idols, and if in a moment of forgetfulness they shed a tear it makes a furrow where it rolls down the painted cheek."

It cannot be matter of surprise that, however justified his indignation was, his manner of expressing it aroused resentment. His own reputation was attacked with similar vigor; even his simplicity, his walk and smile, the expression of his countenance were found

fault with. Neither did the severe virtue of the ladies that were under his direction nor the reservedness of his own behavior protect him from calumny: scandalous gossip was circulated about his relations with St. Paula. He was properly indignant and decided to return to the East, there to seek a quiet retreat. He embarked at Porto in August 385. At Antioch nine months later he was joined by Paula, Eustochium and the other Roman religious women who had resolved to exile themselves with him in the Holy Land. With the help of Paula's generosity a monastery for men was built near the basilica of the Nativity at Bethlehem, together with buildings for three communities of women. St. Jerome himself lived and worked in a large rock-hewn cell near to our Savior's birthplace, and opened a free school, as well as a hospice. Here at last were some years of peace.

But Jerome could not stand aside and be mute when Christian truth was threatened. He had at Rome composed his book against the concept that Mary had other children, by St. Joseph, after the birth of Christ. This and certain associated errors were again put forward by one Jovinian. St. Paula's son-in-law, St. Pammachius, and other laymen sent his writings to St. Jerome who in 393 wrote two books against Jovinian. In the first he shows the excellence of virginity embraced for the sake of virtue, which had been denied by Jovinian, and in the second confutes his other errors. This treatise was written in Jerome's characteristically strong style and certain expressions in it seemed to some persons in Rome harsh and derogatory from the honor due to matrimony; St. Pammachius informed St. Jerome of the offense which he and many others took at them. Thereupon Jerome wrote his Apology to Pammachius, sometimes called his third book against Jovinian, in a tone that can hardly have given his critics satisfaction.

But his denunciations and controversies, necessary as most of them were, are the less important part of his activities: nothing has rendered the name of St. Jerome so famous as his critical labors on the Holy Scriptures. For this the Church acknowledges him to have been raised by God through a special providence, and she styles him the greatest of all her doctors in expounding

the divine word. He was furnished with the greatest helps for such an undertaking, living many years upon the spot where the remains of ancient places, names, customs which were still recent, and other circumstances set before his eyes a clearer representation of many things recorded in holy writ than it is possible to have at a greater distance of place and time. Greek and Aramaic were then living languages, and Hebrew, though it had ceased to be such from the time of the captivity, was not less understood and spoken among the doctors of the law. Above other conditions it is necessary that an interpreter of the Bible be a man of prayer and sincere piety. This alone can obtain light and help from Heaven, give to the mind a turn and temper which are necessary for being admitted into the sanctuary of the divine wisdom, and furnish the key. Jerome was prepared by a great purity of heart and a life spent in penance and contemplation before he was called by God to this undertaking. His new translation from the Hebrew of most of the books of the

Old Testament was the work of his years of retreat at Bethlehem, which he undertook at the earnest entreaties of many devout and illustrious friends, and in view of the preference of the original to any version however venerable. He did not translate the books in order, but began by the books of Kings, and took the rest in hand at different times. The only parts of the Latin Bible called the Vulgate which were not either translated or worked over by St. Jerome are the books of Wisdom, Ecclesiasticus, Baruch and the two books of Maccabees. The psalms he revised again, with the aid of Origen's *Hexapla* and the Hebrew text.

In the year 404 a great blow fell on St. Jerome in the death of St. Paula and a few years later in the sacking of Rome by Alaric; many refugees fled into the East, and he wrote of them: "Who would have believed that the daughters of that mighty city would one day be wandering as servants and slaves on the shores of Egypt and Africa? That Bethlehem would daily receive noble Romans, distinguished ladies brought up in wealth and now reduced to beggary? I cannot help them all, but I grieve and weep with them, and, completely given up to the duties which charity imposes on me, I have put aside my commentary on Ezekiel and almost all study. For to-day we must translate the words of the Scriptures into deeds, and instead of speaking saintly words we must act them." Again towards the end of his life he was obliged to interrupt his studies by an incursion of barbarians, and some time after by the violence and persecution of the Pelagians who sent a troop of ruffians to Bethlehem to assault the monks and nuns who lived there under the direction of St. Jerome, who had opposed them. In the following year St. Eustochium died and Jerome himself soon followed her: worn out with penance and work, his sight and voice failing, his body like a shadow, he died peacefully on September 30, 420. He was buried under the church of the Nativity close to Paula and Eustochium, but his body was removed long after and now lies somewhere in Sta. Maria Maggiori at Rome.

SS. URSULA AND HER MAIDENS, MARTYRS

October 21

T HE FEAST OF ST. URSULA and the maiden martyrs of Cologne is now treated with considerable reserve in the Roman liturgy. It is accorded only a commemoration, with no proper lesson at Matins; the martyrology ventures to say that they suffered at the hands of the Huns on account of their constancy in religion and chastity, but gives no particulars of numbers or other circumstances.

The legend of St. Ursula and her Eleven Thousand Virgins, as it took shape in Cologne at the latter part of the tenth century is as follows. Ursula, the daughter of a Christian king in Britain, was asked in marriage by the son of a pagan king. She, desiring to remain unwed, got a delay of three years, which time she spent on shipboard, sailing about the seas; she had ten noble ladies-in-waiting, each of whom, and Ursula, had a thousand companions, and they were accommodated in eleven vessels. At the end of the period of grace contrary winds drove them into the mouth of the Rhine, they sailed up to Cologne and then on to Bâle, where they disembarked and went over the Alps to visit the tombs of the apostles at Rome. They returned by the same way to Cologne, where they were set upon and massacred for their Christianity by the heathen Huns, Ursula having refused to marry their chief. Then the barbarians were dispersed by angels, the citizens buried the martyrs, and a church was built in their honor by Clematius. Another and parallel story, of Gaulish provenance, is given in a later version by Geoffrey of Monmouth. He says that the Emperor Maximian (he means Magnus Clemens Maximus), having become master of Britain and Gaul (which Maximus did in 383), planted Armorica with British colonists and soldiers and put them under a prince called Cynan Meiriadog. Cynan appealed to the king of Cornwall, curiously named Dionotus, to send out women as wives for his settlers. Dionotus responded very handsomely by dispatching his own daughter Ursula, with 11,000 maidens of noble birth and 60,000 young women of the meaner sort. Ursula was very beautiful and was intended to be married to Cynan himself. But on its voyage to Brittany the fleet was scattered and blown north by a storm; the women were cast away among strange islands and barbarous peoples, and suffered servitude and martyrdom at the hands of the Huns (and the Picts, adds Geoffrey). The Cologne version represents the more or less official legend, the date 451 being assigned to the martyrdom.

Quite apart from any other consideration, it may be emphasized that we learn from the inscription of Clematius that he restored a small basilica, or *cella memorialis* (which possibly had been laid waste by the Franks *circa* 353); the martyrs seem to have been buried there, and Clematius laid a ban upon other interments in that spot. The language is quite inconsistent with the idea of a vast cemetery in which thousands of bodies had been heaped together.

SS. URSULA AND HER MAIDENS
Vittore Carpaccio. *The Apotheosis of St. Ursula*. Accademia, Venice

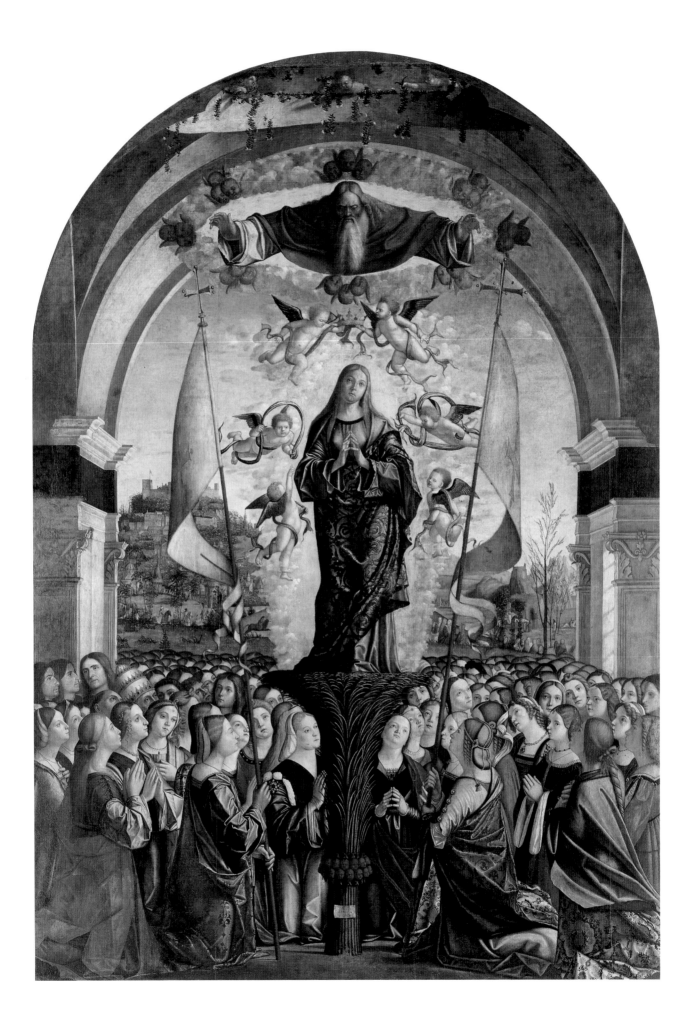

ST. GENEVIÈVE,
OR GENOVEFA, VIRGIN

January 3

Patron Saint of Paris

GENEVIÈVE WAS BORN about the year 422 at Nanterre, a small village four miles from Paris, near Mont Valérien. When St. Germanus, Bishop of Auxerre, went with St. Lupus into Britain, he spent a night at Nanterre on his way. The inhabitants flocked about them to receive their blessing, and St. Germanus took particular notice of Geneviève, though she was only seven years of age. After his sermon he inquired for her parents, and foretold their daughter's future sanctity. He then asked Geneviève whether it was not her desire to serve God only. She answered that this was what she desired, and begged that by his blessing she might be from that moment consecrated to God. The holy prelate went to the church, followed by the people, and during the long singing of psalms and prayers he laid his hand upon the maiden's head. After he had supped he dismissed her, telling her parents to bring her again to him the next morning. The father obeyed, and St. Germanus asked the child whether she remembered the promise she had made to God. She said she did, and declared that she hoped to keep her word. The bishop gave her a medal or coin, on which a cross was engraved, to wear about her neck, in memory of the consecration she had received the day before. The author of her life tells us that the child, begging one day that she might go to church, her mother struck her on the face, but in punishment lost her sight; she only recovered it two months after, by washing her eyes with water which her daughter fetched from the well and over which she had made the sign of the cross. Hence the people look upon the well at Nanterre as having been blessed by the saint.

When she was about fifteen years of age, Geneviève was presented to the bishop of Paris to receive the religious veil. After the death of her parents, she left Nanterre, and settled with her godmother in Paris, but sometimes undertook journeys for motives of charity. The cities of Meaux, Laon, Tours, Orléans and all other places she visited bore witness to her miracles and remarkable predictions. God permitted her to meet with some severe trials; for at a certain time everybody seemed to be against her, and persecuted her under the opprobrious names of visionary, hypocrite and the like. The arrival of St. Germanus at Paris for some time silenced her calumniators; but it was not long before the storm broke out anew. Her enemies were fully determined to discredit and even to drown her, when the archdeacon of Auxerre arrived with *eulogiae*, blessed bread, sent her by St. Germanus as a testimony of his particular esteem and a token of communion. The tribute thus paid her converted the prejudices of her calumniators into veneration for the remainder of her life.

The Franks had at this time gained possession of the better part of Gaul, and Childeric, their king, took Paris. During the long blockade of that city, the citizens being reduced to extremities by famine, St. Geneviève went out at the head of a company who were sent to procure provisions, and brought back several boats laden with corn. Childeric, when he had made himself master of Paris, though always a pagan, respected St. Geneviève, and upon her intercession spared the lives of many prisoners and did other generous acts. She also awakened the zeal of many persons to build a church in honor of St. Dionysius (or

Denis) of Paris, which King Dagobert I afterwards rebuilt with a monastery in 629.

Upon the report of the march of Attila with his army of Huns the Parisians were preparing to abandon their city, but St. Geneviève encouraged them to avert the scourge by fasting and prayer. Many of her own sex passed whole days with her in prayer in the baptistery; from whence the particular devotion to St. Geneviève, formerly practiced at S.-Jean-le-Rond, the ancient public baptistery of the church of Paris, seems to have taken rise. She assured the people of the protection of Heaven, and though she was treated by many as an impostor, the event verified the prediction, for the barbarous invader suddenly changed the course of his march. Our author attributes to St. Geneviève the first suggestion of the church which Clovis began to build in honor of SS. Peter and Paul, in which church the body of St. Geneviève herself was enshrined after her death about the year 500.

The miracles which were performed there from the time of her burial rendered this church famous over all France, so that at length it began to be known by her name. The fabric, however, fell into decay, and a new church was begun in 1764. This has long been secularized and, under the name of the Panthéon, is now used as a national mausoleum. The city of Paris has frequently received sensible proofs of the divine protection, through St. Geneviève's intercession. The most famous instance is that called the miracle *des Ardents,* or of the burning fever. In 1129 a disease, apparently poisoning by ergot, swept off in a short time many thousand persons, nor could the art of physicians afford any relief. The epidemic did not abate till the shrine of St. Geneviève was carried in a solemn procession to the cathedral. Many sick persons were cured by touching the shrine, and of all who then were suffering from the disease in the whole town only three died, and no others fell ill. Pope Innocent II after due investigation ordered an annual festival in commemoration of the miracle on November 26, which is still kept in Paris. The greater part of the relics of the saint were destroyed or pillaged at the French Revolution.

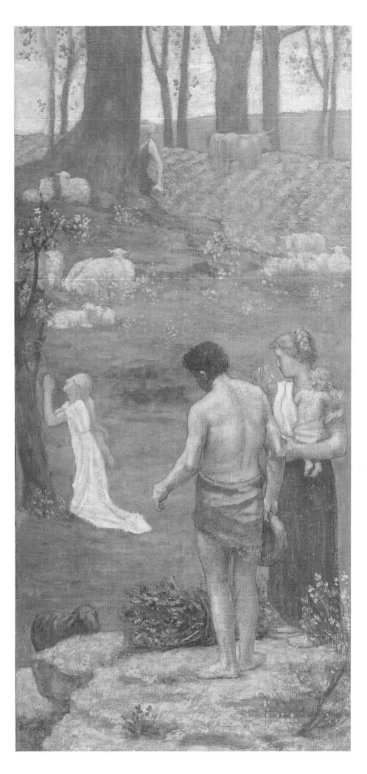

ST. GENEVIÈVE

Pierre-Cécile Puvis de Chavannes. *St. Geneviève as a Child at Prayer,* 1879. Fogg Art Museum, Harvard University, Cambridge, Massachusetts

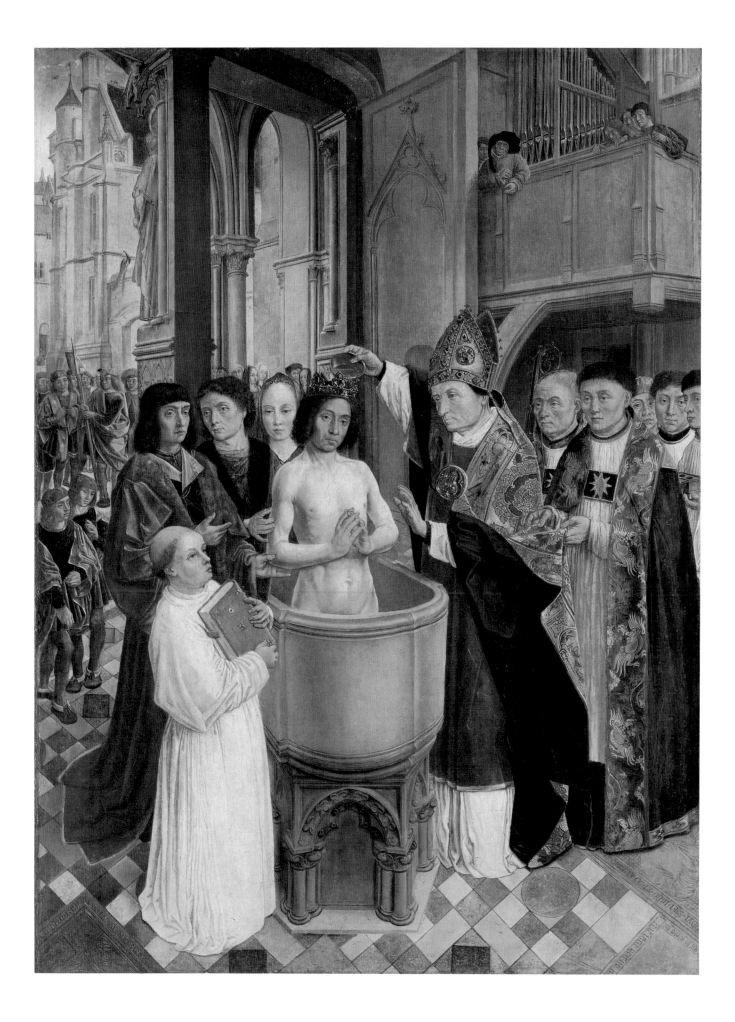

ST. REMIGIUS, OR REMI, BISHOP OF RHEIMS

October 1

Patron Saint of France

St. Remigius, the great apostle of the Franks, was illustrious for his learning, sanctity and miracles, which in his episcopacy of seventy and more years rendered his name famous in the Church. His father and his mother were both descended from Gaulish families, and lived at Laon. The boy made great progress in learning, and in the opinion of St. Sidonius Apollinaris, he became the most eloquent person in that age. When only twenty-two, too young to be a priest, much less a bishop, he was chosen in 459 to fill the vacant see of Rheims. But he was ordained and consecrated in spite of his youth, and amply made up for lack of experience by his fervor and energy. Sidonius had a manuscript of his sermons from a man at Clermont, and wrote to tell Remigius how much he admired them: the delicacy and beauty of thought and expression were so smooth that it might be compared to ice or crystal upon which a nail runs without meeting the least unevenness. With this equipment of eloquence (of which unfortunately there is no specimen extant for us to judge its quality for ourselves) allied to the yet more valuable quality of personal holiness, St. Remigius set out to spread Christianity among the Franks.

Clovis, king of all northern Gaul, was himself yet a pagan, though not unfriendly to the Church. He had married St. Clotildis, daughter of the Christian king of Burgundians, Chilperic, and she made repeated attempts to convert her husband. In 496, the Alemanni crossed the Rhine and the Franks marched out to drive them back. One account says that St. Clotildis had said to Clovis in taking leave, "My lord, to be victorious invoke the God of the Christians. If you call on Him with confidence, nothing can resist you"; and that the wary Clovis had promised that he would be a Christian if he were victorious. The battle was going badly against him when the king, either reminded of these words or moved by desperation, shouted to the heavens, "O Christ, whom Clotildis invokes as son of the living God, I implore thy help! I have called upon my gods, and they have no power. I therefore call on thee. I believe in thee! Deliver me from my enemies and I will be baptized in thy name!" The Franks rallied and turned the tide of battle; the Alemanni were overcome.

Queen St. Clotildis was not trusting to any enthusiasm of victory, and sent for St. Remigius, telling him to touch the heart of the king while he was well disposed. When Clovis saw her he cried out, "Clovis has vanquished the Alemanni and you have triumphed over Clovis. What you have so much at heart is done." The queen answered, "To the God of hosts is the glory of both these triumphs due." Clovis suggested that perhaps the people would not be willing to forsake their gods, but said he would speak to them according to the bishop's instructions. He assembled the chiefs and warriors, but they prevented his speaking, and cried out, "We abjure mortal gods, and are ready to follow the immortal God whom Remigius preaches." St. Remigius and St. Vedast therefore instructed and

ST. REMIGIUS
Master of St. Giles. *The Baptism of Clovis*, c. 1500. National Gallery of Art, Washington, D.C.

135

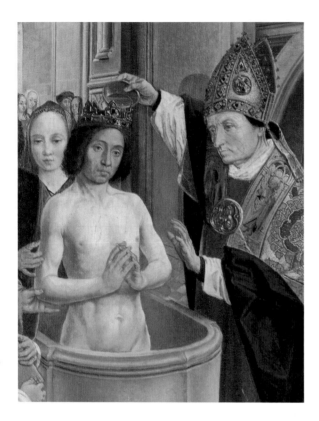

wrote a Life of St. Remigius in the ninth century, is the first to mention a legend that at the baptism of Clovis the chrism for the anointing was found to be missing, whereupon St. Remigius prayed and a dove appeared from the heavens, bearing in its beak an *ampulla* of chrism. A phial of oil, fabled to be the same, was preserved at the abbey of Saint-Remi and used in the consecration of the kings of France until Charles X in 1825. It was broken up at the Revolution, but a piece of *la Sainte Ampoule* and its contents were saved and are kept in Rheims Cathedral.

Under the protection of Clovis, St. Remigius spread the gospel of Christ among the Franks, in which work God endowed him with an extraordinary gift of miracles, if we may trust his biographers on this point. The bishops who were assembled in a conference that was held at Lyons against the Arians in his time declared they were stirred to exert their zeal in defense of the Catholic faith by the example of Remigius. He did best to promote orthodoxy in Arian Burgundy, and at a synod in 517 converted an Arian bishop who came to it to argue with him. But the actions of St. Remigius did not always meet with the approval of his brother bishops. Sometime after the death of Clovis the bishops of Paris, Sens and Auxerre wrote to him concerning a priest called Claudius, whom he had ordained at the request of the king. They blamed Remigius for ordaining a man whom they thought to be fit only for degradation, hinted that he had been bribed to do it, and accused him of condoning the financial malpractices of Claudius. St. Remigius thought these bishops were full of spite and told them so, but his reply was a model of patience and charity. Very different was his tone towards a bishop who had exercised jurisdiction outside his diocese. "If your Holiness was ignorant of the canons it was ill done of you to transgress the diocesan limits without learning them. . . . Be careful lest in meddling with the rights of others you lose your own."

St. Remigius, whom St. Gregory of Tours refers to as "a man of great learning, fond of rhetorical studies, and equal in his holiness to St. Silvester," died about the year 530.

prepared them for baptism. To strike the senses of barbarous people and impress their minds, Queen Clotildis took care that the streets from the palace to the church should be adorned with hangings, and that the church and baptistery should be lighted with a great number of candles and scented with incense. The catechumens marched in procession, carrying crosses, and singing the litany; St. Remigius conducted the king by the hand, followed by the queen and the people. At the font the bishop is said to have addressed Clovis in words that are memorable, if not actually pronounced: "Humble yourself, Sicambrian! Worship what you have burned, and burn what you have worshipped!" Words which may be emphatically addressed to every penitent, to express the change of heart and conduct that is required of him.

St. Remigius afterwards baptized the king's two sisters and three thousand men of his army, as well as women and children, with the help of the other bishops and priests present. Hincmar of Rheims, who

ST. PATRICK, ARCHBISHOP OF ARMAGH, APOSTLE OF IRELAND

March 17

Patron Saint of Ireland

"I F," SAYS ALBAN BUTLER, "the virtue of children reflects an honour on their parents, much more justly is the name of St. Patrick rendered illustrious by the lights of sanctity with which the Church of Ireland shone during many ages, and by the colonies of saints with which it peopled many foreign countries." The field of his labors, he adds, was the remote corner of the then known world, and he himself was born upon its confines. We may infer from what he says of himself that he was of Romano-British origin. His father Calpurnius was a deacon and a municipal official, his grandfather a priest, for in those days no strict law of celibacy had yet been imposed on the Western clergy. The saint's full name in the Roman style was not improbably Patricius Magonus Sucatus. We cannot be far wrong in supposing that he was born about 389, and that about 403 he with many others was carried off by raiders to become a slave among the still pagan inhabitants of Ireland. There for six years he served his master, and amid the bodily hardships of this bondage his soul grew marvelously in holiness.

After this time he heard a voice in his sleep warning him to be ready for a brave effort which would bring him back to freedom in the land of his birth. Accordingly he ran away from his master and traveled 200 miles to the ship of whose approaching departure he had had some strange intimation. His request for free passage was refused at first, but, in answer to his silent prayer to God, the sailors called him back, and with them he made an adventurous journey. They were three days at sea, and when they reached land it was only to travel in company for a

month through some uninhabited tract of country until all their provisions gave out.

At length they reached human habitations — probably in Gaul — but the fugitive was safe, and thus eventually Patrick, at the age of twenty-two or twenty-three, was restored to his kinsfolk. They welcomed him warmly and besought him not to depart from them again, but after a while, in the watches of the night, fresh visions came to him, and he heard "the voices of those who dwelt beside the wood of Foclut which is nigh to the western sea, and thus they cried, as if with one mouth, 'We beseech thee, holy youth, to come and walk among us once more.' " "Thanks be to God," he adds, "that after many years the Lord granted to them according to their cry."

With regard to the order of events which followed there is no certainty. St. Patrick could hardly have set out upon such an undertaking as the conversion of Ireland without study and preparation, without priestly orders, without some sort of commission from ecclesiastical authority. It seems therefore beyond dispute, and it is quite in agreement with the statements of the saint's earliest biographers, that he spent several years in France before he made any attempt to take up his work in Ireland. The evidence for a considerable sojourn on the island of Lérins (off Cannes) is strong, and so also is that which represents him as being in personal contact with Bishop St. Germanus, at Auxerre. Some have maintained that he journeyed to Rome at this period and was dispatched on his special mission to the Irish by Pope St. Celestine I. Since the publication of Professor Bury's *Life of St. Patrick* the

view has gained favor that he was three years at Lérins, from 412 to 415, that he then spent some fifteen years at Auxerre, during which time he received holy orders, that meanwhile Pope Celestine had sent Palladius to Ireland, who after less than a twelvemonth died among the Picts in North Britain, and that then, in 432, St. Germanus consecrated Patrick bishop to replace Palladius and carry on his work of evangelization, which as yet was hardly begun.

To trace in detail the course of the saint's heroic labors in the land of his former captivity is impossible, left as we are to the confused, legendary and sometimes contradictory data supplied by his later biographers. But it seems probable that there is an historical basis for a preliminary stay of St. Patrick in Ulster, whence after the foundation of Saul he embarked with characteristic energy on his attempt to gain the favor of the High-King Laoghaire, who held his court at Tara in Meath. There is doubtless much that is purely mythical in the legend of the encounter of Patrick with the magicians or Druids, but it is clear that something momentous was decided on that occasion, and that the saint, either by force of character or by the miracles he wrought, gained a victory over his pagan opponents which secured a certain amount of toleration for the preaching of Christianity.

Although King Laoghaire seems not to have become a Christian himself, certain members of his family did, and from that time the work of the great apostle was openly favored by many powerful chieftains. The druids, as the most interested representatives of paganism, were his bitter opponents. How full of peril the mission was we learn from the incident of Odhran, St. Patrick's charioteer, who by some presentiment asked to take the chief seat while Patrick himself drove. Odhran was killed by a spear-thrust intended for his master, while the saint himself escaped. But the work of the evangelization of Ireland went steadily on, despite opposition. Proceeding northwards from Tara, Patrick overthrew the idol of Crom Cruach in Leitrim, and built a Christian church in the place where it had stood. Thence he passed to Connaught, and amongst his other doings there Tírechán has preserved the story of the conversion of Ethne and Fedelm, the two daughters of King Laoghaire, though the incident of the shamrock, used as an illustration of the Trinity in their instruction, is an accretion of much later date.

When Patrick had gathered many disciples round him, such, for example, as Benignus, who was destined to be his successor, the work of evangelization was well under way. He maintained his contacts abroad, and it has been suggested that the "approval" of which we read was a formal communication from Pope St. Leo the Great. In 444, according to the Annals of Ulster, the cathedral church of Armagh, the primatial see of Ireland, was founded, and no long time probably elapsed before it became a center of education as well as administration. There is good reason to believe that St. Patrick held a synod and many of the decrees then enacted are still preserved to us as they were originally framed. It is likely that the synod was held towards the close of Patrick's days, and he must have been by that time a man in broken health, for the physical strain of his austerities and endless journeys cannot, apart from some miraculous intervention of Providence, have failed to produce its effect. Nevertheless the story of his forty days' fast upon Croagh Patrick and of the privileges he then extorted from the divine clemency by his importunity in prayer must be connected with the end of his life. As Tírechán briefly tells us: "Patrick went forth to the summit of Mount Aigli, and he remained there for 40 days and 40 nights, and the birds were a trouble to him, and he could not see the face of the heavens, the earth or the sea on account of them; for God told all the saints of Erin, past, present and future, to come to the mountain summit — that mountain which overlooks all others, and is higher than all the mountains of the West — to bless the tribes of Erin, so that Patrick might see [by anticipa-

Hibernia et fot populi nel nome di dio ✠ Come S p

tion] the fruit of his labours, for all the choir of the saints of Erin came to visit him there, who was the father of them all."

The British chronicler Nennius gives a similar account, but adds that "from this hill Patrick blessed the people of Ireland, and his object in climbing to its summit was that he might pray for them and see the fruit of all his labours. . . . Afterwards he went to his reward in a good old age, where now he rejoices for ever and ever. Amen." It seems certain that Patrick died and was buried, in or about the year 461, at Saul on Strangford Lough, where he had built his first church. That he spent his last days as abbot of Glastonbury is quite untrue.

It need hardly be said that in all the ancient lives of St. Patrick the marvelous is continuously present and often in a very extravagant form. If we were dependent for our knowledge of him upon such material as is supplied in the *Vita Tripartita* we should understand little of his true character. Fortunately in the case of the apostle of Ireland we have a slender collection of his own writings, and these show us the man himself as he was and felt and acted. It is only by a study of the "Confession," the *Lorica* and the Coroticus letter, that we come to understand the deep human feeling and the still more intense love of God which were the secret of the extraordinary impression he produced upon those with whom he came into contact. If he had not possessed a strongly affectionate nature which clung to his own kith and kin, he would not have referred so many times to the pang it had cost him to leave them, turning a deaf ear to their efforts to detain him. He was deeply sensitive. If he had not been that, he could never have laid so much stress upon his disinterestedness. The suggestion that he was seeking profit for himself in the mission he had undertaken stung him almost beyond endurance. All that was most human, and at the same time most divine, in Patrick comes out in such a passage as the following, from his "Confession."

And many gifts were proffered me, with weeping and with tears. And I displeased them, and also, against my wish, not a few of my elders; but, God being my guide, in no way did I consent or yield to them. It was not any grace to me, but God who conquereth in me, and He resisted them all, so that I came to the heathens of Ireland to preach the gospel and to bear insults from unbelievers so as to hear the reproach of my going abroad and to endure many persecutions even unto bonds, the while that I was surrendering my liberty as a man of free condition for the profit of others. And if I should be found worthy, I am ready to give even my life for His name's sake unfalteringly and very gladly, and there I desire to spend it until I die, if only our Lord should grant it to me.

On the other hand, the marvel of the wondrous harvest which God had allowed him to reap was always before his eyes and filled him with gratitude. It is unquestionably true that, in his apostolate of less than thirty years, Patrick had converted Ireland as a whole to Christianity. This is not a mere surmise based upon the unmeasured encomiums of his enthusiastic biographers. It is the saint himself who alludes more than once to the "multitudes" *(innumeros),* the "so many thousands," whom he had baptized and confirmed. And again he says: "Wherefore then in Ireland they who never had the knowledge of God, but until now only worshipped idols and abominations — how has there been lately prepared a people of the Lord, and they are called children of God? Sons and daughters of Scottic chieftains are seen to become monks and virgins of Christ." Paganism and rapine and vice had not entirely loosed their hold. The saint in this same "Confession," which was written in his later days, still declares: "Daily I expect either a violent death or to be robbed and reduced to slavery or the occurrence of some such calamity." But he adds: "I have cast myself into the hands of Almighty God, for He rules everything; as the Prophet saith, 'Cast thy care upon the Lord, and He Himself will sustain thee.' " This was apparently the secret of the inexhaustible courage and determination manifested by St. Patrick throughout his whole career.

ST. BRIGID, OR BRIDE, ABBESS OF KILDARE, VIRGIN

February 1

Patron Saint of Ireland; Scholars

FOR ANYTHING in the nature of a connected story the numerous "lives" of St. Brigid, written by her countrymen up to four centuries after her death, supply no materials. Her memory, as it lived in the hearts of the people, was identified with an extraordinary spirit of charity.

We are probably safe in saying that St. Brigid was born about the middle of the fifth century at Faughart, near Dundalk. She undoubtedly consecrated herself to God at an early age. Strangely enough, St. Brigid's foundation of the nunnery at Kildare is not much dwelt upon in the lives, though this seems to have been the great historic fact of her career and the achievement which made her in some sense the mother and exemplar of all the consecrated virgins of Ireland for many centuries to come.

We may perhaps form an idea of the general tone of the early lives by translating a few paragraphs from the lessons in the *Breviarium Aberdonense*:

The holy Brigid, whom God foreknew and predestined to grow unto His own likeness, sprang from a worthy and prudent Scottish [i.e. Irish] stock, having for father Dubthac and for mother Brocca, from earliest years making progress in all good. For this maiden, the elect of God, full of soberness and wisdom, ever advanced towards what was more perfect. Sent by her mother to collect the butter made from the milk of the cows, as other women were sent, she gave it all to the poor. And when the others returned with their load and she sought to make restitution of the produce of the cows, turning in tender deference to our Lord, God for His virgin's

sake gave back the butter with usury. In due time, when her parents wished to bestow her in marriage, she vowed chastity, and as in the presence of a most holy bishop she made her vow, it happened that she touched with her hand the wooden pillar on which the altar rested. In memory of that maiden's action long ago up to the present hour this wood remains as it were green, or, as if it had not been cut and stripped of its bark, it flourishes in its roots and heals cripples innumerable.

Saintly as she was and faithful, Brigid, seeing that the time for her espousals was drawing near, asked our Lord to send her some deformity so as to frustrate the importunity of her parents, whereupon one of her eyes split open and melted in her head. Therefore, having received the holy veil, Brigid with other consecrated virgins remained in the city of Meath, where our Lord at her prayer vouchsafed to work many miracles. She healed a stranger, by name Marcus; she supplied beer out of one barrel to eighteen churches, which sufficed from Maundy Thursday to the end of paschal time. On a leprous woman asking for milk, there being none at hand she gave her cold water, but the water was turned into milk, and when she had drunk it the woman was healed. Then she cured a leper and gave sight to two blind men. Making a journey in answer to an urgent call, she chanced to slip at a ford and cut her head, but with the blood that flowed therefrom two dumb women recovered their speech. After this a precious vessel of the king's, slipping from the hand of a yokel, was broken, and that he might not be punished it was restored uninjured by Brigid.

Certilike þouȝte þ he was euel a cold: for al þ he on hi caste
þo he dide him al þ he myȝte: & þe colde so longe laste
He bi held þis holi man & mesel as he wende
As sone as oure lord wolde: his colour be gan to amende
Atte laste he becam: so fair a man as myȝte be
And so cler & schinende liȝe: þ vnneþe men myȝte hi se
Iulian he seide god it þe ȝelde: þat þou hast me do
In oure lordis message: of heue i am come þe to
Oure lord þe sente word be me: þat þ art dene schryue
And þi penaüce þ hast don: & þi sinnes be þe for ȝeue
Wol wel þou hast him payd: and þi wif also
And ȝe schul wone wᵗ alle ioie: neueh come hi to
þo he hadde þis word seid: he nyste wher he be com
þis holi man sein Iulian: to goddis seruise hi nom
And to his bi leue al ȝare: he made hi & his wif also
And sone þer aft in his seruise: þei deiden wþen to
And wenten to þe ioye of heuen: þe þei schul euere be
Good it is to herberwe strange men: as we moun bi hi se
& for þ wiþ þis holi man: his herne lette i nouȝ
And a greet seint in heue is: þat sad i mod slouȝ
Now bidde we ȝerue seint Iulian: þ he oure ardyn lede
þat oure lord ȝeue vs his grē: & alle þat han nede
Whan we or ony oþ man: ouer londe schul wende
For his fadris soule & his mod: good herberwe vs sende
And atte laste dai þoˀ goddis wille: þat we mote fle
To þe ioye of heuen: & wiþ outen eude þe be

Seint Bride þe holy maide: of irloude was
We ȝete sche was in spouse breke: in a wonder cas
Duptake was hir fadris name: þ i spouthod had a wif
in þe liþe bi leue of paynyme: þei ledde þo here lyf
A seruaut he hadde in his hous: brok set was hir name
þis duptake he þouȝte on hir: of lecchorie & schame
On hire he be ȝat a child: in spouse breke & wiþ wough
his owen wif it vnd ȝat: sche was sory a nough
most sche dredde hire of þ child: þ it schulde wel the
To surmounte hire owen childre: her maist for to be
þer fore sche criede on hir lord: to be war be fore
To selle out of londe his seruaut: or þe child was bore
þe housbonde wolde it ginte not: lof hi were it to do
þe wif criede nyȝt & day: ȝif sche it myȝte brige þ to
So þat it bi tel þer afterward: þat þis housbonde
wᵗ his seruaut a lone he wente: i a carte on londe

S Bride

But among these and many similar extravagances, some legends are beautiful. One such, in particular, concerning the blind nun Dara, can hardly be told more sympathetically than in the words of Sabine Baring-Gould:

One evening, as the sun went down, Brigid sat with Sister Dara, a holy nun who was blind, and they talked of the love of Jesus Christ and the joys of Paradise. Now their hearts were so full that the night fled away whilst they spoke together, and neither knew that so many hours had passed. Then the sun came up from behind the Wicklow mountains, and the pure white light made the face of earth bright and gay. Then Brigid sighed, when she saw how lovely were earth and sky, and knew that Dara's eyes were closed to all this beauty. So she bowed her head and prayed, and extended her hand and signed the dark orbs of the gentle sister. Then the darkness passed away from them, and Dara saw the golden ball in the east and all the trees and flowers glittering with dew in the morning light. She looked a little while, and then, turning to the abbess, said, "Close my eyes again, dear Mother, for when the world is so visible to the eyes, God is seen less clearly to the soul." So Brigid prayed once more, and Dara's eyes grew dark again.

Of the saint's great religious foundation at Killdara (the church of the oak) and of the rule which was there followed we know little or nothing that is reliable. It is generally supposed that it was a "double monastery," i.e. that it included men as well as women, for such was the common practice in Celtic lands. It is also quite possible that St. Brigid presided over both communities, for this arrangement would by no means have been without a parallel. But the text of her rule — there is mention of a "regula Sanctae Brigidae" in the Life of St. Kieran of Clonmacnois — appears not to have survived.

Despite the predominance of legendary material, the enthusiasm which the memory of St. Brigid evoked among her countrymen is unmistakable. It would not be easy to find anything more fervent in expression than the rhapsodies of the Book of Lismore:

Everything that Brigid would ask of the Lord was granted her at once. For this was her desire: to satisfy the poor, to expel every hardship, to spare every miserable man. Now there never hath been anyone more bashful or more modest or more gentle or more humble or more discerning or more harmonious than Brigid. In the sight of other people she never washed her hands or her feet or her head. She never looked at the face of man. She never spoke without blushing. She was abstemious, she was innocent, she was prayerful, she was patient: she was glad in God's commandments: she was firm, she was humble, she was forgiving, she was loving: she was a consecrated casket for keeping Christ's body and His blood; she was a temple of God. Her heart and her mind were a throne of rest for the Holy Ghost. She was single-hearted [towards God]: she was compassionate towards the wretched; she was splendid in miracles and marvels: wherefore her name among created things is Dove among birds, Vine among trees, Sun among stars. . . . She is the prophetess of Christ: she is the Queen of the South: she is the Mary of the Gael.

In early times St. Brigid was much honored in Scotland and also in those parts of England which were more directly in contact with Celtic influences, and there are several places in Wales called Llansantffraid, St. Bride's Church. In Ireland the churches dedicated to her are innumerable; in England we know of nineteen pre-Reformation dedications, and one church in London is famous, St. Bride's in Fleet Street. Her feast is observed throughout Ireland, Wales, Australia and New Zealand.

ST. BRIGID
From *Lives of the Saints*, MS Tanner 17. Bodleian Library, Oxford University

S Brandan

þ inne he sette þe goode man ꝫ til
þe goode man worschipid iħu ꝛ
So þat þe emꝑoꝛ seigħ ꝫ þ he ue
Wiþ a swerd he smot hi þo þe he
And his soule to heuyn wente ꝫ
God foꝛ þe loue of seint quirie

Eint Brandan þe holi m̄
monk he was of hard liī
Of fastynge and of pen

Of a pouersent monkis ꝫ þat all
So þat it was on a dai ꝫ as our
þat barint an oþ abbot ꝫ to hī
Seint brādan hi be souзte a noꝛ
And telle hī þat he seigħ ꝫ a bo
þis goode man þo he þat herde
þo he began to siзhe soꝛe ꝫ ꝛ fel
bi twen his armes seint brāda
And cried faste on hī ꝫ til his wit
stad he seide puꝛ charite ꝫ oþ re
hidir you come foꝛ oure solas
Telle vs what you hast ꝛ seiзe ꝫ
In þe meche see occian ꝫ as oure b
Now is þe occion ꝫ grettest and
ffoꝛ it goþ a boute þe woꝛld ꝫ ꝛ a
So þat barint þis olde man ꝫ riз
biding he gan to telle ꝫ what h
he seide he hadde a god soue ꝫ ꝛ
Monk he was as we ben ꝫ and
So þat his herte зaf hym to we
he as he myзte a lone be ꝫ to se
So þat bi my leue he wente ꝫ and

ST. BRENDAN, ABBOT OF CLONFERT

May 16

Patron Saint of Sailors

THERE IS HARDLY ANY Irish saint whose name is more widely known than that of St. Brendan, though this exceptional prominence is due rather to the popularity of the saga, called his *Navigatio* (sea-voyage), admittedly a fiction, than to the tradition of his saintliness. On the other hand, it is certain that St. Brendan was a real personage, and that he exercised great influence amongst his contemporaries in the sixth century. He was probably born near Tralee on the west coast of Ireland. For five years as a tiny child he was committed to the care of St. Ita, and after that he was watched over by Bishop Erc who had already baptized him as an infant and who was in due time to ordain him priest.

To determine the chronological sequence of events is quite impossible, but we should be led to infer that shortly after being raised to the priesthood, St. Brendan assumed the habit of a monk and gathered followers around him in a settled community. How he could have left these behind to start off with sixty chosen companions in skin-covered coracles to discover the Isles of the Blessed is a difficulty which does not seem to have troubled his biographers. One or other of these speaks of two separate voyages, though the first expedition is said to have lasted for five or seven years, as a sort of floating monastery. At the same time, Dr. J. F. Kenney states: "It is reasonably certain that Brendan himself made a voyage to the Scottish isles and perhaps to the Strathclyde, Cumbria or Wales." Adamnan, writing little more than a century after St. Brendan's death, describes him as visiting St. Columba in the little island of Himba, or Hinba, in Argyll; this island has not been identified, and on the point of this visit Adamnan has the Old Life against him. The biographers, whose narratives are probably later in date, discourse at considerable length of a visit he paid to St. Gildas in Britain and of the marvels which happened on that occasion.

The most reliable fact which we can connect with the life of St. Brendan is his foundation of a monastic community at Clonfert in 559 (?). His biographers speak of his governing a community of three thousand monks. He is also said to have had a rule of life dictated to him by an angel. We know nothing of its nature, but we are told that the rule was followed "down to the present day" by those who succeeded him in the office of abbot. He did not die at Clonfert, but God called him to his reward when he was paying a visit to his sister, Brig, who governed a community at Enach Duin. After offering Mass, he said, "Commend my departure in your prayers"; and Brig replied, "What do you fear?" "I fear," he said, "if I go alone, if the journey be dark, the unknown region, the presence of the King, and the sentence of the Judge." St. Brendan's feast is observed throughout Ireland.

ST. BRENDAN
From *Lives of the Saints,* MS Tanner 17. Bodleian Library, Oxford University

ST. BENEDICT, ABBOT, PATRIARCH OF WESTERN MONKS

March 2

Patron Saint of Europe; Victims of Poisoning; Speleologists

IN VIEW OF THE IMMENSE influence exerted over Europe by the followers of St. Benedict, it is disappointing that we have no contemporary biography of the great legislator, the father of Western monasticism. The little we know about his earlier life comes from the *Dialogues* of St. Gregory.

Benedict was of good birth, and was born and brought up at the ancient Sabine town of Nursia. In his early teens, he was sent to Rome for his "liberal education." Overrun by pagan and Arian tribes, the civilized world seemed during the closing years of the fifth century to be rapidly lapsing into barbarism: the Church was rent by schisms, town and country were desolated by war and pillage, shameful sins were rampant amongst Christians as well as heathens, and it was noted that there was not a sovereign or a ruler who was not an atheist, a pagan or a heretic. The youths in schools imitated the vices of their elders, and Benedict, revolted by the licentiousness of his companions, yet fearing he might become contaminated by their example, made up his mind to leave Rome. Absence from the temptations of Rome, he soon realized, was not enough; God was calling him to be a solitary and to abandon the world, and he could no more live a hidden life in a village than in the city.

In search of complete solitude Benedict started forth once more, alone, and climbed further among the hills until he reached a place now known as Subiaco. In this wild and rocky country he came upon a monk called Romanus, to whom he opened his heart,

explaining his intention of leading the life of a hermit. Romanus eagerly assisted the young man, clothing him with a sheepskin habit and leading him to a cave in the mountain. In this desolate cavern Benedict spent the next three years of his life, unknown to all except Romanus, who kept his secret and daily brought bread for the young recluse, who drew it up in a basket let down by a rope over the rock. The first outsider to find his way to the cave was a priest who, when preparing a dinner for himself on Easter Sunday, heard a voice which said to him, "You are preparing yourself a savory dish whilst my servant Benedict is afflicted with hunger." The priest immediately set out in quest of the hermit, whom he found with great difficulty. After they had discoursed for some time on God and heavenly things the priest invited him to eat, saying that it was Easter day, on which it was not reasonable to fast. Benedict, who doubtless had lost all sense of time, replied that he knew not that it was the day of so great a solemnity. They ate their meal together, and the priest went home. Shortly afterwards the saint was discovered by some shepherds, who took him at first for a wild animal because he was clothed in the skin of beasts and because they did not think any human being could live among the rocks. When they discovered that he was a servant of God they were greatly impressed, and derived much good from his discourses. From that time many people visited him, bringing such sustenance as he would accept and receiving from him instruction and advice.

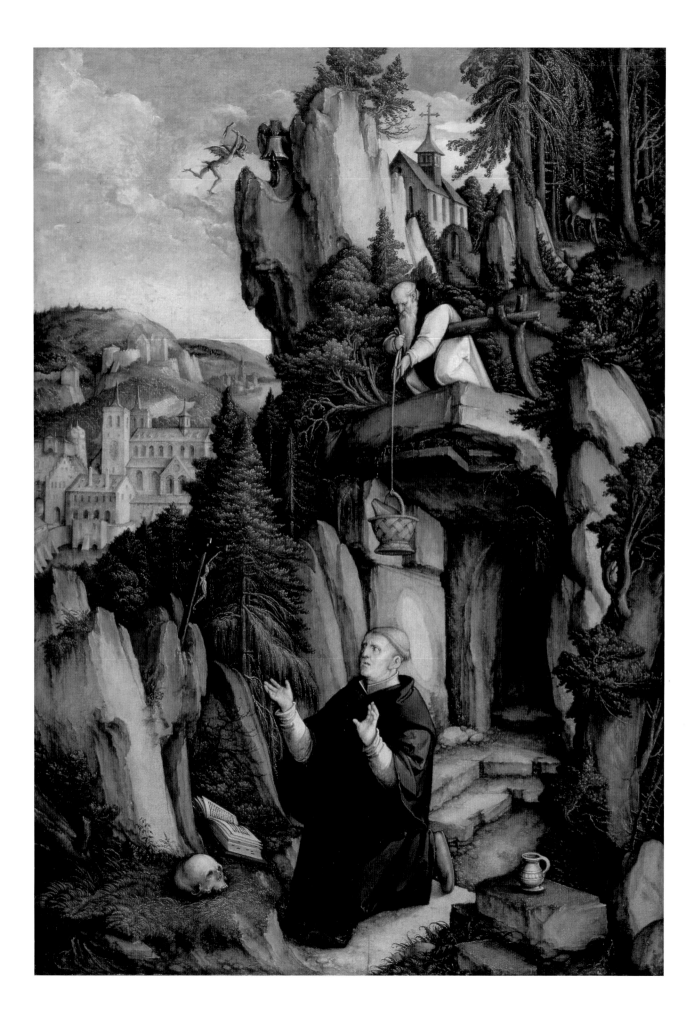

Although he lived thus sequestered from the world, St. Benedict, like the fathers in the desert, had to meet the temptations of the flesh and of the Devil, one of which has been described by St. Gregory. "On a certain day when he was alone the tempter presented himself. For a small dark bird, commonly called a blackbird, began to fly round his face, and came so near to him that, if he had wished, he could have seized it with his hand. But on making the sign of the cross, the bird flew away. Then such a violent temptation of the flesh followed as he had never before experienced. The evil spirit brought before his imagination a certain woman whom he had formerly seen, and inflamed his heart with such vehement desire at the memory of her that he had very great difficulty in repressing it; and being almost overcome he thought of leaving his solitude. Suddenly, however, helped by divine grace, he found the strength he needed, and seeing close by a thick growth of briars and nettles, he stripped off his garment and cast himself into the midst of them. There he rolled until his whole body was lacerated. Thus, through those bodily wounds he cured the wounds of his soul," and was never again troubled in the same way.

On the summit of a cliff overlooking the Anio, there resided at that time a community of monks who, having lost their abbot by death, resolved to ask St. Benedict to take his place. He at first refused, assuring the community that their ways and his would not agree. Their importunity, however, induced him to consent, and he returned with them to take up the government. It soon became evident that his strict notions of monastic discipline did not suit them, and in order to get rid of him they went so far as to mingle poison in his wine. When as was his wont he made the sign of the cross over the jug, it broke in pieces as if a stone had fallen upon it. "God forgive you, brothers," the abbot said without anger. "Why have you plotted this wicked thing against me? Did I not tell you that my customs would not accord with yours? Go and find an abbot to your taste, for after this deed you can no longer keep me among you." With these words he returned to Subiaco to begin the great work for which God had been preparing him.

Disciples began to gather about him, attracted by his sanctity and by his miraculous powers, seculars fleeing from the world as well as solitaries who lived dispersed among the mountains. He therefore settled all who would obey him in twelve wood-built monasteries of twelve monks, each with its prior. He himself exercised the supreme direction over all from where he lived with certain chosen monks whom he wished to train with special care. Romans and barbarians, rich and poor, placed themselves at the disposal of the saint, who made no distinction of rank or nation, and after a time parents came to entrust him with their sons to be educated and trained for the monastic life. It was not the least of St. Benedict's miracles that he broke down the deeply-rooted prejudice against manual work as being degrading and servile: he believed that labor was not only dignified but conducive to holiness, and therefore he made it compulsory for all who joined his community — nobles and plebeians alike.

We do not know how long the saint remained at Subiaco, but he stayed long enough to establish his monasteries on a firm and permanent basis. His departure was sudden and seems to have been unpremeditated. There lived in the neighborhood an unworthy priest called Florentius, who, seeing the success which attended St. Benedict and the great concourse of people who flocked to him, was moved to envy and tried to ruin him. Having failed in all attempts to take away his character by slander, and his life by sending him a poisoned loaf (which St. Gregory says was removed miraculously by a raven), he tried to seduce his monks by introducing women of evil life. The abbot, who fully realized that the wicked schemes of Florentius were aimed at him personally, resolved to leave Subiaco, lest the souls of his spiritual children should continue to be assailed and endangered. Having set all things in order, he withdrew from Subiaco to the territory of Monte Cassino. The town of Casinum, once an important place, had been destroyed by the Goths, and the remnant of its inhabitants had relapsed into — or perhaps had never lost — their paganism. They were wont to offer sacrifice in a temple dedicated to Apollo, which stood on the crest of Monte Cassino,

and the saint made it his first work after a forty days' fast to preach to the people and to bring them to Christ. His teaching and miracles made many converts, with whose help he proceeded to overthrow the temple, its idol and its sacred grove. Upon the site of the temple he built two chapels, and round about these sanctuaries there rose little by little the great pile which was destined to become the most famous abbey the world has ever known, the foundation of which is likely to have been laid by St. Benedict in the year 530 or thereabouts. It was from here that went forth the influence that was to play so great a part in the christianization and civilization of post-Roman Europe: it was no mere ecclesiastical museum that was destroyed during the second World War.

Disciples soon flocked to Monte Cassino too. Profiting no doubt by the experience gained at Subiaco, he no longer placed them in separate houses but gathered them together in one establishment, ruled over by a prior and deans under his general supervision. Not only laymen but dignitaries of the Church came to confer with the holy founder. It is almost certainly at this period that he composed his Rule. Though it was primarily intended for the monks at Monte Cassino, there is something in favor of the view that it was written at the desire of Pope St. Hormisdas for all monks of the West. It is addressed to all those who, renouncing their own will, take upon them "the strong and bright armor of obedience to fight under the Lord Christ, our true king," and it prescribes a life of liturgical prayer, study and work, living socially in a community under one common father. Then and for long afterwards a monk was but rarely in holy orders, and there is no evidence that St. Benedict himself was ever a priest. He sought to provide "a school for the Lord's service," intended for beginners, and the asceticism of the rule is notably moderate. Self-chosen and abnormal austerities were not encouraged. The great vision, when Benedict saw as in one sunbeam the whole world in the light of God, sums up the inspiration of his life and rule.

The holy abbot, far from confining his ministrations to those who would follow his rule, extended his solicitude to the population of the surrounding country: he cured their sick, relieved the distressed, distributed alms and food to the poor, and is said to have raised the dead on more than one occasion. While Campania was suffering from a severe famine he gave away all the provisions in the abbey, with the exception of five loaves. "You have not enough today," he said to his monks, marking their dismay, "but tomorrow you will have too much." The following morning two hundred bushels of flour were laid by an unknown hand at the monastery gate. Other instances have been handed down of St. Benedict's prophetic powers, to which was added ability to read men's thoughts.

When Totila the Goth was making a triumphal progress through central Italy, he conceived a wish to visit St. Benedict, of whom he had heard much. He therefore sent word of his coming to the abbot, who replied that he would see him. To discover whether the saint really possessed the powers attributed to him, Totila ordered Riggo, the captain of his guard, to don his own purple robes, and sent him, with the three counts who usually attended the king, to Monte Cassino. The impersonation did not deceive St. Benedict, who greeted Riggo with the words, "My son, take off what you are wearing; it is not yours." His visitor withdrew in haste to tell his master that he had been detected. Then Totila came himself to the man of God and, we are told, was so much awed that he fell prostrate. But Benedict, raising him from the ground, rebuked him for his evil deeds, and foretold in a few words all that should befall him. Thereupon the king craved his prayers and departed, but from that time he was less cruel.

The great saint who had foretold so many other things was also forewarned of his own approaching death. He notified it to his disciples and six days before the end bade them dig his grave. As soon as this had been done he was stricken with fever, and on the last day he received the Body and Blood of the Lord. Then, while the loving hands of the brethren were supporting his weak limbs, he uttered a few final words of prayer and died — standing on his feet in the chapel, with his hands uplifted towards heaven. He was buried beside St. Scholastica his sister, on the site of the altar of Apollo which he had cast down.

ST. GREGORY THE GREAT, POPE, DOCTOR OF THE CHURCH

March 12

Patron Saint of England; Musicians; Singers; Teachers

POPE GREGORY I, most justly called "the Great," and the first pope who had been a monk, was elected to the apostolic chair when Italy was in a terrible condition after the struggle between the Ostrogoths and the Emperor Justinian, which ended in 562. The state of Rome itself was deplorable: it had been sacked four times within a century and a half, and conquered four times in twenty years, but no one restored the damage done by pillage, fire and earthquake. St. Gregory, writing about 593, says: "We see what has become of her who once appeared the mistress of the world. She is broken by all she has suffered from immense and manifold misfortunes. . . . Ruins upon ruins everywhere! . . . Where is the senate? Where are the people? . . . We, the few who are left, are menaced every day by the sword and innumerable trials. . . . Deserted Rome is in flames: her buildings also."

The saint's family, one of the few patrician families left in the city, was distinguished also for its piety, having given to the Church two popes, Agapitus I and Felix III, Gregory's great-great-grandfather. Gregory appears to have received the best education obtainable at that time in Rome, and to have taken up the career of a public official. In 568 a fresh calamity fell upon Italy in the form of the first Lombard invasion, and three years later the barbarian horde came alarmingly near Rome. At that time of panic Gregory probably showed something of the wisdom and energy which distinguished him later, for at the age of about thirty we find him exercising the highest civil office in Rome — that of prefect of the city. Faithfully and honorably though Gregory fulfilled his duties, he had long been feeling the call to a higher vocation, and at length he resolved to retire from the world and to devote himself to the service of God alone. He was one of the richest men in Rome, but he gave up all, retiring into his own house, which he turned into a monastery and which he placed under the patronage of St. Andrew. The few years the saint spent in this seclusion were the happiest of his life.

It was not likely that a man of St. Gregory's talents and prestige would be left long in obscurity at such a time, and we find him ordained seventh deacon of the Roman church, and then sent as papal ambassador at the Byzantine court. In Constantinople he met St. Leander, Bishop of Seville, with whom he formed a lifelong friendship, and at whose request he began a commentary on the Book of Job which he afterwards finished at Rome and which is generally known as his *Moralia*. Most of the dates in St. Gregory's life are uncertain, but it was probably about the beginning of the year 586 that he was recalled to Rome by Pelagius II. He immediately settled down again, deacon of Rome though he was, in his monastery of St. Andrew, of which he soon became abbot; and it seems that it is to this period we must refer the celebrated story told by the Venerable Bede on the strength of an old English tradition.

St. Gregory, it appears, was one day walking through the market when he noticed three golden-haired, fair-complexioned boys exposed for sale and inquired their nationality. "They are Angles or Angli," was the reply. "They are well named," said the saint, "for they have angelic faces and it becomes such to be companions with the angels in heaven." Learning that

ST. GREGORY THE GREAT

Giovanni di Paolo. *The Procession of St. Gregory to Sant'Angelo.* Louvre, Paris

they were pagans, he asked what province they came from. "Deira." — "De ira!" exclaimed St. Gregory. "Yes, verily they shall be saved from God's ire and called to the mercy of Christ. What is the name of the king of that country?" — "Aella." — "Then must Alleluia be sung in Aella's land." So greatly was he impressed by their beauty and by pity for their ignorance of Christ that he resolved to preach the gospel himself in Britain, and started off with several of his monks. However, when the people of Rome heard of their departure they raised such an outcry that Pope Pelagius sent envoys to recall them to Rome.

The whole episode has been declared apocryphal by modern historians on the ground of the flimsiness of the evidence. They also point out that Gregory never alludes to the incident, and moreover that even in his most informal writings he never indulges in puns. On the other hand, the first part of the story — the scene in the market-place — may easily be true: men sometimes pun in familiar conversation who would abstain from the practice when writing. Also it might plausibly be urged that St. Gregory's admiration for the fair complexion and hair of the English lads, while natural enough in an Italian, is not the sort of trait which it would have occurred to a northern scribe to invent; while finally there can be no dispute that Gregory later on was deeply interested in St. Augustine's mission, however it came about.

A terrible inundation of the Tiber was followed by another and an exceptionally severe outbreak of the plague: Rome was again decimated, and in January 590 Pelagius died of the dread disease. The people unanimously chose Gregory as the new pope, and to obtain by penitence the cessation of the plague he ordered a great processional litany through the streets of Rome. From seven churches in the city proceeded seven columns of people, who met at St. Mary Major. St. Gregory of Tours, after the report of one who was present, describes it: "The procession ordered for Wednesday took place on three successive days: the columns proceeded through the streets chanting 'Kyrie eleison' while the plague was still raging; and as they walked people were seen falling and dying about them. Gregory inspired these poor people with courage, for

he did not cease preaching and wished that prayer should be made continually." The faith of the people was rewarded by the speedy diminution and cessation of the plague, as we learn from contemporary writers, but no early historian mentions the appearance of the Archangel Michael sheathing his sword on the summit of Hadrian's mausoleum during the passing of the procession. This legend, which subsequently gained great credence, accounts for the figure of the angel which now surmounts the ancient pile and for the name of Sant' Angelo which the castle has borne since the tenth century. Although St. Gregory had thus been publicly devoting himself to the help of his fellow-citizens, his inclinations still lay in the direction of the contemplative life, and he had no intention of becoming pope if he could avoid it: he had written to the Emperor Maurice, begging him not to confirm the election; but, as we are told by Gregory of Tours, "while he was preparing to run away and hide himself, he was seized and carried off to the basilica of St. Peter, and there, having been consecrated to the pontifical office, was given as pope to the city." This took place on September 3, 590.

A correspondence with John, Archbishop of Ravenna, who had modestly censured him for trying to avoid office, led to Gregory's writing the *Regula Pastoralis*, a book on the office of a bishop. In it he regards the bishop as first and foremost a physician of souls whose chief duties are preaching and the enforcement of discipline. The work met with immediate success, and the Emperor Maurice had it translated into Greek. Later St. Augustine took it to England, where 300 years later it was translated by King Alfred, and at the councils summoned by Charlemagne the study of the book was enjoined on all bishops, who were to have a copy delivered to them at their consecration. For hundreds of years Gregory's ideals were those of the clergy of the West and "formed the bishops who have made modern nations."

From the very outset of his pontificate the saint was called upon to face the aggressions of the Lombards, who from Pavia, Spoleto and Benevento made incursions into other parts of Italy. No help was obtainable from Constantinople or from Ravenna, and

it fell upon Gregory, the one strong man, not only to organize the defenses of Rome, but also to lend assistance to other cities. When in 593 Agilulf with a Lombard army appeared before the walls of Rome and general panic ensued, it was not the military or the civil prefect but the Vicar of Christ who went out to interview the Lombard king. Quite as much by his personality and prestige as by the promise of an annual tribute Gregory induced him to withdraw his army and leave the city in peace. For nine years he strove in vain to bring about a settlement between the Byzantine emperor and the Lombards; Gregory then proceeded on his own account to negotiate a treaty with King Agilulf, obtaining a special truce for Rome and the surrounding districts. Anticipating a few years we may add that Gregory's last days were cheered by news of the re-establishment of peace.

It must have been a relief to the saint to turn his thoughts sometimes from the busy world to his writings. Towards the end of 593 he published his celebrated *Dialogues* — one of the most popular books of the middle ages. It is a collection of tales of visions, prophecies and miracles gathered from oral tradition and designed to form a sort of picture of Italian efforts after holiness. His stories were obtained from people still living who, in many cases, claimed to be eye-witnesses of the events recorded. St. Gregory's methods were not critical, and the reader today must often feel misgivings as to the trustworthiness of his informants. Modern writers have wondered whether the *Dialogues* could have been the work of anyone so well balanced as St. Gregory, but the evidence in favor of his authorship seems conclusive; and we must remember that it was a credulous age and that anything unusual was at once put down to supernatural agency.

Of all his religious work in the West that which lay closest to Gregory's heart was the conversion of England, and the success which crowned his efforts in that direction was to him the greatest triumph of his life. From his own monastery of St. Andrew he selected a band of forty missionaries whom he sent forth under the leadership of Augustine.

Into the thirteen years of his pontificate Gregory had crowded the work of a lifetime. His deacon Peter declared that he never rested, and he certainly did not spare himself, though he suffered from chronic gastritis and was a martyr to gout. He became reduced almost to a skeleton, and the sands of life were running low, yet he dictated letters and looked after the affairs of the Church to the very end. Almost his last action was to send a warm winter cloak to a poor bishop who suffered from the cold. Gregory was buried in St. Peter's, and as the epitaph on his tomb expresses it, "after having conformed all his actions to his doctrines, the great consul of God went to enjoy eternal triumphs."

St. Gregory has been credited with the compilation of the Antiphonary, the revision and rearrangement of the system of church music, the foundation of the famous Roman *schola cantorum*, and the composition of several well-known hymns. These claims have been contested, though he certainly had considerable effect on the Roman liturgy. But his true work lies in other directions. He is venerated as the fourth doctor of the Latin church, in which capacity he is said to have popularized St. Augustine and to have given clear expression to certain religious doctrines which had not previously been perfectly defined. For several centuries his was the last word on theology, though he was a popular preacher, catechist and moralist rather than a theologian. Perhaps his chief work was in strengthening the position of the Roman see.

ST. DAVID, OR DEWI, BISHOP IN MYNYW

March 1

Patron Saint of Wales; Poets

IT IS CERTAINLY UNFORTUNATE that we have no early history of St. David (as we anglicize his name Dewi), the patron of Wales and perhaps the most celebrated of British saints. All the accounts preserved to us are based on the biography written about 1090 by Rhygyfarch, a learned man whose claim to have drawn on old written sources is probably justified.

David was born perhaps about the year 520. He became an ordained priest in due course, and afterwards retired to study for several years under the Welsh St. Paulinus, who lived on an island which has not been identified. He is said to have restored sight to his master, who had become blind through much weeping. Upon emerging from the monastery, David seems to have embarked upon a period of great activity. "He [in legend] founded twelve monasteries to the glory of God: first, upon arriving at Glastonbury, he built a church there; then he came to Bath, and there, causing deadly water to become healing by a blessing, he endowed it with perpetual heat, rendering it fit for people to bathe in. . . ." Finally, and here we are on surer ground, he settled in the extreme southwest corner of Wales, at Mynyw (Menevia), with a number of disciples and founded the principal of his many abbeys.

The community lived a life of extreme austerity. Hard manual labor was obligatory for all, and they were allowed no cattle to relieve them in tilling the ground. They might never speak without necessity, and they never ceased praying mentally, even when at work. Their food was bread, with vegetables and salt, and they drank only water, sometimes mingled with a

ST. DAVID
From MS. Rawl. D. 939. Bodleian Library, Oxford University (from left: SS. David, Chadd, Perpetua, and Felicity)

little milk. When any outsider wished to join them, he had to wait at the gate for ten days and be subjected to harsh words ere he could be admitted.

Of St. David himself Giraldus tells us that he was the great ornament and example of his age and that he continued to rule his diocese until he was a very old man. At his death, St. Kentigern at Llanelwy saw his soul borne to Heaven by angels. His body was subsequently translated from the monastery church to Saint Davids cathedral, where the empty tomb is still shown. It is said that the relics were moved to Glastonbury, but they were apparently at Saint Davids in 1346.

ST. COLUMBA, OR COLMCILLE, ABBOT OF IONA

June 9

Patron Saint of Ireland; Scotland

THE MOST FAMOUS of Scottish saints, Columba, was actually an Irishman of the Uí Néill of the North and was born, probably about the year 521, at Gartan in County Donegal. As soon as he was considered old enough, he was removed from the care of his priest guardian at Temple Douglas to St. Finnian's great school at Moville. There he must have spent a number of years, for he was a deacon when he left. From Moville he went to study in Leinster under an aged bard called Master Gemman. The bards preserved the records of Irish history and literature, and Columba himself was a poet of no mean order. He afterwards passed on to another famous monastic school, that of Clonard, presided over by another Finnian, who was called the tutor of Erin's saints. Columba was one of that distinguished band of his disciples who are reckoned as the Twelve Apostles of Erin. It was probably while he was at Clonard that he was ordained priest, but it may have been a little later when he was living at Glasnevin, with St. Comgall, St. Kieran and St. Canice, under their former fellow student St. Mobhi. In 543 an outbreak of plague compelled Mobhi to break up his flourishing school and Columba, now twenty-five years of age and fully trained, returned to his native Ulster.

A striking figure of great stature and of athletic build, with a voice "so loud and melodious it could be heard a mile off," Columba spent the next fifteen years going about Ireland preaching and founding monasteries of which the chief were those of Derry, Durrow and Kells. Like the true scholar that he was, Columba dearly loved books and spared no pains to obtain them. Amongst the many precious manuscripts his former master, St. Finnian, had obtained in Rome was the first copy of St. Jerome's psalter to reach Ireland. St. Columba borrowed the book of which he surreptitiously made a copy for his own use. St. Finnian, however, on being told what he had done, laid claim to the transcript. Columba refused to give it up, and the case was laid before King Diarmaid, overlord of Ireland. The verdict went against Columba.

This sentence Columba bitterly resented, but he was soon to have a much more serious grievance against the king. For when Curnan of Connaught, after fatally injuring an opponent in a hurling match, took refuge with Columba, he was dragged from his protector's arms and slain by Diarmaid's men in defiance of the rights of sanctuary. The war which broke out shortly afterwards between Columba's clan and Diarmaid's followers is stated in most of the Irish *Lives* to have been instigated by Columba, and after the battle of Cuil Dremne in which 3000 were slain he was accused of being morally responsible for their death. The synod of Telltown in Meath passed upon him a censure which would have been followed by an excommunication but for the intervention of St. Brendan. Columba's own conscience was uneasy, and by the advice of St. Molaise he determined to expiate his offense by exiling himself from his own country and by attempting to win for Christ as many souls as had perished in the battle of Cuil Dremne.

This is the traditional account of the events which led to Columba's departure from Ireland, and it is probably correct in the main. At the same time it must be admitted that missionary zeal and love of Christ are

the only motives ascribed to him by his earliest biographers or by St. Adamnan, who is our chief authority for his subsequent history. In the year 563 Columba embarked with twelve companions — all of them his blood relations — in a wicker coracle covered with leather, and on the eve of Pentecost he landed on the island of Iona. He was in his forty-second year. His first work was the building of the monastery which was to be his home for the rest of his life and which was to be famous throughout western Christendom for centuries. At first Columba appears to have devoted his missionary effort to teaching the imperfectly instructed Christians of Dalriada — most of whom were of Irish descent — but after about two years he turned his attention to the evangelization of the Scotland Picts. Accompanied by St. Comgall and St. Canice he made his way to the castle of the redoubtable King Brude at Inverness.

That pagan monarch had given orders that they were not to be admitted, but when St. Columba upraised his arm to make the sign of the cross, bolts were withdrawn, gates fell open, and the strangers entered unhindered. Impressed by their supernatural powers the king listened to their words and ever afterwards held Columba in high honor.

When not engaged on missionary or diplomatic expeditions his headquarters continued to be at Iona, where he was visited by persons of all conditions, some desiring spiritual or bodily help, some attracted by his reputation for sanctity, his miracles and his prophecies. His manner of life was most austere; and in his earlier life he was apt to be no less hard with others. But with the passage of time his character mellowed and the picture painted by St. Adamnan of his serene old age shows him in a singularly attractive light, a lover of man and beast. As his strength began to fail he spent much time transcribing books. On the day before his death he was copying the Psalter, and had written, "They that love the Lord shall lack no good thing," when he paused and said, "Here I must stop: let Baithin do the rest." Baithin was his cousin whom he had nominated as his successor.

That night when the monks came to the church for Matins, they found their beloved abbot outstretched helpless and dying before the altar. As his faithful attendant Diarmaid gently upraised him he made a feeble effort to bless his brethren and then immediately breathed his last. Columba was indeed dead, but his influence lasted on, extended until it came to dominate the churches of Scotland, Ireland and Northumbria. For three-quarters of a century and more, Celtic Christians in those lands upheld Columban traditions in certain matters of order and ritual in opposition to those of Rome itself.

Adamnan, St. Columba's biographer, had not personally known him. A successor in the office of abbot at Iona itself, he must have been steeped in the traditions which such a personality could not fail to have created for those who followed in his footsteps. Adamnan in any case deserves to be quoted. "He had the face of an angel; he was of an excellent nature, polished in speech, holy in deed, great in counsel. He never let a single hour pass without engaging in prayer or reading or writing or some other occupation. He endured the hardships of fasting and vigils without intermission by day and night, the burden of a single one of his labors would seem beyond the powers of man. And, in the midst of all his toils, he appeared loving unto all, serene and holy, rejoicing in the joy of the Holy Spirit in his inmost heart."

ST. COLUMBA

From MS. Rawl. B. 514. Bodleian Library, Oxford University

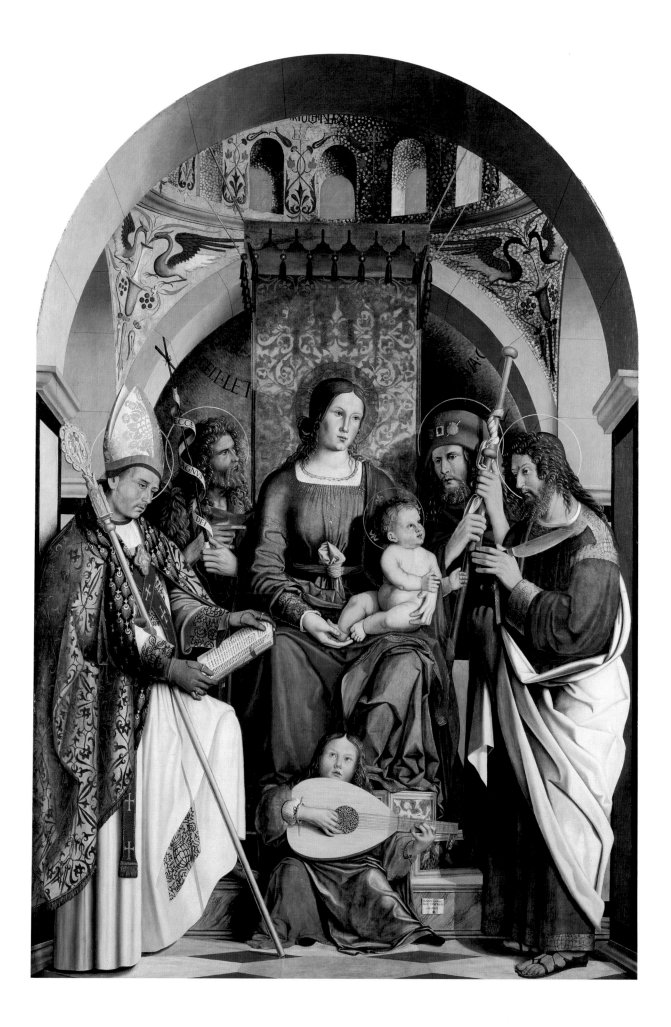

ST. GALL

October 16

Patron Saint of Sweden; Switzerland

S<small>T. GALL WAS BORN</small> in Ireland and educated in the great monastery of Bangor under the direction of the holy abbot Comgall and of St. Columban. When St. Columban left Ireland St. Gall was one of those twelve who accompanied him into France, where they founded the monastery of Annegray and two years afterwards that of Luxeuil, where St. Gall lived for twenty years. When Columban was driven thence in 610 St. Gall shared his exile and they eventually found themselves in Austrasia. The people did not receive their new teachers gladly, and they soon left. Then one Willimar, priest of Arbon, afforded them a retreat. The servants of God built themselves cells near Bregenz, converted many idolaters, and at the end of one of his sermons Gall broke their brazen statues and threw them into the lake. The bold action made as many enemies as it did converts, but they stayed there for two years. But the people who remained obstinate persecuted the monks and slew two of them; and on his opponent King Theoderic becoming master of Austrasia St. Columban decided to retire into Italy, about 612. St. Gall was unwilling to be separated from him, but was prevented from bearing him company by sickness. St. Columban, however, did not believe Gall was so ill as all that and thought he was malingering, wherefore he imposed on him never again to celebrate Mass during his (Columban's) lifetime. This unjust sentence St. Gall obeyed. After his master and brethren had departed, Gall packed up his nets and went off by boat to stay with Willimar at Arbon. Then, directed by the deacon Hiltibod, he selected a suitable spot by the river Steinach and settled down there to be a hermit. He soon had disciples, who lived under his direction according to the Rule of St. Columban.

St. Gall learned in a vision of the death of St. Columban at Bobbio. At the death of St. Eustace, whom Columban had left abbot of Luxeuil, the monks chose St. Gall; but that house was then grown rich in lands and possessions, and the humble servant of God understood too well the advantages of poverty in a penitential life to suffer himself to be robbed of it. Instead he continued to be taken up in the apostolic labors of the ministry. He only left his cell to preach and instruct.

St. Gall was certainly a principal missionary of Switzerland (his feast is kept there as well as in Ireland), but his own fame has been exceeded by that of the monastery bearing his name which grew up on the site of his hermitage on the Steinach, where is now the town of Saint-Gall in the *canton* of the same name. In the eighth century it was organized by Otmar, and during the middle ages it rendered incalculable service to learning, literature, music and other arts; its library and *scriptorium* were among the most famous of western Europe. It was secularized after the Revolution, but happily a large part of the library remains, adjoining the rebuilt abbey church, now the cathedral of the diocese of Saint-Gall.

ST. GALL

Marco Marziale. *Altarpiece: The Virgin and Child with Saints*, 1507. National Gallery, London (from left to right: SS. Gall and John the Baptist; the Blessed Virgin Mary with the Infant Jesus; SS. James the Greater and Bartholomew)

ST. ELIGIUS, OR ELOI, BISHOP OF NOYON

December 1

Patron Saint of Farriers; Jewelers; Metalworkers; Smiths; Tertiaries

THE NAME OF ELIGIUS, and those of his father, Eucherius, and his mother, Terrigia, show him to have been of Roman Gaulish extraction. He was born at Chaptelat, near Limoges, about the year 588, the son of an artisan. His father, seeing in due course that the boy had a remarkable talent for engraving and smithing, placed him with a goldsmith named Abbo, who was master of the mint at Limoges. When the time of his apprenticeship was finished Eligius went into France, that is, across the Loire, and became known to Bobbo, treasurer to Clotaire II at Paris. This king gave Eligius an order to make him a chair of state, adorned with gold and precious stones. Out of the materials furnished he made two such thrones instead of one. Clotaire admired the skill and honesty of the workman, and finding that he was a man of parts and intelligence took him into his household and made him master of the mint. Eligius did not let the corruption of a court infect his soul or impair his virtue, but he conformed to his state and was magnificently dressed, sometimes wearing nothing but silk (a rare material in France in those days), his clothes embroidered with gold and adorned with precious stones. But he also gave large sums in alms. When a stranger asked for his house he was told, "Go to such a street, and it's where you see a crowd of poor people."

St. Eligius was chosen to be bishop of Noyon and Tournai, at the same time as his friend St. Audoenus was made bishop of Rouen. They were consecrated together in the year 641. Eligius proved as good a bishop as he had been a layman, and his pastoral solicitude, zeal and watchfulness were most admirable. Soon he turned his thoughts to the conversion of the infidels, who were a large majority in the Tournai part of his diocese, and a great part of Flanders was chiefly indebted to St. Eligius for receiving the gospel.

When he had governed his flock nineteen years Eligius was visited with a foresight of his death, and foretold it to his clergy. Falling ill of a fever, he on the sixth day called together his household and died a few hours later, on December 1, 660. After some dispute, the people of Noyon saw that the remains of their pastor were left with them and not brought to the monastery at Chelles. They were afterwards translated into the cathedral, where a great part of them remain. St. Eligius was for long one of the most popular saints of France, and his feast was universal in north-western Europe during the later middle ages. In addition to being the patron saint of all kinds of smiths and metalworkers, he is invoked by farriers and on behalf of horses: this on account of legendary tales about horses that have become attached to his name. He practiced his art all his life, and a number of existing "pieces" are attributed to him.

ST. ELIGIUS
Petrus Christus. *St. Eligius*, 1449. Metropolitan Museum of Art, New York

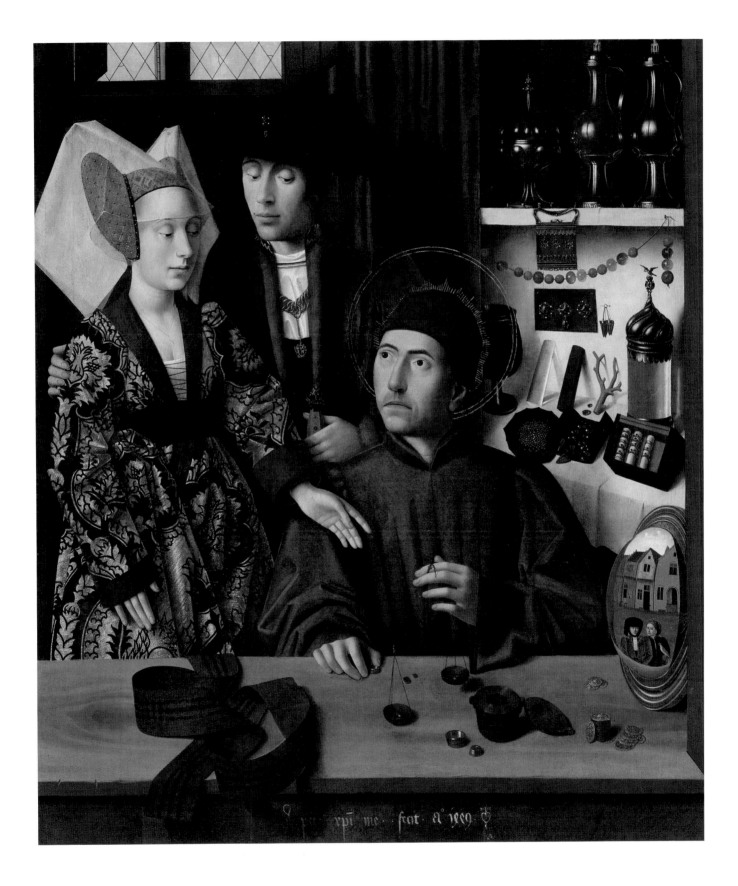

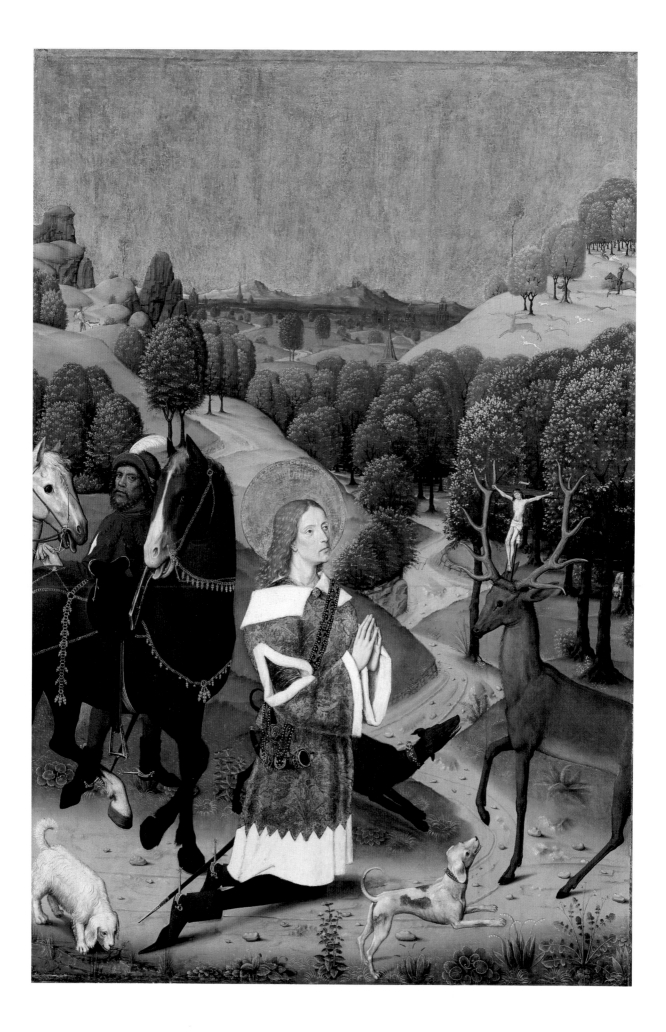

ST. HUBERT, BISHOP OF LIÈGE

November 3

Patron Saint of Hunters

HUBERT WAS VERY FOND of hunting and one Good Friday went out after a stag when everybody else was going to church. In a clearing of the wood the beast turned, displaying a crucifix between its horns. Hubert stopped in astonishment, and a voice came from the stag, saying, "Unless you turn to the Lord, Hubert, you shall fall into Hell." He cast himself on his knees, asking what he should do, and the voice told him to seek out Lambert, the bishop of Maestricht, who would guide him. This is the same as the legend of the conversion of St. Eustace (September 20).

Hubert entered the service of St. Lambert and was ordained priest. When the bishop was murdered at Liège about the year 705 Hubert was selected to govern the see in his place. Some years later he translated Lambert's bones from Maestricht to Liège, then only a village upon the banks of the Meuse, which from this grew into a flourishing city. St. Hubert placed the relics of the martyr in a church which he built upon the spot where he had suffered and made it his cathedral, removing thither the episcopal see from Maestricht. Hence St. Lambert is honored at Liège as principal patron of the diocese and St. Hubert as founder of the city and church, and its first bishop.

In those days the forest of Ardenne stretched from the Meuse to the Rhine and in several parts the gospel of Christ had not yet taken root. St. Hubert penetrated into the most remote and barbarous places of this country and abolished the worship of idols; and as he performed the office of the apostles, God bestowed on him a like gift of miracles. Amongst others, the author of his life relates as an eye-witness that on the rogation-days the holy bishop went out of Maestricht in procession through the fields and villages, with his clergy and people according to custom, following the standard of the cross and the relics of the saints, and singing the litany. This procession was disturbed by a woman possessed by an evil spirit; but St. Hubert silenced her and restored her to her health by signing her with the cross. Before his death he is said to have been warned of it in a vision and given as it were a sight of the place prepared for him in glory. Twelve months later he went into Brabant to consecrate a new church. He was taken ill immediately after at Tervueren, near Brussels. On the sixth day of his sickness he quietly died, on May 30, in 727. His body was conveyed to Liège and laid in the church of St. Peter. It was translated in 825 to the abbey of Andain, since called Saint-Hubert, in Ardenne, on the frontiers of the duchy of Luxembourg. November 3, the date of St. Hubert's feast, is probably the day of the enshrining of his relics at Liège sixteen years after his death. St. Hubert is, with St. Eustace, patron saint of hunting-men, and is invoked against hydrophobia.

ST. GILES, ABBOT

September 1

Patron Saint of Beggars; Blacksmiths; Cripples

THE LEGEND OF St. GILES (Aegidius) is one of the most famous of the middle ages. According to this he was an Athenian by birth, and during his youth cured a sick beggar by giving him his own cloak. Giles dreaded temporal prosperity and the applause of men and he therefore took ship for the west, landed at Marseilles, and eventually made his hermitage in a wood near the mouth of the Rhône. In this solitude he was for some time nourished with the milk of a hind, which was eventually pursued by a certain king of the Goths, Flavius, who was hunting in the forest. The beast took refuge with St. Giles in his cave, and the hounds gave up their chase; on the following day the hind was found again and the same thing happened; and again on the third day, when the king had brought with him a bishop to watch the peculiar behavior of his hounds. This time one of the huntsmen shot an arrow into the cave, and when they had forced their way through the bushes they found Giles, wounded by the arrow, sitting with the hind between his knees. Later when Flavius heard Giles' story he begged his pardon and promised to send physicians to attend him. Giles begged them to leave him alone and refused all the gifts they pressed upon him.

King Flavius continued frequently to visit St. Giles, who eventually asked him to devote his proffered alms to founding a monastery; this the king agreed to do provided Giles would become its first abbot. In due course the monastery was built near the cave. Giles was sent for to the court at Orléans, where the king consulted him on spiritual matters but was ashamed to name a grievous sin that was on his conscience. "On the following Sunday, when the holy man was celebrating Mass, an angel of the Lord appeared to him and laid on the altar a scroll on which was written the sin which the king had committed, and which further said that he would be forgiven at Giles's intercession, provided he did penance and desisted from that sin in the future. . . . When Mass was ended Giles gave the scroll to the king to read, who fell at the saint's feet, begging him to intercede with the Lord for him. And so the man of the Lord commended him to God in prayer and gently admonished him to refrain from that sin in the future." St. Giles then returned to his monastery and afterwards went to Rome to commend his monks to the Holy See. The pope granted them many privileges and made a present of two carved doors of cedar-wood; to emphasize his trust in divine providence St. Giles threw these doors into the Tiber, and they safely preceded him to France. After being warned of his approaching end in a dream, he died on a Sunday, September 1.

The most that is known for certain of St. Giles is that he may have been a hermit or monk near the mouth of the Rhône in the sixth or eighth century, and that his relics were claimed by the famous monastery that bore his name. His cult spread throughout western Europe; England had so many as 160 parish churches dedicated in his honor.

ST. GILES
Master of St. Giles. *St. Giles and the Hind.* National Gallery, London

164

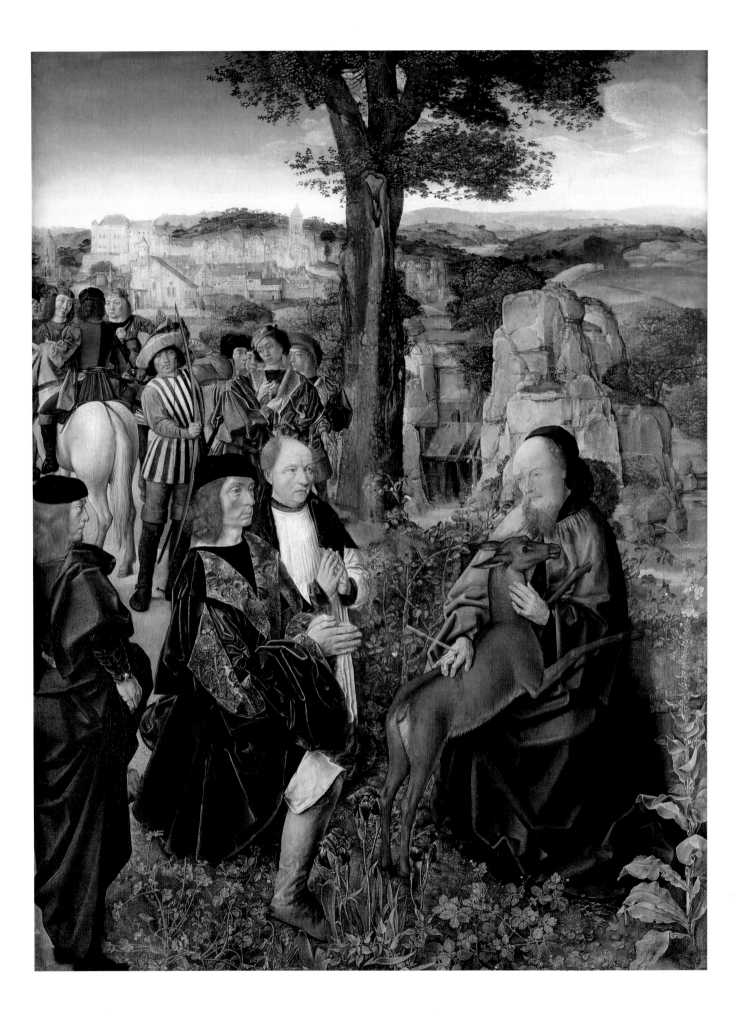

ST. BEDE THE VENERABLE, DOCTOR OF THE CHURCH

May 27

ALMOST ALL THAT IS KNOWN about the life of St. Bede is derived from a short account he has given of himself and from a touching description of his last hours written by one of his disciples, a monk called Cuthbert.

That Bede sometimes visited friends in other monasteries has been inferred from the fact that in 733 he stayed for a few days in York with Archbishop Egbert; but except for such brief interludes his life was spent in a round of prayer and praise, of writing and of study. A fortnight before Easter 735 he began to be much troubled by shortness of breath, and all seem to have realized that the end was near. Nevertheless his pupils continued to study by his bedside and to read aloud, their reading often interrupted by tears. He for his part gave thanks to God. During the "Great Forty Days" from Easter to the Ascension, in addition to singing the office and instructing his pupils, he was engaged on a translation of St. John's Gospel into English, and a collection of notes from St. Isidore; for, he said, "I will not have my scholars read what is false or labour unprofitably on this after my death."

After a wakeful night spent in thanksgiving he began to dictate the last chapter of St. John. At three in the afternoon he sent for the priests of the monastery, distributed to them some pepper, incense and a little linen which he had in a box and asked for their prayers. In the evening the boy who was acting as his amanuensis said, "There is still one sentence, dear master, which is not written down," and when that last passage had been supplied and he was told that it was finished, Bede exclaimed, "You have well said . . . all is finished. Take my head in your hands that I may have the comfort of sitting opposite the holy place where I used to pray and that, so sitting, I may call upon my Father." And on the floor of his cell, singing "Glory be to the Father and to the Son and to the Holy Ghost," he breathed his last.

Several fantastic stories have been invented to account for the title of "Venerable" by which Bede is known. We find it applied to Bede by the Council of Aachen in 836, and the title seems to have struck the public imagination as peculiarly suitable. It has clung to him through the succeeding centuries and, though in 1899 he was authoritatively recognized as saint and doctor of the Church, it remains his special designation to this day.

Bede, the only English doctor of the Church, is the only Englishman who sufficiently impressed Dante to name him in the *Paradiso*. That that one should be Bede is not surprising: the monk who hardly left his monastery became known throughout England and far beyond — his homilies and his famous work, the *Ecclesiastical History of the English People*, are read in the Divine Office everywhere in the Western church. St. Boniface said of Bede that he was "a light of the Church lit by the Holy Ghost"; and that light has never been quenched, even in this world.

Incipit prephatio vene-
rabilis bede presbiteri.
in uitam beati patris
cuthberti lindisfarnensis.

DOMINO AC BEATISSIMO pa-
patri EADFRIDO epo. &
omni egregacioni fratru q
in lindisfarnensi insula
xpo deseruiunt. beda fidel-
iū eternuus salutē. Quia iuf-
sistis dilectissimi. ut libro quē
de uita beate memorie patris nri
CVTHBERTI uiro rogatu compofui. prefatione aliq in fron-
te iuxta morē prefigerē. p quā legentib unuisis. & uire
uoluntatis desideriū. & obedicionis nre parte assensio
fina clarescerē. placuit incapite prefationis & uob
q noftis. ad memoriā reuocare. & eis q ignorant hec
forte legentib. notū facere. qa nec sine certissima in-
qfitione reru geftaru. aliqd de tanto uiro scribe. nec tan-
dē ea que scripserā sine subtili examinatione teftiū
in dubiors pisti trāfscribenda qbufdā dare prefumfisse.
qn potiq prefimo diligent exordiū. pgressū. & tmū glo-
fiffimē cū satonis acumine illā ab his q nouerant. in-
ueftigasse. Quorū etiā nomina in ipso libro aliquot-
ens ob certū cognite ueritatis indiciū apponenda iu-
dicaui. & sic demum ad scedulas manum mittere
incipio. At digefto opuscule. sed adhuc in scedulis
retento. ufq frequentē & reuerentiffimo fri nro herefrido
presbitero huc aduentanti. & aliis qui diutiq cuiu-
ro di cūfati. uitā illuf optime nouerant. que scrip-
si legenda atq; extpore pfcire retractanda. ac ñ
nulla ad arbitriū eors pire uidebantur. sedulo em-
daui. sicq; ablatis oīb. scrupulors ambagibʼ ad
purū. certi ueritatis indagine simplicib. explici-
tū sermonibʼ comdare membranulis. atq; ad uirā
qq; trinitatis prefentiā asportare curaui. quatinus

ST. WENCESLAUS OF BOHEMIA, MARTYR

September 28

Patron Saint of Bohemia; Czechoslovakia

THE BAPTISM OF THE RULER of Bohemia, Borivoy, and his wife St. Ludmila was not by any means followed by the conversion of all their subjects, and many of the powerful Czech families were strongly opposed to the new religion. From the year 915 Duke Borivoy's son Ratislav governed the whole country. He married a nominally Christian woman, Drahomira, and they had two sons, Wenceslaus (Vaclav), and Boleslaus. St. Ludmila, who was still living, arranged that the upbringing of the elder might be entrusted to her. Wenceslaus was still young when his father was killed fighting against the Magyars, and his mother Drahomira assumed the government, pursuing an anti-Christian or "secularist" policy. In so doing she was probably acting chiefly at the instigation of the semi-pagan elements in the nobility, and these encouraged her jealousy of St. Ludmila's influence over her son, and represented him as being more suitable for a cloister than for a throne. St. Ludmila, afflicted at the public disorders and full of concern for the interest of religion, which she and her consort had established with so much difficulty, showed Wenceslaus the necessity of taking the reins of government into his own hands. Fearing what might happen, two nobles went to Ludmila's castle at Tetin and there strangled her, so that, deprived of her support, Wenceslaus should not undertake the government of his people. But it turned out otherwise: other interests drove Drahomira out, and proclaimed Wenceslaus. He straightway announced that he would support God's law and His Church, punish murder severely, and endeavor to rule with justice and mercy. His mother had been banished to Budech, so he recalled her to the court, and there is no evidence that for the future she ever opposed him. When the young duke married and had a son, his jealous brother Boleslaus lost his chance of the succession, and he threw in his lot with the malcontents.

In September 929 Wenceslaus was invited by Boleslaus to go to Stara Boleslav to celebrate the feast of its patron saints Cosmas and Damian. On the evening of the festival, after the celebrations were over, Wenceslaus was warned he was in danger. Early the next morning, as Wenceslaus made his way to Mass, he met Boleslaus, who struck him. The brothers closed and struggled; whereupon friends of Boleslaus ran up and killed Wenceslaus, who murmured as he fell at the chapel door, "Brother, may God forgive you."

At once the young prince was acclaimed by the people as a martyr and at least by the year 984 his feast was being observed. Boleslaus, frightened at the reputation of many miracles wrought at his brother's tomb, caused the body to be translated to the church of St. Vitus at Prague three years after his death. The shrine became a place of pilgrimage, and at the beginning of the eleventh century St. Wenceslaus, Svaty Vaclav, was already regarded as the patron saint of the Bohemian people; and as the patron of modern Czechoslovakia devotion to him has sometimes been very highly charged with nationalist feeling.

ST. WENCESLAUS OF BOHEMIA
Heinrich Parler. *St. Wenceslaus,* 1353. Chapel of St. Wenceslaus, St. Vitus Cathedral, Prague

ST. DUNSTAN,
ARCHBISHOP OF CANTERBURY

May 19

Patron Saint of Armorers; Blacksmiths; Goldsmiths; Jewelers; Lighthouse Keepers;
Locksmiths; Musicians; Silversmiths

St. DUNSTAN, THE MOST FAMOUS of all the Anglo-Saxon saints, was born (*c.* 910) near Glastonbury of a noble family closely allied to the ruling house. While still a lad, he was sent to the court of King Athelstan. There he incurred the ill-will of some: they accused him of practicing incantations — he was a very studious youth — and obtained his expulsion. He had already received the tonsure, and his uncle, St. Alphege the Bald, Bishop of Winchester, to whom he now betook himself, urged him to embrace the religious life. Dunstan demurred for a time, but after his recovery from a skin trouble which he took to be leprosy he hesitated no longer, receiving the habit and subsequently holy orders at the hands of his saintly kinsman. Returning to Glastonbury, he is said to have built himself a small cell adjoining the old church. There he divided his time between prayer, study, and manual labor which took the form of making bells and sacred vessels for the church and of copying or illuminating books. He also played the harp, for he was very musical. Indeed we probably possess the actual music of one or more of St. Dunstan's compositions. The chant known as the *Kyrie Rex splendens* is especially famous.

Athelstan's successor, Edmund, recalled St. Dunstan to court and in 943 appointed him abbot of Glastonbury, in consequence of an escape from death while hunting at Cheddar, the king having previously listened to those who wanted Dunstan dismissed. This began the revival of monastic life in England, and has been called a turning point of our religious history. At once the new abbot set about reconstructing the monastic buildings and restoring the church of St. Peter. By introducing monks amongst the clerks already in residence, he was able without too much friction to enforce regular discipline. Moreover, he made of the abbey a great school of learning. Other monasteries were revived from Glastonbury, and the work was carried on as well by St. Ethelwold from Abingdon and St. Oswald from Westbury.

St. Dunstan has always been honored as the patron of goldsmiths, jewelers and locksmiths. His dexterity as a metal-worker seized upon the popular imagination and, in the eleventh century, gave rise to the popular legend that he once, with a pair of blacksmith's pincers, seized the nose of the Devil who was trying to tempt him; a story which tended to make people forget he was "one of the makers of England." His feast is kept in several English dioceses and by the English Benedictines.

Dunstanum memet clemens rogo xpe tuere
Tenarias me non sinas sorbsisse procellas

ST. EDWARD THE CONFESSOR

French School (about 1395). *Richard II Presented to the Virgin and Child by His Patron Saints* ("*The Wilton Diptych*"),
c. 1394–1399. National Gallery, London (left panel, from left to right: SS. Edmund, Edward the Confessor, and John the Baptist)

ST. EDWARD THE CONFESSOR

October 13

Patron Saint of the City of Westminster

AFTER THE NEGLECT, quarreling and oppression of the reigns of the two Danish sovereigns Harold Harefoot and Harthacanute, the people of England gladly welcomed the representative of the old English line of kings, known in history as Edward the Confessor. For the peace and relief that prevailed during his reign, he was undoubtedly one of the most popular of English sovereigns, though his significance was much exaggerated later by the Normans. And the noble qualities for which Edward is venerated as a saint belonged to him rather as a man than as a king; he was devout, gentle and peace-loving but with hardly sufficient force to stand up to some of the strong characters by whom he was surrounded. On the other hand he was not feeble and pietistic, as is now sometimes alleged, and had a quiet determination. Edward was the son of Ethelred the Redeless by his Norman wife Emma, and during the Danish supremacy was sent to Normandy for safety, with his brother Alfred, when he was ten years old. Alfred came to England in 1036 but was seized and mutilated, and died by the brutality of Earl Godwin. Thus Edward did not set foot again in his native land until he was called to be king in 1042: he was then forty years old. Two years later he married Edith, the daughter of Godwin: a beautiful and religious girl.

Godwin for his part was the chief opponent of a certain Norman influence which had its center at the royal court and made itself felt in appointments to bishoprics and offices as well as in lesser matters. After a series of "incidents," things came to a crisis and Godwin and his family were banished; even his daughter, Edward's queen, was confined to a convent for a time. In the same year, 1051, William of Normandy visited the English court, and it can hardly be doubted that Edward then offered him the succession to the crown: the Norman conquest began, not at the battle of Hastings, but at the accession of St. Edward.

The last year of St. Edward's life was disturbed by troubles between the Northumbrians and their earl, Tostig Godwinsson, whom eventually the king was constrained to banish. At the end of the year, when the nobles of the realm were gathered at the court for Christmas, the new choir of Westminster abbey-church was consecrated with great solemnity, on Holy Innocents' day, 1065. St. Edward was too ill to be present; he died a week later, and was buried in his abbey.

In 1161 he was canonized, and two years later his incorrupt body was translated to a shrine in the choir by St. Thomas Becket, on October 13. There was a further translation, in the thirteenth century, to a shrine behind the high altar, and there the body of the Confessor still lies. St. Edward is the principal patron of the city of Westminster and a lesser patron of the archdiocese; his feast is not only kept all over Great Britain but throughout the Western church since 1689.

ST. OLAF OF NORWAY, MARTYR

July 29

Patron Saint of Norway

OLAF WAS THE SON of Harold Grenske, a lord in Norway, and after eight years of piracy and fighting succeeded his father in 1015 at the age of twenty, at a time when most of Norway was in the hands of the Danes and Swedes. These parts he conquered and then set about the subjection of the realm to Christ, for he himself had already been baptized at Rouen by Archbishop Robert; the work had been begun, but had not made much real progress, by Haakon the Good and by Olaf Tryggvason, whose methods of "evangelization" seem to have been preposterous and wicked. In 1013 Olaf Haraldsson had sailed to England and assisted King Ethelred against the Danes, and he now turned to that country for help in his more peaceable task. He brought over from England a number of priests and monks, one of whom, Grimkel, was chosen bishop of Nidaros, his capital. Olaf relied much on the advice of this prelate, and by his counsel published many good enactments and abolished ancient laws and customs contrary to the gospel. Unfortunately, like St. Vladimir of Russia and other princes who sought to convert their people, he was not content with exhortation, his zeal was often more than his prudence, and he used force without compunction. To his enemies he was merciless, added

to which some of his legislation and political objects were not everywhere approved. Therefore many rose in arms, and, with the assistance of Canute, King of England and Denmark, defeated and expelled him. St. Olaf fled, but returned with a few Swedish troops to recover his kingdom; he was slain by his rebellious and infidel subjects in a battle fought at Stiklestad, on July 29, 1030.

The king's body was buried in a steep sandbank by the river Nid, where he had fallen; here a spring gushed out whose waters became credited with healing power, and the bishop, Grimkel, in the following year ordered that he was to be there venerated as a martyr and a chapel built over the place. Miracles were reported at the shrine, and on the return of his son Magnus to power the veneration of St. Olaf became widespread; in 1075 the chapel was replaced by a bishop's church, dedicated to Christ and St. Olaf, which in time became the metropolitan cathedral of Nidaros (Trondhjem), which was, both as a building and a shrine, to Scandinavia what Canterbury was to England. During the middle ages the *cultus* of "the perpetual King of Norway" spread to Sweden, Denmark, the British Isles and beyond, and he is still regarded by Norwegians as the patron and national hero of his country.

ST. OLAF OF NORWAY
Unknown sculptor. *St. Olaf,* c. 1470. Museum für Kunst und Kulturegeschichte de Hansestadt, Lübeck

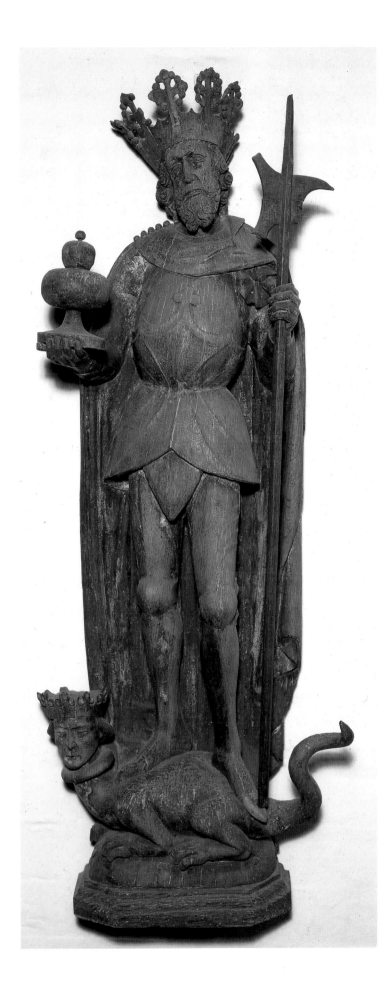

И слышавъ володимиръ ре . аще истинна боудеть .
то поистинѣ великъ бг҃ъ крт҃ьянескъ . и повелѣ крести
ти . ѥпї же корсоуньскый . спопы цр҃цны . ѿ
гласивъ крти володимира . и ꙗко възложи роукоу
на нь про зрѣ . видѣ же володимеръ . на
прасное исцѣлѣниѥ . и прослави бг҃а рекъ перво ведѣ ба҃

И ѥже видѣвъши дроужина . мнози крт҃иша . крт҃ꙗ же а въ цр҃кви
не то ꙗ бꙋ . не цр҃кви стоꙗщи . в корсꙋни на гра на мѣстѣ
дѣ ꙗ же на торгꙋ̀ . полата володимира въ краи цр҃кви
стоить . и до сего дн҃и . а цр҃цна полата за олтаремъ . по кре
щении же приведе цр҃цю на бр҃оучаниѥ :.

ST. VLADIMIR OF KIEV

July 15

Patron Saint of Russia; Russian Catholics

URING THE LAST QUARTER of the tenth century the grand-prince of Kiev was Vladimir, a man not only reared in idolatry but one who freely indulged in the barbarous excesses that were available to one in his position: he was brutal and bloodthirsty, and a contemporary Arabian chronicler, ibn-Foslan, comments on his five wives and numerous female slaves. The circumstances of this prince's conversion to Christianity have been and still are much debated, but converted he was, probably in the year 989, when he was about thirty-two; and he then received in marriage Anne, daughter of the emperor Basil II at Constantinople. The conversion of the Russian people is dated from then.

The fact that pious writers have attributed perfect purity of motive to Vladimir, when undoubtedly he was moved in great measure by the prospect of political and economic advantages from an alliance with the Byzantines and the Christian Church, must not be allowed to obscure that, once having accepted Christianity, he is said to have been wholehearted in his adherence to it. He put away his former wives and mistresses and amended his life; he had idols publicly thrown down and destroyed; and he supported the Greek missionaries with energy and enthusiasm — indeed, with an excess of energy, for at times he did not stop short of "conversion" by force: to refuse baptism was to incur penalties. Nevertheless he was revered in after years not only because he was a sinner

who repented but also because he brought about the reconciliation of the Russian people with God.

It would seem that his repentance and understanding of his new obligations were of that simple, straightforward kind which will forever remain at the heart of the most developed and complex Christianity: "When he had in a moment of passion fallen into sin he at once sought to make up for it by penitence and almsgiving," says the Chronicle of Nestor. It is said that he even had scruples whether, now that he was a Christian, he was entitled to punish robbers or even murderers by putting them to death. Such ideas astonished the sophisticated Greek ecclesiastics, who appealed to examples in the Old Testament and Roman history to show that punishment of the wicked was the duty of a Christian prince. But Vladimir seems to have been only half convinced.

Vladimir's conversion brought his people within the Byzantine patriarchate, but he was not particularist. He exchanged ambassadors with the apostolic court of Rome and he even borrowed certain canonical features from the West, notably the institution of tithes, which were unknown to the Byzantines. Not till the Mongol invasions was Christian Russia cut off from the West.

St. Vladimir died in 1015, after giving away all his personal belongings to his friends and to the poor. His feast is solemnly celebrated by the Russians, Ukrainians and others.

ST. VLADIMIR OF KIEV
The Baptism of Vladimir, Prince of Kiev, in Cherson in 988, 15th cent. Academy of Science, St. Petersburg

ST. BORIS, MARTYR

July 24

Patron Saint of Russia

AFTER THE DEATH of the first Christian prince in Russia, St. Vladimir of Kiev, the inheritance should, according to the custom of succession at that time and place, have passed to all his sons and been divided among them. But the elder, Svyatopolk, had other ideas on the subject and determined to remove the two young princes Boris and Gleb, Vladimir's sons. Boris was on his way back from an expedition against some troublesome nomadic tribes when he learned what was in the wind, and his military following prepared to defend him. But he would not allow it. "It is not right," he said, according to a chronicler, "that I should raise my hand against an elder brother who now stands for me in the place of my father. It is better for me to die alone than to be the occasion of death to many."

So Boris dismissed his followers, and sat down to wait with one attendant on the bank of the river Alta. During the night he meditated on those martyrs who had been put to death by near relatives, on the emptiness of all earthly things "except good deeds and true love and right religion," and he was sad to think that he must leave the "marvelous light" of day and his "good and beautiful body."

Early in the morning a gang of ruffians sent by Svyatopolk found Boris and set upon him; they ran him through with spears, while he called down peace on them. As they approached Kiev with the body, Boris was found still to be breathing, so two Varangians finished him with their swords. St. Gleb, younger than Boris, met his end soon after.

Five years later, in 1020, another son of St. Vladimir, Yaroslav, buried the incorrupt bodies of Boris and Gleb in the church of St. Basil at Vyshgorod; their tomb became a place of pilgrimage and miracles were reported there. The Greek metropolitan of Kiev was asked to declare their formal canonization, but he was more than dubious, for they did not come under any of the categories of saints with which he was familiar: they had not been great ascetics, they had not been bishops or teachers, they had not been martyrs, for they did not die for the faith. But the Russians saw them as *strastoterptsy,* "passion-bearers," innocent men who, unwilling to die, had yet repudiated violence and quietly accepted suffering and death in the unresisting spirit of Christ. It was a conception characteristically Russian, as it is characteristically Christian, and popular feeling was so strong that the Greek ecclesiastical authorities in Russia submitted to what they seem not to have understood, and Boris and Gleb were enrolled among the saints. This verdict was confirmed by Pope Benedict XIII in 1724.

These brothers are sometimes referred to as SS. Romanus and David, names they were given at baptism. Liturgically they are called martyrs.

ST. BORIS
Ikon of SS. Boris and Gleb on Horseback, second half of 14th cent. Tretyakov Gallery, Moscow

ST. STANISLAUS,
BISHOP OF CRACOW, MARTYR

May 7

Patron Saint of Cracow

THE *cultus* of St. Stanislaus is widespread in Poland — especially in his episcopal city of Cracow, which honors him as principal patron and preserves the greater part of his relics in the cathedral. His biography, written some four hundred years after his death, by St. Casimir's tutor, the historian John Dlugosz, seems to be an uncritical compilation from various earlier writings and from oral tradition, for it contains several conflicting statements, besides a certain amount of matter which is obviously purely legendary.

Stanislaus Szczepanowski was born on July 26, 1030, at Szczepanow. He came of noble parents, who had been childless for many years until this son was vouchsafed to them in answer to prayer. They devoted him from his birth to the service of God, and encouraged in every way the piety which he evinced from early childhood. He was educated at Gnesen and afterwards, we are told, "at the University of Paris," which at that time had not yet come into existence. Eventually he was ordained priest by Lampert Zula, bishop of Cracow, who gave him a canonry in the cathedral and subsequently appointed him his preacher and archdeacon. The eloquence of the young priest and his saintly example brought about a great reformation of morals amongst his penitents — clergy as well as laity flocking to him from all quarters for spiritual advice. Bishop Lampert wished to resign the episcopal office in his favor, but Stanislaus refused to consider the suggestion. However, upon Lampert's death, he could not resist the will of the people seconded by an order from Pope Alexander II, and he was consecrated bishop in 1072. He proved himself a zealous apostle, indefatigable in preaching, strict in maintaining discipline, and regular in his visitations. His house was always crowded with the poor, and he kept a list of widows and other distressed persons to whom he systematically distributed gifts.

Poland at that epoch was ruled by Boleslaus II, a prince whose finer qualities were completely eclipsed by his unbridled lust and savage cruelty. Stanislaus alone ventured to beard the tyrant and to remonstrate with him at the scandal his conduct was causing. At first the king endeavored to vindicate his behavior, but when pressed more closely he made some show of repentance. The good effects of the admonition, however, soon wore off: Boleslaus relapsed into his evil ways. There were acts of rapacity and political injustice which brought him into conflict with the bishop and at length he perpetrated an outrage which caused general indignation. A certain nobleman had a wife who was very beautiful. Upon this lady Boleslaus cast lustful eyes, and when she repelled his advances he caused her to be carried off by force and lodged in his palace. The Polish nobles called upon the archbishop of Gnesen and the court prelates to expostulate with the monarch. Fear of offending the king closed their lips, and the people openly accused them of conniving at the crime. St. Stanislaus, when appealed to, had no such hesitation; he went again to Boleslaus and rebuked him for his sin. He closed his exhortation by reminding the prince that if he persisted in his evil courses he would bring upon himself the censure of the Church, with the sentence of excommunication.

The threat roused the king to fury. He declared that a man who could address his sovereign in such

ST. STANISLAUS

Unknown artist. *Martyrdom of St. Stanislaus of Cracow,*
c. 1490. Museum of Fine Arts, Budapest

terms was more fit to be a swineherd than a shepherd of souls, and cut short the interview with threats. He first had recourse to slander — if we may believe a story related by the saint's later historians. St. Stanislaus, we are told, had bought some land for the Church from a certain Peter, who died soon after the transaction. It was suggested to the deceased man's nephews that they should claim back the land on pretense that it had not been paid for. The case came up before Boleslaus: no witnesses for the defense were allowed to be heard and the verdict seemed a foregone conclusion, when, in answer to a dramatic appeal from St. Stanislaus, the dead man appeared before the court in his grave-clothes and vindicated the bishop. If we can credit this story we are further asked to believe that the marvel produced no permanent change of heart in

Boleslaus, whose barbarity had only increased with time.

At last, finding all remonstrance useless, Stanislaus launched against him a formal sentence of excommunication. The tyrant professed to disregard the ban, but when he entered the cathedral of Cracow he found that the services were at once suspended by order of the bishop. Furious with rage, he pursued the saint to the little chapel of St. Michael outside the city, where he was celebrating Mass, and ordered some of his guards to enter and slay him. The men, however, returned, saying that they could not kill the saint as he was surrounded by a heavenly light. Upbraiding them for cowardice, the king himself entered the building and dispatched the bishop with his own hand. The guards then cut the body into pieces and scattered them abroad to be devoured by beasts of prey. Protected, it is said, by eagles, the sacred relics were rescued three days later by the cathedral canons and privately buried at the door of the chapel in which Stanislaus had been slain.

The above summarizes the story of the martyrdom of St. Stanislaus as it is commonly told. Considerable discussion was caused in Poland by the publication in 1904 of an historical work by Professor Wojchiechowski in the course of which he maintained that Stanislaus had been guilty of treason, had plotted to dethrone his sovereign, and had therefore rightly been put to death. To this charge Professor Miodonski and others replied with vigor. But there seems no doubt that there were some political considerations behind the murder of St. Stanislaus, though the whole business is very uncertain and obscure. It is not true that the action of Boleslaus led to an immediate rising of the people which drove him from Poland; but it certainly hastened his fall from power. Pope St. Gregory VII laid the country under an interdict, and nearly two centuries later, in 1253, St. Stanislaus was canonized by Pope Innocent IV.

ST. MARGARET OF SCOTLAND, MATRON

June 10 or November 16 (in Scotland)

Patron Saint of Scotland

ARGARET WAS A DAUGHTER of Edward d'Outremer ("The Exile"), next of kin to Edward the Confessor, and sister to Edgar the Atheling, who took refuge from William the Conqueror at the court of King Malcolm Canmore in Scotland. There Margaret, as beautiful as she was good and accomplished, captivated Malcolm, and they were married at the castle of Dunfermline in the year 1070, she being then twenty-four years of age. This marriage was fraught with great blessings for Malcolm and for Scotland. He was rough and uncultured but his disposition was good, and Margaret, through the great influence she acquired over him, softened his temper, polished his manners, and rendered him one of the most virtuous kings who have ever occupied the Scottish throne. To maintain justice, to establish religion, and to make their subjects happy appeared to be their chief object in life. Malcolm not only left to Margaret the whole management of his domestic affairs, but also consulted her in state matters.

What she did for her husband Margaret also did in a great measure for her adopted country, promoting the arts of civilization and encouraging education and religion. She found Scotland a prey to ignorance and to many grave abuses, among both priests and people. At her instigation synods were held which passed enactments to meet these evils. She herself was present at these meetings, taking part in the discussions. The due observance of Sundays, festivals and fasts was made obligatory, Easter communion was enjoined upon all, and many scandalous practices, such as simony, usury and incestuous marriages, were strictly prohibited. St. Margaret made it her constant effort to obtain good priests and teachers for all parts of the country, and formed a kind of embroidery guild among the ladies of the court to provide vestments and church furniture. With her husband she founded several churches, notably that of the Holy Trinity at Dunfermline.

In 1093 King William Rufus surprised Alnwick castle, putting its garrison to the sword. King Malcolm in the ensuing hostilities was killed by treachery, and his son Edward was also slain. St. Margaret at this time was lying on her death-bed. When her son Edgar arrived back from Alnwick she asked how his father and brother were. Afraid of the effect the news might have upon her in her weak state, he replied that they were well. She exclaimed, "I know how it is!" Soon afterwards she repeated the words, "O Lord Jesus Christ who by thy death hast given life to the world, deliver me from all evil!" and breathed her last. She died four days after her husband, on November 16, 1093, being in her forty-seventh year, and was buried in the church of the abbey of Dunfermline which she and her husband had founded. St. Margaret was canonized in 1250 and was named patroness of Scotland in 1673.

ST. MARGARET OF SCOTLAND
William Hole. *The Landing of St. Margaret at Queensferry.* National Portrait Gallery, Edinburgh

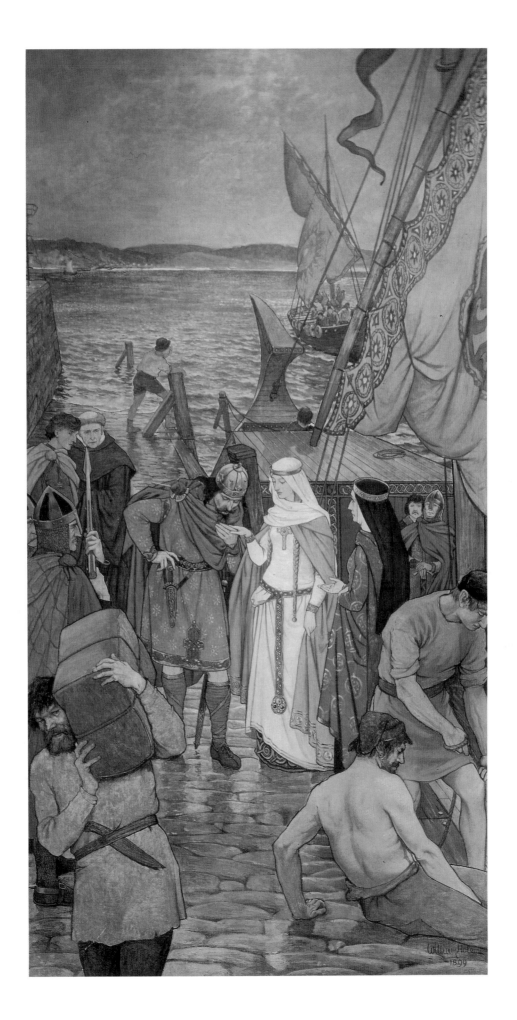

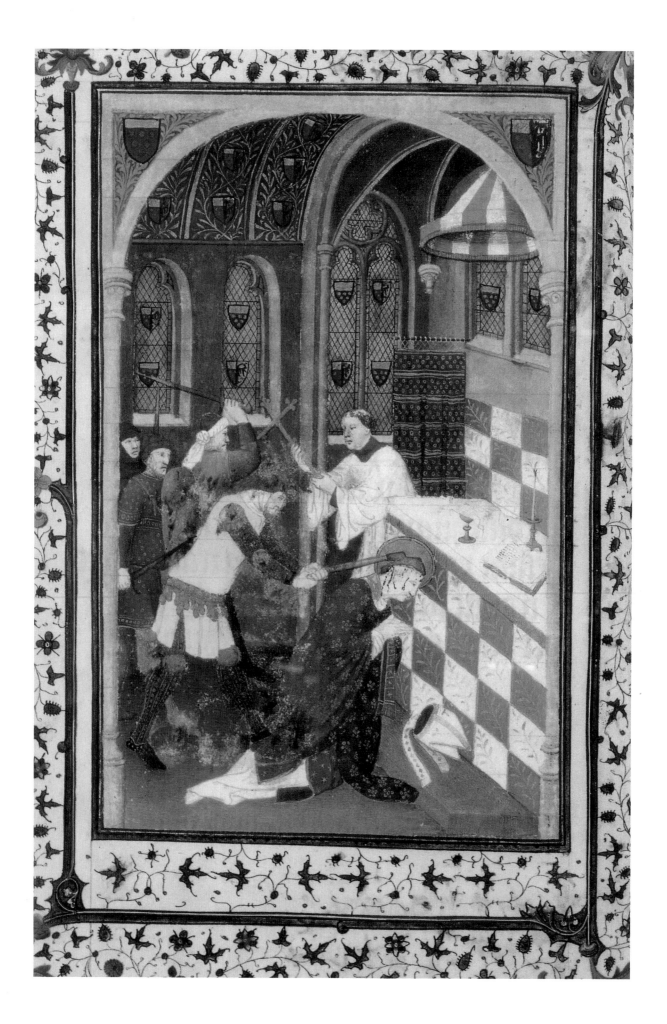

ST. THOMAS BECKET, ARCHBISHOP OF CANTERBURY, MARTYR

December 29

ST. THOMAS BECKET was born on St. Thomas's day 1118, in London. When he was about twenty-four he obtained a post in the household of Theobald, archbishop of Canterbury. He received minor orders and was greatly favored by Theobald, who saw to it that Thomas was provided with a number of benefices. In 1154 he was ordained deacon and the archbishop nominated him archdeacon of Canterbury.

In 1155, at the age of thirty-six, he was appointed chancellor by King Henry II. One of the outstanding virtues of Thomas the Chancellor was unquestionably magnificence — but it is to be feared that he erred by excess of it. His household compared with that of the king, and when he was sent into France to negotiate a royal marriage his personal retinue numbered two hundred men. His entertainments were on a correspondingly generous scale, and his liberality to the poor proportionate. In 1159 Henry raised an army of mercenaries in France to recover his wife's county of Toulouse. In the resulting war Becket served and showed himself not only a good general, but a good fighting-man as well. Clad in armor he led assaults and even, cleric though he was, engaged in hand-to-hand encounters. Though immersion in public affairs and a secular grandeur of state was the predominating aspect of Becket's life as chancellor, it was not the only one. He was proud, irascible, violent and remained so all his life; but we also hear of "retreats" at Merton, of taking the discipline and of prayer in the nightwatches;

and his confessor during the first part of his career testified to the blamelessness of his private life under conditions of extreme danger and temptation.

Theobald died in 1161. King Henry was then in Normandy with his chancellor, whom he had resolved to raise to that dignity. Thomas flatly told the king, "Should God permit me to be archbishop of Canterbury I should soon lose your Majesty's favour, and the affection with which you honour me would be changed into hatred. For several things you do in prejudice of the rights of the Church make me fear you would require of me what I could not agree to; and envious persons would not fail to make this the occasion of endless strife between us." The king paid no regard to his remonstrance; and Thomas refused to acquiesce in accepting the dignity till Cardinal Henry of Pisa, legate from the Holy See, overruled his scruples. The election was made in May 1162. Soon after he received the *pallium* from Pope Alexander III, and by the end of the year there was a notable change in his manner of life. Next his skin he wore a hair-shirt, and his ordinary dress was a black cassock and linen surplice, with the sacerdotal stole about his neck.

Relations between St. Thomas and the king remained for some time pretty much as before. However, accumulation of conflicts provoked the king in October 1163 to call the bishops to a council at Westminster, at which he demanded the handing over of criminal clergy to the civil power for punishment. Then Henry required a promise of observance of his

(unspecified) royal customs. For a brief space St. Thomas, having received little encouragement from Pope Alexander III, was very conciliatory and promised to accept the customs; but when he saw the constitutions in which were expressed the royal customs which he was to uphold, he exclaimed, "By the Lord Almighty, no seal of mine shall be put to them!"

The archbishop was bitterly remorseful for having weakened in his opposition to the king and setting an example which the other bishops were too ready to follow. For forty days and more, while awaiting absolution and permission from the pope, he would not celebrate Mass. He tried assiduously to heal the breach, but Henry now pursued him with persecution. The king refused him audience, and Thomas twice made vain attempts to cross the Channel to put his case before the pope. Then Henry summoned a council at Northampton. It resolved itself into a concerted attack on the archbishop, in which the prelates followed in the wake of the lords. On Tuesday, October 13, 1164, without mitre or *pallium*, but bearing his metropolitan's cross in his own hand, St. Thomas went to the council-hall. The king and the barons were deliberating in an inner room. After a long delay the Earl of Leicester came out and addressed the archbishop. "The king commands you to render your accounts. Otherwise you must hear judgement." "Judgement?" exclaimed St. Thomas, "I was given the church of Canterbury free from temporal obligations. I am therefore not liable and will not plead concerning them." As Leicester turned to report this to the king, Thomas stopped him. "Son and earl, listen: You are bound to obey God and me before your earthly king. Neither law nor reason allows children to judge their father and condemn him. Wherefore I refuse the king's judgement and yours and everybody's; under God, I will be judged by the pope alone. You, my fellow bishops, who have served man rather than God, I summon to the presence of the pope. And so, guarded by the authority of the Catholic Church and the Holy See, I go hence." Cries of "Traitor!" followed him as he left the hall. That night St. Thomas fled from Northampton through the rain, and three weeks later secretly embarked at Sandwich.

St. Thomas and his few followers landed in Flanders and sent deputies to Louis VII, King of France, who received them graciously and invited the archbishop into his dominions. The pope, Alexander III, was then at Sens. The bishops and others from King Henry arrived there and accused St. Thomas before him, but left again before the archbishop reached the city. Thomas showed the pope the sixteen Constitutions of Clarendon, of which some were pronounced intolerable, and he was rebuked for ever having considered their acceptance. Then Alexander recommended the exiled prelate to the abbot of Pontigny, to be entertained by him.

St. Thomas regarded this monastery of the Cistercian Order as a religious retreat and school of penance for the expiation of his sins; he submitted himself to the rules of the house and was unwilling to allow any distinction in his favor. His time he passed in study, but also in writing both to his supporters and opponents letters which were increasingly unlikely to help on a peaceful settlement. King Henry meanwhile confiscated the goods of all the friends, relations and domestics of Thomas, banished them, and obliged all who were adults to go to the archbishop that the sight of their distress might move him. These exiles arrived in troops at Pontigny. Negotiations between the pope, the archbishop, and the king dragged on for nearly six years. Suddenly, in July 1170, king and archbishop met again in Normandy and a reconciliation was at last patched up, apparently without any overt reference to the matters in dispute.

On December 1 St. Thomas landed at Sandwich, and though the sheriff of Kent had tried to impede him the short journey from there to Canterbury was a triumphal progress: the way was lined with cheering people and every bell of the primatial city was ringing. But it was not peace. St. Thomas had sent in advance the letters of suspension of Roger de Pont-l'Evêque, archbishop of York, and others and of excommunication of the bishops of London and Salisbury, and the three bishops together had gone over to appeal to King Henry in France. After a week at Canterbury St. Thomas visited London, where he was joyfully received, except by Henry's son, who refused to see

him; he arrived back in Canterbury on or about his fifty-second birthday. Meanwhile the three bishops had laid their complaints before the king and somebody declared aloud that there would be no peace for the realm while Becket lived. And Henry, in one of his fits of ungovernable rage, pronounced the fatal words which were interpreted by some of his hearers as a rebuke for allowing this pestilent clerk to continue to live and disturb him. At once four knights set off for England — Reginald Fitzurse, William de Tracy, Hugh de Morville, and Richard le Breton.

On St. John's day the archbishop received a letter warning him of his danger, and all south-east Kent was in a state of suppressed ferment and ominous expectation. In the afternoon of December 29 the knights from France came to him. There was an interview, in which several demands were made, particularly that St. Thomas should remove the censures on the three bishops; it began quietly and ended angrily, the knights departing with threats and oaths. A few minutes later, shouting, breaking of doors and clangor of arms was heard, and St. Thomas, urged and hustled by his attendants, began to move slowly towards the church, his cross carried before him. Vespers was being sung, and at the door of the north transept he was met by a crowd of terrified monks. They drew back a little, and as he entered the church armed men were seen behind in the dim light of the cloister. Monks slammed the door and bolted it, shutting out some of their brethren in the confusion. These beat loudly at the door. Becket turned round. "Away, you cowards!" he cried, "a church is not a castle," and re-opened the door himself. Then he went up the steps towards the choir. The knights ran in, shouting, "Where is Thomas the traitor?"

"I am ready to die," said St. Thomas, "but God's curse be on you if you harm my people." Fitzurse seized his cloak and pulled him towards the door. Becket snatched himself clear. Then they tried to carry him outside bodily, and he threw one of them to the ground. Fitzurse flung away his axe and drew his sword. St. Thomas covered his face and called aloud on God and his saints. Tracy struck a blow, which grazed Thomas's head and blood ran down into his eyes. He

wiped it away, and when he saw the crimson stain cried, "Into thy hands, O Lord, I commend my spirit!" Another blow from Tracy beat him to his knees, and murmuring, "For the name of Jesus and in defence of the Church I am willing to die," he pitched forward onto his face. Le Breton with a tremendous stroke severed his scalp, breaking his sword against the pavement.

The murderers dashed away through the cloisters — the whole thing was over in ten minutes — while the great church filled with people and a thunderstorm broke overhead. The archbishop's body lay alone, stretched in the middle of the transept, and for long no one dared to touch or even go near it.

Even after making full allowance for the universal horror which such a deed of sacrilege was bound to excite in the twelfth century, the indignation and excitement which soon spread throughout Europe and the spontaneous canonization of Thomas Becket by the common voice testify to the fact that the inner significance of his death was realized on all hands. The discovery of evidences of an austere private life, and the miracles which from the very first were reported in large numbers at his tomb, added fuel to this fire of devotion. The public conscience could not be satisfied by anything less than that the most powerful sovereign in Europe should undergo a public penance of a most humiliating kind. This he did in July, 1174, eighteen months after the solemn canonization of St. Thomas as a martyr by Pope Alexander at Segni. On July 7, 1220, the body of St. Thomas was solemnly translated from its tomb in the crypt to a shrine behind the high altar. From that day until September 1538 the shrine of St. Thomas was one of the half-dozen most favored places of pilgrimage in Christendom, famous as a spiritual sanctuary, for its material beauty and for its wealth. No authentic record of its destruction and spoliation by Henry VIII remains; even the fate of the relics is a matter of uncertainty, though they were probably destroyed at that time when his memory was, naturally enough, particularly execrated by the king. The feast of St. Thomas of Canterbury is kept throughout the Western church, and in England he is venerated as protector of the secular clergy.

ST. BERNARD, ABBOT OF CLAIRVAUX, DOCTOR OF THE CHURCH

August 20

Patron Saint of Candlemakers; Skiers

ST. BERNARD WAS THE THIRD son of Tescelin Sorrel, a Burgundian noble, and Aleth, who was daughter of Bernard, lord of Montbard. He was born in 1090 at Fontaines, a castle near Dijon, a lordship belonging to his father. Bernard was sent to Châtillon on the Seine, to pursue a complete course of studies in a college of secular canons. He even then loved to be alone, largely at first because of shyness; his progress in learning was far greater than could be expected from one of his age; and he was soon alert to listen to what God by His holy inspirations spoke to his heart. One Christmas-eve, while waiting with his mother to set out for Matins, he fell asleep and seemed to see the infant Jesus newly born in the stable at Bethlehem; from that day he ever had a most tender devotion towards that great mystery of love and mercy, the manhood of Christ.

Bernard made his appearance in the world with all the advantages and talents which can make it attractive to a young man, or which could make him loved by it. His personal attractiveness and wit, his affability and sweetness of temper, endeared him to everybody. But he began to think of forsaking the world and the pursuit of letters, which greatly attracted him, and of going to Cîteaux, where only a few years before had been established the first monastery of that strict interpretation of the Benedictine rule, called after it "Cistercian." He wavered for some time in his mind, and one day in great anxiety he went into a church by the road and prayed that God would direct him to

discover and follow His will. He arose steadily fixed in the resolution of following the severe Cistercian life. His friends endeavored to dissuade him from it; but he not only remained firm — he enlisted thirty-one men to follow him — he who himself had been uncertain of his call only a few weeks before. It is a happening unparalleled in Christian history. Bernard's eloquent appeals were irresistible; mothers feared for their sons, wives for their husbands, lest they came under the sway of that compelling voice and look.

The company arrived at Cîteaux about Easter in 1112 and the abbot, the English St. Stephen, who had not had a novice for several years, received them with open arms. St. Bernard was then twenty-two years old. He entered this house with the desire to die to the remembrance of men, to live hidden and be forgotten, that he might be occupied only with God. After three years the abbot, seeing the great progress which Bernard had made and his extraordinary abilities, ordered him to go with twelve monks to found a new house in the diocese of Langres in Champagne. They walked in procession, singing psalms, with their new abbot at their head, and settled in a place called the Valley of Wormwood, surrounded by a forest. This young colony lived through a period of extreme and grinding hardship. The land was poor and their bread was of coarse barley; boiled beech leaves were sometimes served up instead of vegetables. Bernard at first was so severe in his discipline, coming down upon the smallest distractions and least transgressions of his

ST. BERNARD
Alonso Cano. *St. Bernard and the Virgin.* Prado, Madrid

188

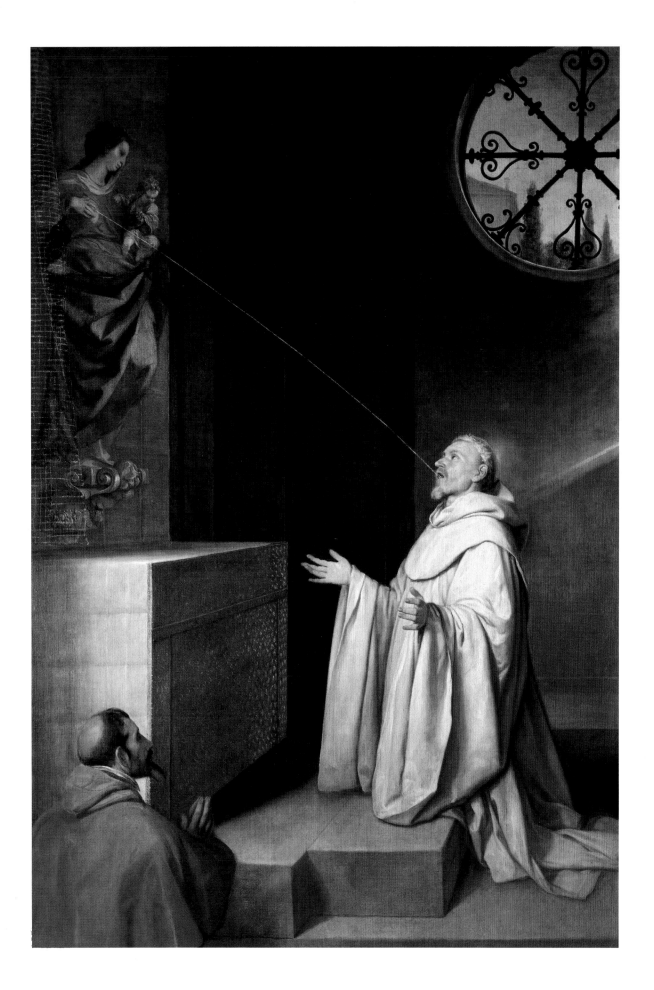

brethren, whether in confession or in chapter, that although his monks behaved with the utmost humility and obedience they began to be discouraged, which made the abbot sensible of his fault. He condemned himself for it to a long silence. At length he resumed his preaching, and provided that meals should be more regular, though the food was still of the coarsest. The reputation of the house and of the holiness of its abbot soon became so great that the number of monks had risen to a hundred and thirty; and the name of the valley was changed to Clairvaux, because it was situated right in the eye of the sun. The first four daughter-houses of Cîteaux became each a mother-house to others, and Clairvaux had the most numerous offspring, including Rievaulx and, in a sense, Fountains in England.

In 1121 Bernard wrought his first miracle, restoring, while he sang Mass, power of speech to a certain lord that he might confess his sins before he died, three days after, having made restitution for numerous acts of injustice. It is related that other sick persons were cured instantaneously by his making the sign of the cross upon them; and we are also told that the church of Foigny was infested with flies till, by Bernard saying he "excommunicated" them, they all died. The malediction of the flies of Foigny became a proverb in France.

Notwithstanding St. Bernard's love of retirement, obedience and the Church's needs frequently drew him from his cell. So great was the reputation of his character and powers that princes desired to have their differences determined by him and bishops regarded his decisions with the greatest respect, referring to him important affairs of their churches. The popes looked upon his advice as the greatest support of the Holy See, and all people had a profound respect and veneration for his person and opinion. It was said of him that he was "the oracle of Christendom."

After the disputed papal election of 1130 the cause of Pope Innocent II took St. Bernard up and down France, Germany and Italy. On one of his returns to Clairvaux he took with him a new postulant, a canon of Pisa, Peter Bernard Paganelli, who was to become a beatified pope as Eugenius III. No sooner was the

trouble of the papal schism over than St. Bernard was involved in the controversy with Abelard. If St. Bernard was the most eloquent and influential man of his age, the next was the brilliant and unhappy Peter Abelard, who was moreover of far wider learning. The two were bound to come into collision, for they represented two currents of thought which, not necessarily opposed, were not yet properly fused: on the one hand, the weight of traditional authority and "faith not as an opinion but a certitude"; on the other, the new rationalism and exaltation of human reason. St. Bernard himself has since been grievously criticized for his unrelenting pursuit of Abelard: but it seemed to him he had detected in Abelard vanity and arrogance masquerading as science, and rationalism masquerading as the use of reason, and his ability and learning made him the more dangerous.

Probably about the beginning of the year 1142 the first Cistercian foundation was made in Ireland, from Clairvaux, where St. Malachy of Armagh had put some young Irishmen with St. Bernard to be trained. The abbey was called Mellifont, in county Louth, and within ten years of its foundation six daughter-houses had been planted out. At the same time Bernard was busied in the affair of the disputed succession to the see of York, set out in the account of St. William of York (June 8), in the course of which Pope Innocent II died. His third successor, within eighteen months, was the Cistercian abbot of Tre Fontane, that Peter Bernard of Pisa to whom reference has been made, known to history as Bd. Eugenius III. Bernard was rather frightened, for Eugenius was shy and retiring, not accustomed to public life. Later he encouraged Pope Eugenius to reserve time for self-examination and daily contemplation.

In the meantime the Albigensian heresy and its social and moral implications had been making alarming progress in the south of France. St. Bernard had already been called on to deal with a similar sect in Cologne, and in 1145 the papal legate, Cardinal Alberic, asked him to go to Languedoc. Bernard was ill and weak and hardly able to make the journey, but he obeyed, preaching on the way. Geoffrey, the saint's secretary, accompanied him, and relates many miracles

to which he was an eye-witness. He tells us that at Sarlat in Périgord, Bernard, blessing with the sign of the cross some loaves of bread which were brought, said, "By this shall you know the truth of our doctrine, and the falsehood of that which is taught by the heretics, if such as are sick among you recover their health by eating of these loaves." A number of sick persons were cured by eating the bread. Bernard preached against the heresy throughout Languedoc; its supporters were stubborn and violent, especially at Toulouse and Albi, but in a very short time he had restored the country to orthodoxy and returned to Clairvaux. But he left too soon, the restoration was more apparent than real, and twenty-five years later Albigensianism had a stronger hold than ever.

On Christmas-day, 1144, the Seljuk Turks had captured Edessa, center of one of the four principalities of the Latin kingdom of Jerusalem, and appeals for help were at once sent to Europe, for the whole position was in danger. Pope Eugenius commissioned St. Bernard to preach a crusade. He began at Vézelay on Palm Sunday 1146, when Queen Eleanor and many nobles were the first to take the cross, and were followed by such large numbers of people, moved by the monk's burning words, that the supply of badges was exhausted and he had to tear strips off his habit to make others. When he had roused France, he wrote letters to the rulers and peoples of western and central Europe, and then went in person into Germany, then made a triumphant journey through the Rhineland, confirming his appeals by an amazing succession of miracles, vouched for by his companions. The Emperor Conrad III took the cross from him, and set out with an army in May of 1147, followed by Louis of France. But this, the second, crusade was a miserable failure, in no small measure due to the crusaders themselves, of whom a great part were led by no other motive than the prospect of plunder, were lawless, and committed every kind of disorder in their march. This unfortunate expedition raised a storm against St. Bernard, because he had seemed to promise success.

His answer was that he confided in the divine mercy for a blessing on an enterprise undertaken for the honor of the divine name, but that the sins of the army were the cause of its misfortunes.

Early in the year 1153 St. Bernard entered on his last illness. When he received the last sacraments and his spiritual children assembled about him in tears, he comforted and encouraged them, saying that the unprofitable servant ought not to occupy a place uselessly, that the barren tree ought to be rooted up. His love for them inclined him to remain till they should be gathered with him to God; but his desire to enjoy Christ made him long for death. God took him to Himself, on August 20, 1153; he was sixty-three years old, had been abbot for thirty-eight, and sixty-eight monasteries had been founded from Clairvaux — Bernard may indeed be counted among the founders of the Cistercian Order, who brought it out of obscurity into the center of western Christendom. He was canonized in 1174, and in 1830 formally declared a doctor of the Church: *Doctor mellifluus*, the Honey-sweet Doctor, as he is now universally called.

Since his death St. Bernard continues to comfort and instruct by his writings. He had so meditated on the Holy Scriptures that in almost every sentence he borrows something from their language, and diffuses the marrow of the sacred text with which his own heart was filled. He was well read in the writings of the fathers of the Church, especially SS. Ambrose and Augustine, and often takes his thoughts from their writings and by a new turn makes them his own. Though he lived after St. Anselm, the first of the scholastics, and though his contemporaries are ranked in that class, yet he treats theological subjects after the manner of the ancients. On this account, and for the great excellence of his writings, he is himself reckoned among the fathers. And though he is the last among them in time, he is one of the greatest to those who desire to study and to improve their hearts in sincere religion.

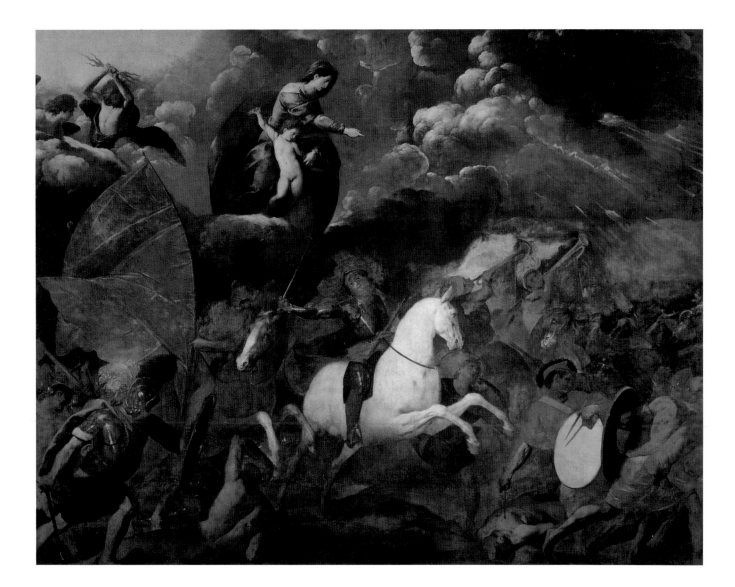

ST. DOMINIC

Giovanni Battista Crespi. *The Madonna Guiding St. Dominic to Victory over the Albigensians*, c. 1632. Museo Civico, Cremona

ST. DOMINIC, FOUNDER OF THE ORDER OF PREACHERS

August 4

Patron Saint of the Dominican Republic; Astronomers

ST. DOMINIC WAS BORN soon after 1170 at Calaruega in Castile. Practically nothing is known with certainty of his father Felix, though he is said to have been of the Guzmán family; his wife was Bd. Joan of Aza. When he was fourteen years old he left the care of his uncle, who was the archpriest of Gumiel d'Izan, and was entered at the school of Palencia. While still a student he was made a canon of the cathedral of Osma, and after his ordination he took up his duties there. The chapter lived a community life under the Rule of St. Augustine, and their regularity of observance was such as to provide an admirable school for the young priest. Dominic seldom left the canons' house and spent much time in church, "weeping for the sins of others, and reading and putting into practice the *Conferences* of Cassian." When Diego d'Azevedo became bishop of Osma about 1201 he succeeded him as prior of the chapter. He was then thirty-one years old, and had been leading this contemplative life for six or seven years; it at last came to an end, and Dominic began his work in the world in unexpected fashion in 1204.

In that year Alfonso IX, King of Castile, chose the bishop of Osma to go as ambassador to Denmark to negotiate a marriage for his son. The bishop took Dominic with him. On their way they passed through Languedoc, which was then filled with the heresy of the Albigenses. He in whose house they lodged at Toulouse professed it, and St. Dominic, pierced to the heart with compassion for the man, spent the whole night in discussion with him, and with such effect that with the light of morning came the light of faith, and the man abjured his errors. It is generally supposed

that from this moment Dominic knew what work God required of him.

A series of conferences was held between the Albigensians and the bishop of Osma and St. Dominic. They influenced some of the rank and file heretics, but had little effect on the leaders. St. Dominic was greatly concerned by the activities of women in the propagation of Albigensianism, and also by the fact that many girls were, on the one hand, exposed to evil influences in their homes and, on the other, were sent to Albigensian convents to be educated. On the feast of St. Mary Magdalen in 1206 he had a sign from Heaven, and in consequence of it within six months he had founded at Prouille, near Fanjeaux, a monastery to shelter nine nuns, all of whom were converts from the heresy. Near by was a house for his helpers, and thus St. Dominic began to provide for a supply of trained and virtuous preachers, for a shelter for converted women, for the education of girls, and for a permanent house of prayer.

St. Dominic spent more than ten years preaching in Languedoc, and as leader, though with no canonical status, of a small band of special preachers. During this time he had worn the habit of a regular canon of St. Augustine, and followed that rule. But he earnestly desired to revive an apostolic spirit in the ministers of the altar, the want of which in many was a subject of great scandal to the people, and a great source of the overflowing of vice and heresy. With this view he projected a body of religious men not like the monks who were contemplatives and not necessarily priests, but who to contemplation should join a close application to sacred studies and all the functions of a

pastoral life, especially that of preaching. In order that he might have means at his disposal Fulk, Bishop of Toulouse, in 1214 gave him an endowment and extended his episcopal approval to the embryonic order in the following year. A few months later Dominic accompanied Fulk to the Fourth Lateran Council.

Pope Innocent III received the saint with great kindness and gave his approbation of the nunnery of Prouille. Moreover, he drew up a decree, which he inserted as the tenth canon of the council, to enforce the obligation of preaching, and the necessity of choosing for pastors men who are powerful in words and works, who will instruct and edify their flocks both by example and preaching, and ordering that fit men be selected specially for this office of preaching. But to get approval for Dominic's project was no easy matter, especially as that very council had legislated against the multiplication of new religious orders. It is said that Innocent had decided to refuse but that, the night following, he dreamed he saw the Lateran church in danger of falling, and that St. Dominic stepped in and supported it with his shoulders. Be that as it may, the pope at last gave a guarded approval by word of mouth, bidding the founder return to his brethren and select which of the already approved rules they would follow. They met at Prouille in August 1216, and after consultation with his sixteen colleagues, he made choice of the Rule of St. Augustine, the oldest and least detailed of the existing rules, written for priests by a priest, who was himself an eminent preacher. St. Dominic added certain particular constitutions, some borrowed from the Order of Prémontré. Pope Innocent III died on July 18, 1216, and Honorius III was chosen in his place. This change retarded St. Dominic's second journey to Rome; and in the meantime he finished his first friary, at Toulouse, to which the bishop gave the church of St. Romain, wherein the first community of Dominicans assembled and began common life under vows.

St. Dominic arrived at Rome again in October 1216, and Honorius III confirmed his order and its constitutions the same year. St. Dominic remained in Rome till after Easter, preaching with great effect. It was during this time that he formed his friendships with Cardinal Ugolino, afterwards Pope Gregory IX, and St. Francis of Assisi. The story goes that Dominic saw in a vision the sinful world threatened by the divine anger but saved by the intercession of our Lady, who pointed out to her Son two figures, in one of whom St. Dominic recognized himself, but the other was a stranger. Next day while at prayer in a church he saw a ragged beggar come in, and recognized him at once as the man of his dream; going up to him therefore, he embraced him and said, "You are my companion and must walk with me. For if we hold together no earthly power can withstand us." This meeting of the two founders of the friars is commemorated twice a year, when on their respective feast-days the brethren of the two orders sing Mass in each other's churches, and afterwards sit at the same table "to eat that bread which for seven centuries has never been wanting."

On the feast of the Assumption, 1217, to the surprise of all, for heresy was again gaining ground in all the neighborhood, St. Dominic broke up his band of friars and dispersed them in all directions. Four were sent to Spain, seven to Paris, two returned to Toulouse, two remained at Prouille, and the founder himself in the following December went back to Rome.

On his arrival in Rome the pope gave him the church of St. Sixtus (San Sisto Vecchio), and while making a foundation there the saint lectured on theology, and preached in St. Peter's with such eloquence as to draw the attention of the whole city. It is related that on Ash Wednesday in 1218 the young Napoleon, Cardinal Stephen's nephew, was thrown from his horse and killed. The saint ordered the body of Napoleon to be brought into the house, and bid Brother Tancred make an altar ready that he might offer Mass. When he had prepared himself, the cardinals with their attendants, the abbess with her nuns, the friars, and a great concourse of people went to the church. The Sacrifice being ended, Dominic, standing by the body, disposed the bruised limbs in their proper places, prayed, rose from his knees, and made the sign of the cross over the corpse; then, lifting up his hands to Heaven, he cried out, "Napoleon, I say to you in the

name of our Lord Jesus Christ, arise." That instant, in the sight of all, the young man arose sound and whole.

In 1218-19 Dominic journeyed in Spain, France and Italy, establishing friaries in each country, and arrived at Bologna about the end of summer 1219, which city he made his ordinary residence to the end of his life.

Wherever the saint traveled, he preached; and he never ceased to pray for the conversion of infidels and sinners. It was his earnest desire, if it had been God's will, to shed his blood for Christ, and to travel among the barbarous nations of the earth to announce to them the good news of eternal life. Therefore did he make the ministry of the word the chief end of his institute: he would have all his religious to be applied to it, every one according to his capacity, and those who had particular talents for it never to discontinue the office of preaching, except in intervals allotted to retirement that they might preach to themselves in silence. He taught his missionaries the art of preaching to the heart by animating them with charity. Being once asked after preaching in what book he had studied his sermon, "In no other," said he, "than in that of love." Learning, study of the Bible, and teaching were from the beginning of first importance in the order: some of its chief achievements have been in intellectual work and the founder has been called "the first minister of public instruction in modern Europe." But an eminent spirit of prayer and recollection has at all times been the characteristic of the Dominicans, as it was of St. Dominic, whose constant and most characteristic prayer was that he might have a true love of his neighbor and the ability to help others. He was inflexible in maintaining the discipline he had established. Coming to Bologna in 1220, he was so much

offended to find the convent of his friars in that city being built in a stately manner, not consistent with his idea of the poverty which he professed by his rule, that he would not allow the work to be continued.

After the second general chapter Dominic visited Cardinal Ugolino at Venice. On his return he was ill, and he was taken to a country place for the better air. But he knew he was dying. To his brethren he spoke of the beauty of chastity, and, having no temporal goods, made his last testament in these words: "These, my much-loved ones, are the bequests which I leave to you as my sons: have charity among you; hold to humility; keep willing poverty." At his request he was carried back to Bologna that he might be buried "under the feet of his brethren." Gathered round him, they said the prayers for the dying; at the *Subvenite* St. Dominic repeated those great words, and died. It was the evening of August 6, 1221; he was about fifty-two years old; and he died in that poverty of which he had so lately spoken.

It may be said of him after death what Bd. Jordan of Saxony wrote of him in life: "Nothing disturbed the even temper of his soul except his quick sympathy with every sort of suffering. And as a man's face shows whether his heart is happy or not, it was easy to see from his friendly and joyous countenance that he was at peace inwardly. With his unfailing gentleness and readiness to help, no one could ever despise his radiant nature, which won all who met him and made him attract people from the first." When he signed the decree of canonization of his friend in 1234 Pope Gregory IX (Cardinal Ugolino) said that he no more doubted the sanctity of Dominic than he did that of St. Peter or St. Paul.

ST. FRANCIS OF ASSISI, FOUNDER OF THE FRIARS MINOR

October 4

Patron Saint of Italy; Catholic Action; Ecologists; Merchants

IT HAS BEEN SAID of St. Francis that he entered into glory in his lifetime, and that he is the one saint whom all succeeding generations have agreed in canonizing. He captured the imagination of his time by presenting poverty, chastity and obedience in the terms of the troubadours and courts of love, and that of a more complex age by his extraordinary simplicity.

St. Francis was born at Assisi in Umbria in 1181 or 1182. In his youth he was devoted to the ideas of romantic chivalry propagated by the troubadours; he had plenty of money and spent it lavishly, even ostentatiously. He was uninterested alike in his father's business and in formal learning. He was bent on enjoying himself. Nevertheless, he was not licentious, and would never refuse an alms to any poor man who asked it of him for the love of God.

When he was about twenty, strife broke out between the cities of Perugia and Assisi, and Francis was carried away prisoner by the Perugians. This he bore a whole year with cheerfulness and good temper. But as soon as he was released he was struck down by a long and dangerous sickness, which he suffered with so great patience that by the weakness of his body his spirit gathered greater strength and became more serious. On his recovery he determined to join the forces of Walter de Brienne, who was fighting in southern Italy. He bought himself expensive equipment and handsome outfit, but as he rode out one day in a new suit, meeting a gentleman reduced to poverty and very ill-clad, he was touched with compassion and changed clothes with him. That night he seemed to see in his sleep a magnificent palace, filled with rich arms,

all marked with the sign of the cross; and he thought he heard one tell him that these arms belonged to him and his soldiers. He set out exultingly for Apulia, but never reached the front. At Spoleto he was taken ill again, and as he lay there a heavenly voice seemed to tell him to turn back, "to serve the master rather than the man." Francis obeyed. At first he returned to his old life, but more quietly and with less enjoyment. His preoccupation was noticed, and he was told he was in love. "Yes," he replied, "I am going to take a wife more beautiful and worthy than any you know." He began to give himself much to prayer and to have a desire to sell his goods and buy the precious jewel of the gospel. He knew not yet how he should do this, but certain strong inspirations made him understand that the spiritual warfare of Christ is begun by mortification and victory over one's self. Riding one day in the plain of Assisi he met a leper, whose sores were so loathsome that at the sight of them he was struck with horror. But he dismounted, and as the leper stretched out his hand to receive an alms, Francis, whilst he bestowed it, kissed the man.

Henceforward he often visited the hospitals and served the sick, and gave to the poor sometimes his clothes and sometimes money. One day as he was praying in the church of St. Damian, outside the walls of Assisi, he seemed to hear a voice coming from the crucifix, which said to him three times, "Francis, go and repair my house, which you see is falling down." The saint, seeing that the church was old and ready to fall, thought our Lord commanded him to repair it. He therefore went home, and in the simplicity of his heart took a horseload of cloth out of his father's warehouse

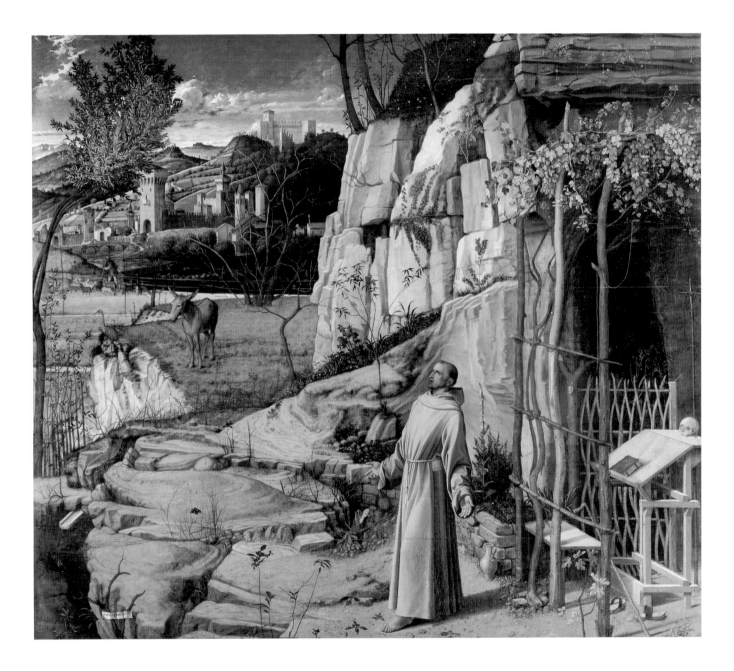

ST. FRANCIS OF ASSISI

Giovanni Bellini. *St. Francis in the Desert.* The Frick Collection, New York

and sold it, with the horse. The price he brought to the poor priest of St. Damian's, asking to be allowed to stay with him. The priest consented, but would not take the money, which Francis therefore left on a window-sill. His father, hearing what had been done, came in great indignation to St. Damian's, but Francis had hid himself. After some days spent in prayer and fasting, he appeared again, though so disfigured and ill-clad that people pelted him and called him mad. His father, more annoyed than ever, carried him home, beat him unmercifully (Francis was about twenty-five), put fetters on his feet, and locked him up, till his mother set him at liberty while his father was out. Francis returned to St. Damian's. His father, following him thither, hit him about the head and insisted that he should either return home or renounce all his share in his inheritance and return the purchase-price of the goods he had taken. Francis had no objection to being disinherited, but said that the other money now belonged to God and the poor. He was therefore summoned before Guido, Bishop of Assisi, who told him to return it and have trust in God: "He does not wish His Church to profit by goods which may have been gotten unjustly." Francis did as he was told and, with his usual literalness, added, "The clothes I wear are also his. I'll give them back." He suited the action to the word, stripped himself of his clothes, and gave them to his father, saying cheerfully, "Hitherto I have called you father on earth; but now I say, 'Our Father, who art in Heaven.'" The frock of a laborer, a servant of the bishop, was found, and Francis received this first alms with many thanks, made a cross on the garment with chalk, and put it on.

Francis went in search of some convenient shelter, singing the divine praises along the highways. He was met by a band of robbers, who asked him who he was. He answered, "I am the herald of the great King." They beat him and threw him into a ditch full of snow. He went on singing the praises of God. He passed by a monastery, and there received alms and a job of work as an unknown poor man. In the city of Gubbio, one who knew him took him into his house, and gave him a tunic, belt and shoes, such as pilgrims wore, which were decent though poor and shabby. These he wore

two years, and he walked with a staff in his hand like a hermit. He then returned to San Damiano at Assisi. For the repair of the church he gathered alms and begged in Assisi, where all had known him rich, bearing with joy the railleries and contempt with which he was treated by some. For the building he himself carried stones and served the masons and helped put the church in order. He next did the same for an old church which was dedicated in honor of St. Peter. After this he went to a little chapel called Portiuncula, belonging to the abbey of Benedictine monks on Monte Subasio, who gave it that name probably because it was built on so small a parcel of land. It stands in a plain two miles from Assisi, and was at that time forsaken and ruinous. The retiredness of this place appealed to St. Francis, and he was delighted with the title which the church bore, it being dedicated in honor of our Lady of the Angels. He repaired it, and fixed his abode by it. Here, on the feast of St. Matthias in the year 1209, his way of life was shown to St. Francis. In those days the gospel of the Mass on this feast was Matt. x 7–19: "And going, preach, saying: The kingdom of Heaven is at hand. . . . Freely have you received, freely give. . . . Do not possess gold . . . nor two coats nor shoes nor a staff. . . . Behold I send you as sheep in the midst of wolves. . . ." The words went straight to his heart and, applying them literally to himself, he gave away his shoes, staff and girdle, and left himself with one poor coat, which he girt about him with a cord. This was the dress which he gave to his friars the year following: the undyed woolen dress of the shepherds and peasants in those parts. Thus garbed, he began to exhort to repentance with such energy that his words pierced the hearts of his hearers. As he passed them on the road he saluted the people with the words, "Our Lord give you peace." God had already given him the gifts of prophecy and miracles. When he was begging alms to repair the church of St. Damian, he used to say, "Help me to finish this building. Here will one day be a monastery of nuns by whose good fame our Lord will be glorified over the whole Church." This was verified in St. Clare five years after. A man in Spoleto was afflicted with a cancer, which had disfigured him hideously. He met

St. Francis and would have thrown himself at his feet; but the saint prevented him and kissed his diseased face, which was instantly healed. "I know not," says St. Bonaventure, "which I ought most to wonder at, such a kiss or such a cure."

Many began to admire Francis, and some desired to be his companions and disciples. When his followers had increased to a dozen, Francis drew up a short informal rule consisting chiefly of the gospel counsels of perfection. This he took to Rome in 1210 for the pope's approbation. Innocent III appeared at first averse, and many of the cardinals alleged that the orders already established ought to be reformed and their number not multiplied, and that the intended poverty of this new body was impracticable. Cardinal John Colonna pleaded in its favor that it was no more than the evangelical counsels of perfection. The pope afterwards told his nephew, from whom St. Bonaventure heard it, that in a dream he saw a palm tree growing up at his feet, and in another he saw St. Francis propping up the Lateran church, which seemed ready to fall (as he saw St. Dominic in another vision five years after). He therefore sent again for St. Francis, and approved his rule, but only by word of mouth, tonsuring him and his companions and giving them a general commission to preach repentance.

St. Francis and his companions now lived together in a little cottage at Rivo Torto, outside the gates of Assisi, whence they sometimes went into the country to preach. After a time they had trouble with a peasant who wanted the cottage for the use of his donkey. "God has not called us to prepare a stable for an ass," observed Francis, and went off to see the abbot of Monte Subasio. The abbot, in 1212, handed over the Portiuncula chapel to St. Francis, upon condition that it should always continue the head church of his order. The saint refused to accept the property "in fee simple" but would only have the use of the place; and in token that he held it of the monks, he sent them every year a basket of fish caught in a neighboring river. The monks sent the friars in return a barrel of oil. This custom is now revived between the friars of Santa Maria degli Angeli and the Benedictines of San Pietro at Assisi.

At the beginning of his conversion, finding himself assailed with violent temptations against purity he sometimes cast himself naked into ditches full of snow. Once, under a more grievous trial than ordinary, he began to discipline himself sharply, and when this failed of its effect threw himself into a briar-patch and rolled therein. The humility of Francis was no emotional self-depreciation, but grounded in the certainty that "what each one is in the eyes of God, that he is and no more." He never proceeded in holy orders beyond the diaconate, not daring to be ordained priest. He had no use for singularity. In a certain house he was told that one of the friars was so great a lover of silence that he would only confess his faults by signs. The saint did not like it, and said, "This is not the spirit of God but of the Devil. A temptation, not a virtue." God illuminated the understanding of His servant with a light and wisdom that is not taught in books. When a certain brother asked leave to study, Francis told him that if he would often repeat the *Gloria Patri* with devotion he would become very learned before God. He was himself an example of knowledge so attained. His love for and power over the lower animals were noted and often referred to by those who knew him: his rebuke to the swallows while he was preaching at Alviano, "My sisters the swallows, it is now my turn to speak. You have been talking enough all this time"; the birds that perched around him while he told them to praise their Creator; the rabbit that would not leave him at Lake Trasimene; and the tamed wolf at Gubbio, which some maintain is an allegory and others a plain fact.

St. Francis spent the Christmas of 1223 at Grecchio in the valley of Rieti where, he told his friend John da Vellita, "I would make a memorial of that Child who was born in Bethlehem and in some sort behold with bodily eyes the hardships of His infant state, lying on hay in a manger with the ox and the ass standing by." Accordingly a "crib" was set up at the hermitage, and the peasants crowded to the midnight Mass, at which Francis served as deacon and preached on the Christmas mystery. The custom of making a crib was probably not unknown before this time, but this use of it by St. Francis is said to have begun its subsequent

popularity. He remained for some months at Grecchio in prayer and quietness, and the graces which he received from God in contemplation he was careful to conceal from men. Brother Leo, his secretary and confessor, testified that he had seen him in prayer sometimes raised above the ground so high that he could only touch his feet, and that sometimes he was raised much higher. Towards the festival of the Assumption in 1224, St. Francis retired to Mount Alvernia and there made a little cell. He kept Leo with him, but forbade any other person to come to him before the feast of St. Michael. Here it was, on or about Holy Cross day 1224, that happened the miracle of the *stigmata.* Having been thus marked with the signs of our Lord's passion, Francis tried to conceal this favor of Heaven from the eyes of men, and for this purpose he ever after covered his hands with his habit, and wore shoes and stockings on his feet. Yet having first asked the advice of Brother Illuminato and others, he with fear disclosed to them this wonderful happening, and added that several things had been manifested to him which he never would disclose to anyone. To soothe him during illness he was one day asked to let someone read a book to him; but he answered, "Nothing gives me so much consolation as to think of the life and passion of our Lord. Were I to live to the end of the world I would stand in need of no other book." Before he left Alvernia St. Francis composed that poem which has been called the "Praise of the Most High God," then, after the feast of St. Michael, he came down from the mountain bearing in his flesh the marks of the sacred wounds, and healed the sick who were brought to him in the plain below.

Some time before his death he made a testament for his religious brethren, in which he recommends that they faithfully observe their rule and work with their hands, not out of a desire of gain but for the sake of good example and to avoid idleness. "If we receive nothing for our work, let us have recourse to the table of the Lord, begging alms from door to door." When he knew the end was close at hand, he called for bread and broke it and to each one present gave a piece in token of mutual love and peace, saying, "I have done my part; may Christ teach you to do yours." He was laid on the ground and covered with an old habit, which the guardian lent him. He exhorted his brethren to the love of God, of poverty, and of the gospel "before all other ordinances," and gave his blessing to all his disciples, the absent as well as those that were present. The passion of our Lord in the gospel of St. John was read aloud, and in the evening of Saturday, October 3, 1226, St. Francis died.

He had asked to be buried in the criminals' cemetery on the Colle d'Inferno, but the next day his body was taken in solemn procession to the church of St. George in Assisi. Here it remained until two years after his canonization when, in 1230, it was secretly removed to the great basilica built by Brother Elias. For six hundred years it was not seen by the eyes of man, till in 1818 after fifty-two days' search it was found deep down beneath the high altar in the lower church. St. Francis was only forty-four or forty-five years old at the time of his death. This is not the place to relate, even in outline, the checkered and glorious history of the order which he founded; but in its three branches of Friars Minor, Friars Minor Capuchin and Friars Minor Conventual, together making the one Order of St. Francis, it is the most numerous religious institute in the Church today. And it is the opinion of Professor David Knowles that by the foundation of this brotherhood St. Francis "did more than any other man to save the medieval Church from decay and revolution."

ST. CLARE, VIRGIN, FOUNDRESS OF THE POOR CLARES OR MINORESSES

August 12

Patron Saint of Television

S T. CLARE WAS BORN about the year 1193. Her mother was Ortolana di Fiumi and her father Faverone Offreduccio, and she had a younger sister, Agnes, and another, Beatrice, but of her childhood, adolescence and home-life there are no certain facts. When she was eighteen St. Francis came to preach the Lenten sermons at the church of San Giorgio in Assisi; his words fired her, she sought him out secretly, and asked him to help her that she too might live "after the manner of the holy gospel." Francis spoke to her of contempt for the world and love of God, and strengthened her nascent desire to leave all things for Christ. On Palm Sunday in the year 1212 Clare attended at the cathedral of Assisi for the blessing of palms; when all the rest went up to the altar-rails to receive their branch of olive a sudden shyness kept her in her place, which the bishop seeing, he went from the altar down to her and gave her the branch. In the evening she ran away from home and went a mile out of the town to the Portiuncula, where St. Francis lived with his little community. He and his brethren met her at the door of the chapel of our Lady of the Angels with lighted tapers in their hands, and before the altar she put off her fine clothes, and St. Francis cut off her hair, and gave her his penitential habit, which was a tunic of sackcloth tied about her with a cord. The holy father not having yet any nunnery of his own, placed her for the present in the Benedictine convent of St. Paul near Bastia, where she was affectionately received.

No sooner was her action made public but her friends and relations came in a body to draw her out of her retreat. It is said that Clare resisted and held to the altar so fast as to pull its cloths half off when they endeavored to drag her away; and, uncovering her head to show her hair cut, she said that Christ had called her to His service and that she would have no other husband, and that the more they should continue to persecute her, the more God would strengthen her to resist and overcome them. And God triumphed in her. St. Francis soon after removed her to another nunnery, where her sister Agnes joined her, which drew on them both a fresh persecution. Eventually St. Francis placed them in a poor house contiguous to the church of San Damiano, on the outskirts of Assisi, and appointed Clare the superior. She was later joined by her mother and others, among whom three were of the illustrious family of the Ubaldini in Florence. St. Clare saw founded within a few years monasteries of her nuns at several places in Italy, France and Germany. Bd. Agnes, daughter to the King of Bohemia, founded a nunnery of the order in Prague, in which she took the habit, and was called by Clare "my half self."

St. Clare and her community practiced austerities which till then had scarcely been known among women. They wore neither stockings, shoes, sandals nor any other covering on their feet; they slept on the ground, observed perpetual abstinence from meat, and never spoke but when they were obliged by necessity and charity. The foundress recommended this holy silence as the means to avoid innumerable sins of the tongue, and to preserve the mind always recollected in God and free from the dissipation of the world which, without this guard, penetrates even the walls of cloisters. Not content with the fasts and other

mortifications of the rule, she always wore next her skin a rough shirt of hair; she fasted on vigils and all Lent on bread and water; and on some days she ate nothing at all. All Clare's austerities were on the same scale, and after a time it became necessary for Francis and the bishop of Assisi to oblige her to lie upon a mattress and never pass one day without taking at least some bread for nourishment. Discretion came with experience, and years later she wrote to Bd. Agnes of Bohemia: "Since our bodies are not of brass and our strength is not the strength of stone but rather are we weak and subject to corporal infirmities, I implore you vehemently in the Lord to refrain from that exceeding rigor of abstinence which I know you practice, so that living and hoping in the Lord you may offer Him a reasonable service and a sacrifice seasoned with the salt of prudence."

St. Francis wished that his order should never possess any rents or other property even in common, subsisting on daily contributions, and St. Clare possessed this spirit in perfection. As the living depository of the spirit and tradition of St. Francis himself, St. Clare set to work to draw up a rule which should truly express them, and which unequivocally provides that the sisters shall possess no property, either as individuals or as a community.

From the time when she was appointed abbess, much against her will, by St. Francis in 1215, St. Clare governed the convent for forty years. But it was her wish always to be the servant of servants, beneath all, washing and kissing the feet of the lay-sisters when they returned from begging, serving at table, attending the sick. She had as it were wings to fly wherever St. Francis directed her, and was always ready to do anything or to put her shoulders under any burden that was enjoined. She had a wonderful devotion towards the Blessed Sacrament, and even when sick in bed she made fine linen corporals and cloths for the service of the altar, which she distributed among the churches of Assisi.

The powerful force and efficacy of St. Clare's prayer is well illustrated by a story told by Thomas of Celano, which may well be true. In 1244 the Emperor Frederick II ravaged the valley of Spoleto, because it was the patrimony of the Holy See. He had in his army many Saracens, and these infidels came once in a body to plunder Assisi, and as San Damiano stood without the walls they first assaulted it. St. Clare, though very sick, caused herself to be carried to the wall and the Blessed Sacrament to be placed there in a pyx in the very sight of the enemies; prostrating herself before it, she prayed, saying, "Does it please thee, O God, to deliver into the hands of these beasts the defenseless children whom I have nourished with thy love? I beseech thee, good Lord, protect these whom I am now not able to protect." And she heard a voice like the voice of a little child saying, "I will have them always in my care." Then she turned to the trembling nuns and said, "Have no fear, little daughters, trust in Jesus." Terror at the same time seized the assailants and they fled with such precipitation that several were hurt without being wounded by any enemy.

St. Clare bore years of sickness with sublime patience, and at last in 1253 the long-drawn-out agony began. Seeing her spiritual children weep, she comforted them and tenderly exhorted them to be constant lovers and faithful observers of holy poverty, and gave them her blessing, calling herself the "little plant" of her holy father Francis. And to herself she was heard to say, "Go forth in peace, for you have followed the good road. Go forth without fear, for He that created you has sanctified you, has always protected you, and loves you as a mother. Blessed be thou, O God, for having created me." "Thus was the passing of blessed Clare."

Follower of Guido da Siena. *St. Clare Driving Saracens out of San Damiano by Force of Her Prayers* (detail), 14th cent. Pinacoteca Comunale, Siena

ST. ANTONY OF PADUA, DOCTOR OF THE CHURCH

June 13

Patron Saint of Barren Women; Lost Articles; Poor and Oppressed; Travelers

PORTUGUESE BY NATIONALITY and a native of Lisbon, St. Antony nevertheless derives his surname from the Italian city of Padua where he made his last home and where his relics are still venerated. He was born in 1195 and his parents, young members of the Portuguese nobility, confided his early education to the clergy of the cathedral of Lisbon, but at the age of fifteen he joined the regular canons of St. Augustine. Two years later he obtained leave to be transferred to the priory at Coïmbra. There he devoted himself to prayer and study, acquiring, with the help of an unusually retentive memory, an extraordinary knowledge of the Bible. He had been living at Coïmbra for eight years when Don Pedro of Portugal brought from Morocco in 1220 the relics of the Franciscans who had there lately suffered a glorious martyrdom. The young man was profoundly moved, and conceived an ardent desire to lay down his life for Christ. To some Franciscans who came to his monastery of Holy Cross to beg, he laid open his heart, and eventually he was admitted to their order in 1221.

Within a very short time he was permitted to embark for Morocco with the intention of preaching the Gospel to the Moors. But hardly had he arrived than he was prostrated by a severe illness which necessitated his return to Europe. He made his way to Assisi where a general chapter was about to be held. It was the great gathering of 1221 — the last chapter open to all members of the order — and was presided over by Brother Elias as vicar general, with St. Francis seated at his feet. At the close the brethren returned to the posts allocated to them, and Antony was appointed to the lonely hermitage of San Paolo near Forli. At this time no one suspected the brilliant intellectual and spiritual gifts of the sickly young brother who kept silence about himself. When he was not praying in the chapel or in the little cave which had been made over to him, he was serving the other friars by washing up pots and dishes after the common meal.

But his light was not destined to remain long hidden. It happened that an ordination was held at Forli. Through some misunderstanding none of the Dominicans had come prepared to deliver the customary address at the ceremony, and as no one among the Franciscans seemed capable of filling the breach St. Antony was told to come forward and speak whatever the Holy Ghost should put into his mouth. Very diffidently he obeyed; but once he had begun he delivered an address which amazed all who heard it by its eloquence, its fervor, and the learning it displayed. The minister provincial, informed of the talent possessed by the young friar he had brought from Assisi, promptly recalled him from his retreat and sent him to preach. Antony immediately sprang into fame and proved particularly successful in converting the heretics who abounded in northern Italy.

In addition to his commission as a preacher, he was appointed lector in theology to his brethren — the first member of his order to fill such a post. But it became more and more evident that his true mission lay in the pulpit. He had indeed all the qualifications — learning, eloquence, great power of persuasion, a burning zeal for souls and a sonorous voice which carried far. Moreover, he was said to be endowed with the gift of miracles and, though undersized and

inclined to corpulence, he had an attractive, almost magnetic, personality. Sometimes the mere sight of him brought sinners to their knees: he appeared to radiate holiness. Wherever he went crowds flocked to hear him and hardened criminals, careless folk, and heretics alike were converted and brought to confession. Often the churches could not hold the congregations and he preached to them in the squares and market-places. Shortly after the death of St. Francis he was recalled to Italy, apparently to be minister provincial of Emilia or Romagna. He seems to have acted as envoy from the chapter general in 1226 to Pope Gregory IX. Antony on that occasion obtained from the pope his release from office that he might devote himself to preaching.

From that time St. Antony resided at Padua — a city where he had previously labored, where he was greatly beloved, and where, more than anywhere else, he was privileged to see the great fruit which resulted from his ministry. For not only were his sermons listened to by enormous congregations, but they led to a great and general reformation of conduct. Long-standing quarrels were amicably settled, prisoners were liberated and the owners of ill-gotten goods made restitution, often in public at St. Antony's feet.

After preaching a course of sermons in the spring of 1231, St. Antony's strength gave out and he retired with two other friars to a woodland retreat at Camposanpiero. It was soon clear that his days were numbered, and he asked to be taken back to Padua. He never reached the city, but only its outskirts. On June 13, 1231, in the apartment reserved for the chaplain of the Poor Clares of Arcella, he received the last rites and passed to his eternal reward. He was only thirty-six. Extraordinary demonstrations of veneration were witnessed at his funeral and the Paduans have always regarded his relics as their most precious possession.

Within a year of his death Antony was canonized and Pope Pius XII declared him a doctor of the Church in 1946. Whether he did or did not perform wonders in his lifetime, it is the innumerable favors he has obtained for his devotees since his death that have won for him the title of "The Wonder-worker." Since the seventeenth century St. Antony has been usually repre-

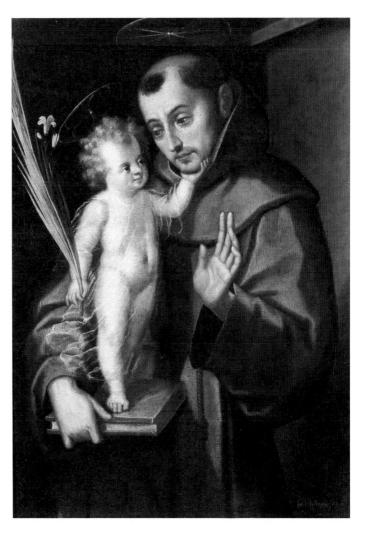

ST. ANTONY OF PADUA

Ascribed to Luis Juarez. *St. Anthony of Padua with the Infant Savior,* c. 1620–1629. Davenport Museum of Art, Davenport, Iowa

sented with the Infant Savior because of a story of late date that once, when he was on a visit, his host, glancing through a window, saw him gazing with rapture on the Holy Child whom he was holding in his arms. In the earliest pictures we find nothing more distinctive than a book, emblematic of his knowledge of Holy Scripture, or a lily. Occasionally he is accompanied by the mule which, according to the legend, knelt before the Blessed Sacrament upheld in the hands of the saint, and by so doing converted its owner to a belief in the real presence. St. Antony is the patron of the poor, and alms specially given to obtain his intercession are called "St. Antony's Bread."

ST. BONAVENTURE, CARDINAL-BISHOP OF ALBANO, DOCTOR OF THE CHURCH

July 14

OF THE YOUTH of this greatest successor of St. Francis of Assisi nothing is known beyond the facts that he was born at Bagnorea, near Viterbo, in the year 1221. He was clothed in the order of Friars Minor and studied at the University of Paris. Bonaventure, who was to become known as the Seraphic Doctor, himself taught theology and Holy Scripture there from 1248 to 1257. His penetrating genius was balanced by the most careful judgment by which, while he dived to the bottom of every subtle inquiry, he cut off whatever was superfluous, dwelling only on that knowledge which is useful and solid, or at least necessary to unravel the false principles and sophistry of erroneous opinions. Whilst he referred all his studies to the divine honor and his own sanctification, he was careful not to lose the end in the means or to let his application degenerate into dissipation of mind and idle curiosity. Not content to make his studies a continuation of prayer, he devoted to formal prayer a great part of his time, knowing this to be the key of all spiritual life. A remarkable cheerfulness always appeared in his countenance, which resulted from the inward peace of his soul, for as he himself says, "A spiritual joy is the greatest sign of the divine grace dwelling in a soul."

He had no eyes to see anything in himself but faults and imperfections, and this humility sometimes withheld him from holy communion. But God by a miracle overcame his fears. "Several days had passed," say the acts of his canonization, "nor durst he yet presume to present himself at the heavenly banquet. But whilst he was assisting at Mass, and meditating on the passion of Jesus Christ, our Savior, to crown his humility and love, put into his mouth by the ministry of an angel part of the consecrated Host, taken from the hand of the priest."

Bonaventure was called by the obligations of his priestly character to labor for the salvation of his neighbor, and to this he devoted himself with enthusiasm. He announced the word of God to the people with an energy which kindled a flame in the hearts of those that heard him. The years of his public lecturing at Paris were greatly disturbed by the attack made on the mendicant friars by the other professors at the university. The leader of the secular party was William of Saint-Amour, who made a bitter onslaught on the mendicants in a book called *The Perils of the Last Times*. Bonaventure, who had to suspend lecturing for a time, replied in a treatise on evangelical poverty, named *Concerning the Poverty of Christ*. The pope, Alexander IV, appointed a commission of cardinals to go into the matter at Anagni, and on their findings ordered Saint-Amour's book to be burnt, vindicated and reinstated the friars, and ordered the offenders to withdraw their attack. A year later, in 1257, St. Bonaventure and St. Thomas Aquinas received the degree of doctor of theology together.

For Blessed Isabella, St. Louis IX's sister, and her nunnery of Poor Clares at Longchamps, St. Bonaventure wrote *Concerning Perfection of Life*. Other mystical works of his are the *Soliloquy* and *Concerning the Threefold Way*. The love which every word breathes in the writings of this doctor pierces the heart, and Gerson, the learned and devout chancellor of the University of Paris, writes of his works, "Among all the

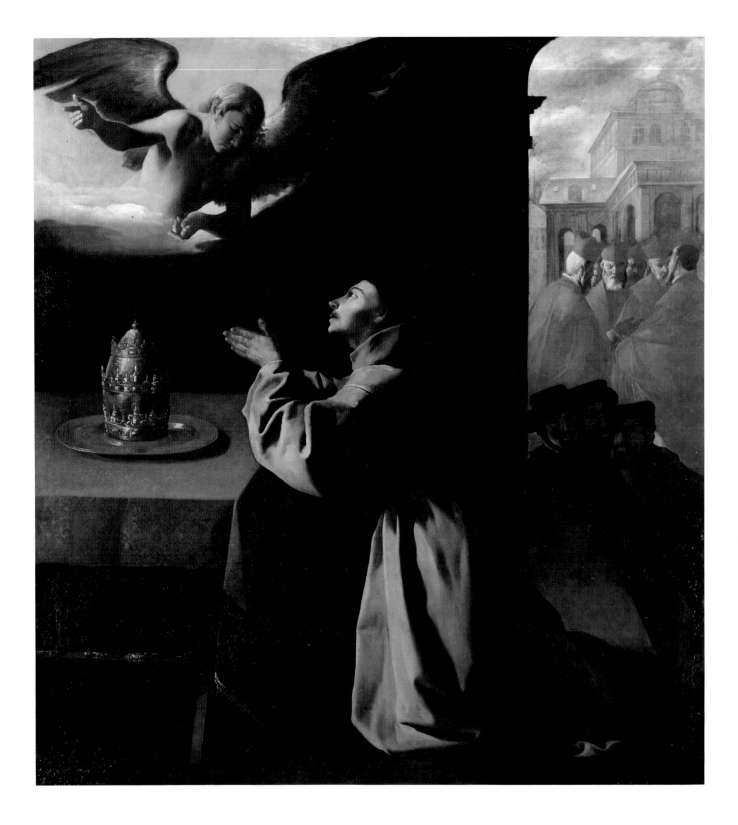

Catholic doctors Eustachius (for so we may translate his name of Bonaventure) seems to me the best for enlightening the understanding and at the same time warming the heart." The joys of Heaven were the frequent meditation of Bonaventure's soul, and he endeavored by his writings to excite in others the same fervent desire for our heavenly country. Bonaventure puts the perfection of Christian virtue, not so much in the more heroic life of a religious state, as in performing our ordinary actions well. "The perfection of a religious man," he says, "is to do common things in a perfect manner. A constant fidelity in small things is a great and heroic virtue."

In 1257 Bonaventure was chosen minister general of the Friars Minor. He was not yet thirty-six years old, and the order was torn by dissensions, some of the friars being for an inflexible severity, others demanding certain mitigations of the rule; between the two extremes were a number of other interpretations. Some of the extreme rigorists, the so-called Spirituals, had even fallen into error and disobedience, and thus given a handle to the friars' opponents in the Paris dispute. Bonaventure wrote a letter to his provincials in which he made it clear that he required a disciplined observance of the rule, involving a reformation of the relaxed, but giving no countenance to the excesses of the Spirituals. At Narbonne in 1260, the first of the five general chapters which he held, he produced a set of constitutions on the rule, which were adopted and had a permanent effect on Franciscan life, but they failed to pacify the excessive rigorists. At the request of the friars assembled in this chapter, he undertook to write the life of St. Francis, which he compiled with a spirit which shows him to have been filled with the virtues of the founder whose life he wrote. He governed his order

for seventeen years and has been justly called its second founder.

In 1265 Pope Clement IV nominated St. Bonaventure to be archbishop of York; he induced the pope to accept his refusal, but in 1273 Bd. Gregory X created him cardinal-bishop of Albano, adding a command to accept that charge without alleging any pretext against it, and immediately to come to Rome. He sent legates to meet him on the road with the hat and other insignia of the office, and it is said that they found the saint in a convent of his order in the Mugello near Florence, washing the dishes. He desired them to hang the cardinal's hat on the bough of a tree, because he could not decently take it in his greasy hands, and left them to walk in the garden till he had finished his work. Then taking up the hat he went to the legates, and paid them the respect due.

Gregory X ordered him to prepare the matters to be dealt with in the general council which he had called to meet at Lyons for the reunion of the Greeks. When the Greek delegates arrived St. Bonaventure conferred with them, and the reunion with Rome was duly effected. In thanksgiving the pope sang Mass on the feast of SS. Peter and Paul, and the epistle, gospel and creed were sung first in Latin then in Greek; St. Bonaventure preached. But amidst all this triumph, on the night of July 14–15, the Seraphic Doctor died; his mortal eyes were spared the pain of seeing Constantinople speedily repudiate the union it had sought and he had labored to make good. Had he never been a member of the Seraphic order he would still deserve the title of Seraphic Doctor because of the angelic virtues with which he adorned his learning. He was declared a doctor of the Church in 1588, having been canonized in 1482.

ST. THOMAS AQUINAS,
DOCTOR OF THE CHURCH

March 7

Patron Saint of Students; Universities, Colleges, and Schools; Protection against Thunderstorms and Sudden Death

THE FAMILY of the counts of Aquino was of noble lineage, tracing its descent back for several centuries to the Lombards. St. Thomas's father was a knight, Landulf, and his mother, Theodora, was of Norman descent. The precise year of his birth is uncertain, but it was about 1225 in the castle of Rocca Secca. Thomas was the youngest of four sons, and there were also several daughters, but the youngest little girl was killed by lightning one night, whilst Thomas, who was sleeping in the same room, escaped unscathed. Throughout life he is said to have been very nervous of storms, often retiring into a church when lightning was about. Hence the popular devotion to St. Thomas as patron against thunderstorms and sudden death.

A few miles to the south of Rocca Secca, on a high plateau, stands the abbey of Monte Cassino, the cradle of Western monasticism and one of the holiest spots in Europe, whose abbot at this time was a kinsman of the Aquino family. As a child of five Thomas was taken here as an oblate, and he remained till he was about thirteen, living in the monastery and getting his schooling there. About 1239 he was sent to the University of Naples, where for five years he studied the arts and sciences, and even began to "coach" others. It was in Naples that he became attracted by the Order of Preachers, whose church he loved to frequent and with some of whose members he soon became intimate. The friars, who saw him often absorbed in prayer in their midst, noticed on several occasions rays of light shining about his head, and one of them, Father John of San Giuliano, exclaimed, "Our Lord has given you to our order." St. Thomas confided to the prior that he

ardently desired to become a Dominican, but in view of the probable opposition of his family, he was advised to foster his vocation and to wait for three years. Time only confirmed his determination, and, at the age of about nineteen, he was received and clothed in the habit of the order.

News of this was soon carried to Rocca Secca, where it aroused great indignation — not because he had joined a religious community, for his mother was quite content that he should become a Benedictine, and indeed probably saw in him the destined abbot of Monte Cassino, but because he had entered a mendicant order. Theodora herself set out for Naples to persuade her son to return home. The friars, however, hurried him off to their convent of Santa Sabina in Rome, and when the angry lady followed in pursuit, the young man was no longer to be found there. The master general of the Dominicans, who was on his way to Bologna, had decided to take Thomas with him, and the little party of friars had already set out on foot together. Theodora, not to be balked, sent word to the saint's elder brothers, who were serving with the emperor's army in Tuscany, desiring them to waylay and capture the fugitive. As Thomas was resting by the roadside at Aquapendente near Siena, he was overtaken by his brothers at the head of a troop of soldiers, and after a vain attempt to take his habit from him by force, was brought back, first to Rocca Secca and then to the castle of Monte San Giovanni, two miles distant, where he was kept in close confinement, only his worldly-minded sister Marotta being allowed to visit him. They sought to undermine his determination in every way, but after a time began to mitigate the

severity of his imprisonment. During his captivity Thomas studied the *Sentences* of Peter Lombard, learned by heart a great part of the Bible, and is said to have written a treatise on the fallacies of Aristotle.

Other devices for subduing him having failed, his brothers conceived the infamous plan of seducing him by introducing into his room a woman of bad character. St. Thomas immediately seized a burning brand from the hearth and chased her out of the place. We are told that he immediately fell into a deep sleep in which he was visited by two angels, who seemed to gird him round the waist with a cord emblematic of chastity.

This captivity lasted two years before Thomas's family gave up, and in 1245 permitted him to return to his order. It was now determined to send him to complete his studies under St. Albert the Great in Cologne. The schools there were full of young clerics from various parts of Europe eager to learn and equally eager to discuss, and the humble, reserved new-comer was not immediately appreciated either by his fellow students or by his professors. His silence at disputations as well as his bulky figure led to his receiving the nickname of "the dumb Sicilian ox." A good-natured companion, pitying his apparent dullness, offered to explain the daily lessons, and St. Thomas humbly and gratefully accepted the offer; but when they came to a difficult passage which baffled the would-be teacher, his pupil explained it to him so clearly and correctly that his fellow student was amazed. Shortly afterwards a student picked up a sheet of Thomas's notes, and passed it on to the master, who marveled at the scholarly elucidation. The next day St. Albert gave him a public test, at the close of which he exclaimed, "We call Brother Thomas 'the dumb ox'; but I tell you that he will yet make his lowing heard to the uttermost parts of the earth." But Thomas's learning was exceeded by his piety, and after he had been ordained priest his union with God seemed closer than ever.

In 1252, at the instance of St. Albert and Cardinal Hugh of Saint-Cher, he was ordered to Paris to teach as a bachelor in the university. Four years later he delivered his inaugural lecture as master and received his doctor's chair, his duties being to lecture, to discuss and to preach. From 1259 to 1268 he was in Italy where he was made a preacher general, and was called upon to teach in the school of selected scholars attached to the papal court, and, as it followed the pope in his movements, St. Thomas lectured and preached in many of the Italian towns. About 1266 he began the most famous of all his written works, the *Summa theologiae.*

In 1269 he was back again in Paris. St. Louis IX held him in such esteem that he constantly consulted him on important matters of state, but perhaps a greater testimony to his reputation was the resolution of the university to refer to his decision a question upon which they were divided, *viz.* whether in the Blessed Sacrament of the altar the accidents remained really or only in appearance. St. Thomas, after fervent prayer, wrote his answer in the form of a treatise which is still extant, and laid it on the altar before making it public. His decision was accepted by the university first and afterwards by the whole Church. It was on this occasion that we first hear of the saint receiving from our Lord's own lips a formal approval of what he had set down. Appearing in a vision, the Savior said to him, "Thou hast written well of the sacrament of my Body"; and almost immediately afterwards Thomas passed into an ecstasy and remained so long raised from the ground that there was time to summon many of the brethren to behold the spectacle.

In 1272 St. Thomas was recalled to Italy and appointed regent of the study-house at Naples. It was to prove the last scene of his labors. On the feast of St. Nicholas the following year he was celebrating Mass when he received a revelation which so affected him that he wrote and dictated no more, leaving his great work, the *Summa theologiae,* unfinished. To Brother

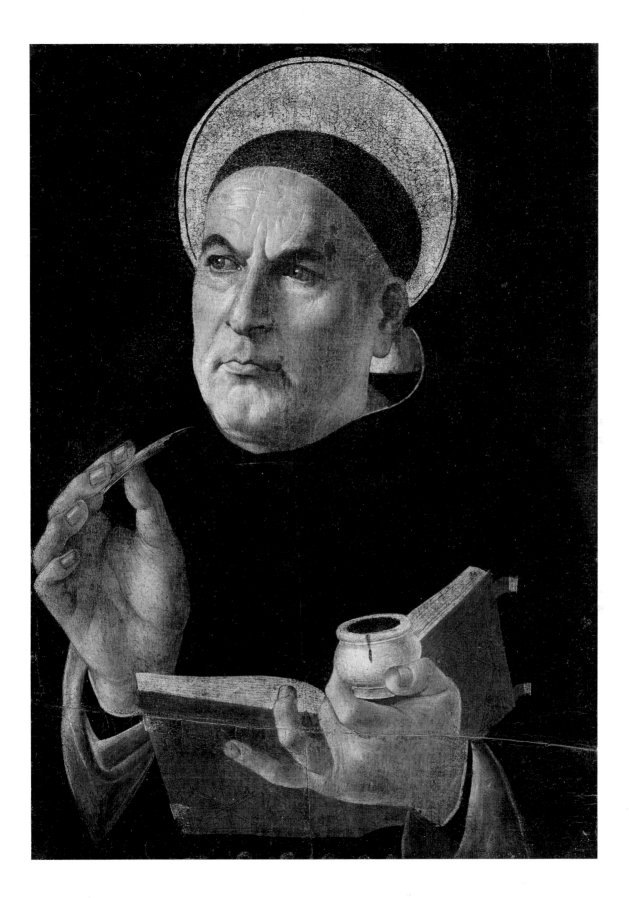

Reginald's expostulations he replied, "The end of my labors is come. All that I have written appears to be as so much straw after the things that have been revealed to me."

He was ill when he was bidden by Pope Gregory X to attend the general council at Lyons for the reunion of the Greek and Latin churches and to bring with him his treatise "Against the Errors of the Greeks." He became so much worse on the journey that he was taken to the Cistercian abbey of Fossa Nuova near Terracina, where he was lodged in the abbot's room and waited on by the monks. In compliance with their entreaties he began to expound to them the Canticle of Canticles, but he did not live to finish his exposition. It soon became evident to all that he was dying. After he had made his last confession and received viaticum from the abbot he gave utterance to the famous words, "I am receiving thee, Price of my soul's redemption: all my studies, my vigils and my labors have been for love of thee. I have taught much and written much of the most sacred body of Jesus Christ; I have taught and written in the faith of Jesus Christ and of the holy Roman Church, to whose judgment I offer and submit everything." Two days later his soul passed to God, in the early hours of March 7, 1274, being only about fifty years of age. That same day St. Albert, who was then in Cologne, burst into tears in the presence of the community, and exclaimed, "Brother Thomas Aquinas, my son in Christ, the light of the Church, is dead. God has revealed it to me."

St. Thomas was canonized in 1323, but it was not until 1368 that the Dominicans succeeded in obtaining possession of his body, which was translated with great pomp to Toulouse, where it still lies in the cathedral of Saint-Sernin. St. Pius V conferred upon him the title of doctor of the Church, and in 1880 Leo XIII declared him the patron of all universities, colleges and schools. The holy man's writings fill twenty thick volumes and were mainly philosophical and theological. He commented much on Aristotle, whose teaching he was in some sense the first to utilize in order to build up a complete system of Christian philosophy.

Of all his works the most important was the *Summa theologiae*, which is the fullest exposition of theological teaching ever given to the world. He worked at it for five years, but, as already stated, he never finished it. It was the greatest monument of the age, and was one of the three works of reference laid on the table of the assembly at the Council of Trent, the other two being the Bible and the Pontifical Decrees. It is almost impossible for us, at this distance of time, to realize the enormous influence St. Thomas exerted over the minds and theology of his contemporaries and their immediate successors. Neither were his achievements confined to matters of dogma, Christian apologetic and philosophy. When Pope Urban IV, influenced by the visions of Bd. Juliana of Liège, decided to institute the feast of Corpus Christi, he appealed to St. Thomas to compose the liturgical office and the Mass for the day. These give proof of an extraordinary mastery of apt expression, and are as remarkable for their doctrinal accuracy as for their tenderness of thought. Two of the hymns, the "Verbum supernum" and "Pange lingua," are familiar to all Catholics, because their final verses, "O salutaris" and "Tantum ergo," are regularly sung at Benediction; but others of the saint's hymns, notably the "Lauda Sion" and the "Adoro te devote," are hardly less popular.

Of the many noble characteristics of St. Thomas Aquinas perhaps the two which may be considered with the greatest profit are his prayerfulness and his humility. He was ever wont to declare that he learnt more at the foot of the crucifix than from books. St. Thomas was singularly modest about his great gifts. Asked if he were never tempted to pride or vainglory, he replied, "No," adding that if any such thoughts occurred to him, his common sense immediately dispelled them by showing him their utter unreasonableness. Moreover he was always apt to think others better than himself, and he was extremely modest in stating his opinion: he was never known to lose his temper in argument, however great the provocation might be, nor was he ever heard to make a cutting remark or to say things which would wound other people.

ST. LOUIS OF FRANCE

August 25

Patron Saint of Barbers; Tertiaries

IN THE PERSON of St. Louis IX were united the qualities which form a great king, a hero of romance, and a saint. He was endowed with qualifications for good government, he excelled in the arts of peace and of war, and his courage and greatness of mind received from his virtue the highest setting; ambition had no share in his enterprises, his only motives in them was the glory of God and the good of his subjects. He was son of Louis VIII and was born at Poissy on April 25, 1214. His mother was Blanche, daughter of Alfonso of Castile and Eleanor of England, and to her care and attention in the education of St. Louis we are indebted.

King Louis VIII died on November 7, 1226, and Queen Blanche was declared regent for her son, who was then only twelve years old. The whole time of the king's minority was disturbed by ambitious barons, but Blanche by several alliances and by her courage and diligence overcame them in the field and forced their submission. Louis rejoiced in his victories chiefly because he procured by them the blessings of peace to his subjects. He was merciful even to rebels, and by his readiness to receive any proposals of agreement gave the proof that he neither sought revenge nor conquests. Never had any man a greater love for the Church, or a greater veneration for its ministers. Yet this was not blind; he opposed the injustices of bishops and did not listen to their complaints till he had given a full hearing to the other party. Louis enjoyed the conversation of priests or other religious men, and he often invited such (e.g. St. Thomas Aquinas) to his house, but he knew how to observe seasons with a decent liberty. He celebrated feasts and rejoicings on the creation of knights and other such occasions with magnificence, but banished from his court all diversions dangerous to morals. And he would tolerate neither vulgar obscenity nor thoughtless profanity. A Dominican testified that he had never heard him speak ill-naturedly of anyone.

When he was nineteen St. Louis married Margaret, the eldest daughter of Raymund Berenger, Count of Provence. The marriage was blessed with a happy union of hearts and eleven children, five sons, six daughters, from whose descendants kings were given to France until that January 21, 1793, when the Abbé Edgeworth, it is often stated, said to Louis XVI as the guillotine was about to fall, "Son of St. Louis, go up to Heaven!" In 1235, having come of age, St. Louis took the government of his kingdom into his own hands. But he continued to show the greatest deference to his mother, and to profit by her counsel.

After an illness in 1244 Louis determined to undertake a crusade in the East, and early the next year he by letter assured the Christians in Palestine that he would make all possible haste to their assistance against the infidels, who a few months before had retaken Jerusalem. But the opposition of his councillors and nobles, the preparation of the expedition, and the settling of his kingdom put off his departure for three and a half years. At the thirteenth general council at Lyons in 1245 all benefices were taxed a twentieth of their income for three years for the relief of the Holy Land, and this gave encouragement to the crusaders. In 1248 Louis sailed for Cyprus, where he was joined by William Longsword, Earl of Salisbury, and two hundred English knights. The objective was Egypt.

Damietta, in the delta of the Nile, was easily taken and St. Louis made a solemn entry into the city, not with the pomp of a conqueror but with the humility of a truly Christian prince, walking barefoot with the queen, the princes his brothers and other great lords, preceded by the papal legate. The king ordered that all plundering and other crimes should be strictly inquired into and punished, and that restitution should be made, and he forbade any infidel to be slain whom it was possible to make prisoner. But notwithstanding all his watchfulness many, to his grief, gave themselves up to debauchery and outrageous acts of violence. Owing to the rising of the Nile and the summer heat the crusaders could not follow up their advantage, and it was not till six months had passed that they advanced to attack the Saracens, who were on the other side of the river. Then followed another six months of desultory fighting, in which the crusaders lost many by battle and sickness, until in April 1250 St. Louis himself was taken prisoner, and his army routed with frightful slaughter.

During his captivity the king recited the Divine Office every day with two chaplains just as if he had been in perfect health in his own palace. When he was asked and refused to give up the castles in Syria he was threatened with the most ignominious treatment and with torture; to which he coolly replied that they were masters of his body, and might do with it what they pleased. The sultan sent to him a proposal by which he demanded a million bezants of gold and the city of Damietta for his ransom and that of the other prisoners. Louis answered that a king of France ought not to redeem himself for money, but that he would give the city for his own release and the million bezants for that of all the other prisoners. The sultan at that time was overthrown by the Mamluk emirs, and these eventually released the king and the other prisoners on these terms. St. Louis then sailed to Palestine with the remainder of his army. There he remained until 1254, visiting all the holy places he could, encouraging the Christians, and strengthening the defenses of the Latin kingdom — such as it was. Then, news being brought to him of the death of his mother, who was regent in his absence, he returned to France.

About 1257 Master Robert de Sorbon, a canon and very learned doctor of Paris, laid the foundations of that theological institute in the city which became known after him as the Sorbonne. Master Robert was a personal friend of St. Louis and sometimes acted as his confessor, and the king enthusiastically seconded his project and helped to endow it. Louis also founded in Paris, for poor blind men, the hospital of Quinze-Vingts, so called because there were in it at the first foundation three hundred such patients.

People were not surprised when in 1267 he announced another crusade: nor were they pleased. The king embarked with his army at Aigues-Mortes on July 1, 1270; soon after landing at Tunis the king himself and his eldest son Philip both sickened with typhus. It was soon seen that Louis was dying. He gave his last instructions to his sons and to his daughter, the queen of Navarre, and composed himself for death. On August 24 he received the last sacraments, and called for the Greek ambassadors, whom he strongly urged to reunion with the Roman Church. He lost his speech the next day from nine till twelve o'clock; then, recovering it and lifting up his eyes towards Heaven, he repeated aloud the words of the psalmist, "Lord, I will enter into thine house; I will worship in thy holy temple, and will give glory to thy name." He spoke again at three in the afternoon, "Into thy hands I commend my soul," and immediately after breathed his last. His bones and heart were taken back to France and enshrined in the abbey-church of St. Denis, whence they were scattered at the Revolution; he was canonized in 1297.

ST. LOUIS OF FRANCE

Claudio Coello. *The Virgin and Child Adored by St. Louis, King of France.* Prado, Madrid

ST. ROCK, OR ROCH

August 17

Patron Saint of Invalids; Plague Victims

W E FIND THIS SERVANT of God venerated in France and Italy during the early fifteenth century, not very long after his death (*c.* 1378), but we have no authentic history of his life. No doubt he was born at Montpellier and nursed the sick during a plague in Italy, but that is almost all that can be affirmed about him. His "lives" are chiefly made up of popular legends, which may have a basis in fact but cannot now be checked. According to the one written by a Venetian, Francis Diedo, in 1478, Rock was son of the governor of Montpellier, and upon being left an orphan at the age of twenty he went on a pilgrimage to Rome. Finding Italy plague-stricken he visited numerous centers of population, Acquapendente, Cesena, Rome, Rimini, Novara, where he not only devoted himself to care of the sick but cured large numbers simply by making the sign of the cross on them. At Piacenza he was infected himself, and not wishing to be a burden on any hospital he dragged himself out into the woods to die. Here he was miraculously fed by a dog, whose master soon found Rock and looked after him; when he was convalescent he returned to Piacenza and miraculously cured many more folk, as well as their sick cattle. At length he got back to Montpellier, where his surviving uncle failed to recognize him; he was there imprisoned, and so he remained five years, till he died. When they came to examine his body it was recognized who he really was, the son of their former governor, by a cross-shaped birth-mark on his breast. He was therefore given a public funeral, and he performed as many miracles when dead as he had done when alive. Another biography, shorter, simpler and perhaps older, says that St. Rock was arrested as a spy and died in captivity at Angera in Lombardy.

The popularity and rapid extension of the *cultus* of St. Rock, a veneration by no means extinct today, was remarkable, and he soon became the saint *par excellence* to be invoked against pestilence. St. Rock is named in the Roman Martyrology, and his feast is kept in many places; there is no evidence that he was a Franciscan tertiary, but the Franciscans venerate him as such.

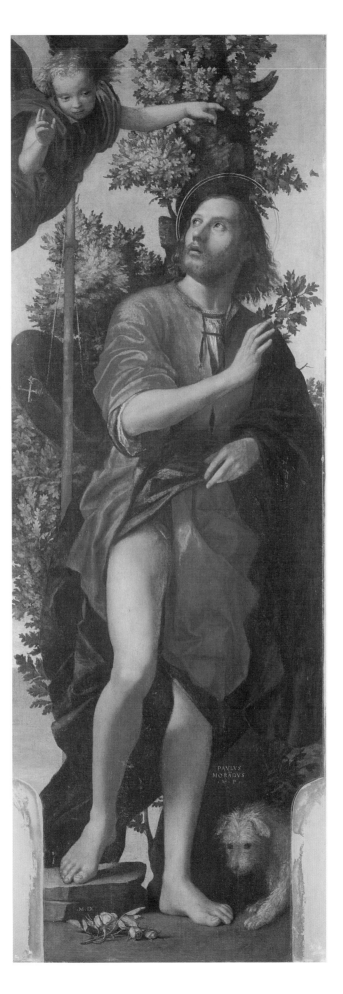

Paolo Morando. *St. Roch*,
1518. National Gallery,
London

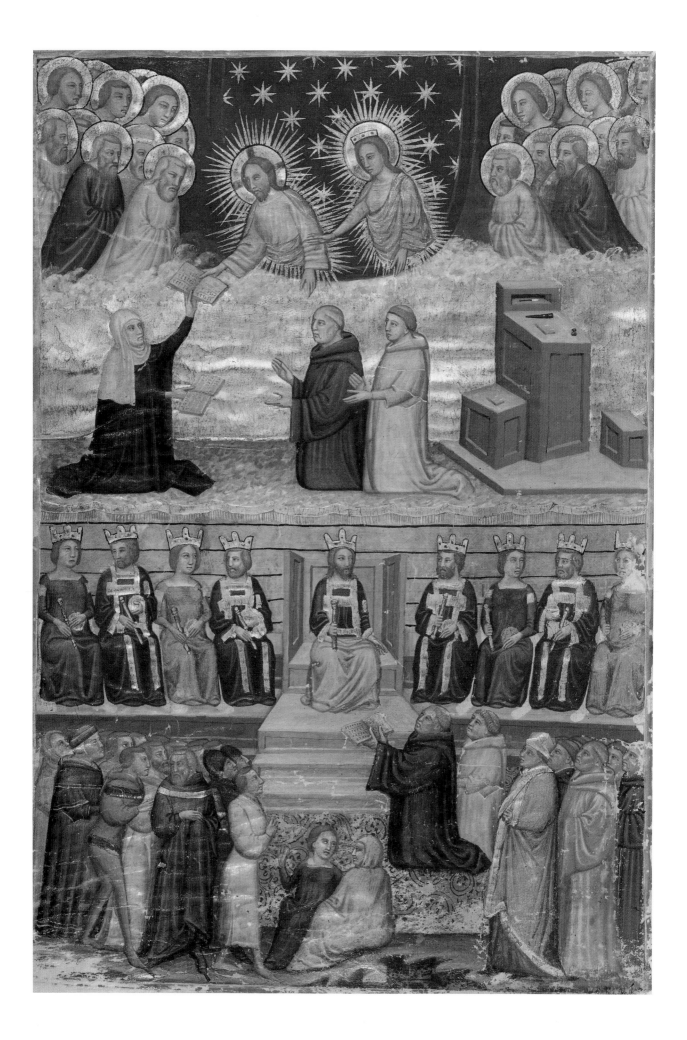

ST. BRIDGET, WIDOW, FOUNDRESS OF THE ORDER OF THE MOST HOLY SAVIOR

October 8

Patron Saint of Sweden

St. Birgitta, more commonly called Bridget, was daughter of Birger, governor of Upland, the principal province of Sweden, and his second wife, Ingeborg, daughter to the governor of East Gothland. Ingeborg, who had several other children, died about the year 1315, some twelve years after the birth of Bridget, who thenceforward was brought up by an aunt at Aspenäs on lake Sommen. She had not begun to speak till she was three years old, and then she spoke quite clearly and unhesitatingly, rather than confusedly like a child; her goodness and devotion matched her speech. When she was seven she had a vision of being crowned by our Lady; at ten she was deeply affected by a sermon on the passion of Christ, and the night following seemed to see Him hanging upon His cross and she thought she heard Him say to her, "Look upon me, my daughter." Before she was fourteen, Bridget married Ulf Gudmarsson, who was himself only eighteen, and the marriage subsisted happily for twenty-eight years. They had eight children, of whom one is venerated as St. Catherine of Sweden.

About the year 1335 St. Bridget was summoned to the court of the young king of Sweden, Magnus II, to be principal lady-in-waiting to his newly-wedded queen, Blanche of Namur. Before she had been long at court Bridget found that her responsibilities could not stop at the duties of her office. Magnus was weak and tended to be wicked; Blanche was good-willed but irre-sponsible and luxury-loving. The saint bent all her energies to developing the better side of the queen's character and to establishing an influence for good over both of them. She earned the respect of the young sovereigns, but did not succeed in making much difference in their lives; they could not or would not take her altogether seriously. And St. Bridget had troubles of her own. Her eldest daughter had married a riotous noble and about 1340 her youngest son, Gudmar, died. St. Bridget thereupon made a pilgrimage to the shrine of St. Olaf of Norway at Trondhjem, and on her return, fortified thereby, she made a further attempt to curb the excesses of Magnus and Blanche. Meeting with no more success than before, she got leave of absence from the court, and with Ulf went on pilgrimage to Compostela. On the way back Ulf was taken ill and died in 1344, at the monastery of Alvastra of the Cistercian Order.

After living at Alvastra for four years, St. Bridget founded a monastery at Vadstena, on Lake Vättern. In this house St. Bridget provided for sixty nuns, and in a separate enclosure monks, to the number of thirteen priests, in honor of the twelve Apostles and St. Paul, four deacons, representing the Doctors of the Church, and eight choir-brothers not in orders, making the number of our Lord's apostles and disciples, eighty-five, in all. All surplus income had every year to be given to the poor, and ostentatious buildings were forbidden; but each religious could have as many

ST. BRIDGET
St. Bridget of Sweden, Revelations in Latin, 14th cent. The Pierpont Morgan Library, New York

books for study as he or she pleased. During the fifteenth century Vadstena was the literary center of Sweden.

In consequence of a vision St. Bridget wrote a very outspoken letter to Pope Clement VI, urging him to abandon Avignon for Rome, and to bring about peace between Edward III of England and Philip IV of France. The pope declined to leave Avignon, but sent Hemming, Bishop of Abö, to Philip's court, where, however, he could do nothing. She was now out of favor at the Swedish court, but was beloved by the people, among whom she went traveling about the country and looking after their temporal and spiritual welfare. Many of them were not long converted, and she enforced the preaching of her chaplains by miracles of healing.

The saint's prophecies and revelations had reference to most of the burning political and religious questions of her time, of both Sweden and Rome. She prophesied that pope and emperor would shortly meet amicably in Rome (which Bd. Urban V and Charles IV did in 1368), and the using of her by factions did somewhat to abate her popularity among the Romans. Her prophecies that their iniquities would be visited with condign punishments had the same effect, and several times her ardor drew down persecution and slander upon her. On the other hand, she was not sparing of her criticisms, and did not fear to denounce a pope as "a murderer of souls, more unjust than Pilate and more cruel than Judas." Once she was turned out of her house at a month's notice, and more than once she and her daughter, St. Catherine, found themselves seriously in debt; they sometimes even had to beg food at a convent of Poor Clares. On her return from a pilgrimage to Amalfi she had a vision in which our Lord appeared to tell her to go to the pope, warn him that his death was near, and show him the rule of the religious at Vadstena. This rule had already been submitted to Urban V when he arrived in Rome, and he had done nothing about it. So now Bridget set off to Montefiascone on her white mule, and as a result the

pope gave a general approval to her religious foundation, prescribing for it the general Rule of St. Augustine with the Bridgettine constitutions. Four months later Urban was dead.

In 1371, in consequence of another vision, St. Bridget embarked on the last of her journeys, a pilgrimage to the Holy Places. In Palestine, after being nearly drowned in a wreck off Jaffa, her progress through the Holy Places was a succession of visions of the events that had happened there and other heavenly consolations. The party arrived back in Rome in March 1373. She died on July 23 in her seventy-first year. She was temporarily buried in the church of St. Lawrence *in Panisperna;* four months after, the body was taken up and was carried in triumphal progress by way of Dalmatia, Austria, Poland and Danzig to Vadstena, where it was laid to rest in the abbey. St. Bridget was canonized in 1391 and is the patron saint of the kingdom of Sweden.

Nothing is more famous in the life of St. Bridget than the many revelations with which she was favored by God, chiefly concerning the sufferings of our Savior and events which were to happen in certain kingdoms. St. Bridget with true simplicity of heart always submitted her revelations to the judgment of the pastors of the Church; and she was far from ever glorying in any extraordinary graces, which she never desired and on which she never relied except to be obedient thereto and to increase her love and humility. To have the knowledge of angels without charity is to be only a tinkling cymbal; both to have charity and to speak the language of angels was the happy privilege of St. Bridget. The book of her revelations was first printed at Lübeck in 1492, and has been translated into many languages. The lessons at Matins in the Bridgettine office are taken from the revelations on the glories of our Lady, the *Sermo angelicus,* according to the alleged words of our Lord to St. Bridget, "I will send my angel who will reveal to you the lesson that shall be read at Matins by the nuns of your monastery, and you shall write it as he tells you."

ST. CATHERINE OF SIENA, VIRGIN

April 30

Patron Saint of Italy; Fire Prevention; Nursing Service

S T. CATHERINE WAS BORN in Siena on the feast of the Annunciation in 1347, the youngest of twenty-five children. Her father, Giacomo Benincasa, a well-to-do dyer, lived with his wife Lapa, daughter of a now forgotten poet, in the spacious house which the piety of the Sienese has preserved almost intact to the present day. Catherine as a little girl is described as having been very merry, and sometimes on her way up or downstairs she used to kneel on every step to repeat a Hail Mary. She was only six years old when she had the remarkable mystical experience which may be said to have sealed her vocation. In the company of her brother Stephen she was returning from a visit to her married sister Bonaventura when she suddenly came to a dead stop, standing as though spellbound in the road, with her eyes gazing up into the sky, utterly oblivious to the repeated calls of the boy who, having walked on ahead, had turned round to find that she was not following. Only after he had gone back and had seized her by the hand did she wake up as from a dream. "Oh!" she cried, "if you had seen what I saw you would not have done that!" Then she burst into tears because the vision had faded — a vision in which she had beheld our Lord seated in glory with St. Peter, St. Paul and St. John. The Savior had smiled upon the child: He had extended His hand to bless her . . . and from that moment Catherine was entirely His. In vain did her shrewish mother seek to inspire her with the interests common to girls of her age: she cared but for prayer and solitude, only mingling with other children in order to lead them to share her own devotion.

When she had reached the age of twelve, her parents urged her to devote more care to her personal appearance. In order to please her mother and Bonaventura she submitted for a time to have her hair dressed and to be decked out in the fashion, but she soon repented of her concession. Uncompromisingly she now declared that she would never marry, and as her parents still persisted in trying to find her a husband she cut off her golden-brown hair — her chief beauty. The family, roused to indignation, tried to overcome her resolution by petty persecution. She was harried and scolded from morning to night, set to do all the menial work of the house, and because she was known to love privacy she was never allowed to be alone, even her little bedroom being taken from her. All these trials she bore with patience which nothing could ever ruffle. At last her father realized that further opposition was useless, and Catherine was allowed to lead the life to which she felt called. In the small room now ceded for her use, a cell-like apartment which she kept shuttered and dimly lighted, she gave herself up to prayer and fasting, took the discipline and slept upon boards.

Sometimes now Catherine was favored by celestial visions and consolations, but often she was subjected to fierce trials. Loathsome forms and enticing figures presented themselves to her imagination, whilst the most degrading temptations assailed her. She passed through long intervals of desolation, during which God would appear to have abandoned her altogether. On Shrove Tuesday, 1366, while Siena was keeping carnival, she was praying in her room when the Savior appeared to her, accompanied by His blessed Mother

and a crowd of the heavenly host. Taking the girl's hand, our Lady held it up to her Son who placed a ring upon it and espoused Catherine to Himself, bidding her to be of good courage, for she was now armed with faith to overcome the assaults of the enemy. The ring remained visible to her though invisible to others. This spiritual betrothal marked the end of the years of solitude and preparation. Very shortly afterwards, it was revealed to Catherine that she must now go forth into the world to promote the salvation of her neighbor, and she began gradually to mix again with her fellow creatures. Like the other tertiaries she undertook to nurse in the hospitals, and she always chose for preference the cases from which they were apt to shrink. Amongst these was a woman afflicted with a repulsive form of cancer and a leper called Tecca — both of whom rewarded her loving care by ingratitude, abusing her to her face and spreading scandal about her behind her back. In the end, however, they were won by her devotion.

As may be readily supposed, public opinion in Siena was sharply divided about Catherine. Although many acclaimed her as a saint, some dubbed her a fanatic, whilst others loudly denounced her as a hypocrite, even some of her own order. The new lector to Siena, Bd. Raymund of Capua, was appointed her confessor. Their association was a happy one for both. The learned Dominican became not only her director but in a great measure her disciple, whilst she obtained through him the support of the order. In later life he was to be the master general of the Dominicans and the biographer of his spiritual daughter.

Catherine's return to Siena almost coincided with the outbreak of a terrible epidemic of plague, during the course of which she devoted herself to relieving the sufferers, as did also the rest of her circle. But Catherine's care for the dying was not confined to the sick. She made it a regular practice to visit in prison those condemned to execution, in order that she might lead them to make their peace with God.

In February 1375 she accepted an invitation to visit Pisa, where she was welcomed with enthusiasm and where her very presence brought about a religious revival. She had only been in the city a few days when she had another of those great spiritual experiences which appear to have preluded new developments in her career. After making her communion in the little church of St. Christina, she had been looking at the crucifix, rapt in meditation, when suddenly there seemed to come from it five blood-red rays which pierced her hands, feet and heart, causing such acute pain that she swooned. The wounds remained as stigmata, apparent to herself alone during her life, but clearly visible after her death.

She was still at Pisa when she received word that the people of Florence and Perugia had entered into a league against the Holy See and its French legates; and Bologna, Viterbo, Ancona, together with other cities, not without provocation from the mismanagement of papal officials, promptly rallied to the insurgents. That Lucca as well as Pisa and Siena held back for a time was largely due to the untiring efforts of Catherine, who paid a special visit to Lucca besides writing numerous letters of exhortation to all three towns. From Avignon, after an unsuccessful appeal to the Florentines, Pope Gregory laid Florence under an interdict. This ban soon entailed such serious effects upon the city that its rulers in alarm sent to Siena, to accept Catherine's offer to become their mediatrix with the Holy See. Always ready to act as peacemaker, she promptly set out for Florence. The magistrates promised she should be followed to Avignon by their ambassadors. Catherine arrived at Avignon on June 18, 1376, and soon had a conference with Pope Gregory, to whom she had already written six times. But the Florentines proved fickle and insincere; their ambassadors disclaimed Catherine, and the pope's peace terms were so severe that nothing could be done.

Although the immediate purpose of her visit to Avignon had thus failed, Catherine's efforts in another direction were crowned with success. Many of the religious, social and political troubles under which Europe was groaning were to a great degree attributable to the fact that for seventy-four years the popes had been absent from Rome, living in Avignon, where the curia had become almost entirely French. Gregory XI had indeed himself proposed to transfer his residence to the Holy City, but had been deterred by the opposition

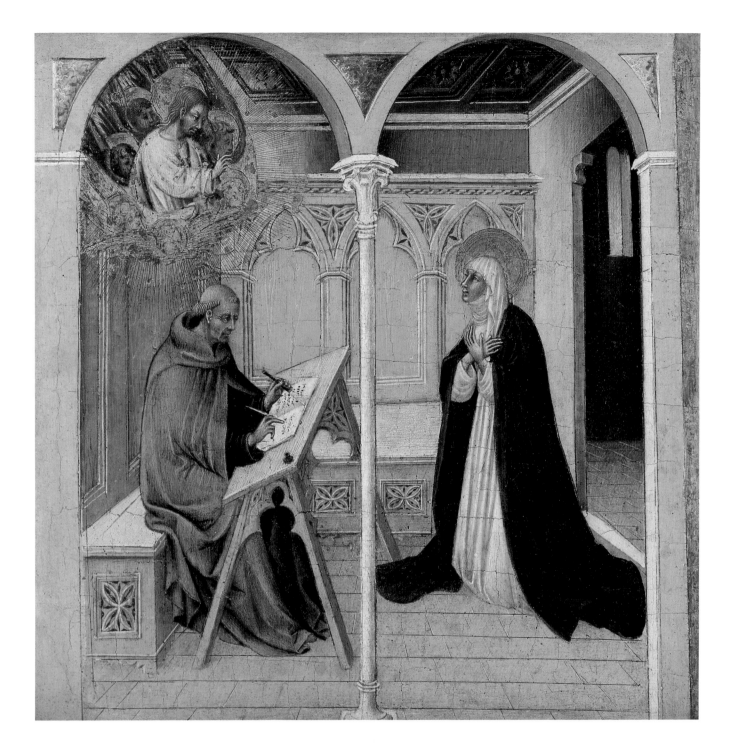

ST. CATHERINE OF SIENA

Giovanni di Paolo, *St. Catherine of Siena Dictating Her Dialogues to Raymond of Capua*, 15th cent. Detroit Institute of Arts

of his French cardinals. Since Catherine in her previous letters had urged his return to Rome, it was only natural that the pope should talk with her on the subject when they came face to face. "Fulfill what you have promised," was her reply — recalling to him, it is said, a vow which he had never disclosed to any human being. Gregory decided to act without loss of time. On September 13, 1376, he started from Avignon to travel by water to Rome, Catherine and her friends leaving the city on the same day to return overland to Siena. The two parties met again, almost accidentally, in Genoa, where Catherine was detained by the illness of two of her secretaries. It was a month before she was back in Siena, from whence she continued to write to Pope Gregory, exhorting him to contribute by all means possible to the peace of Italy. By his special desire she went again to Florence, still rent by factions and obstinate in its disobedience. There she remained for some time, amidst daily murders and confiscations, in danger of her life but ever undaunted, even when swords were drawn against her. Finally she did indeed establish peace with the Holy See, although not during Gregory's reign, but in that of his successor.

After this memorable reconciliation the saint returned to Siena where, as Raymund of Capua tells us, "she occupied herself actively in the composition of a book which she dictated under the inspiration of the Holy Ghost." This was the very celebrated mystical work, written in four treatises, known as the "Dialogue of St. Catherine." That she was favored with some infused knowledge had indeed already been made clear on several occasions when learned theologians had plied her with hard questions, and had retired disconcerted with the wisdom of her replies. Her health had long since become so seriously impaired that she was never free from pain: yet her emaciated face habitually bore a happy and even smiling expression, and her personal charm was as winning as ever.

But within two years of the ending of the papal "captivity" at Avignon began the scandal of the great schism which followed the death of Gregory XI in 1378, when Urban VI was chosen in Rome and a rival pope was set up in Avignon by certain cardinals who declared Urban's election illegal. Christendom was divided into two camps, and Catherine wore herself out in her efforts to obtain for Urban the recognition which was his due. Letter after letter she addressed to the princes and leaders of the various European countries. To Urban himself she continued to write, sometimes to urge him to bear up under his trials, sometimes admonishing him to abate a harshness which was alienating even his supporters. Far from resenting her reproof, the pope told her to come to Rome that he might profit by her advice and assistance. In obedience to the call she took up her residence in the City, laboring indefatigably by her prayers, exhortations and letters to gain fresh adherents to the true pontiff. Her life, however, was almost ended. Early in 1380 she had a strange seizure, when a visible presentment of the ship of the Church seemed to crush her to the earth and she offered herself a victim for it. After this she never really recovered. On April 21 there supervened a paralytic stroke, and eight days later, at the age of thirty-three, St. Catherine of Siena passed away.

Besides the Dialogue mentioned above, about 400 of St. Catherine's letters are still extant, many of them of great interest and historical value, and all of them remarkable for the beauty of their diction; they are addressed to popes and princes, priests and soldiers, religious and men and women in the world. Those, especially, addressed to Gregory XI show a remarkable combination of deep respect, outspokenness and familiarity — "my sweet babbo" she calls the pontiff. The Church canonized her in 1461.

ST. BERNARDINO OF SIENA

May 20

Patron Saint of Italy; Advertisers; Public Relations

St. Bernardino was born in the Tuscan town of Massa Marittima, in which his father, a member of the noble Sienese family of the Albizeschi, occupied the post of governor. The little boy lost both his parents before he was seven and was entrusted to the care of a maternal aunt and her daughter — both excellent women, who gave him a religious training and loved him as though he had been their own child. Upon reaching the age of eleven or twelve he was placed by his uncles at school in Siena, where he passed with great credit through the course of studies deemed requisite for a boy of his rank. He grew up a good-looking lad, so merry and entertaining that it was impossible to be dull in his company; but a coarse or blasphemous remark would always bring a blush to his cheek and generally a remonstrance to his lips. Except when moved by righteous indignation, Bernardino was singularly sweet-tempered; indeed, throughout his life he was noted for his unfailing affability, patience and courtesy.

At the age of seventeen he enrolled himself in a confraternity of our Lady, the members of which pledged themselves to certain devotional practices as well as to the relief of the sick. In 1400 Siena was visited by the plague in a virulent form. So serious was its toll that from twelve to twenty persons died daily in the famous hospital of Santa Maria della Scala, which found itself bereft of almost all who tended the sick. In this extremity Bernardino offered to take entire charge of the establishment, with the help of some other young men whom he had fired with the determination to sacrifice their lives if necessary to aid the sufferers. Their services were accepted, and for four months the noble band worked tirelessly, day and night, under the direction of Bernardino, who, besides nursing the patients and preparing them for death, saw to everything and brought order as well as cleanliness into the hospital. Though several of his companions died, Bernardino escaped the contagion and returned home after the epidemic was over. He was, however, so exhausted by his labors that he fell an easy prey to a fever which laid him low for several months.

Free from all earthly ties, Bernardino was led to enter the Franciscan Order, the habit of which he received shortly afterwards in Siena. The house, however, proved too accessible to the novice's many friends and relations, and with the consent of his superiors he retired to the convent of Colombaio outside the city, where the rule of St. Francis was strictly observed. Here in 1403 he was professed and here he was ordained priest — exactly a year later. Gradually he was being prepared by God for the twofold mission of apostle and reformer. When at last his hour had come, the way was made clear in a singular manner. A novice in the convent at Fiesole in which the saint was staying startled the community on three consecutive nights after Matins by exclaiming, "Brother Bernardino! Hide no longer the gift that is in you. Go to Lombardy, for all are awaiting you there!" Reprimanded and questioned as to why he had thus spoken, he replied, "Because I could not help it!" To Bernardino and his superiors this seemed to be a call from on high, and he obeyed. He opened his apostolic career at Milan to which he went as a complete stranger towards the end of 1417, but soon his eloquence and zeal began to attract enormous congre-

ST. BERNARDINO OF
SIENA

El Greco. *St. Bernardino of
Siena.* Museo del Greco,
Toledo

gations. At first he was hampered in his delivery by hoarseness and inability to make himself heard, but afterwards, as the result, he firmly believed, of fervent prayer to our Lady, his voice became singularly clear and penetrating.

In his missionary journeys he covered nearly the whole of Italy. He traveled always on foot, preached sometimes for three or four consecutive hours and often delivered several sermons on the same day. In large cities he frequently had to speak from an open-air pulpit because no church could contain the multitudes who crowded to hear him. At the end of every sermon he would hold up for veneration a tablet upon which he had written the letters I.H.S., surrounded by rays, and after telling the people to implore God's mercy and to live in peace he would give them a blessing with the Holy Name. In cities torn by faction he would heal deadly feuds and would persuade men to substitute the sacred monogram for the Guelf or Ghibelline emblems that too often surmounted their front doors. In Bologna, which was overmuch addicted to games of hazard, he preached with such effect that the citizens gave up gambling and brought their cards and dice to be burnt in a public bonfire. A card-manufacturer who complained that he was deprived of his only means of livelihood was told by St. Bernardino to manufacture tablets inscribed with the I.H.S., and so great was the demand for them that they brought in more money than the playing-cards had ever done. All over Italy men spoke of the wonderful fruit of St. Bernardino's missions. Nevertheless there were some who took exception to his teaching and accused him of encouraging superstitious practices. They went so far as to denounce him to Pope Martin V, who for a time commanded him to keep silence. However, an examination of his doctrine and conduct led to a complete vindication and he received permission to preach wherever he liked.

In 1430, nevertheless, he was obliged to give up missionary work to become vicar general of the friars of the Strict Observance. This movement within the Franciscan Order had originated about the middle of the fourteenth century and had only maintained a struggling existence until the coming of St. Bernardino, who became its organizer and its second founder. When he received the habit there were only three hundred friars of the Observance in all Italy; when he died there were four thousand. He consolidated and regulated the reform with so much wisdom and tact that many convents passed voluntarily and without friction from the Conventual to the Observant rule. The original Observants had shunned scholarship as they had shunned riches, but St. Bernardino was aware of the danger of ignorance. He therefore insisted upon instruction in theology and canon law as part of the regular curriculum.

Important as was the work with which he was now entrusted, the saint longed to return to his apostolic labors which he regarded as his only vocation, and in 1442 he obtained permission from the pope to resign his office as vicar general. He then resumed his missionary journeys, which led him through the Romagna, Ferrara and Lombardy. He was by this time in failing health, and so emaciated that he looked like a skeleton, but the only concession he would allow himself was the use of a donkey to convey him from one place to another. At Massa Marittima in 1444 he preached on fifty consecutive days a course of Lenten sermons, which he wound up by exhorting the inhabitants to preserve harmony among themselves and by bidding a pathetic farewell to his native town. Though obviously dying, he still continued his apostolic work and set out for Naples, preaching as he went. He succeeded in reaching Aquila, but there his strength gave out and he died on the eve of the Ascension, May 20, 1444, in the monastery of the Conventuals. His tomb at Aquila was honored by many miracles and he was canonized within six years of his death.

ST. JOAN OF ARC, VIRGIN

May 30

Patron Saint of France; Soldiers

ST. JEANNE LA PUCELLE was born at Domrémy, a little village of Champagne on the bank of the Meuse. Her father, Jacques d'Arc, was a peasant farmer of some local standing, a worthy man, frugal and rather morose; but his wife was a gentle, affectionate mother to their five children. Impressive and often touching testimony to her piety and exemplary conduct appears in the sworn depositions of her former neighbors presented in the process for her rehabilitation. Priests and former playmates amongst others recalled her love of prayer and church, her frequent reception of the sacraments, her care of the sick, and her sympathy with poor wayfarers to whom she often gave up her own bed. A happy childhood hers seems to have been, though clouded by the disasters of her country as well as by the dangers of attack to which a frontier town like Domrémy was specially exposed.

She had been but a very young child when Henry V of England invaded France, overran Normandy and claimed the crown of the insane king, Charles VI. France, in the throes of civil war between the contending parties of the Dukes of Burgundy and Orléans, had been in no condition from the first to put up an adequate resistance, and after the Duke of Burgundy had been treacherously murdered the Burgundians threw in their lot with the English, who supported their claims. The death of the rival kings in 1422 brought no relief to France. The Duke of Bedford, as regent for the infant King of England, prosecuted the war with vigor, one fortified town after another falling into the hands of the allies, while Charles VII, or the Dauphin as he was still called, seems to have regarded the position as hopeless and spent his time in frivolous pastimes with his court.

St. Joan was in her fourteenth year when she experienced the earliest of those supernatural manifestations which were to lead her through the path of patriotism to death at the stake. At first it was a single voice addressing her apparently from nearby, and accompanied by a blaze of light: afterwards, as the voices increased in number, she was able to see her interlocutors whom she identified as St. Michael, St. Catherine, St. Margaret and others. Only very gradually did they unfold her mission: she, a simple peasant girl, was to save France! By May 1428 they had become insistent and explicit. She must present herself at once to Robert Baudricourt, who commanded the king's forces in the neighboring town of Vaucouleurs. But Baudricourt only laughed and dismissed her.

After Joan's return to Domrémy her Voices gave her no rest. When she protested that she was a poor girl who could neither ride nor fight, they replied; "It is God who commands it." Unable to resist such a call she secretly left home and went back to Vaucouleurs. Baudricourt's skepticism as to her mission was somewhat shaken when official confirmation reached him of a serious defeat of the French which Joan had previously announced to him. He now not only consented to send her to the king but gave her an escort of three men-at-arms. At her own request she traveled in male dress to protect herself. Although the little party reached Chinon, where the king was residing, on March 6, 1429, it was not till two days later that Joan was admitted to his presence. Charles had purposely disguised himself, but she identified him at once and,

ST. JOAN OF ARC
Jules Bastien-Lepage. *Joan of Arc,* 1879. Metropolitan Museum of Art, New York

by a secret sign communicated to her by her Voices and imparted by her to him alone, she obliged him to believe in the supernatural nature of her mission. She then asked him for soldiers whom she might lead to the relief of Orléans. This request was opposed by La Trémouille, the king's favorite, and by a large section of the court, who regarded the girl as a crazy visionary or a scheming impostor. To settle the matter it was decided to send her to be examined by a learned body of theologians at Poitiers.

After a searching interrogatory extending over three weeks this council decided that they found nothing to disapprove of, and advised Charles to make prudent use of her services. Accordingly after her return to Chinon arrangements were pushed forward to equip her to lead an expeditionary force. A special standard was made for her bearing the words "Jesus: Maria," together with a representation of the Eternal Father to whom two kneeling angels were presenting a fleur-de-lis. On April 27 the army left Blois with Joan at its head clad in white armor, and entered Orléans on April 29. Her presence in the beleaguered city wrought marvels. By May 8, the English forts which surrounded Orléans had been captured and the siege raised. The

Maid was then allowed to undertake a short campaign on the Loire with the Duc d'Alençon, one of her best friends. It was completely successful and ended with a victory at Patay in which the English forces under Sir John Fastolf suffered a crushing defeat.

On July 17, 1429, Charles VII was solemnly crowned, Joan standing at his side with her standard. That event, which completed the mission originally entrusted to her by her Voices, marked also the close of her military successes. Upon the resumption of hostilities she hurried to the relief of Compiègne which was holding out against the Burgundians. She entered the city at sunrise on May 23, 1430, and that same day led an unsuccessful sortie. Through panic or some miscalculation on the part of the governor, the drawbridge over which her company was retiring was raised too soon, leaving Joan and some of her men outside at the mercy of the enemy. She was dragged from her horse with howls of execration, and led to the quarters of John of Luxembourg. From that time until the late autumn she remained the prisoner of the Duke of Burgundy. Never during that period or afterwards was the slightest effort made on her behalf by King Charles or any of his subjects. But the English leaders desired to have her if the French did not: and on November 21 she was sold to them. Once in their hands her execution was a foregone conclusion. Though they could not condemn her to death for defeating them in open warfare, they could have her sentenced as a sorceress and a heretic.

In the castle of Rouen Joan was confined at first in an iron cage, for she had twice tried to escape. Afterwards she lay in a cell where, though chained to a plank bed, she was watched day and night by soldiers. On February 21, 1431, she appeared for the first time before a tribunal presided over by Peter Cauchon, bishop of Beauvais, an unscrupulous man who hoped through English influence to become archbishop of Rouen. The prisoner was examined and cross-examined as to her visions and "voices," her assumption of male attire, her faith and her willingness to submit to the Church. Alone and undefended she bore herself fearlessly, her shrewd answers and accurate memory astonishing and frequently embarrassing her ques-

tioners. Only very occasionally was she betrayed into making damaging replies, through her ignorance of theological terms and lack of education. Nevertheless, at the conclusion of the sittings a grossly unfair summing-up of her statements was drawn up and submitted first to the judges, who on the strength of it declared her revelations to have been diabolical, and then to the University of Paris, which denounced her in violent terms.

In a final deliberation the tribunal decided that she must be handed over to the secular arm as a heretic if she refused to retract. This she declined to do, though threatened with torture. Only when she was brought into the cemetery of St. Ouen before a huge crowd, to be finally admonished and sentenced, was she intimidated into making some sort of retractation. She was led back to prison but her respite was a short one. Either as the result of a trick played by those who thirsted for her blood or else deliberately of her own free-will, she resumed the male dress which she had consented to discard; and when Cauchon with some of his satellites visited her in her cell to question her concerning what they chose to regard as a relapse, they found that she had recovered from her weakness. Once again she declared that God had truly sent her and that her voices came from God. On May 30, 1431, Joan was led out into the market-place of Rouen to be burned at the stake. Joan's demeanor on that occasion was such as to move even the most hardened to tears. When the faggots had been lighted, a Dominican friar at her request held up a cross before her eyes, and as the flames leaped up she was heard to call upon the name of Jesus before surrendering her soul to God.

She was not yet twenty years old. After her death her ashes were contemptuously cast into the Seine. Twenty-three years later Joan's mother and her two brothers appealed for a reopening of the case, and Pope Callistus III appointed a commission for the purpose. Its labors resulted, on July 7, 1456, in the quashing of the trial and verdict and the complete rehabilitation of the Maid. Over four hundred and fifty years later, on May 16, 1920, she was canonized with all the solemnity of the Church.

ST. IGNATIUS OF LOYOLA, FOUNDER OF THE SOCIETY OF JESUS

July 31

Patron Saint of Retreats; Soldiers; Spiritual Exercises

St. Ignatius was born, probably in 1491, in the castle of Loyola at Azpeitia, in Guipuzcoa, a part of Biscay that reaches to the Pyrenees. His father, Don Beltran, was lord of Oñaz and Loyola, head of one of the most ancient and noble families of that country, and his mother, Marina Saenz de Licona y Balda, was not less illustrious. They had three daughters and eight sons, and Ignatius (Iñigo he was christened) was the youngest child; he was trained to arms and saw some service against the French in northern Castile; but his short military career came to an abrupt end on May 20, 1521, when, in the defense of Pamplona, a cannon ball broke his right shin and tore open the left calf. At his fall the Spanish garrison surrendered.

The French used their victory with moderation, and sent him carried in a litter to the castle of Loyola. His broken leg had been badly set, and the surgeons therefore thought it necessary to break it again, which he suffered without any apparent concern. But a violent fever followed the second setting, which was attended with dangerous symptoms; on the eve of the feast of SS. Peter and Paul it was believed he could not hold out till the next morning, but he suddenly took a turn for the better, though he was convalescent for many months.

While he was confined to his bed, finding the time tedious, Ignatius called for some book of romances. None such being then found in the castle of Loyola, a book of the life of our Savior and another of legends of the saints were brought him. He read them first only to pass away the time, but afterward began to relish them and to spend whole days in reading them. He said to

himself: "These men were of the same frame as I; why then should I not do what they have done?" and in the fervor of his good resolutions he thought of visiting the Holy Land and becoming a Carthusian lay-brother. But these ideas were intermittent; and his passion for glory and inclination for a lady of high degree again filled his mind till, returning to the lives of the saints, he perceived in his own heart the emptiness of all worldly glory, and that only God could content the soul.

One night, Ignatius saw the Mother of God surrounded with light, holding the infant Jesus in her arms; this vision replenished his soul with delight and, being cured of his wounds, he went on pilgrimage to the shrine of our Lady at Montserrat, resolved thenceforward to lead a life of penance. Three leagues from Montserrat is the small town of Manresa, and here he stayed, sometimes with the Dominican friars, sometimes in a paupers' hospice; and there was a cave in a neighboring hill whither he might retire for prayer and penance. So he lived for nearly a year. After enjoying much peace of mind and heavenly consolation he was soon visited with the most terrible trial of fears and scruples. He found no comfort in prayer, no relief in fasting, no remedy in disciplines, no consolation from the sacraments, and his soul was overwhelmed with sadness. During this time he began to note down material for what was to become the book of his *Spiritual Exercises*. At length his tranquillity of mind was restored, and his soul overflowed with spiritual joy. From this experience he acquired a particular talent for curing scrupulous consciences, and a singular light to discern them.

In February 1523, Ignatius started on his journey to the Holy Land; begging his way, he took ship from Barcelona, spent Easter at Rome, sailed from Venice to Cyprus, and thence to Jaffa. He went by donkey from thence to Jerusalem, with the firm intention of staying there. But after visiting and spiritually rejoicing in the scenes of the passion of Jesus, the Franciscan guardian of the Holy Places commanded him to leave Palestine. Ignatius obeyed, with no knowledge of what he was going to do.

He returned to Spain in 1524; and he now set himself to study, "as a means of helping him to work for souls," and began at Barcelona with Latin grammar. He was then thirty-three years old: and it is not hard to imagine what difficulties he went through in learning the rudiments of grammar at that age. At first his mind was so fixed only on God that he forgot everything he read, and conjugating *amo,* for example, could only repeat to himself, "I love God; I am loved by God," and the like; but he began to make some progress, still joining contemplation and austerities with his studies. He bore the jeers and taunts of the little boys, his schoolfellows, with patience and even amusement.

After studying two years at Barcelona he went to the University of Alcala, where he attended lectures in logic, physics and divinity. He lodged at a hospice, lived by begging, and wore a coarse gray habit. He catechized children, held assemblies of devotion in the hospice, and by his mild reprehensions converted many loose livers. Those were the days of strange cults in Spain, and Ignatius, being a man without learning or authority, was accused to the bishop's vicar general, who confined him to prison two-and-forty days, but declared him innocent of any fault at the end of it; but forbidding him and his companions to wear any singular dress, or to give any instructions in religious matters for three years. So he migrated with his three fellows to Salamanca, where he was exposed again to suspicions of introducing dangerous doctrines, and the inquisitors imprisoned him; but after three weeks declared him innocent. Ignatius looked upon prisons, sufferings and ignominy as trials by which God was pleased to purge and sanctify his soul. Recovering his liberty again, he resolved to leave Spain, and in the middle of winter traveled on foot to Paris, where he arrived in the beginning of February 1528.

He studied philosophy in the college of St. Barbara, where he induced many of his fellow-students to spend the Sundays and holy days in prayer, and to apply themselves more fervently to good works. Pegna, his master, thought he hindered their studies and prepossessed Gouvea, principal of the college, against him, so that he was ordered to undergo a public flogging, that this disgrace might deter others from following him. Ignatius offered himself joyfully to suffer all things; yet fearing lest the scandal of this disgrace should make those whom he had reclaimed fall back, he went to the principal and modestly laid open to him the reasons of his conduct. Gouvea made no answer, but taking him by the hand led him into the hall, where the whole college stood assembled. He then turned to Ignatius and begged his pardon for having too lightly believed false reports. In 1534 the middle-aged student — he was forty-three — graduated as master of arts of Paris.

At that time six students in divinity associated themselves with Ignatius in his spiritual exercises. They were Peter Favre, a Savoyard; Francis Xavier, a Basque like Ignatius; Laynez and Salmeron, both fine scholars; Simon Rodriguez, a Portuguese; and Nicholas Bobadilla. These fervent students, moved by the exhortations of Ignatius, made all together a vow to observe poverty and chastity and to go to preach the gospel in Palestine, or if they could not go thither to offer themselves to the pope to be employed in the service of God in what manner he should judge best. Ignatius continued by frequent conferences and joint exercises to animate his companions, and a simple rule of life

was adopted. But his theological studies were soon interrupted, for he was ordered by the physicians to try his native air for the improvement of his health.

Two years later they all met in Venice, but hostilities between Venice and the Turks had then reached an acute phase and it was impossible to find a ship to sail to Palestine. Ignatius's companions (now numbering ten) therefore went to Rome, where Pope Paul III received them well, and they were accordingly ordained and then retired into a cottage near Vicenza to prepare themselves for the holy ministry of the altar. There being no likelihood of their being able soon to go to the Holy Land, it was at length resolved that Ignatius, Favre and Laynez should go to Rome and offer the services of all to the pope, and they agreed that if anyone asked what their association was they might answer, "the Company of Jesus," because they were united to fight against falsehood and vice under the standard of Christ. On his road to Rome, praying in a little chapel at La Storta, Ignatius saw our Lord, shining with an unspeakable light, but loaded with a heavy cross, and he heard the words, *Ego vobis Romae propitius ero,* "I will be favorable to you at Rome."

With a view to perpetuate their work, it was now proposed to form themselves into a religious order. It was resolved, first, besides the vows of poverty and chastity already made by them, to add a third of obedience, the more perfectly to conform themselves to the Son of God who was obedient even unto death; and to appoint a superior general whom all should be bound to obey, who should be for life and his authority absolute, subject entirely to the Holy See. They likewise determined to prescribe a fourth vow, of going wherever the pope should send them for the salvation of souls. Ignatius was chosen the first general superior, but only acquiesced in obedience to his confessor. He entered upon his office on Easter-day, 1541.

For the rest of his life Ignatius lived in Rome, tied there by the immense work of directing the activities of the order which he ruled till his death. St. Francis Borgia in 1550 gave a considerable sum towards building the Roman College for the Jesuits; St. Ignatius made this the model of all his other colleges and took care that it should be supplied with able masters and all possible helps for the advancement of learning. He also directed the foundation of the German College in Rome, originally intended for scholars from all countries seriously affected by Protestantism. Other universities, seminaries and colleges were established in other places; but the work of education for which the Jesuits are so famous was a development that only came by degrees, though well established before the founder's death.

The prudence and charity of St. Ignatius in his conduct towards his religious won him all their hearts. He always showed the affection of the most tender parent towards his brethren, especially towards the sick, for whom he procured every spiritual and temporal succor and comfort, which it was his great delight to give them himself. He received rebukes from anyone with cheerfulness; but would not from a false delicacy abstain from rebuking others who clearly stood in need of it. He particularly reprimanded those whom learning had made conceited, tiresome, or lukewarm in religion, but at the same time he encouraged every branch of learning and would have the fathers in his Society applied to that work, whether in teaching, preaching or the missions, for which God seemed chiefly to qualify and destine them by their genius, talents and particular graces. Charity, the most ardent and pure love of God, was the crown of all virtues. He had often in his mouth these words, which he took for his motto, "To the greater glory of God" — to which end he referred himself, his Society, and all his actions.

In the fifteen years that he directed his order St. Ignatius saw it grow from ten members to one thousand, in nine countries and provinces of Europe, in India and in Brazil. And in those fifteen years he had been ill fifteen times, so that the sixteenth time caused no unusual alarm. But it was the last. He died suddenly, so unexpectedly that he did not receive the last sacraments, early in the morning of July 31, 1556. He was canonized in 1622, and by Pope Pius XI he was declared the heavenly patron of spiritual exercises and retreats.

ST. FRANCIS XAVIER

December 3

Patron Saint of the East Indies; Japan; Foreign Missions

A CHARGE TO GO AND PREACH to all nations was given by Christ to His apostles. Among those who have labored most successfully in this great work is the illustrious St. Francis Xavier. He was one of the greatest of all missionaries, and among numerous eulogies that of Sir Walter Scott is striking: "The most rigid Protestant, and the most indifferent philosopher, cannot deny to him the courage and patience of a martyr, with the good sense, resolution, ready wit and address of the best negotiator that ever went upon a temporal embassy." He was born in Spanish Navarre, at the castle of Xavier, near Pamplona, in 1506 (his mother-tongue was Basque), the youngest of a large family, and he went to the University of Paris in his eighteenth year. He entered the college of St. Barbara and in 1528 gained the degree of licentiate. Here it was that he met Ignatius Loyola and he was one of the band of seven, the first Jesuits, who vowed themselves to the service of God at Montmartre in 1534. With them he received the priesthood at Venice three years later and shared the vicissitudes of the nascent society until, in 1540, St. Ignatius appointed him to join the first missionary expedition it sent out, to the East Indies.

Before he sailed, King John III delivered to him briefs from the pope in which Francis Xavier was constituted apostolic nuncio in the East. The king could not prevail on him to accept any gifts except some clothes and books. Nor would he consent to have a servant, saying that "the best means to acquire true dignity is to wash one's own clothes and boil one's own pot, unbeholden to anyone."

St. Francis was accommodated on the admiral's vessel which contained crew, passengers, soldiers, slaves and convicts, whom Francis considered as committed to his care. He catechized, preached every Sunday before the mast, took care of the sick, converted his cabin into an infirmary, and all this though suffering at first seriously from sea-sickness. It took them five months to get round the Cape of Good Hope and arrive at Mozambique, where they wintered. They continued to hug the east coast of Africa and called at Malindi and Socotra, from whence it took them two months to reach Goa, where they arrived on May 6, 1542, after a voyage of thirteen months (twice the then usual time).

The Portuguese had been established in Goa since 1510 and there was a considerable Christian population, with churches, clergy and a bishop. But among very many of these Portuguese, ambition, avarice, usury and debauchery had extinguished their religion: the sacraments were neglected, there were not four preachers and no priests outside the walls of Goa; when slaves were atrociously beaten, their masters counted the blows on the beads of their rosaries.

The scandalous behavior of the Christians was like a challenge to Francis Xavier and he opened his mission with them, instructing them in the principles of religion and forming the young to the practice of virtue. Having spent the morning in assisting and comforting the distressed in the hospitals and prisons, he walked through the streets ringing a bell to summon the children and slaves to catechism. They gathered in crowds about him, and he taught them the creed and prayers and Christian conduct.

After five months of this St. Francis was told that

on the Pearl Fishery coast, opposite Ceylon, there were people called Paravas, who to get the protection of the Portuguese against the Arabs and others had been baptized, but for want of instruction still retained their superstitions and vices. Xavier went to the help of these people — the first of thirteen repetitions of this torrid and dangerous journey. He set himself to learn the native language and to instruct and confirm those who had been already baptized, especially concentrating on teaching the rudiments of religion to the children. St. Francis, as always, came before the people as one of themselves. His food was that of the poorest, rice and water; he slept on the ground in a hut.

In the spring of 1545 St. Francis set out for Malacca, on the Malay peninsula, where he spent four months. The next eighteen months were a time of great activity and interest, for he was in a largely unknown world, visiting islands, which he refers to in general as the Moluccas, not all of which are now identifiable. In this mission he suffered much, but from it wrote to St. Ignatius: "The dangers to which I am exposed and the tasks I undertake for God are springs of spiritual joy, so much so that these islands are the places in all the world for a man to lose his sight by excess of weeping: but they are tears of joy. I do not remember ever to have tasted such interior delight and these consolations take from me all sense of bodily hardships and of troubles from open enemies and not too trustworthy friends." Before he left he heard about Japan for the first time, from Portuguese merchants and from a fugitive Japanese named Anjiro. Xavier arrived back in India in January 1548.

The next fifteen months were spent in endless traveling between Goa, Ceylon and Cape Comorin, consolidating his work (notably the "international college" of St. Paul at Goa) and preparing for an attempt on that Japan into which no European had yet penetrated. In April 1549, St. Francis set out, accompanied by a Jesuit priest and a lay-brother, by Anjiro — now Paul — and by two other Japanese converts. On

the feast of the Assumption following they landed in Japan, at Kagoshima on Kyushu.

At Kagoshima they were not molested, and St. Francis set himself to learn Japanese (so far from having the gift of tongues with which he is so often credited, he seems to have had difficulty in learning new languages). A translation was made of a simple account of Christian teaching, and recited to all who would listen. The fruit of twelve months' labor was a hundred converts, and then the authorities began to get suspicious and forbade further preaching. So, leaving Paul in charge of the neophytes, Francis decided to push on further with his other companions and went by sea to Hirado, north of Nagasaki. Before leaving Kagoshima he visited the fortress of Ichiku, where the "baron's" wife, her steward and others accepted Christianity. To the steward's care Xavier recommended the rest at departure; and twelve years later the Jesuit lay-brother and physician, Luis de Almeida, found these isolated converts still retaining their first fervor and faithfulness. At Hirado the missionaries were well received by the ruler (daimyô), and they had more success in a few weeks than they had had at Kagoshima in a year. These converts St. Francis left to Father de Torres and went on with Brother Fernandez and a Japanese to Yamaguchi in Honshu. Francis preached here, in public and before the daimyô, but the missionaries made no impression and were treated with scorn.

Seeing that evangelical poverty had not the appeal in Japan that it had in India, St. Francis changed his methods. Decently dressed and with his companions as attendants he presented himself before the daimyô as the representative of Portugal, giving him the letters and presents (a musical-box, a clock and a pair of spectacles among them) which the authorities in India had provided for the mikado. The daimyô received the gifts with delight, gave Francis leave to teach, and provided an empty Buddhist monastery for a residence. When thus he obtained protection, Francis

ST. FRANCIS XAVIER
Bartolomé Estéban Murillo. *St. Francis Xavier,* c. 1670. Wadsworth Athenaeum, Hartford

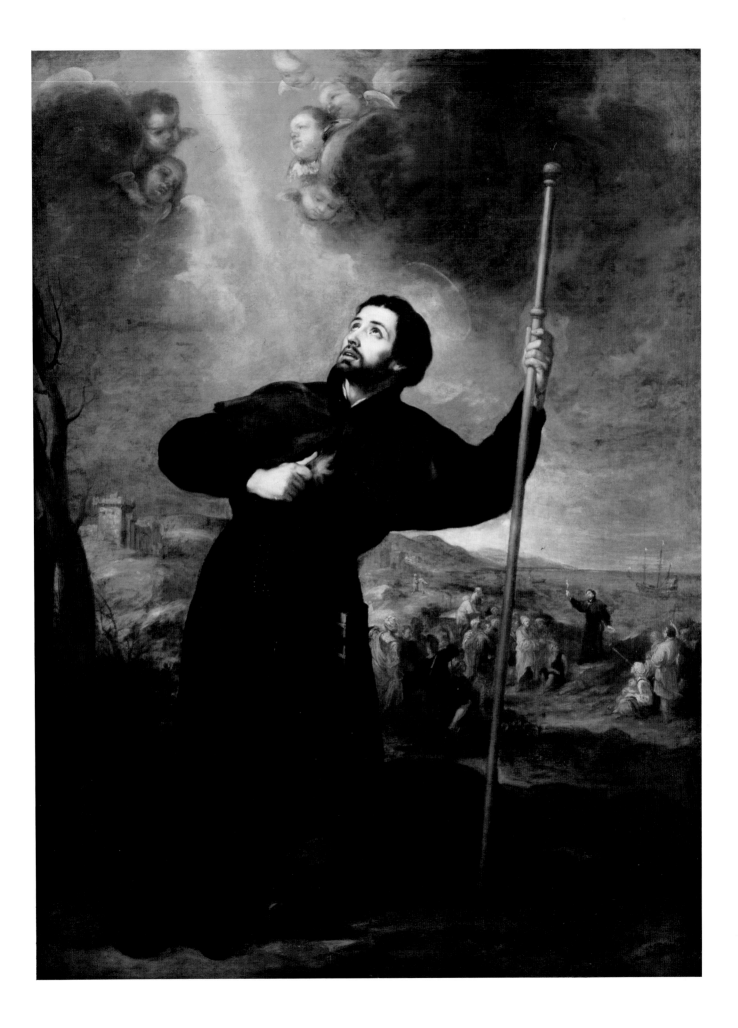

preached with such fruit that he baptized many in that city.

Hearing that a Portuguese ship had arrived at Funai (Oita) in Kyushu St. Francis set out thither. Francis had decided to make use of this ship to revisit his charge in India, from whence he now hoped to extend his mission to China. The Japanese Christians were left in charge of Father Cosmas de Torres and Brother Fernandez: they numbered perhaps 2000 in all, the seed of many martyrs in time to come.

Francis found that good progress had been made in India, but there were also many difficulties and abuses, both among the missionaries and the Portuguese authorities, that urgently needed his attention. These matters he dealt with, lovingly and very firmly and thoroughly. At the end of four months, on April 25, 1552, he sailed eastward again; he was awaited at Malacca by Diogo Pereira, whom the viceroy in India had appointed ambassador to the court of China.

At Malacca St. Francis had to treat about this embassy with Don Alvaro da Ataíde da Gama (a son of Vasco da Gama), the maritime authority there. This Alvaro had a personal grudge against Diogo Pereira, whom he flatly refused to let sail either as envoy or as private trader. Nothing could move him, but at length Don Alvaro conceded that Xavier should go to China in Pereira's ship, but without its owner; and to this Pereira most nobly agreed. When the project of the embassy thus failed Francis sent his priest companion to Japan, and eventually was left with only a Chinese youth, Antony. With him he hoped to find means to land secretly in China, the country closed to foreigners. In the last week of August 1552 the convoy reached the desolate island of Sancian (Shang-chwan), half-a-dozen miles off the coast and a hundred miles south-west of Hong Kong.

From here by one of the ships St. Francis sent off letters, including one to Pereira, to whom he says: "If there is one man in the whole of this undertaking who deserves reward from divine Providence it is undoubtedly you; and you will have the whole credit of it." Then he goes on to tell the arrangements he has made: he had with great difficulty hired a Chinese merchant to land him by night in some part of Canton, for

which Xavier had engaged to pay him, and bound himself by oath that nothing should ever bring him to confess the name of him who had set him on shore. Whilst waiting for his plans to mature, Xavier fell sick and, when the Portuguese vessels were all gone except one, was reduced to extreme want: in his last letter he wrote, "It is a long time since I felt so little inclined to go on living as I do now." The Chinese merchant did not turn up. A fever seized the saint on November 21, and he took shelter on the ship; but the motion of the sea was too much for him, so the day following he requested that he might be set on shore again, which was done. The vessel was manned chiefly by Don Alvaro's men who, fearing to offend their master by common kindness to Xavier, left him exposed on the sands to a piercing north wind, till a friendly Portuguese merchant led him into his hut, which afforded only a very poor shelter. He lay thus in a high fever praying ceaselessly between spasms of delirium. He got weaker and weaker till at last, in the early morning of December 3, which fell on a Saturday, "I [Antony] could see that he was dying and put a lighted candle in his hand. Then, with the name of Jesus on his lips, he rendered his soul to his Creator and Lord with great repose and quietude." St. Francis was only forty-six years old, of which he had passed eleven in the East.

At the suggestion of somebody from the ship the coffin had been packed with lime around the body in case it should later be desired to move the remains. Ten weeks and more later the grave and the coffin were opened. The lime being removed from the face, it was found quite incorrupt and fresh-colored, the rest of the body in like manner whole and smelling only of lime. The body was accordingly carried into the ship and brought to Malacca, where it was received with great honor by all, except Don Alvaro. At the end of the year it was taken away to Goa, where its continued incorruption was verified by physicians; there it still lies enshrined in the church of the Good Jesus. St. Francis Xavier was canonized in 1622, at the same time as Ignatius Loyola, Teresa of Avila, Philip Neri and Isidore the Husbandman — indeed a noble company.

ST. CHARLES BORROMEO, ARCHBISHOP OF MILAN AND CARDINAL

November 4

Patron Saint of Catechists; Seminarians

OF THE GREAT AND HOLY churchmen who in the troubled days of the sixteenth century worked for a true and much-needed reformation within the Church, and sought by the correction of real abuses and evil living to remove the basic excuses for the destructive and false reformation which was working such havoc in Europe, none was greater and holier than Cardinal Charles Borromeo; with Pope St. Pius V, St. Philip Neri and St. Ignatius Loyola he is one of the four outstanding public men of the so-called Counter-reformation. He was an aristocrat by birth, his father being Count Gilbert Borromeo, himself a man of talent and sanctity. His mother, Margaret, was a Medici, of the newly risen house of that name at Milan, whose younger brother became Pope Pius IV. Charles, the second of two sons in a family of six, was born in the castle of Arona on Lake Maggiore on October 2, 1538, and from his earliest years showed himself to be of a grave and devout disposition. At the age of twelve he received the clerical tonsure, and his uncle, Julius Caesar Borromeo, resigned to him the rich Benedictine abbey of SS. Gratinian and Felinus, at Arona, which had been long enjoyed by members of his family *in commendam.* It is said that Charles, young as he was, reminded his father that the revenue, except what was expended on his necessary education for the service of the Church, was the patrimony of the poor and could not be applied to any secular uses. Charles learned Latin at Milan and was afterwards sent to the University of Pavia. On account of an impediment in his speech and a lack of brilliance he was esteemed slow, yet he made good progress. The prudence and strictness of his conduct made him a model to the youth in the university, who had an evil reputation for vice. Count Gilbert made his son a strictly limited allowance from the income of his abbey, and we learn from his letters that young Charles was continually short of cash, owing to the necessity in his position of keeping up a household. It was not till after the death of both his parents that he took his doctor's degree, in his twenty-second year. He then returned to Milan, where he soon after received news that his uncle, Cardinal de Medici, was chosen pope, in 1559, at the conclave held after the death of Paul IV.

Early in 1560 the new pope created his nephew cardinal-deacon and on February 8 following nominated him administrator of the vacant see of Milan. However, he detained him at Rome and entrusted him with many duties. Pope Pius IV had announced soon after his election his intention of reassembling the council of Trent, which had been suspended in 1552. St. Charles used all his influence and energy to bring this about, amid the most difficult and adverse ecclesiastical and political conditions. He was successful, and in January 1562 the council was reopened.

St. Charles received the priesthood in 1563. Two months later he was consecrated bishop. He was not allowed to go to his diocese, and, in addition to his other duties, he had to supervise the drawing-up of the Catechism of the Council of Trent and the reform of liturgical books and church-music.

Milan had been without a resident bishop for eighty years, and was in a deplorable state. St. Charles arrived at Milan in April 1566 and went vigorously to work for the reformation of his diocese. When St.

Charles came first to reside at Milan he sold plate and other effects to the value of thirty thousand crowns, and applied the whole sum for the relief of distressed families. His almoner was ordered to give the poor two hundred crowns a month, besides whatever extra sums he should call upon the stewards for, which were very many. His liberality appears too in many monuments, and his help to the English College at Douay was such that Cardinal Allen called St. Charles its founder. He arranged retreats for his clergy and himself went into retreat twice a year, and it was his rule to confess himself every morning before celebrating Mass. He had a great regard for the Church's liturgy, and never said any prayer or carried out any religious rite with haste, however much he was pressed for time or however long the rite continued.

From this spirit of prayer and the love of God which burned within him, his words infused a spiritual joy into others, gained their hearts, and kindled a desire of persevering in virtue and cheerfully suffering all things for its sake. Partly by tender entreaties and zealous remonstrances and partly by inflexible firmness in the execution of these decrees, without favor, distinction of persons or regard to rank or pretended privileges, the saint in time overcame the obstinate and broke down difficulties which would have daunted the most courageous. He had even to contend with a handicap to his own preaching. An impediment in his speech seemed to disqualify him: this too he overcame by much patience and attention. "I have often wondered," says his friend Achille Gagliardi, "how it was that, without any natural eloquence or anything attractive in his manner, he was able to work such changes in the hearts of his hearers. He spoke but little, gravely, and in a voice barely audible — but his words always had effect." St. Charles directed that children in particular should be properly instructed in Christian doctrine. Not content with enjoining parish-priests to give public catechism every Sunday and holyday, he established the Confraternity of Christian Doctrine, whose schools are said to have numbered 740, with 3000 catechists and 40,000 pupils. Thus St. Charles was an originator of "Sunday-schools."

But the saint's reforms were far from being well received everywhere, and some were carried through only in the face of violent and unscrupulous opposition.

The religious order called Humiliati having been reduced to a few members, but having many monasteries and great possessions, had submitted to reform at the hands of the archbishop, but the order was thoroughly degenerate and the submission was unwilling and only apparent. They tried every means to prevail upon the pope to annul the regulations which had been made, and when these failed three priors of the order hatched a plot to assassinate St. Charles. One of the Humiliati themselves, a priest called Jerome Donati Farina, agreed to do the deed for forty gold pieces, which sum was raised by selling the ornaments from a church. On October 26, 1569, Farina posted himself at the door of the chapel in the archbishop's house, whilst St. Charles was at evening prayers with his household. An anthem by Orlando di Lasso was being sung, and at the words "It is time therefore that I return to Him that sent me," Charles being on his knees before the altar, the assassin discharged a gun at him. Farina made good his escape during the ensuing confusion, and St. Charles, imagining himself mortally wounded, commended himself to God. But it was found that the bullet had only struck his clothes in the back, raising a bruise, and fallen harmlessly to the floor. After a solemn thanksgiving and procession, he shut himself up for some days in a Carthusian monastery to consecrate his life anew to God.

Above all it was to form a virtuous and capable clergy that St. Charles directed his energies. When a certain exemplary priest was sick and likely to die, the great concern shown by the archbishop was a subject of comment. "Ah," he said, "you do not realize the worth of the life of one good priest." He was indefatigable in parochial visitations, and when one of his suffragans said he had nothing to do, wrote out for

ST. CHARLES BORROMEO
Orazio Borgianni. *St. Carlo Borromeo*, 1610/1616. Hermitage, St. Petersburg

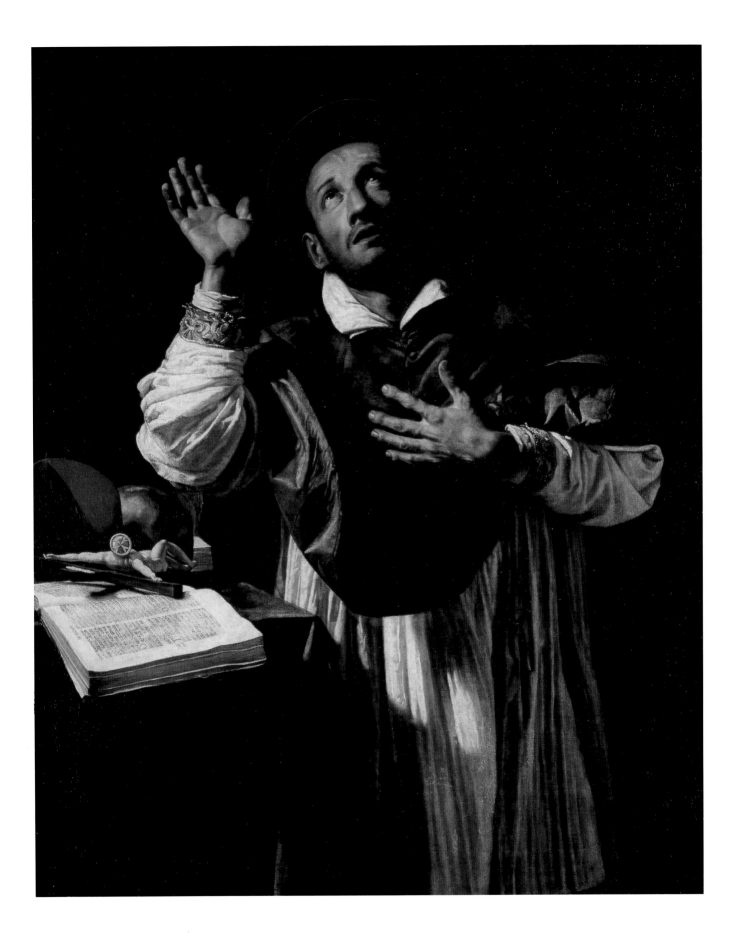

him a long list of episcopal duties, adding the comment to each one, "Can a bishop ever say that he has nothing to do?" In 1575 he went to Rome to gain the jubilee indulgence and in the following year published it at Milan. Huge crowds of penitents and others flocked to the city, and they brought with them the plague, which broke out with great virulence.

The governor fled and many of the rest of the nobility left the town. St. Charles gave himself up completely to the care of the stricken. The number of priests of his own clergy to attend the sick not being sufficient, he assembled the superiors of the religious communities and begged their help. The effect of this appeal was that a number of religious at once volunteered, and were lodged by Charles in his own house. He then wrote to the governor, Don Antony de Guzman, upbraiding him for his cowardice, and induced him and other magistrates to return to their posts and try to cope with the disaster. The hospital of St. Gregory was entirely inadequate, overflowing with dead, dying, sick and suspects, having nobody to care for them. The sight of their terrible state reduced St. Charles to tears, but he had to send for priests and lay helpers to the Alpine valleys, for at first the Milanese clergy would not go near the place. With the coming of the plague commerce was at an end and want began. It is said that food had to be found daily for sixty or seventy thousand persons. St. Charles literally exhausted all his resources in relief and incurred large debts on behalf of the sufferers. He even made use of the colored fabrics that hung up from his house to the cathedral during processions, having it made up into clothes for the needy. Empty houses for the sick were taken outside the walls and temporary shelters built, lay helpers were organized for the clergy, and a score of altars set up in the streets so that the sick could assist at public worship from their windows. But the archbishop was not content with prayer and penance, organization and distribution; he personally ministered to the dying, waited on the sick and helped those in want. The pestilence lasted with varying degrees of

intensity from the summer of 1576 until the beginning of 1578. When it was over St. Charles wanted to reorganize his cathedral chapter on a basis of common life, and it was the canons' refusal which finally decided him to organize his Oblates.

In 1580 St. Charles met St. Aloysius Gonzaga, then twelve years old, to whom he gave his first communion. At this time he was doing much traveling and the strain of work and worry was beginning to tell on him; moreover, he curtailed his sleep too much and Pope Gregory personally had to warn him not to overdo his Lenten fasting. Hearing that Duke Charles of Savoy was fallen sick at Vercelli, he went thither and found him, as was thought, at the last gasp. But the duke, seeing him come into his room, cried out, "I am cured." The saint gave him holy communion the next day, and Charles of Savoy was restored to health, as he was persuaded, by the prayers of St. Charles, and after the saint's death sent a silver lamp to be hung up at his tomb.

During 1584 his own health got worse and, after arranging for the establishment of a convalescent home in Milan, St. Charles went in October to Monte Varallo to make his annual retreat. He had clearly foretold to several persons that he should not remain long with them, and on the 24th he was taken ill. On the 29th he started off for Milan, where he arrived on All Souls', having celebrated Mass for the last time on the previous day at his birth-place, Arona. He went straight to bed and asked for the last sacraments, "At once." He received them from the archpriest of his cathedral; and with the words *Ecce venio*, "Behold I come," St. Charles quietly died in the first part of the night between the 3rd and 4th of November. He was only forty-six years old. Devotion to the dead cardinal spread rapidly, and in 1601 Cardinal Baronius, who called him "a second Ambrose," sent to the clergy of Milan an order of Clement VIII to change the anniversary mass *de requiem* into a solemn mass of the day; and St. Charles was formally canonized by Paul V in 1610.

ST. TERESA OF AVILA, VIRGIN, FOUNDRESS OF THE DISCALCED CARMELITES

October 15

Patron Saint of Spain; Headache Sufferers

S T. T E R E S A, one of the greatest, most attractive and widely appreciated women whom the world has ever known, and the only one to whom the title doctor of the Church is popularly, though not officially, applied, speaks with loving appreciation of her parents. The one was Alonso Sanchez de Cepeda, the other Beatrice Davila y Ahumada, his second wife, who bore him nine children; there were three children by his first marriage, and of this large family St. Teresa says, "all, through the goodness of God, were like our parents in being virtuous, except myself." She was born at or near Avila in Castile on March 28, 1515, and when only seven took great pleasure in the lives of the saints, in which she spent much time with a brother called Rodrigo, who was near the same age. The martyrs seemed to them to have bought Heaven very cheaply by their torments, and they resolved to go into the country of the Moors, in hopes of dying for their faith. They set out secretly, praying as they went that they might lay down their lives for Christ. But when they had got as far as Adaja they were met by an uncle, and brought back to their frightened mother, who reprimanded them; whereupon Rodrigo laid all the blame on his sister.

Her mother died when she was fourteen, and "as soon as I began to understand how great a loss I had sustained I was very much afflicted; and so I went before an image of our Blessed Lady and besought her with tears that she would be my mother." Teresa and Rodrigo began to spend hours reading romances and trying to write them themselves. "These tales," she says in the *Autobiography,* "did not fail to cool my good desires, and were the cause of my falling insensibly into other defects. I was so enchanted that I could not be content if I had not some new tale in my hands. I began to imitate the fashions, to take delight in being well dressed, to have great care of my hands, to make use of perfumes, and to affect all the vain trimmings which my position in the world allowed." The change in Teresa was sufficiently noticeable to disturb the mind of her father, and he placed his daughter, who was then fifteen, with a convent of Augustinian nuns in Avila where many young women of her rank were educated.

After a year and a half spent in this convent Teresa fell sick, and her father took her home, where she began to deliberate seriously about undertaking the religious life, in regard to which she was moved both by emotional attraction and repulsion. She told her father that she wished to become a nun, but he would by no means give his consent: after his death she might dispose of herself as she pleased. Fearing she might relapse, though she felt a severe interior conflict in leaving her father, she went secretly to the convent of the Incarnation of the Carmelite nuns outside Avila, where her great friend, Sister Jane Suarez, lived. "I remember . . . that whilst I was going out of my father's house, I believe the sharpness of sense will not be greater in the very instant or agony of my death than it was then. . . . There was no such love of God in me at that time as was able to quench that love which I bore to my father and my friends." She was then twenty years old and, the step being taken, Don Alonso ceased to oppose it. A year later she was professed. An illness, which seized her before her profession,

increased very much after it, and her father got her removed out of her convent. Sister Jane Suarez bore her company, and she remained in the hands of physicians. Their treatment only made her worse (she seems to have been suffering from malignant malaria), and she could take no rest day or night. The doctors gave her up, and she got worse and worse. Under these afflictions she was helped by the prayer which she had then begun to use. Her devout uncle Peter had put into her hands a little book of Father Francis de Osuna, called the *Third Spiritual Alphabet*. Taking this book for her guide she applied herself to mental prayer, but for want of an experienced instructor she made little solid progress. But after three years' suffering Teresa was restored to bodily health.

St. Teresa was favored by God very frequently with the prayer of quiet, and also with that of union, which latter sometimes continued a long time with great increase of joy and love, and God began to visit her with intellectual visions and interior communications. Though she was persuaded her graces were from God, she was perplexed, and consulted so many persons that, though binding them to secrecy, the affair was divulged abroad, to her mortification and confusion. One to whom she spoke was Francis de Salsedo, a married man who was an example of virtue to the whole town. He recommended that she should consult one of the fathers of the newly-formed Society of Jesus, to whom she made a general confession in which, with her sins, she gave him an account of her manner of prayer and her extraordinary favors. The father assured her these were divine graces, but told her she had neglected to lay the true foundation of an interior life. On his advice, though he judged her experiences in prayer to be from God, she endeavored for two months to resist and reject them. But her resistance was in vain.

Another Jesuit, Father Balthasar Alvarez, told her she would do well to beg of God that He would direct her to do what was most pleasing to Him, and for that purpose to recite every day the *Veni Creator Spiritus.*

She did so, and one day whilst she was saying that hymn she was seized with a rapture, in which she heard these words spoken to her within her soul, "I will not have you hold conversation with men, but with angels." The saint afterwards had frequent experience of such interior speeches and explains how they are even more distinct and clear than those which men hear with their bodily ears, and how they are also operative, producing in the soul the strongest impressions and sentiments of virtue, and filling her with an assurance of their truth, with joy and with peace. Whilst Father Alvarez was her director she suffered grievous persecutions for three years and, during two of them, extreme desolation of soul intermixed with gleams of spiritual comfort and enlightenment. It was her desire that all her heavenly communications should be kept secret, but they became a common subject in conversation and she was censured and ridiculed as deluded or an hypocrite. Father Alvarez, who was a good man but timorous, durst not oppose the tide of disapproval, though he continued to hear her confessions. In 1557 St. Peter of Alcantara came to Avila, and of course visited the now famous, or notorious, Carmelite. He declared that nothing appeared to him more evident than that her soul was conducted by the Spirit of God; but he foretold that she was not come to an end of her persecutions and sufferings. If the various proofs by which it pleased God to try Teresa served to purify her virtue, the heavenly communications with which she was favored served to humble and fortify her soul, to give her a strong disrelish of the things of this life, and to fire her with the desire of possessing God. In raptures she was sometimes lifted in the air. During these raptures or ecstasies the greatness and goodness of God, the excess of His love, the sweetness of His service, are placed in a great light and made sensibly manifest to the soul; all which she understands with a clearness which can be in no way expressed. The desire of Heaven with which these visions inspired St. Teresa could not be declared. "Hence also," she says, "I lost the fear of death, of

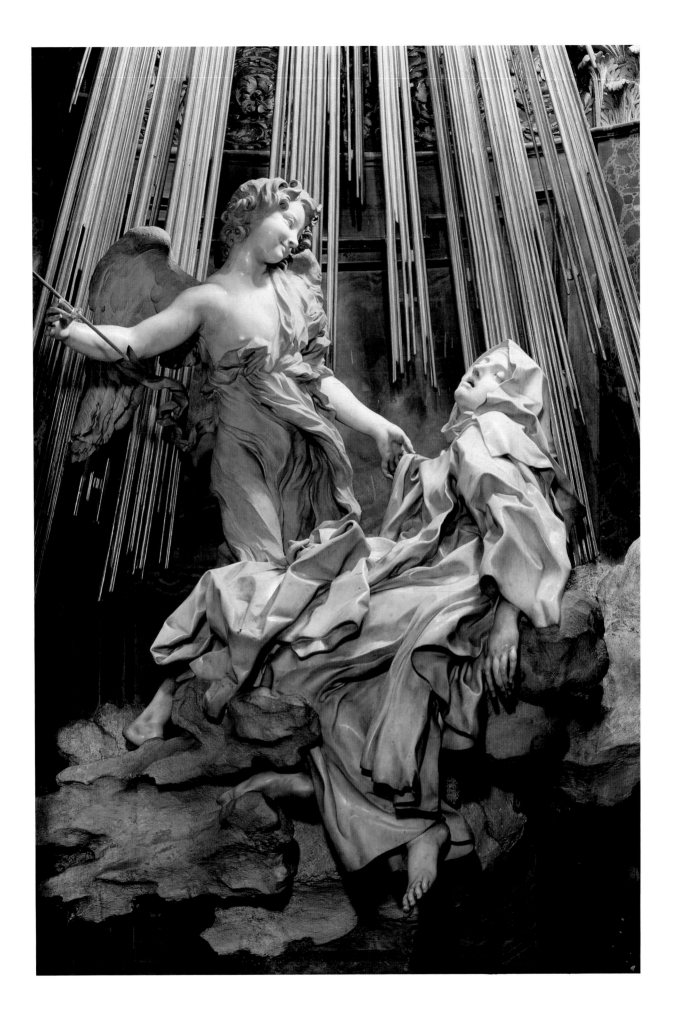

which I had formerly a great apprehension." During this time took place such extraordinary manifestations as spiritual espousals, mystical marriage, and the piercing *(transverberatio)* of the saint's heart.

Of this last she gives the following account: "I saw an angel close by me, on my left side, in bodily form. This I am not accustomed to see, unless very rarely. Though I have visions of angels frequently, yet I see them only by an intellectual vision, such as I have spoken of before. . . . He was not large, but small of stature, and most beautiful — his face burning, as if he were one of the highest angels, who seem to be all of fire: they must be those whom we call cherubim. . . . I saw in his hand a long spear of gold, and at the iron's point there seemed to be a little fire. He appeared to me to be thrusting it at times into my heart, and to pierce my very entrails; when he drew it out, he seemed to draw them out also, and to leave me all on fire with a great love of God. The pain was so great that it made me moan; and yet so surpassing was the sweetness of this excessive pain that I could not wish to be rid of it." Her response to this remarkable happening was in the following year (1560) to make a vow that she would in everything do always that which seemed to be the most perfect and best pleasing to God. To bind oneself by vow to such an undertaking is an action so humanly rash that it can only be justified by the successful keeping of it. St. Teresa kept her vow.

The Carmelite nuns, and indeed those of other orders as well, were very much relaxed from their early austerity and enthusiasm in sixteenth-century Spain. The parlor at Avila was a sort of social center for the ladies and gentlemen of the town, and the nuns went out of their enclosure on the slightest pretext; those who wanted an easy and sheltered life without responsibilities could find it in a convent. The size of the communities was both a cause and an effect of this mitigation; there were 140 nuns in the convent at Avila, and the result afterwards wrung from St. Teresa the cry, "Experience has taught me what a house full of women is like. God preserve us from such a state!" This state of things was taken for granted, there was no rebuking consciousness among religious at large that the nature of their daily life fell far short of what was

required by their profession according to the mind of their founders, so that when a Carmelite of the Incarnation house at Avila, her niece, began to talk of the possibility of the foundation of a small community bound to a more perfect way of life the idea struck St. Teresa not as a very natural one but as an inspiration from Heaven. She had been a nun for 25 years: she now determined to undertake the establishment of such a reformed convent, and received a promise of immediate help from a wealthy widow, Doña Guiomar de Ulloa. The project was approved by St. Peter of Alcantara, St. Louis Bertrand, and the Bishop of Avila, and Teresa procured the license and approbation of Father Gregory Fernandez, prior provincial of the Carmelites; but no sooner had the project taken shape than he was obliged by the objections which were raised to recall his license. A storm fell upon Teresa through the violent opposition which was made by her fellow nuns, the nobility, the magistrates and the people. Father Ibañez, a Dominican, secretly encouraged her, and assisted Doña Guiomar to pursue the enterprise, together with Doña Juana de Ahumada, a married sister of the saint, who began with her husband to build a new convent at Avila in 1561, but in such a manner that the world took it for a house intended for herself and her family. Their son Gonzalez, a little child, was crushed by a wall which fell upon him while playing around this building, and he was carried without giving any signs of life to Teresa, who, taking him in her arms, prayed to God and after some minutes restored him perfectly sound to his mother, as was proved in the process of the saint's canonization. The child used afterwards often to tell his aunt that it was her duty to forward his salvation by her prayers, seeing it was owing to her that he was not long ago in Heaven.

St. Teresa was certainly endowed with great natural talents. The sweetness of her temperament, the affectionate tenderness of her heart, and the liveliness of her wit and imagination, poised by an uncommon maturity of judgment and what we should now call psychological insight, gained the respect of all and the love of most. It was no mere flight of fancy which caused the poet Crashaw to refer both to "the eagle"

and to "the dove" in St. Teresa. She stood up when need be to high authorities, ecclesiastical and civil, and would not bow her head under the blows of the world. It was no hysterical defiance when she bade the prior provincial, Father Angel, "Beware of fighting against the Holy Ghost"; it was no authoritarian conceit that made her merciless to a prioress who had made herself unfit for her duties by her austerities. It is as the dove that she writes to her erring nephew, "God's mercy is great in that you have been enabled to make so good a choice and to marry so soon, for you began to be dissipated when you were so young that we might have had much sorrow on your account." Her wit and "forthrightness" were sublimely good-tempered, even when she used them, as sword or hammer, to drive in a rebuke. When an indiscreet man praised the beauty of her bare feet she laughed and told him to have a good look at them for he would never see them again. The quality of St. Teresa is seen very clearly in her selection of novices for the new foundations. Her first requirement, even before any promise of a considerable degree of piety, was intelligence. A person can train herself to piety, but more hardly to intelligence, by which she meant neither cleverness nor imagination, but a power of good judgment. "An intelligent mind is simple and submissive; it sees its faults and allows itself to be guided. A mind that is deficient and narrow never sees its faults, even when shown them. It is always pleased with itself and never learns to do right."

By the time of the separation between the two observances of the Carmelite Order in 1580 St. Teresa was sixty-five years old and quite broken in health. During her last two years she saw her final foundations, making them seventeen in all: foundations that had been made not only to provide homes of contemplation for individuals but as a work of reparation for the destruction of so many monasteries by Protes-

tantism, notably in the British Isles and Germany. A cruel trial was reserved for her last days. The will of her brother Don Lorenzo, whose daughter was prioress at Valladolid, was in dispute and St. Teresa was drawn unwillingly into the proceedings. A lawyer was rude to her, and to him she said, "Sir, may God return to you the courtesy you have shown to me." But before the conduct of her niece she was speechless and impotent: for the prioress of Valladolid, hitherto an irreproachable religious, showed her aunt the door of the convent of which she was foundress and told her never more to return to it. The last foundation, at Burgos, was made under difficulties, and when it was achieved in July 1582 St. Teresa wished to return to Avila, but was induced to set out for Alba de Tormes, where the Duchess Maria Henriquez was expecting her. Bd. Anne-of-St.-Bartholomew describes the journey, not properly prepared for and the foundress so ill that she fainted on the road; one night they could get no food but a few figs, and when they arrived at Alba St. Teresa went straight to bed. Three days later she said to Bd. Anne, "At last, my daughter, the hour of death has come." She received the last sacraments from Father Antony de Heredia, who asked her where she wished to be buried. She only answered, "Is it for me to say? Will they deny me a little ground for my body here?" When the Blessed Sacrament was brought in she sat up in bed, helpless though she was, and exclaimed, "O my Lord, now is the time that we may see each other!" Apparently in wonder at the things her Savior was showing her, St. Teresa-of-Jesus died in the arms of Bd. Anne at nine in the evening of October 4, 1582. The very next day the Gregorian reform of the calendar came into force and ten days were dropped, so that it was accounted October 15, the date on which her feast was ultimately fixed. Her body was buried at Alba de Tormes, where it remains. She was canonized in 1622.

ST. JOHN OF THE CROSS, DOCTOR OF THE CHURCH

November 24

JOHN DE YEPES WAS BORN at Fontiveros in Old Castile in 1542. He went to a poor-school at Medina del Campo and was then apprenticed to a weaver, but he showed no aptitude for the trade and was taken on as a servant by the governor of the hospital at Medina. He stopped there for seven years, already practicing bodily austerities, and continuing his studies in the college of the Jesuits. At twenty-one years of age he took the religious habit among the Carmelite friars at Medina, receiving the name of John-of-St.-Matthias. It was John's desire to be a lay-brother, but this was refused him. He had given satisfaction in his course of theological studies, and in 1567 he was promoted to the priesthood.

St. Teresa was then establishing her reformation of the Carmelites and, coming to Medina del Campo, heard of Brother John. Whereupon she desired to see him, admired his spirit, and told him that God had called him to sanctify himself in the Order of Our Lady of Mount Carmel; that she had received authority from the prior general to found two reformed houses of men; and that he himself should be the first instrument of so great a work. Soon after the first monastery of discalced (i.e. barefooted) Carmelite friars was established in a small and dilapidated house at Duruelo. St. John entered this new Bethlehem in a perfect spirit of sacrifice, and about two months after was joined by two others, who renewed their profession on Advent Sunday, 1568, St. John taking the new religious name of John-of-the-Cross. It was a prophetic choice. Almighty God, to purify his heart from all natural weaknesses and attachments, made him pass through the most severe interior and exterior trials. St. John, after tasting the first joys of contemplation, found himself deprived of all sensible devotion. This spiritual dryness was followed by interior trouble of mind, scruples and a disrelish of spiritual exercises, and, while the Devil assaulted him with violent temptations, men persecuted him by calumnies. The most terrible of all these pains was that of scrupulosity and interior desolation, which he describes in his book called *The Dark Night of the Soul.* On one occasion St. John was subjected to a bare-faced attempt by an unrestrained young woman of considerable attraction. Instead of the burning brand that St. Thomas Aquinas used on a like occasion, John used gentle words to persuade her of the error of her ways. By like means but in other circumstances he got the better of another lady, whose temper was so fierce that she was known as Robert the Devil.

In 1571 St. Teresa undertook, under obedience, the office of prioress of the unreformed convent of the Incarnation at Avila, and she sent for St. John to be its spiritual director and confessor. "He is doing great things here," she wrote to her sister, and to Philip II, "The people take him for a saint; in my opinion he is one, and has been all his life." He was sought out by seculars as well as religious, and God confirmed his ministry by evident miracles. In 1577, the provincial of Castile ordered St. John to return to his original friary

ST. JOHN OF THE CROSS
Nicolò Lorenese. *The Anticipation of the Coming of Christ by St. John of the Cross,* 1686. Sta. Maria della Vittoria, Rome

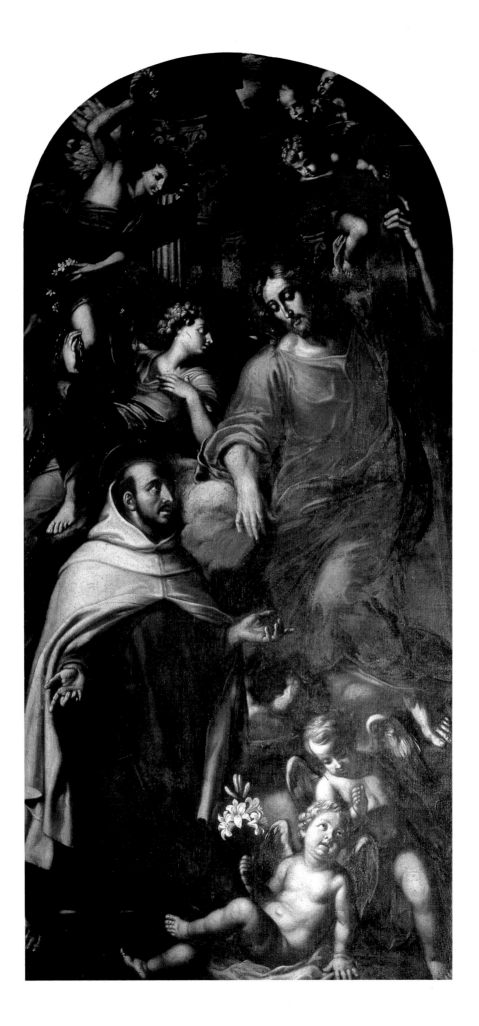

at Medina. He refused, on the ground that he held his office from the papal nuncio and not from the order. Whereupon armed men were sent, who broke open his door and carried him off. Knowing the veneration which the people at Avila had for him, they removed him to Toledo, where he was pressed to abandon the reform. When he refused he was locked up in a small cell and treated in a way that shows only too clearly how little, nearly sixteen hundred years after the Incarnation, the spirit of Jesus Christ had penetrated into the hearts of many who claimed His name.

St. John's cell measured some ten feet by six, and the one window was so small and high up that he had to stand on a stool by it to see to read his office. He was bloodily beaten — he bore the marks to his dying day — publicly in chapter, by order of Jerome Tostado, vicar general of the Carmelites in Spain and a consultor of the Inquisition. St. John's were all those sufferings described in St. Teresa's "Sixth Mansion" — insults, slanders, physical pain, agony of soul and temptation to give in. But, "Do not be surprised," he said in after years, "if I show a great love of suffering; God gave me a high idea of its value when I was in prison at Toledo."

On the night of the feast of the Assumption the Mother of God appeared to her suffering servant. "Be patient, my son," she seemed to say, "Your trials will soon be over." A few days later she appeared again, and showed him in vision a window overlooking the river Tagus. "You will go out that way," she said, "and I will help you." And so it happened, nine months after his imprisonment began, that John had his opportunity when he was allowed a few minutes exercise. He walked through the building, looking for that window; he recognized it, and went back to his cell. He had already begun to loosen the screws of the door lock; that night he broke it off and, though two visiting friars were sleeping close by the window, he let himself down from it on a rope of twisted coverlets and clothes. The rope was too short, he fell down the ramparts to the river bank, picked himself up unhurt, and followed a dog which jumped into an adjoining courtyard.

John made his way to the reformed friary of Beas de Segura and then to the near-by hermitage of Monte Calvario; in 1579 he became head of the college at Baeza, and in 1581 he was chosen prior of Los Martires, near Granada. He began those writings which have made him a doctor of the Church in mystical theology. In his teaching he was a faithful follower of ancient tradition: human life on earth is ordered to an end which is the perfection of charity and transformation in God by love; contemplation is not an end in itself, it does not stop at understanding, but it is for love and for union with God by love, and ultimately involves the experience itself of that union towards which everything is ordered. It is by love that contemplation is attained, and since this love is produced by faith — which alone can bridge the gulf between our understanding and the infinity of God — it is a living and lived faith that is the principle of mystical experience. Sometimes the austerities which he practiced seemed to exceed bounds; he only slept two or three hours in a night, employing the rest in prayer before the Blessed Sacrament. Three things he frequently asked of God: that he might not pass one day of his life without suffering something, that he might not die in office, and that he might end his life in humiliation and contempt. His confidence in God earned miraculous supplies for his monasteries, which firm confidence in divine providence he called the patrimony of the poor. He was frequently so absorbed in God that he was obliged to do violence to himself to treat of temporal affairs. This love appeared in a certain brightness which was seen in his countenance on many occasions, especially when he came from the altar. By experience in spiritual things and an extraordinary light of the Holy Ghost he had the gift of discerning spirits, and could not be easily imposed upon in what came from God.

After the death of St. Teresa in 1582 a disagreement within the ranks of the Discalced friars themselves became more pronounced. The chapter made St. John vicar for Andalusia and he applied himself to the correction of certain abuses, especially those arising from the necessity of religious going out of their

monasteries for the purpose of preaching. It was his opinion that their vocation and life was primarily contemplative. A chapter held at Madrid in 1588 received a brief from the Holy See authorizing a further separation of the Discalced Carmelites from the Mitigated. In spite of protests the venerable Father Jerome Gracián was deprived of all authority; Father Nicholas Doria was made vicar general; and the one province was divided into six, with a consultor for each (St. John himself was one) to help him in the government of the new congregation. This innovation caused grave discontent, especially among the nuns. The consequent troubles were eventually composed, but at a chapter held at Whitsun 1591, St. John spoke in defense both of Father Jerome Gracián and of the nuns. Father Nicholas Doria had suspected him all along of being in league with them, and he now took the opportunity of reducing St. John from all offices to the status of a simple friar and sending him to the remote friary of La Peñuela.

But there were those who would not leave St. John alone even here. When visiting Seville as vicar provincial he had had occasion to restrict the preaching activities of two friars and to recall them to the observance of their rule. They submitted at the time, but the rebuke had rankled, and now one of them, Father Diego, who had become a consultor of the congregation, went about over the whole province making inquiries about St. John's life and conduct, trumping up accusations, and boasting that he had sufficient proofs to have him expelled from the order. Many at that time forsook him, afraid of seeming to have any dealings with him, and burnt his letters lest they might be involved in his disgrace. St. John in the midst of all this was taken ill, and the provincial ordered him to

leave Peñuela and gave him the choice to go either to Baeza or Ubeda. The first was a convenient convent and had for prior a friend of the saint. At the other Father Francis was prior, the other person whom he had corrected with Father Diego. St. John chose this house of Ubeda. The fatigue of his journey made him worse, he suffered great pain, and submitted cheerfully to several operations. But the unworthy prior treated him with inhumanity, forbade any one to see him, changed the infirmarian because he served him with tenderness, and would not allow him any but the ordinary food, refusing him even what seculars sent in for him. This state of affairs was brought to the notice of the provincial who came to Ubeda, did all he could for the saint, and reprimanded Father Francis so sharply that he was brought to repentance for his malice. After suffering acutely for nearly three months, St. John died on December 14, 1591.

Immediately after his death there was an outburst of recognition on all hands, and clergy and laity flocked to his funeral. His body was removed to Segovia, the last house of which he had been prior. He was canonized in 1726. St. John-of-the-Cross was not learned when compared with some learned doctors, but St. Teresa saw in him a most pure soul to whom God had communicated great treasures of light and whose understanding was filled from on high. Her judgment is amply borne out by his writings, principally the poems and their accompanying commentaries, the *Ascent of Mount Carmel*, the *Dark Night of the Soul*, the *Living Flame of Love* and a *Spiritual Canticle;* and its rightness was superlatively recognized by the Church when, in 1926, he was proclaimed a doctor of the Church.

ST. ROSE OF LIMA, VIRGIN

August 30

Patron Saint of South America

ASIA, EUROPE AND AFRICA had been watered with the blood of many martyrs and adorned for ages with the shining example of innumerable saints, whilst the vast regions of America lay barren till the faith of Christ began to enlighten them in the sixteenth century, and this maiden appeared in that land like a rose amidst thorns, the first-fruits of its canonized saints. She was of Spanish extraction, born at Lima, the capital of Peru, in 1586, her parents, Caspar de Flores and Maria del Oliva, being decent folk of moderate means. She was christened Isabel but was commonly called Rose, and she was confirmed by St. Toribio, Archbishop of Lima, in that name only. When she was grown up, she seems to have taken St. Catherine of Siena for her model, in spite of the objections and ridicule of her parents and friends. One day her mother having put on her head a garland of flowers, to show her off before some visitors, she stuck in it a pin so deeply that she could not take off the garland without some difficulty. Hearing others frequently commend her beauty, and fearing lest it should be an occasion of temptation to anyone, she used to rub her face with pepper, in order to disfigure her skin with blotches. A woman happening one day to admire the fineness of the skin of her hands and her shapely fingers, she rubbed them with lime, and was unable to dress herself for a month in consequence. By these and other even more surprising austerities she armed herself against external dangers and against the insurgence of her own senses. But she knew that this would avail her little unless she banished from her heart self-love, which is the source of pride and seeks itself even in fasting and prayer. Rose triumphed over this enemy by humility, obedience and denial of her own will. She did not scruple to oppose her parents when she thought they were mistaken, but she never wilfully disobeyed them or departed from scrupulous obedience and patience under all trouble and contradictions, of which she experienced more than enough from those who did not understand her.

Her parents having been reduced to straitened circumstances by an unsuccessful mining venture, Rose by working all day in the garden and late at night with her needle relieved their necessities. These employments were agreeable to her, and she probably would never have entertained any thoughts of a different life if her parents had not tried to induce her to marry. She had to struggle with them over this for ten years, and to strengthen herself in her resolution she took a vow of virginity. Then, having joined the third order of St. Dominic, she chose for her dwelling a little hut in the garden, where she became practically a recluse. She wore upon her head a thin circlet of silver, studded on the inside with little sharp prickles, like a crown of thorns. So ardent was her love of God that as often as she spoke of Him the tone of her voice and the fire which sparkled in her face showed the flame which consumed her soul. This appeared most openly when she was in the presence of the Blessed Sacrament and when in receiving It she united her heart to her beloved in that fountain of His love.

God favored St. Rose with many great graces, but she also suffered during fifteen years of persecution from her friends and others, and the even more severe trial of interior desolation and anguish in her soul. The

Devil also assaulted her with violent temptations, but the only help she got from those she consulted was the recommendation to eat and sleep more; at length she was examined by a commission of priests and physicians, who decided that her experiences, good and bad, were supernatural. But it is permissible to think that some of them, if correctly reported, were due to natural physical and psychological causes. The last three years of her life were spent under the roof of Don Gonzalo de Massa, a government official, and his wife, who was fond of Rose. In their house she was stricken by her last illness, and under long and painful sickness it was her prayer, "Lord, increase my sufferings, and with them increase thy love in my heart." She died on August 24, 1617, thirty-one years old. The chapter, senate, and other honorable corporations of the city carried her body by turns to the grave. She was canonized by Pope Clement X in 1671, being the first canonized saint of the New World.

The mode of life and ascetical practices of St. Rose of Lima are suitable only for those few whom God calls to them; the ordinary Christian may not seek to copy them, but must look to the universal spirit of heroic sanctity behind them, for all the saints, whether in the world, in the desert or in the cloister, studied to live every moment to God. If we have a pure intention of always doing His will we thus consecrate to Him all our time, even our meals, our rest, our conversation and whatever else we do: all our works will thus be full.

ST. ROSE OF LIMA
Giovanni Battista Tiepolo. *The Virgin Mary and Child with Three Dominican Saints.* Sta. Maria del Rosario (Gesuati), Venice (left to right: SS. Rose of Lima, Catherine of Siena, and Agnes of Montepulciano)

ST. FRANCIS DE SALES, BISHOP OF GENEVA AND DOCTOR OF THE CHURCH, CO-FOUNDER OF THE ORDER OF THE VISITATION

January 29

Patron Saint of Authors; the Catholic Press; the Deaf; Journalists; Writers

ST. FRANCIS DE SALES was born at the Château de Sales in Savoy on August 21, 1567, and on the following day was baptized in the parish church of Thorens. In his fourteenth year Francis was sent to the University of Paris, which at that time, with its 54 colleges, was one of the great centers of learning. He was intended for the Collège de Navarre, as it was frequented by the sons of the noble families of Savoy, but Francis, fearing for his vocation in such surroundings, implored to be allowed to go to the Collège de Clermont, which was under Jesuit direction and renowned for piety as well as for learning.

Francis soon made his mark, especially in rhetoric and philosophy, and he ardently devoted himself to the study of theology. His heart was set upon giving himself wholly to God. He vowed perpetual chastity and placed himself under the special protection of the Blessed Virgin. He was, nevertheless, not free from trials. About his eighteenth year he was assailed by an agonizing temptation to despair. The love of God had always meant more than anything else to him, but he was now the prey of a terrible fear that he had lost God's grace and was doomed to hate Him with the damned for all eternity. This obsession pursued him day and night, and his health suffered visibly from the consequent mental anguish. It was a heroic act of pure love which brought him deliverance. "Lord," he cried, "if I am never to see thee in Heaven, this at least grant me, that I may never curse nor blaspheme thy holy name. If I may not love thee in the other world — for in Hell none praise thee — let me at least every instant of my brief existence here love thee as much as I can." Directly afterwards, while kneeling before his favorite statue of our Lady, in the church of St. Étienne des Grés, humbly saying the *Memorare,* all fear and despair suddenly left him and a deep peace filled his soul. This trial taught him early to understand and deal tenderly with the spiritual difficulties and temptations of others.

He was twenty-four when he took his final degree and became a doctor of law at Padua, and he rejoined his family at the Château de Thuille on the Lake of Annecy, where for eighteen months this singularly attractive youth led, outwardly at least, the ordinary life of a young noble of his time. That he should marry was his father's greatest desire, and the bride destined for him was a charming girl, the heiress of a neighbor of the family. However, by his distant, though courteous manner to the young lady Francis soon showed that he could not follow his father's wishes in this matter. For a similar motive he declined the dignity offered him of becoming a member of the senate of Savoy, an unusual compliment to so young a man. Francis had so far only confided to his mother, to his cousin Canon Louis de Sales, and to a few intimate friends his earnest desire of devoting his life to the service of God. An explanation with his father,

ST. FRANCIS DE SALES
Carlo Maratta. *The Virgin Appears to St. Francis de Sales.* Pinacoteca e Musei Comunali, Forli

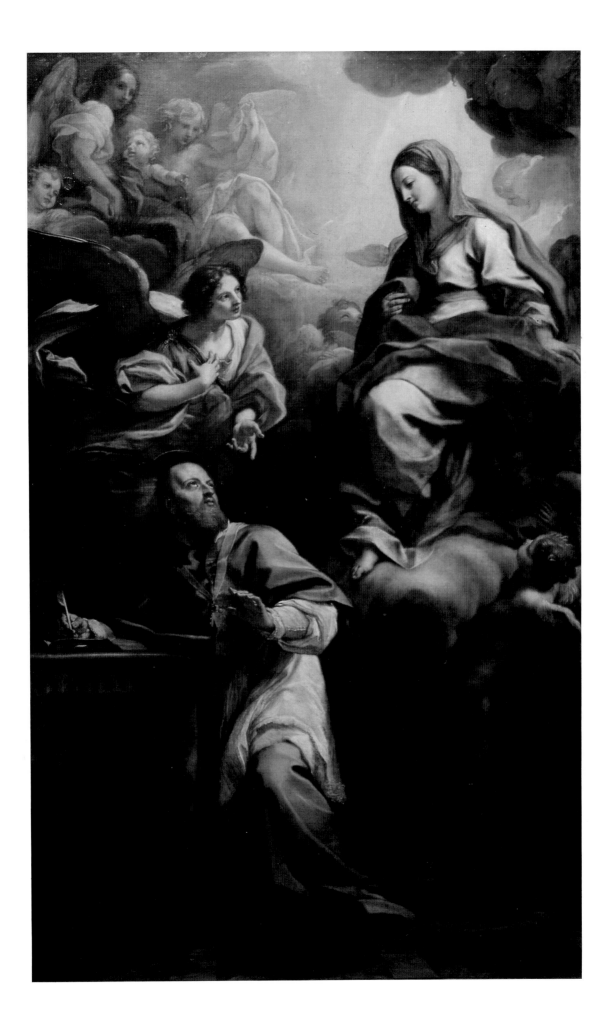

however, became inevitable. The death of the provost of the chapter of Geneva suggested to Canon Louis de Sales the possibility that Francis might be appointed to this post, and that in this way his father's opposition might relax. Aided by Claud de Granier, Bishop of Geneva, but without consulting any of the family, he applied to the pope, with whom the appointment rested, and the letters instituting Francis provost of the chapter were promptly received from Rome. When the appointment was announced to Francis his surprise was extreme, and it was only with reluctance that he accepted the unsought honor. Francis put on ecclesiastical dress the very day his father gave his consent, and six months afterwards, on December 18, 1593, he was ordained priest. He took up his duties with an ardor which never abated. He ministered to the poor with zealous love, and in the confessional devoted himself to the poorest and humblest with special predilection. He preached constantly, not only in Annecy, but in many other places. His style was so simple that it charmed his hearers, and, excellent scholar though he was, he avoided filling his sermons with Greek and Latin quotations, as was the prevailing custom. He was destined, however, soon to be called upon to undertake far more difficult and hazardous work.

At this time, owing to armed hostilities and the inroads of Protestantism, the religious condition of the people of the Chablais was deplorable. The bishop, summoning his chapter, put the whole matter before them, disguising none of the difficulties and dangers. Perhaps of all those present, the provost was the one who best realized the gravity of the task, but nevertheless he stood up and offered himself for the work. The bishop accepted at once, to Francis's great joy. But his father hastened to Annecy to stop what he called "this piece of folly." In his opinion it meant sending Francis to his death. Kneeling at the feet of the bishop he exclaimed, "My lord, I allowed my eldest son, the hope of my house, of my old age, of my life, to devote himself to the service of the Church to be a confessor, but I cannot give him up to be a martyr!" Francis had the disappointment of starting on his mission without his father's blessing. It was on September 14, 1594, Holy Cross day, that, traveling on foot and accompa-

nied only by his cousin, Canon Louis de Sales, he set forth to win back the Chablais.

Time went by with little apparent result to reward the labors of the two missioners, and all the while Francis's father was sending letters to his son, alternately commanding and imploring him to give up so hopeless a task. Francis did not lose heart, notwithstanding the enormous difficulties. He was constantly seeking new ways to reach the hearts and minds of the people, and he began writing leaflets setting forth the teaching of the Church as opposed to the errors of Calvinism. In every spare moment of his arduous day he wrote these little papers, which were copied many times by hand and distributed widely by all available means. These sheets, composed under such stress and difficulty, were later to form the volume of "Controversies," and in their original form are still preserved in the archives of the Visitation Convent at Annecy. This was the beginning of his activities as a writer. To all this work Francis added the spiritual care of the soldiers, quartered in the Château des Allinges, Catholic in name but an ignorant and dissolute crew. In the summer of 1595, going up the mountain of Voiron to restore an oratory of our Lady which had been destroyed by the Bernese, he was attacked by a hostile crowd, who insulted and beat him. Soon afterwards his sermons at Thonon began to be more numerously attended. The tracts too had been doing their work, and his patient perseverance under every form of persecution and hardship had not been without its effect. Conversions became more frequent, and before long there was a steady stream of lapsed Catholics seeking reconciliation with the Church.

After three or four years, when Bishop de Granier came to visit the mission, the fruits of Francis's self-sacrificing work and untiring zeal were unmistakable. Catholic faith and worship had been re-established in the province, and Francis could with justice be called the "Apostle of the Chablais."

Mgr. de Granier, who had long been considering Francis in the light of a possible coadjutor and successor, felt that the moment had now come to give effect to this. When the proposal was made Francis was at first unwilling, but in the end he yielded to the

persistence of the bishop, submitting to what he ultimately felt was a manifestation of the Divine Will. He proceeded to Rome, where Pope Clement VIII desired that he should be examined in his presence. On the appointed day there was a great assemblage of learned theologians and men of eminent intellect. The pope himself, Baronius, Bellarmine, Cardinal Frederick Borromeo (a cousin of St. Charles) and others put no less than thirty-five abstruse questions of theology to Francis, all of which he answered with simplicity and modesty, but in a way which proved his learning. His appointment as coadjutor of Geneva was confirmed, and Francis returned to take up his work with fresh zeal and energy.

Francis succeeded to the see of Geneva on the death of Claud de Granier in the autumn of 1602, and took up his residence at Annecy, with a household organized on lines of the strictest economy. To the fulfillment of his episcopal duties he gave himself with unstinted generosity and devotion. He thought out every detail for the government of his diocese, and apart from all his administrative work continued to preach and minister in the confessional with unremitting devotion. He organized the teaching of the catechism throughout the diocese, and at Annecy gave the instructions himself. Children loved him and followed him about. His unselfishness and charity, his humility and clemency, could not have been surpassed. In dealing with souls, though always gentle, he was never weak, and he could be very firm when kindness did not prevail. In his wonderful *Treatise on the Love of God,* he wrote, "The measure of love, is to love without measure," and this he not only taught, but lived. The immense correspondence which he carried on brought encouragement and wise guidance to innumerable persons who sought his help. His most famous book, the *Introduction to the Devout Life,* grew out of the casual notes of instruction and advice which he wrote to Mme. de Chamoisy, a cousin by marriage, who had placed herself under his guidance. He was persuaded to publish them in a little volume which, with some additions, first appeared in 1608. The book was at once acclaimed a spiritual masterpiece, and soon translated into many languages.

In 1622, the Duke of Savoy, going to meet Louis XIII at Avignon, invited St. Francis to join them there. Anxious to obtain from Louis certain privileges for the French part of his diocese, Francis readily consented, although he was in no state of health to risk the long winter journey. But he seems to have had a premonition that his end was not far off. Before quitting Annecy he put all his affairs in order, and took his leave as if he had no expectation of seeing people again. At Avignon he led as far as possible his usual austere life. But he was greatly sought after — crowds were eager to see him, and the different religious houses all wanted the saintly bishop to preach to them. In bitterly cold weather, through Advent and over Christmas, he continued his preaching and ministrations, refusing no demand upon his strength and time. On St. John's day he was taken seriously ill with some sort of paralytic seizure. He recovered speech and consciousness, and endured with touching patience the torturing remedies used in the hope of prolonging his life, but which only hastened the end. After receiving the last sacraments he lay murmuring words from the Bible expressive of his humble and serene trust in God's mercy. At last clasping the hand of a loving attendant, he whispered, "Advesperascit et inclinata est jam dies." — "It is towards evening and the day is now far spent." The last word he was heard to utter was the name of "Jesus."

Some people who thought St. Francis de Sales too indulgent towards sinners one day spoke freely to him on the subject. The saint replied, "If there were anything more excellent than meekness, God would certainly have taught it us; and yet there is nothing to which He so earnestly exhorts all, as to be 'meek and humble of heart.' Why would you hinder me from obeying the command of my Lord? Can we really be better advised in these matters than God Himself?" The tenderness of Francis was particularly displayed in his reception of apostates and other abandoned sinners. When these prodigals returned to him he used to say, speaking with all the tenderness of a father, "God and I will help you; all I require of you is not to despair: I shall take on myself the burden of the rest."

ST. VINCENT DE PAUL, FOUNDER OF THE CONGREGATION OF THE MISSION AND THE SISTERS OF CHARITY

July 19

Patron Saint of Charitable Groups

EVEN IN THE MOST degenerate ages, when the truths of the Gospel seem almost obliterated among the generality of those who profess it, God fails not to raise to himself faithful ministers to revive charity in the hearts of many. One of these instruments of the divine mercy was St. Vincent de Paul. He was a native of Pouy, a village near Dax, in Gascony. His parents occupied a very small farm, upon the produce of which they brought up a family of four sons and two daughters, Vincent being their third child. His father was determined by the strong inclinations of the boy and the quickness of his intelligence to give him a school education. He therefore placed him under the care of the Cordeliers (Franciscan Recollects) at Dax. Vincent finished his studies at the university of Toulouse, and in 1600 was ordained priest at the extraordinary age of twenty.

On his own showing, Vincent's ambition at that time was to be comfortably off. He was already one of the chaplains of Queen Margaret of Valois and, according to the bad custom of the age, he was receiving the income of a small abbey. He went to lodge with a friend in Paris. And there it was that we first hear of a change in him. His friend was robbed of four hundred crowns. He charged Vincent with the theft, thinking it could be nobody else; and in this persuasion he spoke against him with the greatest virulence among all his friends, and wherever he went. Vincent calmly denied the fact, saying, "God knows

the truth." He bore this slander for six months, when the true thief confessed. St. Vincent related this in a spiritual conference with his priests, but as of a third person; to show that patience, humble silence, and resignation are generally the best defense of our innocence, and always the happiest means of sanctifying our souls under slanders and persecution.

At Paris Vincent became acquainted with the holy priest Peter de Bérulle, afterwards cardinal. Bérulle conceived a great esteem for Vincent, and prevailed with him to become tutor to the children of Philip de Gondi, Count of Joigny. Mme. de Gondi was attracted by Vincent, and chose him for her spiritual director and confessor.

In the year 1617, whilst they were at a country seat at Folleville, Monsieur Vincent was sent for to hear the confession of a peasant who lay dangerously ill. He discovered that all the former confessions of the penitent had been sacrilegious, and the man declared before many persons and the Countess of Joigny herself, that he would have been eternally lost if he had not spoken to Monsieur Vincent. The good lady was struck with horror to hear of such past sacrileges. Far from the criminal illusion of pride by which some masters and mistresses seem persuaded that they owe no care, attention or provision for their dependants, she realized that masters lie under strict ties of justice and charity towards all committed to their care; and that they are bound to see them provided with the necessary spiritual helps for their salvation. To Vincent

ST. VINCENT DE PAUL
Unknown sculptor. *St. Vincent de Paul.* St. Peter's Basilica, Rome

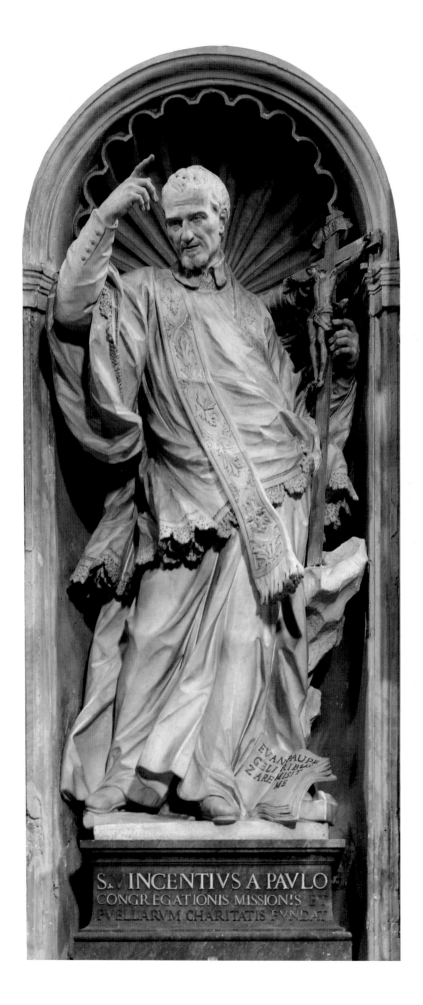

S. VINCENTIVS A PAVLO
CONGREGATIONIS MISSIONIS ET
PVELLARVM CHARITATIS FVNDAT

himself also appears to have come at that moment an enlightening as to the terrible spiritual state of the peasantry of France, and Mme. de Gondi had no difficulty in persuading him to preach in the church of Folleville, and fully to instruct the people in the duty of repentance and confession of sins. He did so; and such crowds flocked to him to make general confessions that he was obliged to call the Jesuits of Amiens to his assistance.

With the help of Father de Bérulle, St. Vincent left the house of the countess in 1617 to become pastor of Châtillon-les-Dombes. He there converted the notorious Count de Rougemont and many others from their scandalous lives. But he soon returned to Paris, and began work among the galley-slaves who were confined in the Conciergerie. He was officially appointed chaplain to the galleys (of which Philip de Gondi was general), and in 1622 gave a mission for the convicts in them at Bordeaux.

Mme. de Gondi now offered him an endowment to found a perpetual mission among the common people in the place and manner he should think fit, but nothing at first came of it, for Vincent was too humble to regard himself as fit to undertake the work. The countess could not be easy herself whilst she was deprived of his direction and advice; she therefore obtained from him a promise that he would never abandon the direction of her conscience so long as she lived, and that he would assist her at her death. But being extremely desirous that others, especially those who were particularly entitled to her care and attention, should want nothing that could contribute to their sanctification and salvation, she induced her husband to concur with her in establishing a company of able and zealous missionaries who should be employed in assisting their vassals and tenants, and the people of the countryside in general. This project they proposed to their brother, who was archbishop of Paris, and he gave the Collège des Bons Enfants for the reception of the new community. Its members were to renounce ecclesiastical preferment, to devote themselves to the smaller towns and villages, and to live from a common fund. St. Vincent took possession of this house in April 1625.

Vincent attended the countess till her death, which happened only two months later; he then joined his new congregation. In 1633 the prior of the canons regular of St. Victor gave to this institute the priory of Saint-Lazare, which was made the chief house of the congregation, and from it the Fathers of the Mission are often called Lazarists, but sometimes Vincentians, after their founder. They are a congregation of secular priests, who make four simple vows of poverty, chastity, obedience and stability. They are employed in missions, especially among country people, and undertake the direction of diocesan and other seminaries; they now have colleges and missions in all parts of the world. St. Vincent lived to see twenty-five houses founded in France, Piedmont, Poland and other places, including Madagascar.

This foundation, though so extensive and beneficial, could not satisfy the zeal of this apostolic man. He by every other means studied to procure the relief of others under all necessities, whether spiritual or corporal. For this purpose he established confraternities of charity (the first had been at Châtillon) to attend poor sick persons in each parish, and from them, with the help of St. Louise de Marillac, sprang the institute of Sisters of Charity, whose "convent is the sick-room, their chapel the parish church, their cloister the streets of the city." He invoked the assistance of the wealthy women of Paris and banded them together as the Ladies of Charity to collect funds for and assist in his good works. He procured and directed the foundation of several hospitals for the sick, foundlings, and the aged, and at Marseilles the hospital for the galley-slaves, which, however, was never finished. All these establishments he settled under excellent regulations, and found for them large sums of money. He instituted a particular plan of spiritual exercises for those about to receive holy orders; and others for those who desire to make general confessions, or to deliberate upon the choice of a state of life; and also appointed regular ecclesiastical conferences on the duties of the clerical state, to remedy somewhat the terrible slackness, abuses and ignorance that he saw about him. It appears almost incredible that so many and so great things could have been effected by

one man, and a man who had no advantages from birth, fortune, or any of those more obvious qualities which the world admires and esteems.

During the wars in Lorraine, being informed of the miseries to which those provinces were reduced, St. Vincent collected alms in Paris. He sent his missionaries to the poor and suffering in Poland, Ireland, Scotland, the very Hebrides, and during his own life over 1200 Christian slaves were ransomed in North Africa, and many others succored. He was sent for by King Louis XIII as he lay dying, and was in high favor with the queen regent, Anne of Austria, who consulted him in ecclesiastical affairs and in the collation of benefices; during the affair of the Fronde he in vain tried to persuade her to give up her minister Mazarin in the interests of her people. It was largely due to Monsieur Vincent that English Benedictine nuns from Ghent were allowed to open a house at Boulogne in 1652.

Amidst so many and so great matters his soul seemed always united to God. Under set-backs, disappointments and slanders he preserved serenity and evenness of mind, having no other desire but that God should be glorified in all things. Astonishing as it may seem, Monsieur Vincent was "by nature of a bilious temperament and very subject to anger." This would seem humble exaggeration but that others besides himself bear witness to it. But for divine grace, he tells us, he would have been "in temper hard and repellent, rough and crabbed"; instead, his will co-operated with grace and he was tender, affectionate, acutely sensible to the calls of charity and religion. Humility he would

have then to be the basis of his congregation, and it was the lesson which he never ceased to repeat. When two persons of unusual learning and abilities once presented themselves, desiring to be admitted into his congregation, he refused them both, saying, "Your abilities raise you above our low state. Your talents may be of good service in some other place. Our highest ambition is to instruct the ignorant, to bring sinners to repentance, and to plant the gospel spirit of charity, humility, meekness and simplicity in the hearts of Christians." He laid it down that, if possible, a man ought never to speak of himself or his own concerns, such discourse usually proceeding from, and nourishing in the heart, pride and self-love.

St. Vincent was greatly concerned at the rise and spread of the Jansenist heresy. "I have made the doctrine of grace the subject of my prayer for three months," he said, "and every day God has confirmed my faith that our Lord died for us all and that He desires to save the whole world." He actively opposed himself to the false teachers and no priest professing their errors could remain in his congregation.

Towards the end of his life he suffered much from serious ill-health. In the autumn of 1660 he died calmly in his chair, on September 27, being fourscore years old. Monsieur Vincent, the peasant priest, was canonized by Pope Clement XII in 1737, and by Pope Leo XIII he was proclaimed patron of all charitable societies, outstanding among which is the society that bears his name and is infused by his spirit, founded by Frederic Ozanam in Paris in 1833.

ST. ELIZABETH ANN SETON, WIDOW, FOUNDRESS OF THE DAUGHTERS OF CHARITY OF ST. JOSEPH

January 4

ELIZABETH WAS BORN in New York of a very distinguished family on August 28, 1774. Her mother Catherine Charlton was the daughter of the Episcopalian Rector of St. Andrew's church, Staten Island, while her father Dr. Richard Bayley was not only a noted physician, but also professor of anatomy at King's College, an institution later to develop into Columbia University.

In 1794 Elizabeth married a young merchant of ample means, William Magee Seton, and she bore him two sons and three daughters. But their happiness was short-lived. William Seton lost his fortune, and with it his health, and though they went to Italy in an attempt to effect a cure, William died there in December 1803. His widow remained on in Italy, where her natural piety was strongly attracted to Roman Catholicism. When, upon her return to the United States, this attraction became apparent, she met a good deal of opposition from her family and her friends. Nonetheless she persevered, and on March 14, 1805, she was received into the Catholic Church.

This step, which estranged her from her family, left her in some financial difficulty. She therefore welcomed the invitation from a priest to establish a school for girls in Baltimore. The school opened in June 1808. Even while her husband had been alive, Elizabeth had devoted much time to the care of the poor in New York, and had founded the Society for the Relief of Poor Widows with Small Children. So active had she and her friends been, that Elizabeth became known in the city as "the Protestant Sister of Charity." Now in Baltimore she again gathered around her a group of like-minded women, and there was the possibility of establishing formally a congregation of nuns. In the Spring of 1809 the community based on the school in Baltimore formed a community, the Sisters of St. Joseph, and from that time onwards Elizabeth, as their superior, was known as Mother Seton.

In the June of that same year Mother Seton and her community moved to the town of Emmitsburg, Maryland, and there, with some modifications and adaptations, the Sisters took over the rule of the Daughters of Charity of St. Vincent de Paul. The congregation from 1812 onwards was therefore known as the Daughters of Charity of St. Joseph. It spread rapidly. The sisters established orphanages and hospitals, but they gained most renown for their commitment to the then burgeoning parochial school system. In moments caught from running her congregation, Mother Seton not only herself worked with the poor and with the sick, but found time to compose music, write hymns and prepare spiritual discourses, many of which have since been published.

It was at Emmitsburg that Elizabeth died, on January 4, 1821, by which date her congregation, the first to be founded in America, numbered some twenty communities across the United States. Her cause was introduced in 1907, and she was canonized in 1975. She is the first native-born North American to be raised to the altars.

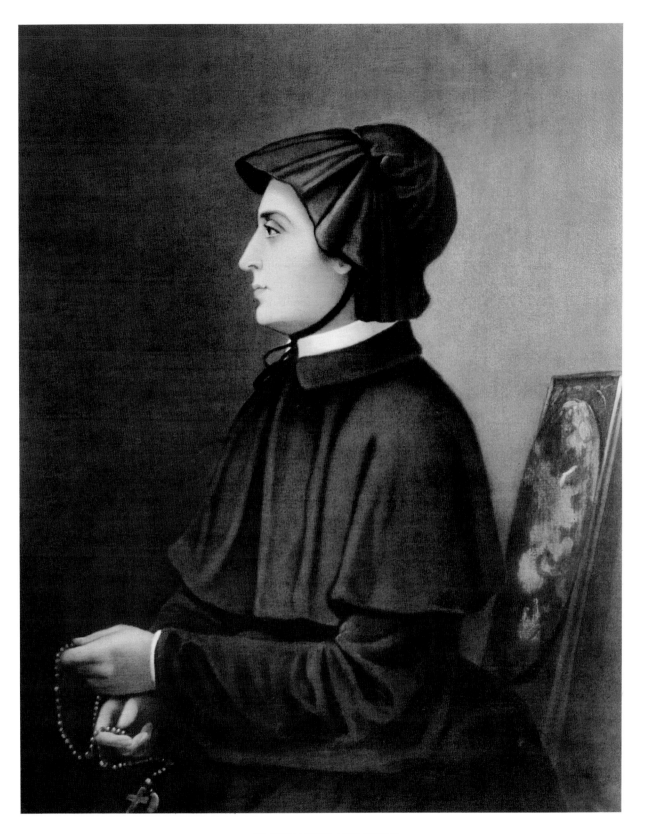

ST. ELIZABETH ANN SETON

Unknown artist. *The Filicchi Portrait of St. Elizabeth Ann Seton,* c. 1804.
St. Joseph's Provincial House Archives, Emmitsburg, Maryland

ST. CATHERINE LABOURÉ, VIRGIN

November 28

Zoé Labouré was the daughter of a yeoman-farmer at Fain-les-Moutiers in the Côte d'Or, where she was born in 1806. From the age of fourteen or so she heard a call to the religious life, and after some opposition was allowed to join the Sisters of Charity of St. Vincent de Paul at Châtillon-sur-Seine in 1830. She took the name of Catherine, and after her postulancy was sent to the convent in the rue du Bac at Paris, where she arrived four days before the translation of the relics of St. Vincent. On the evening of those festivities began the series of visions which were to make her name famous. The first of the three principal ones took place three months later, on July 18, when she was woken up suddenly by the appearance of a "shining child," who led her down to the sisters' chapel. There our Lady appeared and talked with her for over two hours, telling her that she would have to undertake a difficult task. On November 27 following, our Lady appeared to Sister Catherine in the same chapel, in the form of a picture and as it were standing on a globe with shafts of light streaming from her hands towards it, surrounded by the words: "O Mary, conceived free from sin, pray for us who turn to thee!" Then the picture turned about, and Sister Catherine saw on the reverse side a capital M, with a cross above it and two hearts, one thorn-crowned and the other pierced with a sword, below. She seemed to hear a voice telling her to have a medal struck representing these things, and promising that all who wore it with devotion should receive great graces by the intercession of the Mother of God.

Sister Catherine confided in her confessor, and he,

ST. CATHERINE LABOURÉ

Unknown sculptor. *St. Catherine Labouré as a Novice with the Blessed Virgin, Her Guardian.* Chapel of the Miraculous Medal, Paris

after making very careful investigations, was given permission by the archbishop of Paris to have the medal struck. In June 1832 the first 1500 were issued — the medal now known to Catholics throughout the world as "miraculous." Not until eight months before her death in 1876 did she speak to anyone else of the extraordinary graces she had received, and then she revealed them only to her superior, Sister Dufès. Her funeral was the occasion of an outburst of popular veneration, and a child of twelve, crippled from birth, was instantaneously cured at her grave soon after. St. Catherine Labouré was canonized in 1947.

ST. BERNADETTE, VIRGIN

February 11: The Appearing of Our Lady at Lourdes
April 16: The Death of St. Bernadette

ON FEBRUARY 11, 1858, three little girls, Bernadette Soubirous, aged fourteen, her sister Marie-Toinette, aged eleven, and their friend Jeanne Abadie, aged twelve, started out from their home in Lourdes to pick up wood. To reach a place where driftwood and broken branches were likely to be found on the bank of the Gave they had to pass in front of a grotto or natural cavity in the rocky cliff of Massabielle, and they had first to cross a shallow mill-stream. The two younger girls made their way over, but exclaimed at the icy coldness of the water. Bernadette hesitated to follow their example. When, however, the other two refused to help her to cross, she began to take off her stockings. Suddenly she heard beside her a rustling sound as of a gust of wind. She looked up and saw that the trees on the other side of the river were still, but she seemed to notice some waving of boughs in front of the grotto which she had nearly reached. She paid no further attention and had already put one foot into the water when the rustling sound came again. This time she looked intently towards the grotto and saw the bushes violently agitated, and then, in the opening of a niche behind and above the branches, she perceived "a girl in white, no taller than I, who greeted me with a slight bow of the head." The apparition, she afterwards said, was very beautiful: it was clad in white, with a blue girdle, whilst a long rosary hung over the arm. The figure seemed to the child to invite her to pray, and when Bernadette knelt down and, taking her rosary out of her pocket, began to say it, the apparition also took her rosary in her hand and passed the beads through her fingers, although the lips did

not move. No words were exchanged, but at the end of the five decades, the figure smiled, withdrew into the shadow and disappeared. When the other children returned and saw Bernadette on her knees, they laughed at her. Toinette said, "You were frightened: did you see anything?" Bernadette told her, making her promise to say nothing, but she told her mother that evening. Madame Soubirous questioned Bernadette. "You were mistaken . . . you saw a white stone." — "No," said the child, "she had a beautiful face." Her mother thought it might be a soul from Purgatory, and forbade her to return to the grotto.

She kept away the next two days, but some children who had heard about the apparition tried to persuade her to go. Madame Soubirous, harassed, sent her to ask advice of the Abbé Pomian, but he paid no attention: the mother then told her to ask her father, who after some demur said she might go. They returned home and, taking a bottle of holy water, they went to the grotto and knelt down to say the rosary. At the third decade "the same white girl showed herself in the same place as before." To quote Bernadette's own words. "I said, 'There she is,' and put my arm round the neck of one of them and pointed to the white girl, but she saw nothing." A girl called Marie Hillot gave her the holy water and she went forward and threw some towards the vision, which smiled and made the sign of the cross. Bernadette said, "If you come from God, come nearer." The vision advanced a little. At that moment, Jeanne Abadie with some other children came to the top of the rock above the grotto and threw a stone down which fell near Bernadette. The apparition disappeared, but Bernadette remained kneeling

and in a trance, with her eyes upraised. They could not make her move and went to fetch help. The miller Nicolau and his mother with great difficulty pulled her up the hill to his mill where she suddenly came to and cried bitterly. Here quite a crowd collected and her mother began to scold her — after which they all returned to Lourdes. Not one of Bernadette's relations nor the nuns who taught her the catechism would, for a moment, believe her story.

On Sunday, February 21, a large number of people accompanied her to the grotto, including Dr. Dozous, then a skeptic, who felt her pulse and tested her breathing while she was in the trance. The vision said to her, "You will pray to God for sinners." On Thursday the 25th, Bernadette, after repeating a decade of the rosary, dragged herself on her knees up the sloping floor of the cave, gently brushing aside the hanging sprays of foliage. At the back of the grotto she turned round and came back — still on her knees — and, after looking inquiringly at the niche, walked to the left of the grotto. What Bernadette herself related is as follows: The Lady had said to her, "Go, drink at the spring and wash in it." She did not know of any spring in the rock, so she turned towards the river. The Lady said she did not mean that. "She pointed with her finger, showing me the spring: I went there: I only saw a little dirty water; I put my hand in, but could not get enough to drink. I scratched and the water came — but muddy. Three times I threw it away, but the fourth time I could drink it." The child was seen to stoop, and when she rose, her face was bedaubed with mud. She again stooped and appeared to eat a little of a bright green plant that grew there. A moment later she rose and returned to Lourdes. The crowd began by scoffing, but they were amazed later in the day when the saucerful of muddy water was seen to be running into the Gave. Within a week, it was pouring forth its 27,000 gallons of water as it does to this day.

On March 2 there were 1700 people present when Bernadette saw the apparition for the thirteenth time. She was then bidden to tell the clergy that a chapel should be built and a procession held. Bernadette went to the curé, who received her harshly, and who gave the civil officials to understand that he strongly discouraged the whole business. On March 25 — Lady day — the Lady appeared and told her to come nearer. Bernadette then asked, "Would you kindly tell me who you are?" At these words the apparition smiled and made no reply. Bernadette repeated her question twice more, and then the Lady, joining her hands on her breast and raising her eyes to heaven answered, "I am the Immaculate Conception." Then she added, "I want a chapel built here." Bernadette replied, "I have already told them what you have asked me; but they want a miracle to prove your wish." The Lady smiled again and passed from Bernadette's sight.

The eighteenth and final apparition was on July 16, the feast of our Lady of Mount Carmel. The grotto was then barricaded to exclude the public and Bernadette could only see the top of the niche above the planks from the opposite bank of the Gave, and yet the figure seemed no farther off than before. Never again, after this day, had Bernadette Soubirous any vision of our Blessed Lady. To none but her had sight of any of these visions been granted.

Bernadette was born on January 7, 1844, the oldest of a family of six, and though christened Marie Bernarde, was known to the family and neighbors by the pet name of Bernadette. At the date of the first apparition the family were living in the dark airless basement of a dilapidated building in the rue des Petits Fossés. The child herself had not yet made her first communion and was regarded as a very dull pupil, but she was notably good, obedient and kind to her younger brothers and sisters, in spite of the fact that she was continually ailing.

The apparitions and the popular excitement which accompanied them did eventually have some effect in relieving the destitution of the Soubirous family, but for Bernadette, apart from the spiritual consolation of these visions, they left a heavy load of embarrassment from the ceaseless and indiscreet questionings which allowed her no peace.

In 1864 she offered herself to the sisters of Notre-Dame de Nevers and in 1866 she was allowed to join the novitiate in the mother-house of the order. Separation from her family and from the grotto cost her

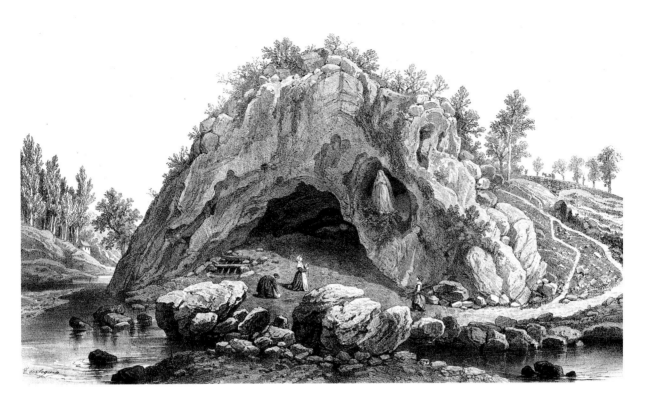

ST. BERNADETTE

The Appearance of the Virgin to St. Bernadette, 11 February 1858.

much, but with her fellow-novices at Nevers she was gay, while remaining still the humble and patient child she had always been. Her ill-health continued, so that within four months of her arrival she received the last sacraments and by dispensation was permitted to take her first vows. She recovered, however, and had strength enough to act as infirmarian and afterwards as sacristan, but the asthma from which she suffered never lost its hold, and before the end came she suffered grievously from further complications.

Characteristic of Bernadette were her simplicity of a truly child-like kind, her peasant "sanity," and her self-effacement. She likened herself to a broom: "Our Lady used me. They have put me back in my corner. I am happy there, and stop there. . . ." But even at Nevers she had sometimes to resort to little stratagems to avoid "publicity." Though her heart was always centered in Lourdes, she had no part in the celebrations connected with the consecration of the basilica in 1876. The abstention seems to have been in large measure her own voluntary choice; she preferred to efface herself. There are few words more pathetic than the cry of Bernadette from her cell at Nevers: "Oh! if only I could see without being seen." The conjecture suggests itself strongly that one of Bernadette's "secrets" must have been this, that she was never of her own free will to do anything which would attract to herself the notice of other people.

Bernadette Soubirous died on April 16, 1879; she was thirty-five years old. In 1933 she was canonized, and she now appears in the Church's official records as St. Mary Bernarda: but in the hearts and on the lips of the faithful she is always St. Bernadette.

Editor's note: The Church calendar includes two feasts for St. Bernadette — that commemorating her first vision of Our Lady at Lourdes, on February 11, and that for her death, on April 16. The preceding material is composed of excerpts from both entries in Butler's Lives of the Saints.

ST. THÉRÈSE OF LISIEUX, VIRGIN

October 15

Patron Saint of France; Russia; Aviators; Florists; Missions

THE SPREAD AND ENTHUSIASM of the *cultus* of St. Teresa-of-the-Child-Jesus is one of the most impressive and significant religious phenomena of contemporary times. Within a few years of her death in 1897 she became known throughout the world; her "little way" of simplicity and perfection in the doing of small things and discharge of daily duties has become a pattern to numberless "ordinary" folk; her autobiography, written at the command of her superiors, is a famous book; miracles and graces without number are attributed to her intercession.

The parents of the saint-to-be were Louis Martin, a watchmaker of Alençon, son of an officer in the armies of Napoleon I, and Azélie-Marie Guérin, a maker of *point d'Alençon*. Five of the children born to them survived to maturity, of whom Thérèse was the youngest. She was born on January 2, 1873, and baptized Marie-Françoise-Thérèse. Her childhood was happy, ordinary and surrounded by good influences. She had a quick intelligence and an open and impressionable mind, but there was no precocity or priggishness about the little Thérèse; when the older sister Léonie offered a doll and other playthings to Céline and Thérèse, Céline chose some silk braid, but Thérèse said, "I'll have the lot." "My whole life could be summed up in this little incident. Later . . . I cried out, 'My God, I choose all! I don't want to be a saint by halves.' "

In 1877 Mme. Martin died, and M. Martin sold his business at Alençon and went to live at Lisieux (Calvados), where his children might be under the eye of their aunt, Mme. Guérin, an excellent woman.

M. Martin had a particular affection for Thérèse, but it was an elder sister, Marie, who ran the household and the eldest, Pauline, who made herself responsible for the religious upbringing of her sisters. During the winter evenings she would read aloud to the family, and the staple was not some popular manual or effervescent "pious book" but the *Liturgical Year* of Dom Guéranger. When Thérèse was nine this Pauline entered the Carmel at Lisieux and Thérèse began to be drawn in the same direction. She had become rather quiet and sensitive, and her religion had really got hold of her. About this time she one day offered a penny to a lame beggar, and he refused it with a smile. Then she wanted to run after him with a cake her father had given her; shyness held her back, but she said to herself, "I will pray for that poor old man on my first communion day" — and she remembered to do it, five years later: a day "of unclouded happiness." For some years she had been going to the school kept by the Benedictine nuns of Notre-Dame-du-Pré, and among her remarks about it she says: "Observing that some of the girls were very devoted to one or other of the mistresses, I tried to imitate them, but I never succeeded in winning special favor. Happy failure, from how many evils have you saved me!" When Thérèse was nearly fourteen her sister Marie joined Pauline in the Carmel, and on Christmas eve of the same year Thérèse underwent an experience which she ever after referred to as her "conversion." "On that blessed night the sweet child Jesus, scarcely an hour old, filled the darkness of my soul with floods of light. By becoming weak and little, for love of me, He made me strong and brave; He put His own weapons into my

hands so that I went on from strength to strength, beginning, if I may say so, 'to run as a giant.' " Characteristically, the occasion of this sudden accession of strength was a remark of her father about her child-like addiction to Christmas observances, not intended for her ears at all.

During the next year Thérèse told her father her wish to become a Carmelite, and M. Martin agreed; but both the Carmelite authorities and the bishop of Bayeux refused to hear of it on account of her lack of age. A few months later she was in Rome with her father and a French pilgrimage on the occasion of the sacerdotal jubilee of Pope Leo XIII. At the public audience, when her turn came to kneel for the pope's blessing, Thérèse boldly broke the rule of silence on such occasions and asked him, "In honor of your jubilee, allow me to enter Carmel at fifteen." Leo was clearly impressed by her appearance and manner, but he upheld the decision of the immediate superiors. "You shall enter if it be God's will," he said, and dismissed her with great kindness. The pope's blessing and the earnest prayers made at many shrines during this pilgrimage bore their fruit in due season. At the end of the year the bishop, Mgr. Hugonin, gave his permission, and on April 9, 1888, Thérèse Martin entered the Carmel at Lisieux whither her two sisters had preceded her. "From her entrance," deposed her novice mistress, "she surprised the community by her bearing, which was marked by a certain dignity that one would not expect in a child of fifteen."

She was professed on September 8, 1890. A few days before she wrote to Mother Agnes-of-Jesus (Pauline): "Before setting out my Betrothed asked me which way and through what country I would travel. I replied that I had one only wish; to reach the height of the mountain of Love. . . . Then our Savior took me by the hand and led me into a subterranean way, where it is neither hot nor cold, where the sun never shines, where neither rain nor wind find entrance: a tunnel where I see nothing but a half-veiled light, the brightness shining from the eyes of Jesus looking down. . . . I wish at all costs to win the palm of St. Agnes. If it cannot be by blood it must be by love. . . ."

One of the principal duties of a Carmelite nun is

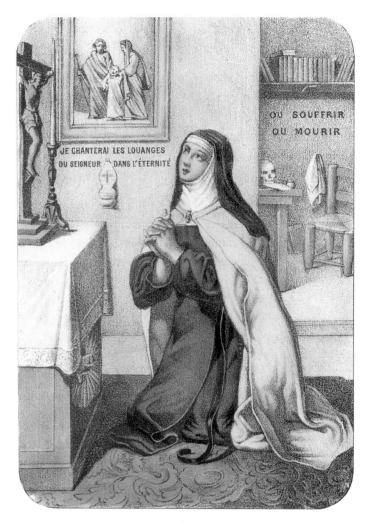

St. Thérèse of Lisieux, 19th cent. Private collection.

to pray for priests, a duty which St. Thérèse discharged with great fervor at all times. Although she was delicate she carried out all the practices of the austere Carmelite rule from the first, except that she was not allowed to fast. "A soul of such mettle," said the prioress, "must not be treated like a child. Dispensations are not meant for her." — "But it cost me a lot," admitted Thérèse, "during my postulancy to perform some of the customary exterior penances. I did not yield to this repugnance because it seemed to me that the image of my crucified Lord looked at me with beseeching eyes, begging these sacrifices." However, the physical mortification which she felt more than any

other was the cold of the Carmel in winter, which nobody suspected until she admitted it on her death-bed. "May Jesus grant me martyrdom either of the heart or of the body, or preferably of both," she had asked, and lived to say, "I have reached the point of not being able to suffer any more — because all suffering is sweet to me."

In 1893 Sister Thérèse was appointed to assist the novice mistress and was in fact mistress in all but name. On her experience in this capacity she comments, "From afar it seems easy to do good to souls, to make them love God more, to mold them according to our own ideas and views. But coming closer we find, on the contrary, that to do good without God's help is as impossible as to make the sun shine at night. . . . What costs me most is being obliged to observe every fault and smallest imperfection and wage deadly war against them." She was only twenty years old. In 1894 M. Martin died and soon after Céline, who had been looking after him, made the fourth Martin sister in the Lisieux Carmel. Eighteen months later, during the night between Maundy Thursday and Good Friday, St. Thérèse heard, "as it were, a far-off murmur announcing the coming of the Bridegroom": it was a hemorrhage at the mouth. At the time she was inclined to respond to the appeal of the Carmelites at Hanoi in Indo-China, who wished to have her, but her disease took a turn for the worse and the last eighteen months of her life was a time of bodily suffering and spiritual trials. The spirit of prophecy seemed to come upon her, and it was now that she made those three utterances that have gone round the world. "I have never given the good God aught but love, and it is with love that He will repay. After my death I will let fall a shower of roses." "I will spend my Heaven in doing good upon earth." "My 'little way' is the way of spiritual childhood, the way of

trust and absolute self-surrender." In June 1897 she was removed to the infirmary of the convent and never left it again; from August 16 on she could no longer receive holy communion because of frequent sickness. On September 30, with words of divine love on her lips, Sister Thérèse of Lisieux died.

So unanimous, swift and impressive was the rise of the *cultus* of Thérèse, miracles at whose intercession drew the eyes of the whole Catholic world upon her, that the Holy See, ever attentive to common convictions expressed by the acclamation of the whole visible Church, dispensed the period of fifty years which must ordinarily elapse before a cause of canonization is begun. She was beatified by Pope Pius XI in 1923, and in 1925 the same pope declared Teresa-of-the-Child-Jesus to have been a saint. Her feast was made obligatory for the whole Western church, and in 1927 she was named the heavenly patroness of all foreign missions, with St. Francis Xavier, and of all works for Russia.

St. Thérèse quite definitely and consciously set out to be a saint. Undismayed by the apparent impossibility of attaining so great a height of disinterestedness, she said to herself: "'The good God would not inspire unattainable desires. I may then, in spite of my littleness, aspire to holiness. I cannot make myself greater; I must bear with myself just as I am with all my imperfections. But I want to seek a way to Heaven, a new way, very short, very straight, a little path. We live in an age of inventions. The trouble of walking upstairs no longer exists; in the houses of the rich there is a lift instead. I would like to find a lift to raise me to Jesus, for I am too little to go up the steep steps of perfection.' Then I sought in the Holy Scriptures for some indication of this lift, the object of my desire, and I read these words from the mouth of the Eternal Wisdom: 'Whosoever is a *little one,* let him come to me' " (Isaiah lxvi 13).

LIST OF WORKS OF ART

PAGE 226
El Greco (Domenikos Theotocopoulos),
Spanish (b. Crete), 1541–1614.
St. Bernardino of Siena
Oil on canvas. 105⅞ x 56¼ in.
(271.5 x 145.5 cm)
Museo del Greco, Toledo
Scala/Art Resource, NY

PAGE 229
Jules Bastien-Lepage, French, 1848–1884.
Joan of Arc, 1879
Oil on canvas. 100 x 110 in.
(254 x 279.4 cm)
Metropolitan Museum of Art, New York
Gift of Erwin Davis, 1889 (89.21.1)

PAGE 233
Giovanni Battista Caracciolo,
Neapolitan, 1578–1635. *St. Ignatius in
Glory and the Works of the Jesuit Fathers*,
c. 1629
Oil on canvas. 17⅞ x 13⅞ in.
(46 x 35.5 cm)
Museo Correale di Terranova, Sorrento

PAGE 237
Bartolomé Estéban Murillo, Spanish,
1618–1682. *St. Francis Xavier*, c. 1670
Oil on canvas. 86⁹⁄₁₆ x 63⅞ in.
(221.3 x 163.8 cm)
Wadsworth Athenaeum, Hartford
The Ella Gallup Sumner and Mary Catlin
Sumner Collection Fund

PAGE 241
Orazio Borgianni, Italian (Roman
School), 1578–1616. *St. Carlo Borromeo*,
1610/16
Oil on canvas. 60 x 48½ in.
(152.5 x 123 cm)
Hermitage, St. Petersburg
Inv. No. 2357

PAGE 245
Gianlorenzo Bernini, Italian, 1598–1680.
The Ecstasy of St. Teresa, 1645–1652
Marble sculpture.
Sta. Maria della Vittoria, Rome
Scala/Art Resource, NY

PAGE 249
Nicolò Lorenese. *The Anticipation of the
Coming of Christ* by St. John of the
Cross, 1686
Oil on canvas. 121 x 60½ in.
(310 x 155 cm)
Sta. Maria della Vittoria, Rome
Foto Father R. Palazzi, Carmelo, Rome

PAGE 253
Giovanni Battista Tiepolo, Venetian,
1696–1770. *The Virgin Mary and Child
with Three Dominican Saints*
Fresco.
Sta. Maria del Rosario (Gesuati), Venice
Erich Lessing/Art Resource, NY

PAGE 255
Carlo Maratta, Italian, 1625–1713.
The Virgin Appears to St. Francis de Sales
Oil on canvas. 130¼ x 80 in.
(335 x 205 cm)
Pinacoteca e Musei Comunali, Forli
Photograph: Giorgio Liverani

PAGE 259
Unknown sculptor. *St. Vincent de Paul*
Marble sculpture.
St. Peter's Basilica, Rome
© ARTEPHOT/NIMATALLAH

PAGE 263
Unknown artist. *The Filicchi Portrait of
St. Elizabeth Ann Seton*, c. 1804
Oil on canvas? (original destroyed)
St. Joseph's Provincial House,
Emmitsburg, Maryland
Courtesy St. Joseph's Provincial House
Archives

PAGE 264
Unknown sculptor.
*St. Catherine Labouré as a Novice with
the Blessed Virgin, Her Guardian*
Sculpture.
Chapel of the Miraculous Medal, Paris

PAGE 267
*The Appearance of the Virgin to
St. Bernadette, 11 February 1858*
Engraving.
Giraudon/Art Resource, NY

PAGE 269
St. Thérèse of Lisieux
Lithograph, 19th cent.
Private collection.
© ARTEPHOT/A.D.P.C.

ENDPAPERS
Procession of Virgin Saints, 6th cent.
S. Apollinave Nuovo, Ravenna
Mosaic
Scala/Art Resource, NY

A LIST OF PATRON SAINTS

Accountants: Matthew
Actors: Genesius; Vitus
Advertisers: Bernardino of Siena
Air travelers: Joseph of Cupertino
Airmen: Joseph of Cupertino; Our Lady
 of Loreto
Alsace: Odilia
Altarboys: John Berchmans
Anaesthetists: René Goupil
Animals
 Domestic: Antony the Abbot
 Wild: Blaise
Angina sufferers: Swithbert
Apulia: Nicholas
Aragon: George
Archers: Sebastian
Architects: Barbara; Thomas
Argentina: Our Lady of Lujan
Armenia: Bartholomew; Gregory the
 Illuminator
Armorers: Dunstan
Art: Catherine of Bologna
Artists: Luke
Asia Minor: John the Evangelist
Astronomers: Dominic
Athletes: Sebastian
Australia: Our Lady Help of Christians
Authors: Francis de Sales
Aviators: Joseph of Cupertino; Thérèse
 of Lisieux

Bakers: Elizabeth of Hungary;
 Honoratus; Nicholas
Bankers: Matthew
Barbers: Cosmas and Damian; Louis
Basket-makers: Antony the Abbot
Bavaria: Kilian
Beggars: Alexius; Giles

Belgium: Joseph
Bell-founders, guilds of: Agatha
Blacksmiths: Dunstan; Giles
Blind, the: Odilia; Raphael the
 Archangel
Blood banks: Januarius
Boatmen: Julian the Hospitaler
Bohemia: Ludmilla; Wenceslaus of
 Bohemia
Bookbinders: Peter Celestine
Bookkeepers: Matthew
Booksellers: John of God
Boy Scouts: George
Brazil: Peter of Alcantara
Brewers: Augustine; Luke; Nicholas of
 Myra
Bricklayers: Stephen
Brides: Nicholas
Broadcasters: Gabriel the Archangel
Builders: Barbara; Vincent Ferrer
Butchers: Adrian; Antony the Abbot;
 Luke

Cab drivers: Fiacre
Cabinetmakers: Anne
Canada: Anne; Joseph
Cancer victims: Peregrine Laziosi
Candlemakers: Bernard
Carpenters: Joseph
Catechists: Robert Bellarmine; Charles
 Borromeo
Catholic action: Francis of Assisi
Catholic press: Francis de Sales
Charitable groups: Vincent de Paul
Childbirth: Gerard Majella
Children: Nicholas
 Abandoned: Jerome Emiliani
 Convulsive: Scholastica

Foundlings: Holy Innocents
 Orphans: Jerome Emiliani
Chile: James the Greater; Our Lady of
 Mount Carmel
China: Joseph
Choirboys: Dominic Savio
Church, the: Joseph
Clerics: Gabriel the Archangel
Colombia: Louis Bertrand; Peter Claver
Comedians: Vitus
Cooks: Laurence; Martha
Coppersmiths: Maurus
Corsica: Alexander Sauli; Julia of
 Corsica
Cracow: Stanislaus
Crete: Titus
Cripples: Giles
Cyprus: Barnabas
Czechoslovakia: Wenceslaus of Bohemia

Dancers: Vitus
Deaf, the: Francis de Sales
Death, sudden, protection against:
 Thomas Aquinas
Denmark: Ansgar; Canute
Dentists: Apollonia
Desperate situations: Gregory of
 Neocaesarea; Jude (Thaddeus);
 Rita of Cascia
Dietitians (Hospital): Martha
Dominican Republic: Dominic; Our
 Lady of High Grace
Druggists: Cosmas and Damian; James
 the Less
Dying, the: Joseph
Dysentry sufferers: Matrona

Earthquakes: Emygdius

East Indies: Francis Xavier; Thomas
Ecologists: Francis of Assisi
Editors: John Bosco
Emigrants: Frances Xavier Cabrini
Engineers: Ferdinand III
England: Augustine of Canterbury; George; Gregory the Great
Epileptics: Dympna; Vitus
Ethiopia: Frumentius
Europe: Benedict
Eye-trouble sufferers: Hervé; Lucy

Falsely accused: Raymund Nonnatus
Farmers: George; Isidore the Farmer
Farriers: Eligius (Eloi); John the Baptist
Fathers of families: Joseph
Finland: Henry of Uppsala
Firemen: Florian
Fire prevention: Barbara; Catherine of Siena
First-communicants: Tarcisius
Fishermen: Andrew; Peter
Florists: Thérèse of Lisieux
Foreign missions: Francis Xavier
Foresters: John Gualbert
Founders: Barbara
France: Dionysius (Denis); Joan of Arc; Martin; Remigius (Rémi); Thérèse of Liseux
Funeral directors: Dismas; Joseph of Arimathea

Gardeners: Adelard; Dorothy; Fiacre; Gertrude of Nivelles; Phocas
Genoa: George
Germany: Boniface; Michael the Archangel; Peter Canisius
Girls: Agnes
Glassworkers: Luke
Goldsmiths: Anastasius; Dunstan
Gravediggers: Antony the Abbot
Greetings: Valentine
Greece: Andrew; Nicholas
Grocers: Michael the Archangel
Gunners: Barbara

Hairdressers: Martin de Porres
Hatters: James the Less
Headache sufferers: Teresa of Avila
Heart patients: John of God

Hospitals: Camillus de Lellis; John of God; Jude (Thaddeus)
 Administrators of: Basil the Great; Frances Xavier Cabrini
Hotelkeepers: Amand; Julian the Hospitaler
Housewives: Anne
Hungary: Stephen
Hunters: Eustachius; Hubert

India: Our Lady of Assumption
Infantrymen: Maurice
Interracial justice: Martin de Porres
Invalids: Rock (Roch)
Ireland: Brigid (Bride); Columba (Colmcille); Patrick
Italy: Bernardino of Siena; Catherine of Siena; Francis of Assisi

Japan: Francis Xavier; Peter Baptist
Jewelers: Eligius (Eloi); Dunstan
Journalists: Francis de Sales
Jurists: John Capistran

Knighthood: George

Laborers: Isadore; James the Greater; John Bosco
Lawyers: Thomas More; Yves
Learning: Ambrose
Leatherworkers: Crispin and Crispinian
Librarians: Jerome
Lighthouse keepers: Dunstan; Venerius
Lithuania: Casimir; John Cantius
Locksmiths: Dunstan
Lorraine: Nicholas
Lost articles: Antony of Padua
Lovers: Raphael the Archangel; Valentine

Madrid: Isadore the Farmer
Maidens: Catherine of Alexandria
Mariners: Nicholas of Tolentine
Medical technicians: Albert the Great
Mentally ill: Dympna
Merchants: Francis of Assisi; Nicholas of Myra
Messengers: Gabriel the Archangel
Metalworkers: Eligius (Eloi)
Mexico: Our Lady of Guadalupe

Missions: Francis Xavier; Thérèse of Lisieux
 Parish: Leonard of Port Maurice
Moscow: Boris
Mothers: Monica
 Expectant: Gerard Majella
Motorists: Christopher; Frances of Rome
Mountaineers: Bernard of Menthon
Music and musicians: Cecilia; Dunstan; Gregory the Great

Netherlands: Plechelm; Willibrord
New Zealand: Our Lady Help of Christians
North America: Isaac Jogues and Companions
Norway: Olaf of Norway
Notaries: Luke; Mark
Nurses: Agatha; Camillus de Lellis; John of God; Raphael the Archangel
Nursing service: Elizabeth of Hungary; Catherine of Siena

Orators: John Chrysostom
Orphans: Jerome Emiliani

Painters: Luke
Paraguay: Our Lady of the Assumption
Paratroopers: Michael the Archangel
Paris: Geneviève
Pawnbrokers: Nicholas
Peru: Joseph
Pharmacists: Cosmas and Damian; James the Greater
Philippines: Sacred Heart of Mary
Philosophers: Catherine of Alexandria; Justin
Physicians: Cosmas and Damian; Luke; Pantaleon; Raphael the Archangel
Pilgrims: James the Greater
Pilots: Joseph of Cupertino
Plague victims: Rock (Roch)
Plasterers: Bartholomew
Poets: Cecilia; David (Dewi)
Poisoning victims: Benedict
Poland: Casimir; Cunegund; Hyacinth; Stanislaus; Stephen
Police: Michael the Archangel
Poor, the: Antony of Padua; Laurence
Porters: Christopher

Portugal: Francis Borgia; George; Vincent

Postal workers: Gabriel the Archangel

Preachers: Catherine of Alexandria; John Chrysostom

Priests: John Vianney

Printers: Augustine; Genesius; John of God

Prisoners: Barbara; Dismas; Nicholas

Prisoners-of-war: Leonard

Prisons: Joseph Cafasso

Public relations: Bernardino of Siena
 For hospitals: Paul

Radiologists: Michael the Archangel

Radio workers: Gabriel the Archangel

Retreats: Ignatius of Loyola

Rheumatism sufferers: James the Greater

Romania: Nicetas

Rome: Philip Neri

Russia: Andrew; Boris; Nicholas; Thérèse of Lisieux; Vladimir of Kiev
 Catholics in: Vladimir of Kiev

Sailors: Brendan; Erasmus; Christopher; Cuthbert; Elmo; Eulalia; Peter Gonzales
 Storm-beset: Nicholas

Scandinavia: Ansgar

Scholars: Brigid

Scientists: Albert the Great

Scotland: Andrew; Columba (Colmcille); Margaret of Scotland; Palladius

Sculptors: Claude

Secretaries: Genesius

Seminarians: Charles Borromeo

Servants: Martha; Zita

Shepherds: Drogo

Shoemakers: Crispin and Crispinian

Sicily: Nicholas

Sick, the: Camillus de Lellis; John of God; Michael the Archangel

Silversmiths: Andronicus; Dunstan

Singers: Cecilia; Gregory the Great

Skaters: Lidwina

Skiers: Bernard

Skin diseases, sufferers from: Marculf

Slovakia: Our Lady of the Assumption

Smiths: Eligius (Eloi)

Social justice: Joseph

Social workers: Louise de Marillac

Soldiers: George; Ignatius of Loyola; Joan of Arc; Martin; Sebastian

South Africa: Our Lady of Assumption

South America: Rose of Lima

Spain: Euphrasius; Felix; James the Greater; John of Avila; Teresa of Avila

Speleologists: Benedict

Spiritual exercises: Ignatius of Loyola

Sri Lanka: Laurence

Stenographers: Cassian of Tangiers; Genesius

Stonecutters: Clement

Stonemasons: Barbara; Reinhold; Stephen

Students: Catherine of Alexandria; Thomas Aquinas

Surgeons: Cosmas and Damian; Luke

Sweden: Ansgar; Bridget; Gall; Sigfrid

Switzerland: Gall

Tailors: Homobonus

Tanners: Crispin and Crispinian; Simon

Tax collectors: Matthew

Teachers: Gregory the Great; John Baptist de la Salle

Telecommunications workers: Gabriel the Archangel

Telephone workers: Gabriel the Archangel

Television: Clare

Television workers: Gabriel the Archangel

Tertiaries: Eligius (Eloi); Louis

Theologians: Alphonsus Liguori; Augustine

Throat afflictions, sufferers of: Blaise

Thunderstorms, protection against: Thomas Aquinas

Travelers: Antony of Padua; Christopher; Gertrude of Nivelles; Julian the Hospitaler; Nicholas of Myra; Raphael the Archangel

United States: Immaculate Conception

Universities, colleges, and schools: Thomas Aquinas

Uruguay: Our Lady of Lujan

Venice: Mark

Verona: Zeno

Wales: David (Dewi)

Weavers: Anastasia; Anastasius; Paul the Hermit

West Indies: Gertrude

Westminster: Edward the Confessor

Widows: Paula

Winegrowers: Morand; Vincent

Wine merchants: Amand

Women
 Barren: Antony of Padua; Felicity
 In difficult labor: John Thwing
 In labor: Anne
 Married: Monica
 Pregnant: Gerard Majella; Margaret; Raymond Nonnatus

Workingmen: Joseph

Writers: Francis de Sales; Lucy

Yachtsmen: Adjutor

Youth: Aloysius Gonzaga; Gabriel Possenti; John Berchmans

DESIGNED BY SUSAN MARSH

COMPOSITION IN ADOBE MINION AND CHARLEMAGNE BY DIX TYPE INC.

PRINTED AND BOUND BY AMILCARE PIZZI, MILAN, ITALY